GERMAN PAINTINGS

OF THE FIFTEENTH

THROUGH SEVENTEENTH CENTURIES

THE COLLECTIONS OF THE
NATIONAL GALLERY OF ART
SYSTEMATIC CATALOGUE

German Paintings

OF THE FIFTEENTH THROUGH SEVENTEENTH CENTURIES

———

John Oliver Hand

WITH THE ASSISTANCE OF
Sally E. Mansfield

NATIONAL GALLERY OF ART · WASHINGTON

CAMBRIDGE UNIVERSITY PRESS

This publication was produced by the
Editors Office, National Gallery of Art, Washington
Editor-in-Chief, Frances P. Smyth
Production Manager, Chris Vogel
Senior Editor and Manager, Systematic Catalogue, Mary Yakush
Editor, Tam Curry

Designer, Klaus Gemming, New Haven, Connecticut
Typeset in Walbaum by Monotype Composition Company, Inc.,
Baltimore, Maryland
Printed in Hong Kong

FRONT COVER: Lucas Cranach the Elder, *A Princess of Saxony*, 1947.6.2
FRONTISPIECE: Master of the Saint Bartholomew Altar, *The Baptism of Christ*, 1961.9.78 (detail)

LIBRARY OF CONGRESS CATALOGING-IN-PUBLICATION DATA
Hand, John Oliver, 1941–
German paintings of the fifteenth through seventeenth centuries /
John Oliver Hand with the assistance of Sally E. Mansfield.—
(The Collections of the National Gallery of Art: systematic catalogue)
Includes bibliographical references and index.
 ISBN 0-89468-188-5
 1. Painting, German—Catalogs. 2. Painting, Renaissance—Germany
—Catalogs. 3. Painting, Modern—17th–18th centuries—Germany
—Catalogs. 4. Painting—Washington (D.C.)—Catalogs. 5. National
Gallery of Art (U.S.)—Catalogs. I. Mansfield, Sally E.
II. Title. III. Series: National Gallery of Art (U.S.).
Collections of the National Gallery of Art.
ND 565.H36 1993
759.3′074′753—dc20 92-44417
 CIP

CONTENTS

FOREWORD

German Paintings of the Fifteenth through Seventeenth Centuries is the fifth volume published in a series of systematic catalogues of the paintings, sculpture, and decorative arts belonging to the National Gallery of Art. When completed, the series will comprise more than thirty volumes and is intended to provide both the inquiring general visitor and the specialized community of scholars with thorough, accurate descriptions and cogent interpretations of the Gallery's extraordinary collections.

The National Gallery's collection of German paintings, although not large in number when compared with its holdings in other areas, is one of the finest in the United States. Thanks to the generosity of Andrew W. Mellon, Samuel H. Kress and the Samuel H. Kress Foundation, and other collectors such as Ralph and Mary Booth, it is possible for Gallery visitors to see excellent examples of fifteenth-century German painting. Works by artists such as the Master of the Saint Bartholomew Altar and Johann Koerbecke are represented, as are outstanding paintings by the great masters of the sixteenth century: Albrecht Dürer, Hans Holbein the Younger, and Lucas Cranach the Elder. The Gallery also holds Matthias Grünewald's *Small Crucifixion,* the only painting by Grünewald in the United States. The Widener Collection includes the only seventeenth-century painting in this catalogue, *The Satyr and the Peasant* by Johann Liss; attributed to Velázquez earlier in this century, it is now regarded generally as an autograph Liss of superior quality that engendered several copies.

German and Austrian painting have not received the attention in the United States accorded other areas of art history. The art of this region is, however, increasingly the subject of exhibition and study, and the Gallery has proudly presented exhibitions focused primarily on the graphic works of Albrecht Dürer and Hans Baldung Grien. John Hand, the Gallery's talented curator of early Netherlandish and German painting, is to be congratulated on this volume, the second of his systematic catalogues to appear in this series. It is anticipated that this catalogue, which combines the results of scholarly research with technical investigations conducted in the Gallery's conservation and scientific research laboratories, will foster a greater understanding and appreciation of the myriad pleasures for the eye and the mind offered by the German paintings in the National Gallery of Art.

Earl A. Powell III
Director

ACKNOWLEDGMENTS

It has taken almost five years to prepare this catalogue. During this time I have benefited immeasurably from the advice and assistance of many colleagues, and their specific contributions are acknowledged at appropriate places in the text. This catalogue contains the results of several technical investigations. Peter Klein of the Institut für Holzbiologie, Universität Hamburg, undertook the dendrochronological examination of the Gallery's panels and contributed an appendix on this subject. In 1981–1982 Molly Faries of Indiana University spent several months at the Gallery documenting with infrared reflectography the underdrawing in early Netherlandish and German paintings, and several of her reflectogram assemblies appear in this volume. I am also grateful to Katherine Crawford Luber, who generously shared the results of her technical investigation of Dürer's *Madonna and Child.* I thank Walter Angst for the accurate heraldic descriptions.

The staffs of the many museums in Europe and the United States that I visited or corresponded with were unfailingly helpful and hospitable. I am particularly grateful to Gisela Goldberg, Bernd Konrad, Fritz Koreny, Kurt Löcher, Jochen Luckhardt, and Karl Schütz in Germany and Austria for sharing their expertise. I also wish to thank Julius Böhler, Nancy C. Little, formerly of M. Knoedler & Co., and Gerald G. Stiebel as well as other dealers, galleries, and auction houses who granted me access to files or undertook provenance research.

A special note of thanks must be sounded for my former research assistant, Sally E. Mansfield. Without her thoroughness, tenacity, and superb organizational skills this catalogue would be inestimably poorer. Several entries are enriched by her art historical observations, and she is the author of the entry on the four panels depicting Saints Alban, Wolfgang, Valentine, and Alcuin

(1972.73.1–4) by a Tyrolean artist. It is a pleasure to acknowledge her assistance.

Within the Gallery I am extremely grateful to J. Carter Brown, director emeritus, for his sustained and enthusiastic support. Several departments were vital to the success of this project. The department of painting conservation not only examined every painting and prepared written reports but also on several occasions reexamined paintings and patiently answered my numerous questions. I am particularly indebted to systematic catalogue conservators Catherine Metzger, Paula de Cristofaro, and Elizabeth Walmsley as well as David Bull, Kermit Cederholm, Kristin Casaletto, Sarah Fisher, Ann Hoenigswald, Maria R. von Möller, Susanna Pauli, Kate Russell, and Michael Swicklik, and technicians Melissa Boring and Barbara Pralle. Valuable analyses were provided by Barbara Berrie and Michael Palmer of the scientific research department. Requests for interlibrary loans were handled with alacrity by Thomas McGill and Ted Dalziel, and my research in the photographic archives was ably assisted by Ruth Philbrick and her staff. In the registrar's office, the art handlers led by John Poliszuk and Daniel Shay safely and carefully moved paintings for examination and treatment. Richard Amt, Ira Bartfield, and their staffs in the department of photographic services did excellent work and cheerfully responded to requests for special photography. My deep thanks go to the following summer interns who assisted my research: Kelly Holbert, Daniel Levine, Louise Martinez, Cynthia Morris, and Tatjana Swihart. I am very grateful to the departmental secretaries, especially Renée Fitzpatrick and Julia Thompson, who typed the manuscript and endured with patience and good humor what must have seemed like countless revisions.

The manuscript was greatly improved by the

expert criticism and comment of the outside readers, Christiane Andersson and Martha Wolff. I am substantially indebted to Suzannah Fabing, coordinator of the systematic catalogue project, her successor Mary Yakush, and Frances Smyth, editor-in-chief, whose continued support, encouragement, and, when necessary, artful prodding, were essential to the successful and timely completion of this catalogue. It was a pleasure to work with editors Barbara Anderman and Tam Curry, and with designer Klaus Gemming. Last, but surely not least, I owe much to Dare Hartwell, whose love and inspiration are as perennial and as welcome as daffodils in the spring.

John Oliver Hand
Curator of Northern Renaissance Painting

Between the late Middle Ages and the modern era the frontiers of Germany and Austria, like those of other European nations, shifted in response to changing economic and political conditions. A glance at a map indicates how Germany's large land area guarantees it a pivotal position in central Europe. The region, including present-day Austria, is bounded on the west by the Netherlands, Belgium, and France, and on the east by Poland, Czechoslovakia, and Hungary. To the south are the Alps, and to the north, Jutland, the North Sea, and the Baltic Sea.

German history may be said to have begun in 911 with the election of a German king. After 962 the king was also crowned by the pope and became a Holy Roman Emperor. As codified by the Golden Bull of 1356, however, the emperor was chosen by an electoral college of seven princes. Of these, three were ecclesiastical: the archbishops of Mainz, Trier, and Cologne; and four were secular: the king of Bohemia, the duke of Saxony, the margrave of Brandenburg, and the count Palatine. This system promoted disunity and self-interest, and the emperor was often stymied by the electors' unwillingness to challenge local authority. Power was diffused among the electors, princes, clergy, and other territorial rulers. Furthermore, "imperial" cities under the protection of the emperor were autonomous and free of princely influence. Beginning with Frederick III, who became king in 1440 and was crowned emperor in 1452, Germany was ruled by members of the Habsburg family of Austria. Frederick's son Maximilian I reigned from 1493 to 1519, and his grandson Charles V reigned from 1519 to 1558; during this period much of the power and wealth of the Habsburgs derived from their holdings, gained through marriage, in the Netherlands and Spain. Thanks to their natural resources and mercantile activities, Germany and Austria also prospered.

Given Germany's large size and numerous territorial and political divisions, it is not surprising that German art between the late fourteenth and the sixteenth century is marked by a strong regional character. At the same time, however, there existed a psychological and linguistic unity and a sense of national identity. As part of the study of classical literature, German humanists, Conrad Celtis in particular, rediscovered Tacitus' *Germania* (an edition was published in Nuremberg in 1473), in which Germans of the first century A.D. are described and favorably compared with their Roman counterparts. Similarly, one of the factors contributing to the success of the Reformation was the outrage and resentment expressed by Martin Luther over the fact that money from the sale of indulgences was drained from Germany to support the papacy in Rome. The Reformation was undoubtedly the decisive event in Germany in the sixteenth century, but its effects were not felt equally in all places. Certain cities suffered upheaval and iconoclasm more than others, and while some artists fled the country, others continued to produce traditional religious images or to depict what have been called "Protestant" subjects such as *Christ Blessing the Children*. German art retained its vitality until the seventeenth century, when it was severely disrupted by the Thirty Years War (1618–1648) and overshadowed by new developments in Italy and Holland.

Although the National Gallery of Art possesses one of the finest collections of German paintings in the United States, its holdings are not large in number. Compared, for example, with the quantities of Italian, Dutch, or French paintings acquired by American collectors and museums, the number of German paintings in such collections is much smaller. I suspect the same is true of collections in Great Britain. In part this is because German paintings were less available; many al-

tarpieces are still in the churches for which they were commissioned or have been absorbed into German museums. Two world wars have also had a dampening effect on the interest in acquiring German painting. It appears that in the postwar period many German art historians turned their talents to the study of other schools of art. Moreover, attention has been focused on major artists and schools. The German genius for graphic art has always been recognized. Holbein, Grünewald, and the School of Cologne have been extensively studied, and it goes almost without saying that the literature on Dürer is enormous. The full range and brilliance of German painting is not generally known, and there is much research and reevaluation to be done. Happily, in recent years there has been increased activity in this field in the form of symposia, scholarly publications, and exhibitions often accompanied by excellent catalogues.

Of the 111 paintings given to the nation by Andrew W. Mellon in 1937, only 3 are German—2 superb portraits by Hans Holbein and a portrait purchased as by Dürer but now attributed to Hans Schäufelein. From the Widener Collection came Johann Liss' *The Satyr and the Peasant*, the only painting by a German artist in that collection and the only seventeenth-century picture in this catalogue. By far the greatest number of works were given to the National Gallery by the Samuel H. Kress Foundation, in three groups in 1952, 1959, and 1961. The Kress Collection is marked by both high quality and diversity, containing works by fifteenth-century masters as well as outstanding pictures by Dürer and the only painting by Matthias Grünewald in the United States, *The Small Crucifixion*. The National Gallery's holdings have been further enriched over the years by donations from Ralph and Mary Booth, Chester Dale, Adolph Caspar Miller, Clarence Y. Palitz, and Joanne Freedman. The Gallery continues to acquire excellent German paintings such as Hans Mielich's *A Member of the Fröschl Family*, purchased in 1984.

Entries in this volume are arranged alphabetically by artist. Each named artist is given a short biography and bibliography, with entries on his individual works following in order of their acquisition. Anonymous artists are also incorporated alphabetically under designations such as German, Master of Heiligenkreuz, or Tyrolean. In 1983 the National Gallery assigned new accession numbers by year of acquisition; these are followed by the old number in parentheses.

The following attribution terms are used to indicate the nature of the relationship to a named artist:

Workshop of: Produced in the named artist's workshop or studio, by students or assistants, possibly with some participation by the named artist. It is important that the creative concept is by the named artist and that the work may have been meant to leave the studio as his.

Attributed to: Indicates the existence of doubt as to whether the work is by the named artist.

School: Indicates a geographical distinction only and is used where it is impossible to designate a specific artist, his studio or followers.

The following conventions for dates are used:

1575	executed in 1575
c. 1575	executed sometime around 1575
1575–1580	begun in 1575, completed in 1580
1575/1580	executed sometime between 1575 and 1580
c. 1575/1580	executed sometime around the period 1575–1580

Dimensions are given in centimeters, height preceding width, followed by dimensions in inches in parentheses. Left and right refer to the viewer's left and right unless the context clearly indicates the contrary.

The author examined each painting jointly with the conservators. Except for the Dürer *Madonna and Child/Lot and His Daughters* and the portraits of *Margarethe Vöhlin* and *Hans Roth* by Strigel, each painting was removed from its frame. The front and back of every painting was

examined under visible light with the naked eye and with the assistance of a binocular microscope having a magnifying power up to 40×. The paintings were studied subsequently under ultraviolet light. All significant areas of retouching are discussed in the Technical Notes. X-radiographs are available for each painting; however, they are discussed in the Technical Notes only when the information they provide is pertinent to understanding the construction and condition of the painting, such as when they show reworking of the original composition. Each picture was also examined with infrared reflectography to reveal underdrawing and changes in composition. When useful information was discovered, reflectograms were prepared, although only those considered essential to the interpretation of a painting are discussed in the Technical Notes.

X-radiography was carried out with equipment consisting of a Eureka Emerald 125 MT tube, a Continental 0–110 kV control panel, and a Duocon M collumator. Kodak X-OMAT x-ray film was used. The x-radiograph composites were prepared from photographs developed from the film and assembled in a manner similar to the reflectogram composites described below.

Infrared reflectography was carried out with a vidicon system consisting of a Hamamatsu C/1000–03 camera fitted with either an N2606–10 or an N214 lead sulphide tube and a Nikon 55mm. macro lens with a Kodak 87A Wratten filter, a C/1000–03 camera controller, and a Tektronics 634 monitor. The reflectogram composites were created by splicing together photographs of the monitor images taken with a Nikon F3 camera, 55mm. macro lens, and Kodak Tmax 35mm. black and white film. The infrared reflectogram assemblies of the details of the *Madonna and Child* by Albrecht Dürer and *The Crucifixion* by the Workshop of Hans Mielich were collected with a modified Kodak thermal imaging camera adapted for the study of paintings. The modifications were made under the guidance of National Gallery conservators Catherine Metzger and Elizabeth Walmsley, whose research was funded by The Circle of the National Gallery of Art, and in consultation with John K. Delaney, Colin Fletcher, and Raymond Rehberg. The infrared reflectogram mosaic of the lower portion of the *Christ in Limbo* by the Workshop of Hans Mielich was digitized from the vidicon signal using IP-Lab Spectrum by Signal Analytics to download them onto a Perceptics frame grabber. The gray-scale values were adjusted using the program "Image" by Wayne Rasband of the National Institutes of Health, then Adobe Photoshop was used to assemble the composite reflectogram from the multiple images collected. The reflectogram composites for the *Madonna and Child*, *The Crucifixion*, and *Christ in Limbo* were printed with a Kodak XL7700 printer. Several of the reflectogram assemblies published in this catalogue were made in 1981–1982 by Molly Faries; the equipment she used is discussed in John Oliver Hand and Martha Wolff, *Early Netherlandish Painting*, Systematic Catalogue of the Collections of the National Gallery of Art (Washington, 1986), 261.

The majority of the paintings were executed on wooden supports. Joins between planks are parallel to the wood grain. The wood has been analyzed scientifically, and results are noted in the technical reports, unless the way in which the panel was cradled or marouflaged prevented a positive determination of the wood type. Dürer's *Portrait of a Clergyman (Johann Dorsch?)* is on parchment, and Johann Liss' *The Satyr and the Peasant* is on fabric.

Consistent with the technique of painting in northern Europe, the panels have a white ground layer, assumed to be chalk ($CaCo_3$) but analyzed as such in only a few cases. In most instances this was applied overall. Panels in engaged frames and those with gold leaf have thicker grounds. Since, with rare exceptions, no paint samples were taken, the paint medium has not been analyzed. The medium is presumably oil, except in a few instances where the application of paint as a buildup of hatched lines is more characteristic of an egg tempera technique. Most of the paintings exhibit a similar working technique. The paint film is quite thin although consisting of many layers. Generally, the layers were built up with wet-

in-wet, blended underlayers, followed by glazes and precise, fine details applied over the dried underlayers. For certain paintings energy dispersive x-ray fluorescence spectroscopy (XRF), a nondestructive analytical technique, was used to obtain elemental information and a preliminary determination of the pigments used by the artist. This was carried out with a Kevex 0750A spectrophotometer.

In the Provenance section parentheses indicate a dealer, auction house, or agent. A semi-colon indicates that the work passed directly from one owner to the next, while a period indicates uncertainty or a break in the chain of ownership. Every attempt has been made to be inclusive in citing references, especially for the earliest publications, but picture books and blatantly trivial publications have been omitted. Sales and exhibition catalogues cited in the provenance and exhibition sections are not repeated in the References list. A list of standard abbreviations used throughout the volume follows.

Abbreviations for Frequently Cited Periodicals

AB	The Art Bulletin
AdGM	Anzeiger des Germanisches Nationalmuseums
AQ	The Art Quarterly
ArtN	Art News
BMMA	The Metropolitan Museum of Art Bulletin
BurlM	The Burlington Magazine
Conn	The Connoisseur
GBA	Gazette des Beaux-Arts
JbBerlin	Jahrbuch der königlich preussischen Kunstsammlungen; Jahrbuch der preussischen Kunstsammlungen; Jahrbuch der Berliner Museen
JMMA	Metropolitan Museum of Art Journal
JWCI	Journal of the Warburg and Courtauld Institutes
MD	Master Drawings
RfK	Repertorium für Kunstwissenschaft
StHist	Studies in the History of Art
WRJ	Wallraf-Richartz-Jahrbuch

Anzelewsky 1971	Anzelewsky, Fedja. *Albrecht Dürer. Das malerische Werk*. Berlin, 1971.
Bartsch	Bartsch, Adam. *Le peintre graveur*. 21 vols. Vienna, 1802–1821.
Broadley 1960	Broadley, Hugh T. *German Painting in the National Gallery of Art*. Washington, 1960.
Cairns and Walker 1962	Cairns, Huntington, and John Walker. *Treasures from the National Gallery of Art*. New York, 1962.
Cairns and Walker 1966	Cairns, Huntington, and John Walker, eds. *A Pageant of Painting from the National Gallery of Art*. 2 vols. New York, 1966.
Cuttler, *Northern Painting*	Cuttler, Charles D. *Northern Painting from Pucelle to Bruegel, Fourteenth, Fifteenth, and Sixteenth Centuries*. New York, 1968.
DNB	*Dictionary of National Biography*. 66 vols. London, 1885–1901.
Eisler 1977	Eisler, Colin. *Paintings from the Samuel H. Kress Collection: European Schools Excluding Italian*. Oxford, 1977.
Kindlers	*Kindlers Malerei Lexikon*. 6 vols. Zurich, 1964–1971.
Kress 1951	National Gallery of Art. *Painting and Sculpture from the Kress Collection Acquired by the Samuel H. Kress Foundation 1945–1951*. Intro. by John Walker, text by William E. Suida. Washington, 1951.
Kress 1956	National Gallery of Art. *Paintings and Sculpture from the Kress Collection Acquired by the Samuel H. Kress Foundation 1951–1956*. Intro. by John Walker, text by William E. Suida and Fern Rusk Shapley. Washington, 1956.
Kress 1959	National Gallery of Art. *Paintings and Sculpture from the Samuel H. Kress Collection*. Washington, 1959.
Kuhn 1936	Kuhn, Charles L. *A Catalogue of German Paintings of the Middle Ages and Renaissance in American Collections*. Cambridge, Mass., 1936.
LexChrI	*Lexikon der christlichen Ikonographie*. 8 vols. Rome, Basel, and Vienna, 1968–1976.
Mellon 1949	National Gallery of Art. *Paintings and Sculpture from the Mellon Collection*. Washington, 1949. Reprinted 1953 and 1958.

NCathEnc	*New Catholic Encyclopedia.* 16 vols. New York and London, 1967.
NGA 1941	National Gallery of Art. *Preliminary Catalogue of Paintings and Sculpture.* Washington, 1941.
NGA 1975	National Gallery of Art. *European Paintings: An Illustrated Summary Catalogue.* Washington, 1975.
NGA 1985	National Gallery of Art. *European Paintings: An Illustrated Catalogue.* Washington, 1985.
Panofsky 1943	Panofsky, Erwin. *Albrecht Dürer.* 2 vols. Princeton, N.J., 1943. 4th ed. in 1 vol. *The Life of Albrecht Dürer.* Princeton, N.J., 1955.
Réau, *Iconographie*	Réau, Louis, *Iconographie de l'art chrétien.* 3 vols. in 6. Paris, 1955–1959.
Ryan and Ripperger, *The Golden Legend*	Ryan, Granger, and Helmut Ripperger, trans. *The Golden Legend of Jacobus Voragine.* 2 vols. London, 1941.
Seymour 1961 (Kress)	Seymour, Charles. *Art Treasures for America: An Anthology of Paintings & Sculpture in the Samuel H. Kress Collection.* London, 1961.
Shapley 1979	Shapley, Fern Rusk. *Catalogue of the Italian Paintings, National Gallery of Art.* 2 vols. Washington, 1979.
Stange *DMG*	Stange, Alfred. *Deutsche Malerei der Gotik.* 11 vols. Berlin and Munich, 1934–1961.
Thieme-Becker	Thieme, Ulrich, and Felix Becker. *Allgemeines Lexikon der bildenden Künstler von der Antike bis zur Gegenwart.* Leipzig, 1907–1950. Continuation by Hans Vollmer. *Allgemeines Lexikon der bildenden Künstler des XX. Jahrhunderts.* Leipzig, 1953–1962.
Thurston and Attwater	Thurston, Herbert, and Donald Attwater. *Butler's Lives of the Saints.* 4 vols. New York, 1956.
Walker 1956	Walker, John. *National Gallery of Art, Washington.* New York, 1956.
Walker 1963	Walker, John. *National Gallery of Art, Washington.* New York, 1963.
Walker 1976	Walker, John. *National Gallery of Art, Washington.* New York, 1976.
Wolff 1983	Wolff, Martha. *German Art of the Later Middle Ages and Renaissance in the National Gallery of Art.* Washington, 1983.

CATALOGUE

Albrecht Altdorfer

c. 1480/1488–1538

THE EXACT DATE and place of Altdorfer's birth are unknown, although he was associated with the Bavarian city of Regensburg for almost all of his life. He is first documented there in 1505 when he acquired citizenship rights and was called a "painter from Amberg," a small town north of Regensburg. Since one could become a citizen in Regensburg at age sixteen, it is possible for Altdorfer to have been born as late as 1488, although an earlier date seems more likely. There is no record of Altdorfer's early training or travels, but it has been suggested that his father was the painter and miniaturist Ulrich Altdorfer, last mentioned in Regensburg in 1491.

Altdorfer's signed and dated engravings and drawings first appeared in 1506 and were followed, in 1507, by several small paintings, notably the *Landscape with Satyr Family* (Gemäldegalerie, Berlin). Woodcut production began in 1511. On or around 1509 Altdorfer received a commission for the wings of an altarpiece for the monastery of Saint Florian in Linz. The sculptures that formed the center are no longer extant, but still in the monastery are the inner wings depicting the Passion of Christ and the outer wings with scenes from the Martyrdom of Saint Sebastian. The series occupied Altdorfer until 1518, the date on one of the panels. Altdorfer's work reflects the influence of Albrecht Dürer, Lucas Cranach the Elder, and Michael Pacher. Although there is no evidence for a trip to Italy, it is apparent that Altdorfer used Italian niello work and the engravings of Marcantonio Raimondi and Andrea Mantegna.

On 1 January 1513 Altdorfer bought a house in Regensburg, and it was around this time that he began working for Maximilian I. He participated in group projects such as the marginal drawings in Maximilian's Prayer Book (Bibliothèque Municipale, Besançon) and the woodcuts of the Triumphal Portal, both c. 1515, as well as the woodcuts of the Triumphal Procession, c. 1517/1518. The artist and his shop also produced a series of illuminations depicting the victorious battles of Maximilian (Graphische Sammlung Albertina, Vienna).

Throughout his life Altdorfer was involved in the municipal government of Regensburg. In 1517 he was a member of the council on external affairs (Ausseren Rates) and in this capacity was involved in the expulsion of the Jews, the destruction of the synagogue, and the construction of a church and shrine to the *Schöne Maria* on the site of the synagogue that occurred in 1519. Altdorfer made etchings of the interior of the synagogue and designed a woodcut of the cult image of the *Schöne Maria*. In 1525 and 1526 he held important positions on the city councils for external and internal affairs and was elected mayor in 1528. The town council, however, granted him time off to finish a painting promised for Duke Wilhelm IV of Bavaria. It is assumed that the painting in question was the *Battle of Alexander*, dated 1529 (Alte Pinakothek, Munich), a cosmic landscape with miniaturelike figures that is probably Altdorfer's most famous work. By 1527 Altdorfer was also architect for the city of Regensburg and in 1529 designed fortifications for protection against the Turks. The influence of Venetian, Milanese, and Lombard architecture, and to a lesser extent that of Bramante, can be seen in the prominent structure in his painting of *Susanna and the Elders*, 1526 (Alte Pinakothek, Munich). None of his architectural projects survives.

On 12 February 1538 Altdorfer died in Regensburg after making his last will and testament. The inventory of his estate, which ran to twenty pages, indicated that he was one of Regensburg's more prosperous citizens.

Along with Wolf Huber, Altdorfer is the outstanding representative of the "Danube School," a rather loose term for the artists active in the vicinity of the Danube River between Regensburg

and Vienna in the first years of the sixteenth century. The term, however, has also become a stylistic designation applied to artists not from the region. In the works of Altdorfer there is a nearly pantheistic synthesis of man and nature that has been compared both to the writings of Paracelsus and the Neoplatonists. His paintings assert the primacy of landscape, his figures are rarely individualized, and he produced only a handful of portraits. While Altdorfer seems to have had a large workshop, few individual members are identifiable. We do know that his brother, Erhard (c. 1480–1561), worked in his manner. Hans Mielich was in his shop in the 1530s and Mielich's miniature of 1536 for the Regensburg *Freiheitenbuch* (Museen der Stadt Regensburg) depicts Altdorfer along with other members of the city council.

Bibliography
Winzinger, Franz. *Albrecht Altdorfer. Die Gemälde*. Munich and Zurich, 1975.
Mielke, Hans. *Albrecht Altdorfer. Zeichnungen, Deckfarbenmalerei, Druckgraphik*. Exh. cat., Kupferstichkabinett, Berlin; and Museen der Stadt Regensburg. Berlin, 1988.

Workshop of Albrecht Altdorfer

1952.5.31a–c (1110)

The Rule of Bacchus,
The Fall of Man, The Rule of Mars

c. 1535
Wood
Left panel: 39 × 15.9 (15⅜ × 6¼);
 center panel: 39 × 31.5 (15⅜ × 12⅜);
 right panel: 39 × 15.7 (15⅜ × 6³⁄₁₆)
Samuel H. Kress Collection

Inscriptions
At top of left panel: [H]*VI* [S]*ANAS MEN*[T]*ES FE*
[BRIS] / *QVVM BACCHIC*[A] / *TVRBAT*
At top of right panel: *TVNC* [D]*VRIT*[E]*R* [PA]*CTVM* /
MISCET MARS IMPIVS / *ORBEM*

Labels
On the reverse of each panel is a National Gallery label
 bearing, in what appears to be black crayon: *CA
 3724*, the M. Knoedler & Co. stock number.[1]

Technical Notes: The present arrangement of these
panels is not the original one. Although they were prob-
ably a triptych, the original center panel is no longer
extant, and the present center panel once existed as
two separate images on the reverse of the wings. Adam
was on the reverse of *The Rule of Bacchus* and Eve was
on the reverse of *The Rule of Mars*. The work existed
as a diptych from 1891 on, and photographs from the
1930s and 1940s indicate that the two panels were
joined so that while the Adam and Eve panels faced
each other correctly, the Bacchus and Mars panels
were consequently incorrectly oriented.[2] Around 1950
the panels[3] were thinned to a veneer and marouflaged
to hardboard that was subsequently veneered; it is as-
sumed that at this time the fronts and backs were sepa-
rated and the backs joined together to form a single
image of *The Fall of Man*.[4]

Left panel, *The Rule of Bacchus*: The x-radiograph
indicates a long check near the top of the left-hand cor-
ner. A small length of barbe is visible at the right edge;
this is the only edge that is clearly original, but there
are no strong compositional indications that the panels
have been significantly altered. Examination with in-
frared reflectography reveals underdrawing in what
appears to be a liquid medium. There are numerous
small losses throughout, most apparent in the area of
the inscription, and also an extensive raised crackle.

Center panel, *The Fall of Man*: Examination with

infrared reflectography revealed only occasional un-
derdrawn strokes, but the x-radiograph indicated
pentimenti around Adam's shoulders, arms, hands,
and feet, and Eve's left arm, leg, and foot. The back-
ground paint overlaps the figures in what was probably
a deliberate attempt to reduce their contours. There
are several large losses throughout; these seem to have
been the result of blistering and may have been the oc-
casion for the marouflage to hardboard. Specifically,
there are losses to the left of and above Adam's head,
through his chest, and around the lower part of his left
leg. At the right of Eve's head is a series of losses that
continue down her arm and a circular loss in her left
calf. The surface is secure but afflicted with vertical
blistering and raised crackle. The vertical join line
along the center is inpainted.

Right panel, *The Rule of Mars*: Examination with in-
frared reflectography reveals underdrawing in the
figure of Mars (fig. 1) in what appears to be a liquid
medium. There are numerous small losses through-
out, and these are particularly evident in the area of the
inscription. There are losses above and to the left of
Mars' head and in his left arm. The surface is secure but
exhibits a vertical, raised crackle pattern.

Provenance: Professor Wieser, Innsbruck, by 1891.[5]
Lacher von Eisack, Bad Tölz, Oberbayern.[6] (Paul Cas-
sirer, Berlin).[7] Baron Heinrich Thyssen-Bornemisza [d.
1947], Villa Favorita, Lugano-Castagnola, by 1930;[8] by
inheritance to his son Heinrich II, Baron Thyssen-
Bornemisza; (M. Knoedler & Co., New York, 1950–

Fig. 1. Infrared reflectogram of a detail of *The Rule of Mars*,
1952.5.31c [infrared reflectography: Molly Faries]

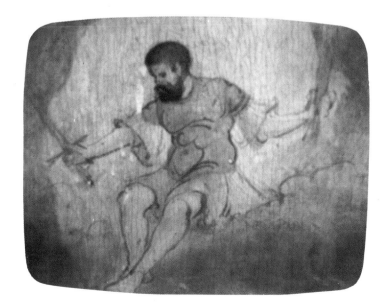

1951);[9] purchased February 1951 by the Samuel H. Kress Foundation, New York.

Exhibitions: Munich, Neue Pinakothek, 1930, *Sammlung Schloss Rohoncz*, no. 4.

As INDICATED in the Technical Notes, the present disposition of the panels does not correspond to their original arrangement. While it appears most likely that the original work was also a triptych, the center panel has been lost since at least the late nineteenth century and its subject is unknown. The inner left wing would have been *The Rule of Bacchus* and the inner right wing *The Rule of Mars*. *The Fall of Man*, presently the center panel, is actually on two separate panels that originally formed the exterior wings. The representation of Adam was on the reverse of the Bacchus panel and that of Eve was on the back of the Mars panel. Closing the triptych formed the coherent image that is now on the center panel.

The inner left wing depicts Bacchus, seated in the clouds and surrounded by an aureole of golden light. His head is wreathed in grape leaves. In one hand he holds a grape vine and with the other pours wine from a ewer onto a throng of men below: some of these men are naked, others wear garlands and girdles of leaves; a few wear small objects attached to cords around their necks. The figures in the lower line are agitated and in strife, and several raise weapons or metal vessels. The inscription in the upper zone, although damaged, is rendered more legible in infrared light and may be translated, "Woe when Bacchic fever brings disorder to sound minds."[10]

In similar fashion Mars is shown on the inner right wing holding a sword and a firebrand. As observed by Mansfield, there is no difference between the men and their weapons and vessels in the lower zone and those in the Bacchus panel.[11] The inscription in the upper zone may be translated, "Then agreement will be difficult when godless Mars disrupts the order of mankind."

The center panel is based on the account in Genesis 3: 1–13. Adam and Eve are shown in the garden of Eden, and the bite taken out of the apple held by Eve indicates that one or both of them have tasted of the forbidden fruit. Eden is rendered as a thick forest, and in the background one

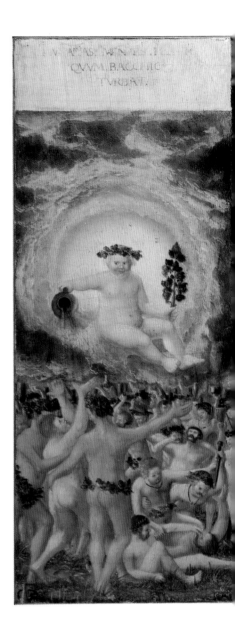

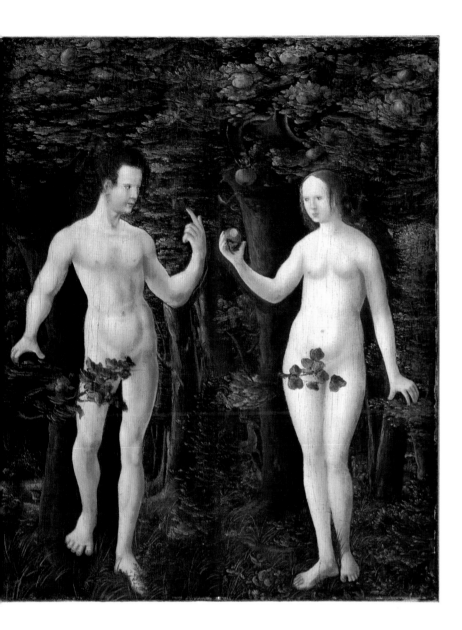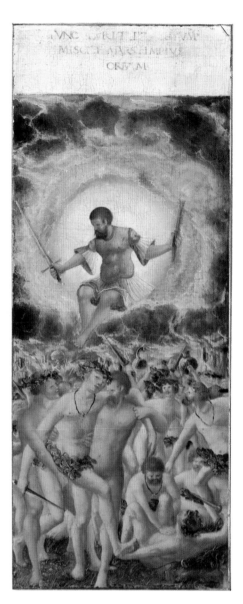

Workshop of Albrecht Altdorfer, *The Rule of Bacchus, The Fall of Man, The Rule of Mars*, 1952.5.31a–c

can glimpse a water bird (crane?) at the left, a stag at center, and just to the right of Eve's right leg, the head of a lion.

This combination of themes from Christianity and classical mythology is, by all accounts, a unique occurrence in northern Renaissance painting. The triptych raises vexing questions regarding function and patronage, the possible subject of the lost center panel, and the overall iconographic program and its source. In addition, the attribution, style, and date of the extant panels as well as their relation to the work of other artists are matters of discussion.

As regards the textual source, one of the most influential interpretations was that put forward by Benesch, who believed the imagery on the inner wings was based on the writings of the German physician and alchemist Paracelsus (Theophrastus Bombast von Hohenheim, c. 1490–1541). Although Paracelsus does mention the power of the planets, Mars and Venus in particular, to inflict pestilence, anger, and numerous other misfortunes upon mankind, his writings are disjointed, contradictory, and inconclusive.[12] Eisler, quite rightly I believe, was not convinced that Paracelsus was the source but failed to provide any specific examples for his own suggestion that the imagery derived from an early sixteenth-century astrological, Neoplatonic text.[13]

There have been two different proposals for the subject of the lost center panel. Baldass suggested that a depiction of the Power of Venus was in the center.[14] As a parallel example of a "secular" triptych with mythological scenes on the interior and Christian scenes on the exterior, he put forward Maerten van Heemskerck's *Venus and Cupid in the Forge of Vulcan* of 1536 (Národní Galerie, Prague), with *Venus and Mars Surprised by Vulcan*, a grisaille of *Prudence and Justice* on the reverse, and *Vulcan Giving Achilles' Shield to Thetis* (both Kunsthistorisches Museum, Vienna). Seriously undermining this comparison, however, is the fact that the Prague and Vienna pictures did not originally form a triptych; the Vienna panels are several years later than the Prague canvas.[15] Thematically, moreover, it is difficult to reconcile the usually benign and pleasant aspects of Venus with the strife engendered by Bacchus and Mars. The second suggestion, made by

Stange and considered feasible by Ruhmer and Winzinger, is that a portrait occupied the center.[16] Although possible, a portrait, as noted by Eisler, would be disruptive and out of scale with the figures on the inner wings.[17] I believe that it is more likely that the center panel, whatever its subject, was compositionally in accord with the side panels and thus may have continued an inscription along the top and a zone of battling figures along the bottom.

A useful addition to the discussion is Broadley's analysis of the exterior and interior panels in relation to the medieval concept of the Four Humors. This is the belief that men contain four humors or fluids—blood, phlegm, yellow bile, and black bile—which give rise to the four temperaments, sanguine, phlegmatic, choleric, and melancholic, respectively. The humors of Adam and Eve were in perfect equilibrium before the temptation; after the Fall there was an imbalance in the temperaments of the First Parents and their descendants. The inner wings thus demonstrate the deleterious effects of an excess of humor. While it is evident that Mars is choleric and prone to anger, there is no tradition to support Broadley's assertion that Bacchus is phlegmatic and given to "gluttony and self-indulgence."[18] One must also assume that the remaining two humors, sanguine and melancholic, were somehow represented together in the center.

Accepting the idea that the exterior panels signal the disruption of the balance of the four humors as a consequence of original sin, Mansfield's alternative hypothesis is that the images of Bacchus and Mars are manifestations of a single temperament, melancholy. Dominated by Bacchus, the sanguine melancholic is given to excesses of food and drink, while the choleric melancholic is under the sway of the anger and warlike state generated by Mars. As has been amply demonstrated by Panofsky and others, melancholy was associated with the planet Saturn, so Mansfield postulates for the center panel a depiction of the Rule of Saturn or the "children of Saturn," the latter a popular subject in German and Netherlandish prints.[19]

Although there is no way of verifying Mansfield's proposal, the relatively small size of the panels and their predominantly secular subject

matter strongly suggest that the triptych was commissioned for a humanist patron. According to Winzinger, the inscriptions on the surviving panels are rendered not in classical, but in sixteenth-century humanist Latin.[20] It is perhaps not unreasonable also to suppose that the patron was—or thought himself to be—a melancholic or child of Saturn. As is evident in Dürer's famous engraving *Melencolia I* or in the writings of Neoplatonists such as Marsilio Ficino, melancholy had become popular and a mark of greatness in philosophy, poetry, and the arts by the late fifteenth century.[21]

The influence of Dürer's engraving of *Adam and Eve*, 1504, on *The Fall of Man* panel was observed by Hugelshofer and subsequent authors.[22] The poses of the figures have been somewhat altered, but there is no doubt that the artist was aware of Dürer's print. In light of this, it is interesting to note that while the animals in Dürer's engraving have been interpreted as representing all four temperaments, those in the National Gallery's panel are incomplete: only the lion can be easily associated with a temperament, the choleric. Possible, but less immediately convincing is Ruhmer's relation of the figures in *The Fall of Man* to those in Dürer's painting of *Adam and Eve*, 1507 (Museo del Prado, Madrid).[23] Mansfield found in paintings by Lucas Cranach the Elder and his workshop parallels to the figures on the inner wings in both somatic type and subject matter. Pictures such as the *Age of Silver*, c. 1530 (National Gallery, London), based on Hesiod's *Works and Days*, or *Bacchus at the Wine Tub*, dated 1530 (private collection, Switzerland), offer the kind of classical, humanistic theme not encountered in Altdorfer's works.[24]

Most discussions have centered on the date of *The Rule of Bacchus*, *The Fall of Man*, and *The Rule of Mars* and their proximity to Altdorfer's work. The panels were first published by Friedländer as competent works in the manner of Altdorfer, but not from his hand.[25] The pictures were not included in the 1923 monographs by Friedländer, Baldass, or Tietze, but from 1930 on they were published as autograph works. The catalogue of the Munich exhibition of 1930 cited Friedländer as proposing a date of about 1525, while Hugelshofer placed them around 1530, and Benesch

compared them to Altdorfer's *Lot and His Daughters*, dated 1537 (Kunsthistorisches Museum, Vienna).[26] Baldass put the panels between about 1526 and the Vienna *Lot and His Daughters*.[27] In the most recent and extensive discussion, Winzinger compared the naked figures in the Washington panels to Lot's daughter in the background of the Vienna picture and pointed out connections between the figures of Adam and Eve and those in Altdorfer's graphics. Qualitatively these comparisons pointed up the weaknesses in color, draftsmanship, and anatomical understanding in the National Gallery's panels, and Winzinger relegated them to an unknown member of Altdorfer's shop working around 1535.[28] Eisler and Goldberg concurred in this opinion and the National Gallery changed the official attribution to Workshop of Albrecht Altdorfer in 1979.[29] Winzinger did not rule out the possibility that the panels were painted by Hans Mielich, but this is not confirmed by comparison with Mielich's known early works such as the *Crucifixion*, dated 1536 (Niedersächsisches Landesmuseum, Hannover).[30] Neither can the panels be successfully associated with the work of other known artists in Altdorfer's orbit, such as Michael Ostendorfer or Nicolaus Kirberger.[31]

Notes

1. The stock number is confirmed by Nancy C. Little, M. Knoedler & Co., letter to the author, 2 March 1988, in NGA curatorial files.

2. Friedländer 1891, 56, no. 27; for reproductions of the panels prior to their separation see Benesch 1930, 184–185, figs. 5–6.

3. The original support was reported to be linden in Benesch 1939, 48, and in Eisler 1977, 33, but it has not been possible to confirm this through direct examination.

4. Kress Condition and Restoration Record in NGA curatorial files indicates that the work was done prior to acquisition by the Samuel H. Kress Foundation. Eisler 1977, 33, states that the panels were treated by William Suhr around 1950.

5. As per Friedländer 1891, 56, no. 27.

6. Cited by Heinemann 1937, 2.

7. Information from annotated copy of exh. cat. Munich 1930, in the possession of Mrs. Walter Feilchenfeldt, Sr., Zurich: letter to the author, 28 January 1989, in NGA curatorial files. I am very grateful to Mrs. Feilchenfeldt for this information. Eisler 1977, 35, erroneously listed Walter Feilchenfeldt as the owner of the pictures.

8. Exh. cat. Munich 1930, no. 4.

9. See note 1 and M. Knoedler & Co. brochure in NGA curatorial files.

10. I am indebted to Megan Fox, in conversation 8 February 1989, for assistance in the translation of this and the inscription on the right panel. Slightly different translations are given in Winzinger 1975 (see Biography), 130–131, and NGA 1985, 17.

11. Sally E. Mansfield, memorandum in NGA curatorial files.

12. Benesch 1939, 48–49; his views are cited, with apparent approval, by Kress 1956, 20; Stange 1964, 39; and Ruhmer 1965, 52. The quotations from Paracelsus' *Liber de Epidemiis* and *Liber de imaginibus* cited by Benesch are to be found in Karl Sudhoff, ed., *Theophrast von Hohenheim. gen. Paracelsus*, pt. 1, 14 vols., *Medizinische, naturwissenschaftliche und philosophische Schriften* (Munich, 1922–1933), 9: 623; 13: 368–369. See also Arthur Edward Waite, ed., *The Hermetic and Alchemical Writings of Aureolus Philippus Theophrastus Bombast of Hohenheim, called Paracelsus the Great*, 2 vols. (1894; reprint, Berkeley, 1976).

13. Eisler 1977, 34.

14. Baldass 1941, 176–178.

15. Ilja M. Veldman, "Het 'Vulcanus-triptiek' van Maarten van Heemskerck," *Oud-Holland* 87 (1973), 95–123 (English translation in *Maarten van Heemskerck and Dutch Humanism in the Sixteenth Century* [Maarssen, 1977], 21–42); Rainald Grosshans, *Maerten van Heemskerck. Die Gemälde* (Berlin, 1980), 119–126, nos. 22–26.

16. Stange 1964, 141, no. 25; Ruhmer 1965, 52; Winzinger 1975 (see Biography), 131.

17. Eisler 1977, 34.

18. Broadley 1960, 26. For a discussion of the four humors and their imbalance after the Fall of Man see Panofsky 1943, 1: 84–85, 156–160. The sanguine temperament, with its weakness for wine, good food, and love, is more likely to be associated with Bacchus than is the phlegmatic.

19. Mansfield, memorandum, in NGA curatorial files. Raymond Klibansky, Erwin Panofsky, and Fritz Saxl, *Saturn and Melancholy: Studies in the History of Natural Philosophy, Religion and Art* (London, 1964), especially 75–81, 117–119, 151–159, 196–214, 397–399, 403–405, and figs. 38–40, 52, 144 (depictions of Saturn and his children). See also Anton Hauber, *Planetenkinderbilder und Sternbilder. Zur Geschichte des menschlichen Glaubens und Irrens* (Strasbourg, 1916), especially 123–126, 264–268; André Chastel, "Le mythe de Saturne dans la renaissance italienne," *Phoebus* 1 (1946), 125–134.

20. Winzinger 1975 (see Biography), 131.

21. See notes 18, 19.

22. Hugelshofer 1930, 409. *The Fall of Man* is reproduced in Panofsky 1943, 2: fig. 117.

23. Ruhmer 1965, 52; the Museo del Prado panels are reproduced in Panofsky 1943, 2: figs. 164–165. The Prado figures appear to this author to have different, more slender proportions.

24. Mansfield, memorandum, in NGA curatorial files. The Cranach *Age of Silver* is reproduced in color in Eberhard Ruhmer, *Cranach* (Greenwich, Conn., 1963), pl. 34. See also Max J. Friedländer and Jakob Rosenberg, *The Paintings of Lucas Cranach*, rev. ed. (Amsterdam, 1978), nos. 263, 260. Mansfield also notes similar body types in Cranach's *A Faun and His Family* (Fürstlich Fürstenbergische Sammlungen, Donaueschingen) and *A Faun and His Family with a Slain Lion* (private collection, Switzerland), both dated c. 1530, reproduced in Friedländer and Rosenberg 1978, nos. 266–267, respectively.

25. Friedländer 1891, 56, no. 27.

26. Exh. cat. Munich 1930, no. 4; Hugelshofer 1930, 409; Benesch 1930, 184–186. Heinemann 1937, 1–2, no. 4, repeated Friedländer's dating of c. 1525.

27. Baldass 1941, 194, noting that the differences between the National Gallery's panels and the Vienna *Lot and His Daughters* are due not to scale but to stylistic development.

28. Winzinger 1975 (see Biography), 131–132; the graphic works that Winzinger found comparable to Adam and Eve are the engravings of *Venus*, c. 1512/1515(?), *Allegorical Figure*, c. 1515/1518, and, in particular, *Hercules and Muse*, c. 1520/1525. He compared the battling figures to those in the engravings of *Lovers with Sea-gods, Battle with a Nymph,* and *Arion and Nereid,* all dated c.1520/1525. Reproduced in Franz Winzinger, *Albrecht Altdorfer Graphik* (Munich, 1963), nos. 114, 123, 160, 163–165. Connections between the Washington panels and Altdorfer's "kleinmeister" prints of the 1520s had been made by Benesch 1930, 184, and Baldass 1941, 194.

29. Eisler 1977, 34–35, found the *Fall of Man* panel closest to Altdorfer in terms of execution, and the ensemble superior to the work of known minor masters. Gisela Goldberg, letter to the author, 3 April 1979, in NGA curatorial files.

30. Winzinger 1975 (see Biography), 60. For the *Crucifixion* in Hannover and related early works see Hans Georg Gmelin, "Ein frühes Gemälde der Kreuzigung Christi von Hans Mielich," *Niederdeutsche Beiträge zur Kunstgeschichte* 16 (1977), 32–44. Gmelin specifically rejected an attribution of the Washington pictures to Mielich, in a letter to the author, 7 March 1978, in NGA curatorial files. For Hans Mielich see 1984.66.1, *A Member of the Fröschl Family* (pp. 146–151 in the present volume).

31. For Altdorfer's workshop and associated works see Winzinger 1975 (see Biography), 59–60, Stange 1964, 82–86, 142–143; Mielke 1988 (see Biography), 301–337, nos. 192–220.

References

1891 Friedländer, Max. *Albrecht Altdorfer, der Maler von Regensburg.* Leipzig: 56, no. 27.

1930 Benesch, Otto. "Altdorfers Badstubenfresken und das Wiener Lothbild." *Jb Berlin* 51: 182–186, figs. 5–6.

1930 Hugelshofer, Walter. "Die altdeutschen Bilder der Sammlung Schloss Rohoncz." *Der Cicerone* 22: 409.

1930 Mayer, August L. "Die Ausstellung der Sammlung 'Schloss Rohoncz' in der Neuen Pinakothek, München." *Pantheon* 6: 304, repro. 299.

1937 Heinemann, Rudolf. *Stiftung Sammlung Schloss Rohoncz.* Lugano-Castagnola: 1–2, no. 4, pl. 35.

1939 Benesch, Otto. *Der Maler Albrecht Altdorfer.* Vienna: 28, 48–49, nos. 71–72, figs. 71–72.

1941 Baldass, Ludwig von. *Albrecht Altdorfer.* Zurich: 176–178, 194, repros. 306–307.

1956 Kress: 20, no. 1, repro. 21.

1956 Walker, John. "The Nation's Newest Old Masters." *National Geographic Magazine* 110, no. 5 (November): 643, repro. 626.

1960 Broadley: 26, repro. 27.

1964 Stange, Alfred. *Malerei der Donauschule.* Munich: 39, 141, no. 25, fig. 118.

1965 Ruhmer, Eberhard. *Albrecht Altdorfer.* Munich: 52, no. 12, figs. 131a–b, 132.

1966 Cairns and Walker: 116, repro. 117.

1975 NGA: 10, repro. 11.

1975 Winzinger (see Biography): 59, 130–132, nos. 109–111, repros.

1976 Walker: 147, nos. 156–158, repro.

1977 Eisler: 33–35, figs. 28–30.

1985 NGA: 17, repro.

1990 Dülberg, Angelica. *Privatporträts. Geschichte und Ikonologie einer Gattung im 15. und 16. Jahrhundert.* Berlin: 299–300, no. 349, figs. 173–175.

Hans Baldung Grien

1484/1485-1545

H ANS BALDUNG, called Grien, was most probably born in Schwäbisch Gmünd in southwestern Germany, the site of the family home. The most important evidence for deducing his date of birth is a self-portrait drawing at age forty-nine (Cabinet des Dessins, Musée du Louvre, Paris), which is preparatory to a woodcut of 1534. It has been noted that Baldung was the only male member of his family not to receive a university education, for, unlike many artists, he belonged to a family of academics, intellectuals, and professionals. His father was an attorney who seems by 1492 to have settled in Alsace. It is usually assumed that Baldung's earliest training took place around 1499 or 1500 in the Upper Rhine, perhaps with a Strasbourg artist, but an apprenticeship in Swabia has also been suggested.

By 1503 Baldung had moved to Nuremberg and had become a member of Albrecht Dürer's workshop. It was probably here that he acquired the nickname "Grien," perhaps a reference to his use of the color green or a preference for green attire. It could also have distinguished him from Hans Schäufelein, Hans Süss von Kulmbach, and Hans Dürer, Albrecht's younger brother, all of whom were in Dürer's atelier. Baldung immediately absorbed Dürer's formal vocabulary, as is evident in one of his earliest dated works, the pen drawing of *Aristotle and Phyllis* of 1503 (Cabinet des Dessins, Musée du Louvre, Paris). It is quite possible that Baldung became head of the workshop during Dürer's second journey to Italy from 1505 to 1507; these years saw the production of designs for stained glass, woodcuts from 1505 on, and engravings beginning in 1507. Dürer and Baldung remained lifelong friends, and on his trip to the Netherlands Dürer took along some of Baldung's woodcuts to sell.

In 1507 Baldung was probably in Halle, where he had received commissions for two altarpieces, one of which is the *Martyrdom of Saint Sebastian*

triptych (Germanisches Nationalmuseum, Nuremberg). In 1509 the artist settled in Strasbourg and became a citizen. The following year he married Margarethe Herlin, joined the guild *zur Steltz*, opened a workshop, and began signing his works with the HGB monogram that he used for the rest of his career. In addition to traditional subjects, Baldung was concerned during these years with the theme of the imminence of death, as for example in the painting *Death and the Three Ages of Woman*, c. 1509/1511 (Kunsthistorisches Museum, Vienna), and with scenes of sorcery and witchcraft, such as the chiaroscuro woodcut of 1510, the *Witches' Sabbath*. (Along with Lucas Cranach and Hans Burgkmair, Hans Baldung Grien was one of the earliest masters of the chiaroscuro woodcut.)

In 1512 Baldung moved to Freiburg im Breisgau to work on his largest and most important commission, the multipaneled high altar of the cathedral, containing on the center panel the *Coronation of the Virgin*. The altarpiece, which was not completed until 1516, draws upon Dürer's graphic compositions, but in place of Dürer's classic restraint there is a highly personal emotional and physical vitality that borders on mannerism. Not surprisingly, the impact of Grünewald's expressive drawings and paintings, particularly the Isenheim altar, can be seen in Baldung's work at this time.

Baldung returned to Strasbourg early in 1517 and, as far as is known, remained there for the rest of his life. From the 1520s onward the pictorial and psychological content of his work becomes increasingly mannered, reflecting in part exposure to Italian art. Forms and surfaces are highly polished and refined, and as Alan Shestack observed, the elaborate draperies "might almost be made of some metallic foil." Strasbourg came under the sway of the Reformation and experienced a brief episode of iconoclasm in 1529 or

1530. Although Baldung continued to produce religious subjects for private patrons, he increasingly painted portraits or scenes from ancient legends and history, such as the *Hercules and Antaeus* of 1531 (Staatliche Gemäldegalerie, Kassel).

At the time of his death in September 1545, Baldung was a member of the city council of Strasbourg and one of that city's richest citizens. His artistic estate went to Nicolaus Kremer, who was probably a pupil. Hans Baldung Grien was Dürer's most inventive and talented disciple, who nonetheless achieved a distinctive style. Baldung's oeuvre consists of approximately 90 paintings and altarpieces, about 350 drawings, and 180 woodcuts and book illustrations.

Bibliography

Hans Baldung Grien. Exh. cat., Staatliche Kunsthalle. Karlsruhe, 1959.

Shestack, Alan. "An Introduction to Hans Baldung Grien." *Hans Baldung Grien. Prints & Drawings.* Exh. cat., National Gallery of Art, Washington; Yale University Art Gallery. New Haven, 1981, 3–18.

Osten, Gert von der. *Hans Baldung Grien. Gemälde und Dokumente.* Berlin, 1983.

1961.9.62 (1614)

Saint Anne with the Christ Child, the Virgin, and Saint John the Baptist

c. 1511
Spruce, 89 × 77.6 (35 × 30½);
 painted surface: 87 × 75 (34¼ × 29½)
Samuel H. Kress Collection

Inscriptions

On the base of the middle pillar of the throne, the

 artist's monogram: ⌶GB

On the halos, from left to right:

 S ⸙ IOHANE

 S ⸙ ANNA ⸙

 ⁂ MARIA ⸙

Fig. 1. Infrared reflectogram assembly of a detail of *Saint Anne with the Christ Child, the Virgin, and Saint John the Baptist,* 1961.9.62 [infrared reflectography: Molly Faries]

Technical Notes: The painting support was thinned to a veneer and marouflaged to hardboard in 1953. Examination of the remaining veneer at the top and bottom edges indicated that the original support was spruce wood (sp. *Picea*).[1] The original support was probably comprised of five, or possibly six boards with vertically oriented grain. At the right side several long cracks suggest a sixth, very narrow plank, but there is no corresponding continuous crack on the surface to verify its position. There is a barbe at the top and bottom edges suggesting that the painting once had an engaged frame. The lateral edges are not original, but are fill material colored with wood stain.

Examination with the naked eye in flesh and white areas, and with infrared reflectography, reveals considerable underdrawing using a brush and what is probably black ink (fig. 1). Striations over the underdrawing, seen with the aid of a stereobinocular microscope, may indicate the presence of an intermediate, or isolation layer over the underdrawing, but the striations are not disclosed in the reflectograms.

The halos are mordant gilded, applied over the mod-

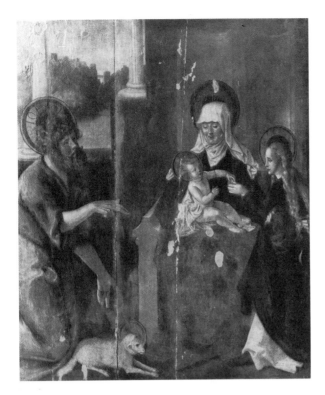

Fig. 2. *Saint Anne with the Christ Child, the Virgin, and Saint John and the Baptist*, 1961.9.62, in 1934 [photo: *Gazette des Beaux-Arts* 11 (January 1934)]

erately thick white ground. Paint overlaps the edges of the leaf. The glazing and inscriptions are applied over the fold.

Relatively large areas of ground have flaked away, and corresponding areas of paint are missing, particularly along the cracks joining the boards. Figure 2 shows the appearance of the painting in 1934, prior to treatment. The painting also suffered generalized abrasion. There is extensive retouching in Saint John's halo, the central areas of the Virgin's halo, and much of Saint Anne's halo. Major areas of retouching exist in John's left thigh, the bottom of the child's left thigh and a portion of Anne's skirt just below it, the front of the lamb's torso, and in much of the sky at the upper left. It should be noted, however, that the background landscape is not heavily retouched and that faces and limbs are in generally good condition.

Provenance: Church of the Order of Saint John in Jerusalem, Grünen Wörth, near Strasbourg, c. 1511–probably c. 1633. Church in the cloister of Saint Marx, probably c. 1687–at least 1741.[2] Village church, Alsace; acquired shortly after 1870 by Dr. Georges-Joseph Wimpfen, [d. 1879], Colmar; by inheritance to his daughter, Marie Emélie Jeanne Siben [d. 1951], Paris and Zimmerbach, near Colmar.[3] (Fritz Fankhausen, Basel, 1952);[4] (Rosenberg & Stiebel, New York, by 1953); purchased 1953 by the Samuel H. Kress Foundation, New York.

Fig. 3. Hans Baldung Grien, *The Mass of Saint Gregory*, panel, The Cleveland Museum of Art, Gift of the Hanna Fund, 52.112 [photo: The Cleveland Museum of Art]

Exhibitions: Karlsruhe, Staatliche Kunsthalle, 1959, *Hans Baldung Grien*, no. 14. New York, Metropolitan Museum of Art; Nuremberg, Germanisches Nationalmuseum, 1986, *Gothic and Renaissance Art in Nuremberg 1400–1550*, no. 179c (shown only in New York).

IN 1977 Gert von der Osten published documents that virtually confirm that *Saint Anne with the Christ Child, the Virgin, and Saint John the Baptist* was originally part of an altarpiece that included *The Mass of Saint Gregory* (fig. 3) and *Saint John on Patmos* (fig. 4).[5] The altarpiece was painted for the Order of Saint John in Jerusalem in Grünen Wörth, just outside of Strasbourg. Since their initial joint publication by Pariset in 1934, the National Gallery's picture and *Saint John on Patmos* have always been associated, and it was thought that they were wings of an altarpiece with a carved center panel.[6] In 1951 Carl Koch dated the Cleveland painting to 1511, in part because of an identification of the figure at the far right as Erhard Kienig (or Künig), a commander (*Komtur*) in the Order of Saint John, who died in 1511.[7] Koch, in a letter of 1957, suggested for the Washington and New York panels a date of c. 1511 and a connection with the commission of the Cleveland *Mass of Saint Gregory*.[8] Even though all three panels were shown at the Hans Baldung Grien exhibition in Karlsruhe in 1959, the Cleveland panel was discussed separately, and subsequent authors noted points of comparison among the three pictures but, until von der Osten, stopped short of proposing a reconstruction based on the assumption of a single commission.

The Order of Saint John in Jerusalem, also called the Knights of Malta or the Knights Hospitaller, was a religious and chivalric order.[9] It began in the eleventh century in Jerusalem as a hospice and infirmary for pilgrims that, together with a church, was dedicated to Saint John the Baptist. The need to defend pilgrims and the Christian kingdom of Jerusalem from Moslem attacks forced the order to become militaristic as well. As it quickly increased in prestige and popularity, it was able to acquire numerous possessions throughout the Near East and Europe. In the late fourteenth century the mystic Rulman Merswin established a monastery at Grünen Wörth, apparently an islandlike piece of land just outside

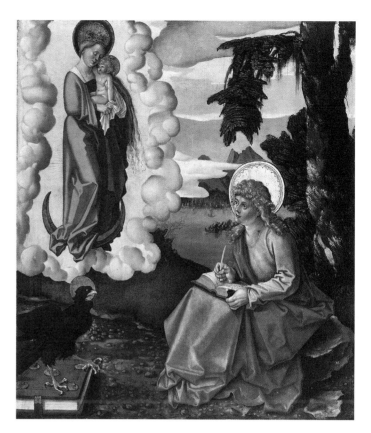

Fig. 4. Hans Baldung Grien, *Saint John on Patmos*, panel, The Metropolitan Museum of Art, New York, Contributions from various donors supplemented by Museum purchase funds, 1983 [photo: The Metropolitan Museum of Art]

the gate of Strasbourg, which was accepted in 1371 by the Order of Saint John in Jerusalem and where, ten years later, a hospital was built by a laybrother.

By the late fifteenth century the Church of the Order of Saint John in Jerusalem had become the richest spiritual institution in Strasbourg and enjoyed the protection of Maximilian I and his family. The Strasbourg "Johanniter" were not knights and were prohibited from taking part in the defense of the Holy Land; rather, they were patricians or belonged to the guilds and engaged in educational and charitable duties.

Von der Osten found two records of payment from the order's accounts of 1510/1511 pertaining to the church in which Hans Baldung received a total of twenty-four gulden for painting a panel or altar. The possibility that the words *fur altar* in the second record refer to *Voraltar*, or a type of antependium, were considered by von der

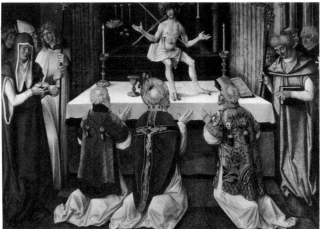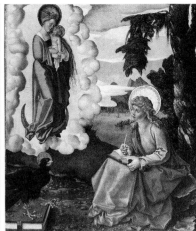

Fig. 5. Reconstruction of the altarpiece of the Order of Saint John in Jerusalem, Grünen Wörth

Osten and rejected in favor of reading the sentence as a clerical abbreviation.[10] Records from the following years, 1511/1512, are no longer extant, so the possibility of further payments should not be excluded.

The second set of documents published by von der Osten comes from a manuscript inventory, dated 1741, of the contents of the Church of the Order of Saint John. It needs to be pointed out that during the Thirty Years' War the order at Strasbourg lost its buildings, and in 1633 the church in Grünen Wörth was pulled down and its contents apparently put in storage. In 1687, after long negotiations, the order moved into the cloister of Saint Marx in Strasbourg, where it remained until the French Revolution. The inventory of 1741 describes three separate paintings as hanging in the sacristy of the church, and these can be convincingly identified with *The Mass of Saint Gregory* in Cleveland, the *Saint John on Patmos* in New York, and the National Gallery's *Saint Anne with the Christ Child, the Virgin, and Saint John the Baptist*. The altarpiece was probably dismantled in the 1630s during the disruption at Grünen Wörth. In the inventory the Washington picture is listed as follows: "26) Item Ein gleiche, worauf S. Anna B.V. und S. Johannes Bapt. pelle indutus in erwaxenem alter, auch in der Sacristy ober dem Kirchfass." That the picture is mentioned as being the same size as the preceding *Saint John on Patmos* and that John the Baptist, in hair shirt, is de-

scribed as an adult help to confirm the identification with the National Gallery's painting.

Von der Osten's proposed reconstruction (fig. 5) calls for a nonfolding triptych with *Saint Anne with the Christ Child, the Virgin, and Saint John the Baptist* on the left wing, *The Mass of Saint Gregory* in the center, and *Saint John on Patmos* on the right wing. In addition to the documents of 1510/1511 and 1741, technical and stylistic evidence reinforces the probable conjunction of these paintings. The dimensions, especially the heights of the three paintings, are in accord, and the reverse of the *Saint John on Patmos*, the only work not marouflaged to hardboard, is unpainted.[11]

The manner of painting, particularly the use of acid greens and yellow-greens in conjunction with red and red-orange, the use of white highlights in the faces and flesh tones, the calligraphic strokes of white in the hair, the general concordance of facial types, and similarly rendered halos, is congruent in all three paintings. Moreover, the underdrawing, as revealed by infrared reflectography, is basically homogeneous in the three pictures. There appear to be several color notations in the Cleveland underdrawing, while in the National Gallery's picture there is one instance of what may be the letter *g*, for *grün*, in the Virgin's robe (fig. 6). In the New York panel the sketchy, looping notations for trees and bushes, for example, are comparable to those in the Wash-

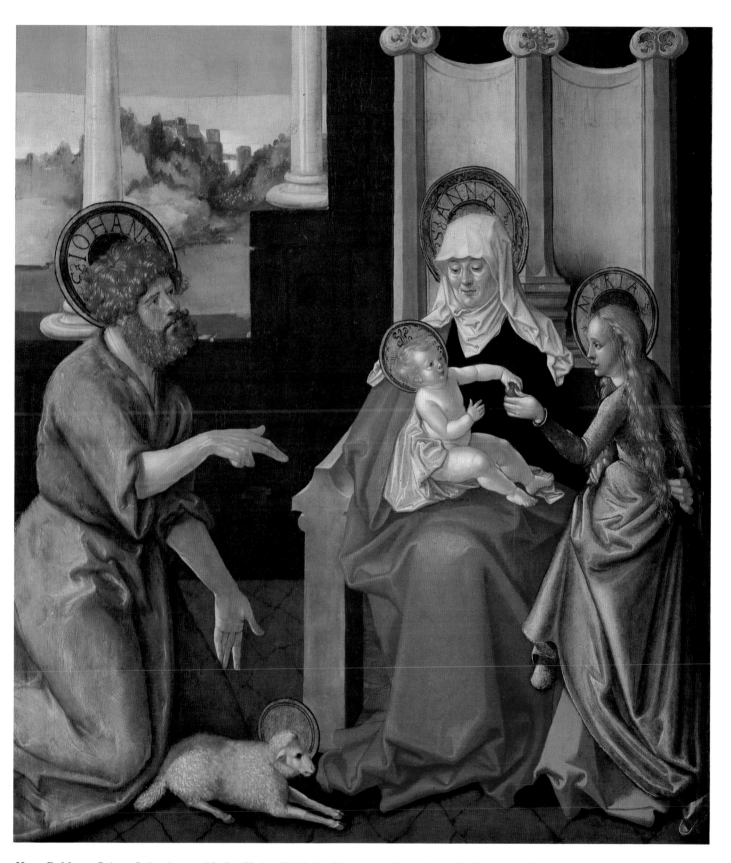

Hans Baldung Grien, *Saint Anne with the Christ Child, the Virgin, and Saint John the Baptist*, 1961.9.62

Fig. 6. Infrared reflectogram of a detail of *Saint Anne with the Christ Child, the Virgin, and Saint John the Baptist*, 1961.9.62 [infrared reflectography: Molly Faries]

ington landscape. In the drapery of the Madonna on the sickle moon, however, there is a cross-hatching that is unique to the New York painting; and there appear to be no discernible color notations.[12]

The iconographic program of the triptych was almost certainly formulated by the members of the Order of Saint John, who were possibly assisted by outside theological advisors.[13] Since, as noted above, this was a nonfolding altarpiece, all three panels would probably have been continuously on view and not just opened on feast days. Unfortunately, the location of the triptych in the church is not known, and by the end of the fifteenth century the church contained several altars. Although there exists no difficulty in identifying the subject matter of the individual panels, this particular combination of scenes is apparently unique and the import of the altarpiece as a whole has not been fully explicated.

The National Gallery's panel, on the left wing of the triptych, shows John the Baptist, patron saint of the order, gesturing toward a lamb and also toward Saint Anne, the infant Christ, and the Virgin. The latter form an iconographic unit known in German as *Anna Selbdritt*. The Christ Child and the Virgin grasp the same fruit. The center panel depicts the legend of the Mass of Saint Gregory the Great, a sixth-century pope. As the pope was celebrating Mass, an assistant doubted the transubstantiated presence of Christ in the host, and as Gregory prayed, the Savior

appeared on the altar in the form of the Man of Sorrows, accompanied by the Instruments of the Passion. This panel is concerned in part with transubstantiation, the miraculous transformation of the host into the body and blood of Christ; but perhaps more important, the appearance of Christ as the Man of Sorrows would remind viewers that the ceremony of the Mass reenacts Christ's sacrifice, necessary for man's salvation.[14] The right wing represents John the Evangelist in exile on the island of Patmos where he composed the Book of Revelation. Appearing to him as he writes is the Madonna and Child standing on a crescent moon, a vision of the Woman of the Apocalypse whose child "is to rule all nations with a rod of iron" and is enthroned with God (Revelation 12:5). At the second coming of Christ salvation and eternal life will be granted to the faithful and Satan will be conquered by the "blood of the Lamb" (Revelation 12:11). The image of "a woman clothed with the sun, with the moon under feet" (Revelation 12:1), was often identified with the Immaculate Conception of the Virgin.[15]

We should note, parenthetically, that John the Evangelist often appears in altarpieces with John the Baptist, for the two are allied in more than name. John the Evangelist was often considered a disciple of John the Baptist, and legend has it that the day of the Baptist's beheading coincided with the birthday of the Evangelist.[16]

Von der Osten, followed by Bauman, stressed the eucharistic character of the center panel.[17] Bauman, in discussing the wings, emphasized the Virgin's role in the redemption of mankind and also suggested a temporal sequence in that the Washington panel portrayed a past event while the right wing depicted an apocalyptic event of the future. Growing out of these observations, Mansfield's analysis stresses how the three panels are unified through their visionary images, and how, taken together, they explicate God's plan for the salvation of mankind.[18]

Regarding the Washington painting, Mansfield proposes that John the Baptist is in the act of witnessing a vision of the *Anna Selbdritt* grouping. The deliberate anachronism of depicting John as an adult even though, biblically, he and Christ were contemporaries underscores the miraculous nature and purpose of Christ's incarnation.

The lamb at his knee refers to John 1:29, "Behold, the lamb of God, who takes away the sin of the world."[19] Christ's role as savior is further evident in his sharing a fruit with the Virgin, for, as noted by Eisler and others, Christ is the new Adam and Mary the new Eve, who are free from sin.[20] This, in turn, may be related to the *Anna Selbdritt* grouping, which expressed an important aspect of the Immaculate Conception, the belief that from the moment of conception Mary was preserved free from the stain of original sin. Such purity was a miraculous but necessary prerequisite to the birth of the Savior who would redeem man's sins.[21]

Thus the three panels of the altarpiece illustrate in sequence the miraculous, visionary nature of Christ's incarnation, sacrifice, and second coming and together put forward the most basic tenet of Christianity: God's promise for man's salvation.

This is Hans Baldung Grien's earliest known commission for the Order of Saint John in Jerusalem, and there is no record of other commissions for altarpieces. Baldung's continued association

Fig. 7. Hans Baldung Grien, *Head of Saint John the Baptist*, 1516, black chalk, 33.6 × 29.8 cm., National Gallery Art, Washington, Pepita Milmore Memorial Fund, 1980.12.1

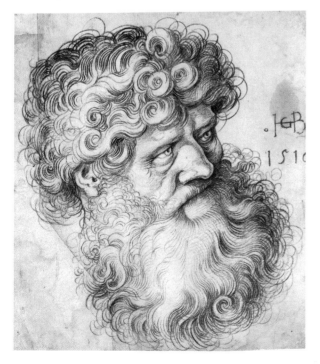

with the Order of Saint John is, however, strongly suggested by two portraits: of Balthasar Gerhardi, monogrammed and dated 1528 (Alte Pinakothek, Munich); and of Gregorius Beit, monogrammed and dated 1534 (Staatsgalerie, Bamberg).[22] Beit succeeded Gerhardi as commander of the order at Grünen Wörth, and it is possible that their portraits were originally part of a series. A group of silverpoint drawings of the harbor and buildings on the island of Rhodes (Staatliche Kunsthalle, Karlsruhe) has also been seen as linking Baldung with the Johannites, for Rhodes was a principal outpost of the order until it was taken by the Turks in the summer of 1522.[23]

Even without the documents, there is no question that *Saint Anne with the Christ Child, the Virgin, and Saint John the Baptist* belongs to Baldung's first Strasbourg period. The Washington panel and the other two panels of the triptych have consistently been dated around 1511, and dated paintings and woodcuts from this time offer abundant confirming comparisons.[24]

In the face of Saint John the Baptist, we have an early example of a stock type used frequently by Baldung. It is preceded by a John the Baptist in a stained glass window, c. 1506, in the church of Saint Lorenz, Nuremberg, based on Baldung's designs.[25] Essentially the same face appears in the National Gallery's drawing of 1516 (fig. 7),[26] the face of Saint John in the *Baptism* wing of the Schnewlin altar of c. 1515/1516 (Münster, Freiburg),[27] and the face of Saint John in the *Baptism of Christ* of c. 1518 (Städelsches Kunstinstitut, Frankfurt).[28]

Notes

1. The identification of the wood was made by the National Gallery's scientific research department.

2. Osten 1977, 52–53, cites two sets of documents, Archives départementales du Bas-Rhin, Strasbourg, nos. H2158, and H2232. The first are records of payment in the accounts of the Order of Saint John, under the heading, "Uff die Kirch": "It. X G(ulden) meister Hans baldung dem maler vff die tafel zu malen. It. XIIII G(ulden) meister Hans baldung dem maler von dem fur altar zu malen." The second is the manuscript of 1741 by F. Francisco Josepho Ignatio Goetzman, Ermelten Hausses Custode, "Inventarium über Alle des Ritterlichen St. Johann Ordens Hauses in Strassburg Custorey-oder Kirchen Schatz," 149, no. 26: "Item Ein gleiche, worauf S. Anna B.V. und S. Johnannes Bapt.

pelle indutus in erwaxenem alter, auch in der Sacristy ober dem Kirchfass." See also notes 5, 10.

3. Pariset 1934, 13–14; Christian Heck, Musée d'Unterlinden, Colmar, letter to Guy Bauman, Metropolitan Museum of Art, New York, 10 June 1985, copy in NGA curatorial files, is the source for full names and death dates. I am grateful to Guy Bauman for making his correspondence available.

4. Osten 1983 (see Biography), 68; Guy Bauman memorandum of telephone conversation with Gerald Stiebel, 3 June 1985, in NGA curatorial files.

5. Osten 1977, 51–61; the other panels of the altarpiece are described in the inventory of 1741 cited in note 2, as follows: "24) Item eine breite Tafel, worauf Christus entblösst auf einem Altar sitzet, auss dessen H1. H1. wunde Blut herunder röhrssweiss spritzet, vor dem altar Unden knyen Celebrans, cum Diacono Und Subdiacono, neben dem altar ein Cardinal einseitzs anderseits Crucifer etc. ist in der Sacristy ob der breiten thür. 25) Item ein schier viereckige zimlich grosse taffel S. Joannis in Insula Patmos, in der Sacristey."

6. As discussed, for example, in exh. cat. Karlsruhe 1959, nos. 14–16.

7. Carl Koch, "Uber drei Bildnisse Baldungs als künstlerische Dokumente vor Beginn seines Spätstils," *Zeitschrift für Kunstwissenschaft* 5 (1951), 62–65.

8. Letter to Fern Rusk Shapley, 26 June 1957, in NGA curatorial files. A handwritten certificate of 1 April 1952 by Ernst Buchner, in NGA curatorial files, also proposes a date of c. 1511.

9. See O. P. Sherbowitz-Wetzor and C. Toumanoff, "Knights of Malta," *NCathEnc*, 8: 217–220; Walter Gerd Rödel, *Das Grosspriorat Deutschland des Johanniter-Ordens im Übergang vom Mittelalter zur Reformation* (Cologne, 1972), especially 181–193 for Strasbourg; Adam Wienand, *Der Johanniterorder. Der Malteser-Orden. Der ritterliche Orden des h1. Johannes vom Spital zu Jerusalem* (Cologne, 1970), especially 386–388 for Strasbourg.

10. Osten 1977, 53, would read the sentence as "Item XIIII gulden meister Hans baldung dem maler von dem (ausgesetzten Geld) für (den) Altar zu malen."

11. For the Cleveland and New York paintings see Jean Kubota Cassill, entry on *The Mass of Saint Gregory* (52.112), in *European Paintings of the 16th, 17th, and 18th Centuries*, pt. 3 of the *Catalogue of Paintings of the Cleveland Museum of Art* (Cleveland, 1982), 160–162, no. 65; Osten 1983 (see Biography), 66–74, nos. 12–13; and the entry by Guy Bauman in exh. cat. New York and Nuremberg 1986, 375–379, no. 179 (the full set of bibliographic references is to be found in the German-language edition of the catalogue). Osten 1983, 74, cites W. Hugelshofer as not accepting the reconstruction and placing the National Gallery and New York panels a few years earlier than the Cleveland picture.

12. I am extremely grateful to Maryan Ainsworth for the opportunity to study and examine with infrared reflectography all three panels together, 26 June 1986,

in the paintings conservation department of the Metropolitan Museum of Art, New York. For several reflectogram assemblies of the *Mass of Saint Gregory*, including those with color notations, see William A. Real, "Exploring New Applications for Infrared Reflectography," *Bulletin of the Cleveland Museum of Art* 72 (1985), 402–403, figs. 13a–b, 14. We do not fully understand the purposes of these notations, and, as noted by Real, the colors of the overlying paint do not always correspond to the underdrawn notation.

13. In addition to Erhard Kienig, mentioned as a subject earlier in the text, the *Mass of Saint Gregory* contains personages identified as Raymundus Perault, cardinal of Santa Maria Nuova, Rome; Wilhelm III von Honstein, bishop of Strasbourg; as well as Dr. Hieronymus Baldung, protonotary apostolic, and possibly his brother Hans Baldung, episcopal procurator in Strasbourg, both relatives of the artist. Osten 1983 (see Biography), 72–73; Bauman in exh. cat. New York and Nuremberg 1986, 377.

14. See Réau, *Iconographie*, vol. 3, pt. 2, 614–615, for the Mass of Saint Gregory; C. Vollert, "Transubstantiation," *NCathEnc*, 14: 259–261.

15. As noted by Osten 1983 (see Biography), 69, the Virgin does not wear the crown of stars mentioned in the text.

16. R. E. Brown, "John, Apostle, St.," *NCathEnc*, 7: 1005–1006; for the two Saint Johns see Réau, *Iconographie*, vol. 2, pt. 1, 441; vol. 3, pt. 2, 713.

17. Osten 1983 (see Biography), 73–74; Bauman in exh. cat. New York and Nuremberg 1986, 376–377.

18. Sally E. Mansfield, memorandum, February 1988, in NGA curatorial files.

19. For John the Baptist see Réau, *Iconographie*, vol. 2, pt. 1, 431–463; M. E. McIver, "John the Baptist," *NCathEnc*, 7: 1030–1031.

20. Eisler 1977, 30, also associates Christ and the Virgin with the bridegroom and bride mentioned in John 3:29–30, which ends "He must increase, but I must decrease."

21. The literature on Saint Anne, the *Anna Selbdritt* grouping, and the doctrine of the Immaculate Conception is considerable, but see Paul-Victor Charland, *Le culte de Sainte Anne en occident, second période de 1400 (environ) à nos jours* (Quebec, 1921); Beda Kleinschmidt, *Die heilige Anna. Ihre Verehrung in Geschichte, Kunst und Volkstum* (Düsseldorf, 1930); Mirella Levi d'Ancona, *The Iconography of the Immaculate Conception in the Middle Ages and Early Renaissance* (New York, 1957); Réau, *Iconographie*, vol. 2, pt. 2, 74–85, 146–148.

22. Osten 1983 (see Biography), 183–185, no. 64, pl. 136; 227, no. 81, pl. 169.

23. Carl Koch, *Die Zeichnungen Hans Baldung Griens* (Berlin, 1941), 177–179, nos. 227–230, repro. The drawings are in the Staatliche Kunsthalle, Karlsruhe.

24. Comparable paintings include two versions of

the *Crucifixion*, both dated 1512 (Gemäldegalerie, Berlin; and Öffentliche Kunstsammlung, Basel), and *Dead Christ with the Virgin, Saint John, and God the Father*, 1512, (National Gallery, London); Osten 1983 (see Biography), 77–84, nos. 16–18, pls. 45–51. In terms of both style and subject matter, comparison has been made to the woodcuts of the *Holy Family with Saint Anne and Joachim*, c. 1510/1511, and the *Holy Family with Saint Anne*, 1511; Shestack 1981 (see Biography), 124–131, nos. 20–21, repro. Oettinger and Knappe 1963, 105, n. 247, compared the National Gallery's painting to Baldung's woodcuts for the *Hortulus animae*, published in Strasbourg, 1511–1512, repro. See also Matthias Mende, *Hans Baldung Grien. Das graphische Werk* (Unterschneidheim, 1978), nos. 329–400.

25. Oettinger and Knappe 1963, figs. 43, 51.

26. Shestack 1981 (see Biography), 221–223, no. 56.

27. Osten 1983 (see Biography), 256–259, no. W97, pls. 188–189, considers the wings to be from Baldung's workshop. J. E. von Borries, in a review of Osten 1983 in *BurlM* 127 (1985), 98, was not convinced of the downgrading and thought the panels were autograph.

28. Osten 1983 (see Biography), 143–146, no. 45, pl. 112, considered the National Gallery's drawing preparatory to the head of John the Baptist in Frankfurt.

References

1934 Pariset, François-Georges. "Deux oeuvres inédites de Baldung Grien." *GBA* 11: 13–23.

1941 Perseke, Helmut. *Hans Baldungs Schaffen in Freiburg.* Freiburg im Breisgau: 49–50, 66–67, fig. 8.

1943 Fischer, Otto. *Hans Baldung Grien.* Munich: 20.

1953 Koch, Carl. "Katalog der erhaltenen Gemälde, der Einblattholzschnitte und illustrierten Bücher von Hans Baldung-Grien." *Kunstchronik* 6: 297.

1956 Kress: 26, no. 5, repro. 27.

1959 Möhle, Hans. "Hans Baldung Grien. Zur Karlsruher Baldung-Ausstellung Sommer 1959." *Zeitschrift für Kunstgeschichte* 22: 128.

1960 Weihrauch, Hans R. "Berichte. Deutschland." *Pantheon* 18: 46.

1960 Broadley: 32, repro. 33.

1963 Oettinger, Karl, and Karl-Adolf Knappe. *Hans Baldung Grien und Albrecht Dürer in Nürnberg.* Nuremberg: 105, no. 247.

1964 Tolzien, G. "Baldung, Hans, genannt Grien." *Kindlers.* 1: 188.

1967 Fritz, Rolf. *Sammlung Becker. I. Gemälde Alter Meister.* Dortmund: under no. 1.

1974 Koch, Robert A. *Hans Baldung Grien. Eve, the Serpent, and Death.* Masterpieces in the National Gallery of Canada, no. 2. Ottawa: 7.

1975 NGA: 16, repro. 17.

1976 Walker: 151, no. 164, repro.

1977 Eisler: 29–30, fig. 32.

1977 ·Osten, Gert von der. "Ein Altar des Hans Baldung Grien aus dem Jahre 1511—und eine Frage nach verschollenen Werken des Malers." *Zeitschrift des deutschen Vereins für Kunstwissenschaft* 31: 51–61, figs. 4, 6, 8.

1979 Pariset, François-Georges. "Réflexions à propos de Hans Baldung Grien." *GBA* 94: 2.

1981 Marrow, James H., and Alan Shestack. *Hans Baldung Grien. Prints & Drawings.* Exh. cat., National Gallery of Art, Washington; Yale University Art Gallery. New Haven: 125, 129, 221, fig. 56a.

1983 Osten, Gert von der (see Biography): 21, 66–69, no. 12a, 71–74, pls. 32, 34–35.

1985 NGA: 35, repro.

Bartholomaeus Bruyn the Elder

1493–1555

THE DATE of Bartholomaeus (or Barthel) Bruyn's birth can be deduced from a portrait medal by Friedrich Hagenauer that is dated 1539 and gives the artist's age as forty-six. The exact place of Bruyn's birth is unknown, but it was almost certainly in the region of the Lower Rhine. Bruyn entered the workshop of Jan Joest and assisted in painting the high altar of the Nikolaikirche, Kalkar, executed between 1505 and 1508. Also in Joest's atelier at this time was Joos van Cleve, who befriended the younger Bruyn and whose art had a decisive influence on him. After possibly working with Joest in Haarlem and Werden, Bruyn arrived in Cologne in 1512 and for a year or two joined the workshop of the artist known as the Master of Saint Severin. Bruyn remained in Cologne for the rest of his life, and his career as a citizen can be followed in some detail. In 1518 and 1521 he was selected for membership on a city council (Rat der Vierundvierzig), and in 1549 and 1553 he served on the town council (Ratsherrn). Sometime between 1515 and 1520 he married a woman named Agnes; their two sons, Arnt and Bartholomaeus the Younger, became artists. In 1533 Bruyn was able to purchase two houses near the Church of Saint Alban. His wife died around 1550, and Bruyn died in 1555; his death was recorded in the parish church of Saint Alban on 22 April.

Although none of Bruyn's paintings is signed, his oeuvre has been constructed around two documented altarpieces. The wings of the high altar of the cathedral in Essen were commissioned in 1522 and completed in 1525; surviving are depictions of the *Nativity* and *Adoration of the Kings*, with the *Crucifixion* and the *Lamentation* on the reverse. The second altar, dating between 1529 and 1534, was commissioned for the high altar of the Church of Saint Victor in Xanten and represents scenes from the life of Saint Victor and Saint Helena. Several paintings are dated, and there is no difficulty in arriving at a general chronological sequence. In the early and middle period Bruyn's works reflect the influence of Jan Joest, Joos van Cleve (who resided in Antwerp from 1511 on), and local Cologne artists.

Beginning around 1525/1528 Bruyn's religious paintings become increasingly "Romanist" and were influenced by the Italianate style and ornamentation of neighboring Netherlandish artists Jan van Scorel in the 1530s and 1540s and Maerten van Heemskerck in the 1550s. Bruyn was also an excellent portraitist who depicted many of Cologne's patrician citizens. He was the dominant painter in Cologne in the first half of the sixteenth century, and with the exception of his last works, which are indebted to Heemskerck, his robust, craftsmanly style is essentially conservative and represents the end of the late Gothic tradition in Cologne.

Bibliography

Tümmers, Horst-Johs. *Die Altarbilder des älteren Bartholomäus Bruyn*. Cologne, 1964.
Westhoff-Krummacher, Hildegard. *Barthel Bruyn der Ältere als Bildnismaler*. Munich, 1965.

Attributed to Bartholomaeus Bruyn the Elder

1953.3.5 (1179)

Portrait of a Man

c. 1530/1540
Oak, 34.6 × 23.8 (13⅝ × 9⅜)
Gift of Adolph Caspar Miller

Technical Notes: The support is a single-member oak panel with vertical grain. A dendrochronological examination conducted by Peter Klein in 1987 suggested a felling date of 1490$^{+4}_{-3}$ and indicated that the wood came from the Baltic/Polish region.[1] The panel has been thinned to 4 cm., and a heavy cradle attached to the reverse. Examination with infrared reflectography discloses a fine, sketchy underdrawing in the face (fig. 1); the precisely painted contour of the face extends farther to the left than the underdrawn edge. There was also a change in the hat. The face has a porcelainlike surface, while the background is textured with visible brushstrokes. The painting is in somewhat poor condition. By preventing movement of the panel, the cradle has caused some new checking, at the upper and lower left. There is an old repaired check at the upper right, extending downward parallel to the right edge. A small piece of the lower right corner is crushed and loose. There is a curved loss in the upper left corner. There appears to be heavy abrasion in the background, the hair, and the hat, as well as extensive glazed overpaint in the costume. The overpaint over the crackle and abrasion in the background has darkened and has become muddy, as has the overpaint in the hair and costume.

Provenance: Adolph Caspar Miller [d. 1953], Washington, D.C., by 1936.[2]

Exhibitions: Durham, North Carolina, Duke University Museum of Art, 1970, *Inaugural Exhibition, European Paintings*.

THE SITTER is set against a green background and wears a reddish brown mantle with a narrow collar over what appears to be a black doublet. Between the doublet and the shirt is a red garment. On his head is a black beret. At the bottom center of the panel is what is probably the upper portion of a pair of gloves.

Almost nothing is known about the *Portrait of a Man* and it has been virtually ignored by critics.

Because of the generally poor condition of the panel, the amount of abrasion and retouching, and the thick, obscuring layers of varnish, any judgments must be tempered with great caution.

The sole publication is that of Kuhn in 1936, which gave the painting to Bartholomaeus Bruyn the Elder and dated it c. 1535.[3] In a recent conversation, Westhoff-Krummacher, author of the standard monograph on Bruyn's portraits, declined to make specific comments on the attribution, finding the painting too generalized in costume and style.[4] This author feels that in the painting's present state the attribution to Bruyn himself is highly questionable, but the association should not be totally disregarded, for there are some points of comparison with Bruyn's por-

Fig. 1. Infrared reflectogram assembly of a detail of *Portrait of a Man*, 1953.3.5

traits, both in general type and, more specifically, in the treatment of the eyes.[5] Bruyn almost always included the sitter's hands, and his panels usually have curved or semicircular tops. It seems likely, however, that the National Gallery's panel was cut at the bottom and possibly at the top and sides as well, so that the hands holding a pair of gloves may originally have been depicted. This suggestion is based on the composition, not on physical evidence.

The mediocre quality and problematic condition of the *Portrait of a Man* tend to inhibit the possibility of finding a viable alternative attribution. On the basis of style and costume a date of c. 1530/1540 may be proposed.[6] Since the sitter is facing left, it is unlikely that the work was ever part of a portrait pair with a female pendant.

Notes
1. See Appendix.
2. Cited as owned by Miller in Kuhn 1936, 27, no. 22.
3. Kuhn 1936, 27, no. 22.
4. In conversation with the author, 20 October 1989.
5. Hildegard Westhoff-Krummacher (see Biography) 1965, especially 110–134, nos. 16–51. Frank Günter Zehnder, letter to the author, 10 January 1990, in NGA curatorial files, thought the painting was produced in Cologne but was uncertain as to whether it was by Bruyn or another artist, possibly in Bruyn's shop. He suggested a date of c. 1528/1531.
6. For mantles with narrow collars see Westhoff-Krummacher 1965 (see Biography), 118, no. 27, *Portrait of a Man with a Rosary* (Germanisches National-almuseum, Nuremberg), and no. 28, *Portrait of a Man with a Letter* (location unknown), both dated 1533, repro. 119. The rather flat black beret is ubiquitous in Bruyn's portraits throughout the 1530s and can be seen not only in individual portraits but also in male donors in altarpieces. See, for example, the *Departure of Saint Helena* panel of the Xanten altarpiece of 1529–1534, reproduced in Tümmers 1964 (see Biography), 196–197.

References
1936 Kuhn: 27, no. 22, pl. 7.
1975 NGA: 50, repro. 51.
1985 NGA: 70, repro.

Attributed to Bartholomaeus Bruyn the Elder, *Portrait of a Man*, 1953.3.5

Lucas Cranach the Elder

1472–1553

LUCAS CRANACH WAS BORN in 1472 and took his name from his birthplace, the Franconian town of Kronach, which was part of the bishopric of Bamberg. His father, Hans Maler, was an artist, and it is assumed that he was Cranach's first teacher. Around 1501 Cranach traveled to Vienna, where he stayed until at least 1504. In addition to several woodcuts that were strongly influenced by the graphic art of Albrecht Dürer, these years saw an outpouring of paintings of extraordinary quality. Pictures such as the *Saint Jerome Penitent* of 1502 (Kunsthistorisches Museum, Vienna) or the portraits of the humanist scholar Johannes Cuspinian and his wife Anna of c. 1502/1503 (Museum Stiftung Oskar Reinhart, Winterthur) are painted with such exuberance and understanding of the primal relationship of man and nature that Cranach must be counted among the founders of the "Danube School" style.

Although the exact date of his appointment is not known, Cranach was employed at the court of Friedrich the Wise, elector of Saxony, at Wittenberg by April 1505. The Venetian Jacopo de' Barbari was also at court from 1503 to 1505, and his art had a continuing influence on Cranach. During this time Cranach supplied paintings, murals, and decorations for the various ducal residences at Wittenberg, Veste Coburg, Torgau, and elsewhere. The murals no longer survive, but the altarpiece of *The Martyrdom of Saint Catherine*, monogrammed and dated 1506 (Staatliche Kunstsammlungen, Gemäldegalerie, Dresden), contains views of the castle of Coburg and was most likely a ducal commission. In 1508 Cranach spent several months in the Netherlands, particularly Antwerp; in his *Holy Kindred* altarpiece of 1509 (Städelsches Kunstinstitut, Frankfurt) the women's kerchiefs are clearly Netherlandish and critics have seen the compositional and stylistic influence of Quentin Massys and Jan Gossaert.

For most of his life Cranach lived in Wittenberg in Saxony and loyally served not only Friedrich the Wise but his successors Johann the Steadfast and Johann Friedrich the Magnanimous. Numerous documents testify to Cranach's industry and prosperity. As one of the leading citizens of Wittenberg, he owned several houses, an apothecary, and a publishing firm that specialized in Reformation literature; on several occasions he served on the city council and as burgomaster. Cranach joined Johann Friedrich in exile in Augsburg and Innsbruck in 1547 when the elector was taken prisoner by Charles V, and in 1552 followed him to Weimar where Johann Friedrich reestablished the Saxon court. Cranach died in Weimar in 1553 at the age of eighty-one.

Cranach headed a large workshop that included his sons Hans (c. 1513–1537) and Lucas the Younger (1515–1586) as well as numerous apprentices and journeymen. Well in excess of four hundred paintings have been assigned to Cranach and his atelier, and at present a proper catalogue raisonné or a method of distinguishing the authorship of these paintings does not exist. It is almost as if the smooth surfaces and decorative aspects of the works from the 1520s onward were created with an eye toward repetition.

Cranach's early works are often signed with the monogram LC, but in 1508 Duke Friedrich the Wise granted him a coat-of-arms depicting a serpent with upright bat wings and a ring held in its mouth. The winged serpent probably had humanistic or hieroglyphic significance and could stand for Kronos, the Greek god of time, a pun on the artist's name in Latin as well as German. Cranach used this device on his paintings from 1508 onward. After 1534, however, the serpent's wings are those of a bird and are shown folded. The new form is prevalent from 1537 onward and has been connected with the death of the artist's son Hans in 1537. The presence of the serpent with folded wings on paintings dated 1535 and 1536 under-

mines this somewhat romantic notion, but has been seen as an attempt by Cranach to distinguish the work of his sons.

Cranach is probably the artist most closely associated with the Protestant Reformation. He was a friend of Martin Luther, who lived and taught in Wittenberg under the protection of the electors of Saxony. Cranach and his shop produced great numbers of portraits of Luther, his wife, and other reformers as well as depictions of such "Protestant" themes as *Christ Blessing the Children* (Church of Saint Wenceslaus, Naumburg) and *Christ and the Woman Taken in Adultery* (Szépmüvészeti Múzeum, Budapest). It should be remembered that the artist also worked for Luther's adversary, Cardinal Albrecht von Brandenburg, and in 1525 and 1527 depicted the cardinal as Saint Jerome in indoor and outdoor settings (Hessisches Landesmuseum, Darmstadt, and Gemäldegalerie, Berlin). The range of subject matter found in Cranach's paintings is, in fact, quite wide. In addition to religious works he produced a variety of mythological and secular subjects, probably intended for humanist or courtly patrons. He was also an excellent portraitist; the full-length portraits of Henry the Pious of Saxony and his wife Catherine, c. 1514 (Staatliche Kunstsammlungen, Gemäldegalerie, Dresden), achieve an almost mannerist decorative grandeur, while others, in particular the portrait of a scholar, possibly Dr. Johannes Scheyring, dated 1529 (Musées Royaux des Beaux–Arts, Brussels), are marked by an intense naturalism.

Along with Dürer, Grünewald, and Holbein, Cranach must be reckoned as one of the dominant German artists of the sixteenth century.

Bibliography

Friedländer, Max J., and Jakob Rosenberg. *Die Gemälde von Lucas Cranach*. Berlin, 1932. English rev. ed., Amsterdam, 1978.

Schade, Werner. *Die Malerfamilie Cranach*. Dresden, 1974. English ed., New York, 1980.

Koepplin, Dieter, and Tilmann Falk. *Lukas Cranach. Gemälde, Zeichnungen, Druckgraphik*. 2 vols. Exh. cat., Kunstmuseum. Basel, 1974, 1976.

1947.6.1 (896)

A Prince of Saxony

c. 1517
Linden, 43.7 × 34.4 (17¼ x 13½)
Ralph and Mary Booth Collection

Technical Notes: The painting is executed on a single piece of linden that was cut tangentially.[1] Additional wooden strips approximately 1 cm. wide have been attached to the left and right edges and retouched to match the adjoining paint. The reverse, including the cradle, has been coated with a paint, possibly containing lead, that is absolutely opaque to x-radiography. The painting is in good condition. The contour lines around the face have been strengthened, and the paint is thin in the face and in areas of shadow beneath the chin. The shadows in the robe have been reinforced.

Provenance: (Julius Böhler, Munich, owned jointly with August Salomon, Dresden, through Paul Cassirer, Berlin);[2] purchased August 1925 by Ralph Harman and Mary B. Booth, Detroit.

Exhibitions: Detroit Institute of Arts, 1926, *The Third Loan Exhibition of Old Masters*, no. 18. Art Institute of Chicago, 1933, *A Century of Progress Exhibition of Paintings and Sculpture*, no. 16. New York, World's Fair, 1939, *Masterpieces of Art*, no. 60.

1947.6.2 (897)

A Princess of Saxony

c. 1517
Linden, 43.4 × 34.3 (17⅛ × 13½)
Ralph and Mary Booth Collection

Technical Notes: The support consists of a single piece of linden that was cut tangentially.[3] The painting has been cradled. Additional strips of wood approximately 1 cm. wide have been attached to the left and right edges and retouched to match the adjoining paint. The painting is in fairly good condition, although there is extensive worm tunneling on the reverse. The face is somewhat abraded, and there is a good deal of thin retouching in the shadows. Scattered throughout are very small retouchings covering losses and abrasion.

Provenance: Same as 1947.6.1.

Lucas Cranach the Elder, *A Prince of Saxony*, 1947.6.1

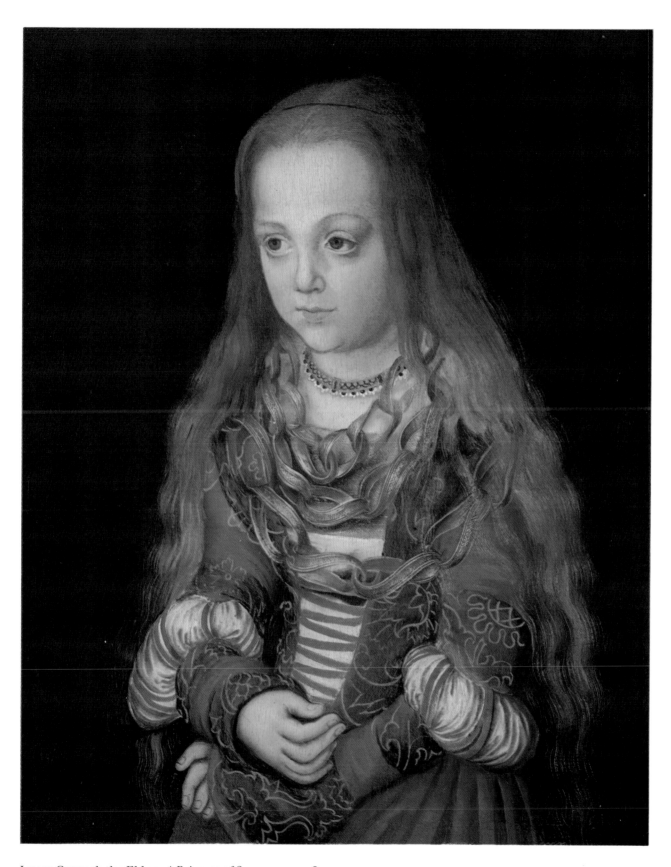

Lucas Cranach the Elder, *A Princess of Saxony*, 1947.6.2

Exhibitions: Detroit Institute of Arts, 1926, *The Third Loan Exhibition of Old Masters*, no. 17. New York, Reinhardt Galleries, 1929, *Portraits of Women and Children from the 15th to the 20th Centuries.* New York, World's Fair, 1939, *Masterpieces of Art*, no. 61.

THESE PICTURES rank among Cranach's most engaging and charming portraits of children. In the expressions of the boy and girl the artist has captured the wistful innocence and gentle seriousness of childhood. Depicted in half length against a black background, the pair are regally dressed. The boy wears a high-necked doublet richly embroidered in gold and white and bearing images of flowers and what appears to be a rabbit and a fox. His sleeves are a lustrous red damask and appear through the armholes of his brown outer robe. At a jaunty angle on his head is a garland made not of flowers but of gold, pearls, and leaves of green enamel. The girl's costume is equally splendid. Her dress is a heavy red fabric, perhaps velvet or a dull satin, with a floral pattern in yellow and with slashed and puffed sleeves. At the top of the bodice is a wide piece of cloth-of-gold, and around her shoulders is an elaborate gold chain. A final touch of elegance is provided by the gold necklace edged with delicate white flowers (daisies?) made of enamel.

Although there is no way of identifying the sitters precisely, it seems reasonable to suggest, as was first done by Friedländer and Rosenberg, that they could be a Saxon prince and princess.[4] The regal costume accords well with that found in other of Cranach's portraits of Saxon nobility. The crown worn by the boy is a traditional sign of engagement.[5] The girl is probably the boy's sister, as the absence of a garland on her head makes it unlikely that she is his fiancée. The betrothal of noble children was not uncommon; Talbot called attention to Bernhard Strigel's portrait of Ludwig of Hungary (Kunsthistorisches Museum, Vienna), aged nine and wearing a crown, painted in 1515 on the occasion of a double engagement of Ludwig and his sister to a daughter and son of Philip the Fair.[6] In addition, Cranach's portrait dated 1529 of a young boy wearing a betrothal crown (Wallraf-Richartz-Museum, Cologne) is tentatively identified as a prince of Saxony.[7]

There have been two attempts to identify the children in the National Gallery portraits. Friedländer and Rosenberg thought they were possibly the children of Duke George the Bearded of Saxony: Prince Friedrich, born in 1504, and Princess Christine, born in 1505.[8] Werl suggested that they might be Count Philipp of Hesse and Duchess Elisabeth of Saxony, but Koepplin, the only author to comment, did not find this proposal convincing.[9] Neither identification can be verified. While it is often difficult to guess the ages of children in portraits, it seems to this author that the girl is several years older than her brother, which argues against the identification put forward by Friedländer and Rosenberg.

Following Friedländer and Rosenberg, most authors agree in dating the portraits to the period around 1516/1518. Ruhmer thought they might be later but declined specific comments, while Werl would like to date them around 1512, primarily because Elisabeth of Saxony was born in 1502.[10] As noted by Talbot, however, there are stylistic comparisons with the pair of portraits of Maurice Buchner, dated 1518, and his wife Anna (Minneapolis Institute of Arts), and further, the National Gallery's paintings are not as patterned and as severe as the *Portrait of a Young Girl*, usually dated around 1520 (Musée du Louvre, Paris).[11]

Notes
1. The wood was identified as linden (sp. *Tilia*) by Peter Klein, examination report, 29 September 1987, in NGA curatorial files.

2. Julius Böhler, letter to the author, 9 November 1987, in NGA curatorial files.

3. Klein, examination report, 29 September 1987, in NGA curatorial files.

4. Friedländer and Rosenberg 1932 (see Biography), 50, nos. 104–105.

5. Compare, for example, Cranach's portraits of Johann Friedrich the Magnanimous and Sibyl of Cleves, both dated 1526 (Schlossmuseum Weimar), Friedländer and Rosenberg 1978 (see Biography), 128, nos. 304–305, repro. Both persons wear crowns; the betrothal took place in September 1526 and the wedding in June of the following year. See also Otto Bramm, "Brautkranz, Brautkrone," *Reallexikon zur deutschen Kunstgeschichte*, 8 vols. (Stuttgart and Munich, 1937–1988), vol. 2 (1948): cols. 1125–1130.

6. Charles Talbot, draft catalogue entry, 1966, in NGA curatorial files. For the portrait of Ludwig of Hungary see Gertrud Otto, *Bernhard Strigel* (Munich and Berlin, 1964), 68, 102, no. 61, fig. 129.

7. Friedländer and Rosenberg 1978 (see Biography), 134, no. 329, repro.

8. Friedländer and Rosenberg 1932 (see Biography), 50, nos. 104–105.

9. Werl 1965, 31–35; Koepplin 1974, 34 n. 47.

10. Ruhmer 1963, 84, nos. 16–17; Werl 1965, 34.

11. Talbot, draft catalogue entry, 166, in NGA curatorial files. For the portraits of Buchner and his wife and of the young girl in the Museé du Louvre see Friedländer and Rosenberg 1978 (see Biography), 95, nos. 127–128, repro., and 100, no. 153, respectively.

References

1929 "New York." *Pantheon* 3: 196, repro. 199.

1932 Friedländer and Rosenberg (see Biography): 50, nos. 104–105, repro. Rev. ed., 1978: 94, nos. 123–124, repro.

1933 Frankfurter, Alfred M. "Art in the Century of Progress." *The Fine Arts* 20: repro. 19.

1936 Kuhn: 37, 90–91, pl. 19.

1939 Craven, Thomas. *A Treasury of Art Masterpieces from the Renaissance to the Present Day.* New York: 261–262, pl. 62.

1943 Posse, Hans. *Lucas Cranach d. Ä.* Vienna: 57, nos. 45–46, repro.

1948 "Gifts from the Booth Collection." *Conn* 122: 40, repro.

1948 Louchheim, Aline B. "Children Should Be Seen." *Art News Annual* 46: 56–57, repro.

1948 *Recent Additions to the Ralph and Mary Booth Collection.* Washington: unpaginated, repro.

1949 L. J. Roggeveen. "De National Gallery of Art te Washington." *Phoenix* 4: 340, repro. 338.

n.d. *National Gallery of Art, Portfolio Number 3.* Washington: no. 1, repro.

1960 Broadley: 28, repro. 29.

1963 Ruhmer, Eberhard. *Cranach.* London: 84, nos. 16–17, repro.

1963 Walker: 124, repro. 125.

1965 Werl, Elisabeth. "Herzogin Elisabeth von Sachsen die Schwester Landgraf Philipps von Hessen in bildlicher Darstellung. Zur Identifizierung von Cranachbildnissen Landgraf Philipps von Hessen Kinderbild?" *Hessisches Jahrbuch für Landesgeschichte* 15: 31–35, repro.

1966 Cairns and Walker. 1: 114, repro. 115.

1974 Koepplin, Dieter. "Zwei Fürstenbildnisse Cranachs von 1509." *Pantheon* 32: 29.

1975 NGA: 84, 86, repro. 85, 87.

1976 Walker: 162, no. 183, 165, no. 186, repro. 163, 164.

1978 King, Marian. *Adventures in Art.* New York: 34, repro.

1979 Watson, Ross. *National Gallery of Art, Washington.* New York: 56, repro. 57.

1985 NGA: 104, repro.

1953.3.1 (1173)

Madonna and Child

Probably c. 1535 or later
Beech, 71.2 × 52.1 (28 × 20½)
Gift of Adolph Caspar Miller

Inscription
At right, above the Madonna's shoulder: a serpent with folded (?) wings

Technical Notes: The painting is comprised of two boards with vertically oriented grain. A dendrochronological examination by Peter Klein yielded dates of 1406–1453 and 1480–1513 for the boards.[1] The panel has been thinned down to a thickness of 0.2 cm. and an auxiliary support added. The support consists of a plywood composite board sandwiched between two thin sheets of wood. The panel was then cradled. Either before or after the panel was thinned, an inset of oak, 16.4 × 17 cm., was added to the top right corner, replacing the original wood and paint, which had been lost. The x-radiograph indicates extensive woodworm damage throughout the panel, and this may be related to the loss of the corner, although it is also possible that this area contained a landscape that was cut out. The x-radiograph also suggests that a knot was removed and replaced with an inset and a filler before the panel was painted, because the craquelure pattern of the paint goes over the inset and also because the worm channels continue into the inset. Examination with infrared reflectography disclosed underdrawing in what appears to be a liquid medium, which is especially visible in the knot of the Madonna's sash (fig. 1).

The painting is not in good condition. In order to disguise the extent of the loss in the top right corner the background has been overpainted; moreover, the orig-

Fig. 1. Infrared reflectogram of a detail of *Madonna and Child*, 1953.3.1

inal paint is badly abraded. Two splits are visible; one extends upward from the bottom edge through the glass, while the second occurred along the join line. There are numerous other losses, some of which are due to flaking, most of which have been filled and inpainted.

Provenance: (Probably H. Michels Gallery, Berlin, by 1929).[2] (Van Diemen & Co., New York, by November 1929).[3] Adolph Caspar Miller, Washington, by April 1937[4].

Exhibitions: New York, Van Diemen Galleries, 1929, *Lucas Cranach (1472–1553)*. Washington, Phillips Memorial Gallery, 1937, *Paintings and Sculpture Owned in Washington*, no. 6.

DRESSED IN ROBES of light and dark blue, bright orange, and orangish red, the Madonna is shown behind a parapet, holding a bunch of grapes in one hand and supporting the Christ Child with the other. The Child stands on the ledge, balancing on one foot; he is about to eat a grape and holds an apple against his upraised knee. On the ledge is another apple and a glass containing what is probably wine. These objects may be interpreted in light of traditional religious symbolism. The apples mark Christ as the "new Adam," who will redeem the sins of mankind, and the liquid in the glass refers to the wine of the Eucharist. The grapes are also widely used symbols of the Eucharist and can refer to other biblical passages that associate Christ with grapes.[5] From the position of the bunch of grapes held by Mary, it is possible to suggest a secondary meaning, based on the Song of Solomon (7: 7–8), which identifies the grapes with Mary's breasts in their function of providing nourishment for the infant Christ.[6]

The *Madonna and Child* is a good example of Cranach's mature style, and although the background is overpainted, other portions of the painting, such as the sleeves of the Madonna's robe, are executed with skill and vigor. Possibly because they thought the wings of the serpent in the artist's device might be folded, Friedländer and Rosenberg dated the panel around 1537,[7] while Talbot proposed a date around 1535, citing stylistic similarities to Cranach's *Madonna and Child with John the Baptist and Angels*, which is dated 1535 (Staatsgalerie, Stuttgart).[8] In terms of both style and compositional type, the Washington painting

may be associated with a group of pictures depicting the Christ Child standing on the Madonna's lap and preparing to eat a grape.[9] Sometimes the Child holds a bunch of grapes, and sometimes the Madonna does. Another related type includes the infant John the Baptist asleep.[10] Because the Child is shown standing on a parapet and not in the Madonna's lap, the National Gallery's picture does not correspond exactly to the other depictions of this theme. A version of the Washington panel that was on the art market in Switzerland in 1972 contains a window looking out on a landscape at the upper right corner.[11] The size of the landscape appears to correspond to the size of the missing top right corner of the National Gallery's painting and suggests that the background may once have been enlivened by a window and a landscape view. A second replica, also containing a landscape, recently appeared on the market.[12]

Interestingly, the *Madonna and Child* was strongly influenced by the early works of Albrecht Dürer. As observed by Talbot, the crinkled, angular drapery folds of the Madonna's robe and knotted sash are similar to those found in Dürer's engraving of the *Madonna with the Monkey* from about 1498.[13] The motif of the standing Child and the placement of the Virgin behind a foreground ledge are found in the Madonnas of Giovanni Bellini, but it is likely that they were transmitted to Cranach through Dürer. For example, Dürer's *The Virgin with the Sleeping Child between Saints Anthony and Sebastian* (Staatliche Kunstsammlungen, Gemäldegalerie, Dresden), painted just after his first trip to Venice, shows the Christ Child on a ledge in the foreground with the Madonna behind. Since Dürer's painting was commissioned by Friedrich the Wise for the palace church in Wittenberg, it would have been well known to Cranach.[14] Moreover, as probably first noted by Shapley, the pose of the infant Christ, balancing on one leg with the other raised and the foot pressed against the knee, is found in reverse in Dürer's *Madonna and Child* (1952.2.16a), which derives from Bellini and was painted following Dürer's first trip to Venice.[15] Although the use of such Venetian-inspired devices as the foreground ledge is perhaps more frequent in Cranach's works from around 1510, they are not

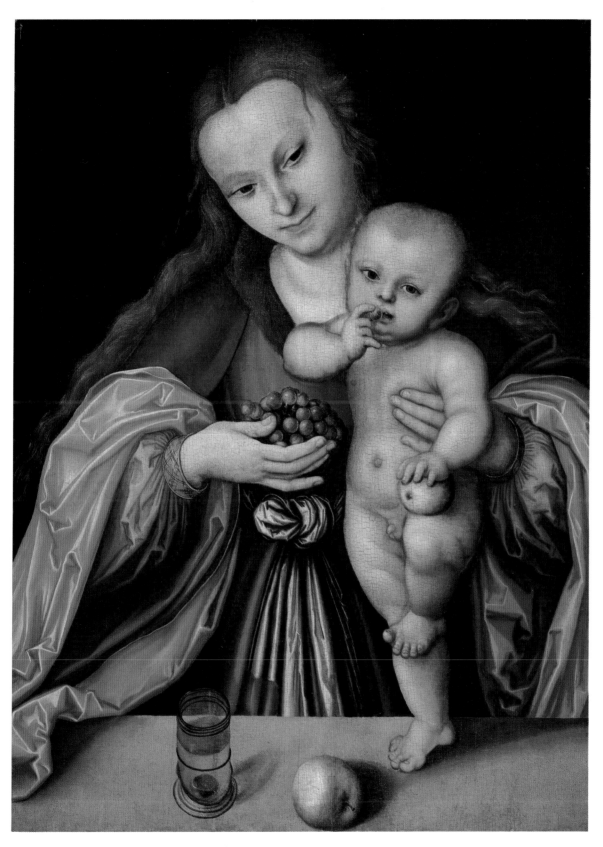

Lucas Cranach the Elder, *Madonna and Child*, 1953.3.1

unknown in the mature paintings, such as the *Virgin and Child with Angels* of c. 1525 (Roseliushaus, Bremen).[16]

Notes

1. The wood was identified as beech by Peter Klein, examination report, 5 May 1987, in NGA curatorial files, and by the National Gallery's scientific research department.

2. Unverified, but cited by Friedländer and Rosenberg 1932 (see Biography), 87, no. 314; the reproduction caption says "formerly" with H. Michels.

3. Exhibited at the Van Diemen Galleries, New York; the exact dates of the show are not known, but there was an advertisement for the exhibition in the *New York Times*, 17 November 1929, sec. 9.

4. Listed as belonging to Miller in exh. cat. Washington 1937.

5. For the symbolism of the apple see George Ferguson, *Signs and Symbols in Christian Art* (New York, 1954), 32; for the various meanings of grapes see E. de Jongh, "Grape Symbolism in Paintings of the 16th and 17th Centuries," *Simiolus* 7 (1974), especially 182, 184–189.

6. E. James Mundy, "Gerard David's *Rest on the Flight into Egypt*: Further Additions to Grape Symbolism," *Simiolus* 12 (1981/1982), 215–222, in which he notes that in the Song of Solomon the Bride and Bridegroom were interpreted as the Virgin and Christ by medieval theologians.

7. Friedländer and Rosenberg 1932 (see Biography), 87, no. 314. The state of the painting is such that the artist's device is more clearly visible in a photograph than in the original, and this author was unable to determine whether the serpent's wings were folded or not.

8. Charles Talbot, draft catalogue entry, 1966, in NGA curatorial files, described the wings as "upright," that is, presumably, unfolded. For the Stuttgart painting see Friedländer and Rosenberg 1978 (see Biography), 114, no. 227, repro.

9. Friedländer and Rosenberg 1978 (see Biography), 147, nos. 388, 389, repros.; numerous versions of no. 388 are listed.

10. Friedländer and Rosenberg 1978 (see Biography), 146–147, nos. 386, 387, repros. There are also similarities to no. 392, *Virgin and Child with the Boy Saint John Proffering a Bunch of Grapes*, whose composition was repeated several times.

11. Wood, 85 × 60 cm., sale, Galerie Fischer, Lucerne, 25 November 1972, no. 2355, called Workshop of Lucas Cranach the Elder. The photocopy of the catalogue, in NGA curatorial files, was sent by Dieter Koepplin, 4 November 1972.

12. Wood, 79.5 × 56 cm., Sotheby & Co., London, 30 October 1991, no. 196.

13. Talbot, draft catalogue entry, 1966, in NGA cura-

torial files. For Dürer's engraving (Bartsch, 42) see Walter L. Strauss, ed., *The Complete Engravings, Etchings and Drypoints of Albrecht Dürer* (New York, 1972), 42–43, no. 21, repro.

14. Pointed out by Talbot, draft catalogue entry, 1966, in NGA curatorial files. For a color reproduction of the Dresden triptych see Peter Strieder, *Albrecht Dürer. Painting, Prints, Drawings* (New York, 1982), 293. Following Anzelewsky 1971, 134–137, nos. 39–40, it is now believed that the center portion is the work of a Netherlandish artist but was possibly reworked by Dürer when he added the wings. This does not obviate the strong Venetian flavor of the painting.

15. Fern Rusk Shapley, discussion, 19 January 1959, in NGA curatorial files.

16. Friedländer and Rosenberg 1978 (see Biography), 102, no. 160, repro. For examples of Cranach's earlier Madonnas set in front of a landscape and including a bunch of grapes held either by the Child or the Virgin, see Friedländer and Rosenberg 1978 (see Biography), 74–75, nos. 29–30, repros. (present location unknown; and Thyssen-Bornemisza collection, Lugano, respectively).

References

1932 Friedländer and Rosenberg (see Biography): 87, no. 314, repro. Rev. ed. 1978 (see Biography): 147, no. 390, repro.

1971 Calvesi, Maurizio. "Caravaggio o la ricerca della salvazione." *Storia dell'arte* 9/10: 98, fig. 7.

1975 NGA: 86, repro. 87.

1976 Walker: 165, no. 188, repro.

1985 NGA: 104, repro.

1957.12.1 (1497)

The Nymph of the Spring

After 1537
Linden, 48.4 × 72.8 (19 × 28⅝)
Gift of Clarence Y. Palitz

Inscriptions

At top left: *FONTIS NYMPHA SACRI SOM: / NVM NE RVMPE QVIESCO*
To the right of the inscription: a serpent with folded wings, facing left, holding a ring in its mouth (fig. 1)

Technical Notes: The panel is composed of three boards with horizontal grain, each of which varies in height from one side to the other.[1] The panel has been thinned, probably at the time the cradle was attached, and the top and right edges may have been slightly trimmed. Examination with infrared reflectography did not disclose underdrawing, although it did indicate

Fig. 1. Detail of *The Nymph of the Spring*, 1957.12.1

that the left branch of the tree on the right was painted later than the trunk. There are also pentimenti visible to the naked eye in the contour of the lower part of the nymph's leg and right forearm and in the townscape.

The painting is generally in good condition but has suffered some damage. There are checks at the left and right sides, chips missing from the top left and right corners, and a few small drill holes on the top and bottom edges. On the top left edge there are two large losses that have been filled and retouched, and there is scattered retouching throughout.

Provenance: Probably Baron von Schenck, Flechtingen Castle, near Magdeburg.[2] (Böhler and Steinmeyer, Lucerne and New York, 1931–1933).[3] Clarence Y. Palitz [d. 1958], New York, by 1939.[4]

Exhibitions: New York, M. Knoedler & Co., 1939, *Classics of the Nude*, no. 5A. New York, World's Fair, 1939, *Masterpieces of Art*, no. 59. Exhibited at National Gallery of Art, Washington, from 1946.[5]

IN THE FOREGROUND a young woman reclines on a lush carpet of leaves and grasses, her head and arm cushioned by the rich fabric of a courtly dress. Her nakedness is emphasized by her jewelry and the transparency of the filmy gauze covering her thighs and head. Behind her is a pool that is filled by a stream of water issuing from a trough carved out of rock at the source. Although connected to the distant town by a bridge, the setting appears psychologically and compositionally secluded and removed from the world of man.

The initial clue to the meaning of this painting is provided by the inscription at the upper left, which in translation reads, "I am the nymph of the sacred spring. Do not disturb my sleep. I am rest-

ing." These words are an abbreviated paraphrase of a poem actually composed in the late fifteenth century but thought to be classical from the sixteenth century well into the nineteenth. Supposedly it was found on a fountain with a statue of a sleeping nymph, situated on the banks of the Danube river. The epigram was popular in Italy and used in conjunction with contemporary fountains adorned with sleeping nymphs. Moreover, there are literary sources in antiquity for representing fountain nymphs as reclining sleeping figures, and the visual precedent for the pose, distinguished by one arm bent back behind the head, lies in ancient sculptural depictions of Ariadne that were known in the fifteenth and sixteenth centuries.[6]

The epigram was also known in humanistic circles in Germany, for it appears shortly before 1500 in the writings of Conrad Celtis.[7] Important visual evidence is provided by a drawing attributed to Albrecht Dürer (fig. 2) that depicts a reclining nymph sleeping in front of a fountain.[8] On the side of the fountain is the complete text of the poem, which identifies the figure as the guardian of the sacred spring and admonishes the reader and visitor not to disturb her slumber.

In the National Gallery's panel the nymph is more than the protectress of the spring, and she is not sleeping; her eyes are open, and she coyly regards her surroundings. The bow and quiver of arrows hanging from the tree at the right suggest an additional association with Diana, goddess of the hunt. The two partridges at the lower right may be part of the Diana imagery, but they could have other meanings as well. Partridges can allude to sexual excess or perversion and are also ancient symbols of Venus and *luxuria*.[9] While it seems clear that *The Nymph of the Spring* had several levels of meaning for the contemporary viewer, these are not now easily elucidated. References to Diana call to mind her chastity as well as the fact that it was both forbidden and fatal for her to be seen by mortals, as the story of Diana and Actaeon makes clear. Both Diana and the Nymph of the Spring are creatures of the natural world and may almost be taken as personifications of nature. Yet the sophisticated and self-conscious presentation of naked allurement is perhaps more suited to an image of Venus and contradicts

the innocence of either Diana or a nymph. As one way of coming to grips with the ambivalence of this type of depiction of the Nymph of the Spring, Talbot, Schade, and Koepplin and Falk have stressed the moralizing qualities of this painting.[10] Comparison is made to Cranach's paintings of *Venus and Cupid* or *Venus with Cupid as the Honey Thief*, in which inscriptions warn the viewer to resist lust and amorality or, in the case of the latter, remind one that pleasure is transitory and mixed with pain and sadness.[11]

The theme of *The Nymph of the Spring*, which was probably produced for a humanist and possibly courtly milieu, occupied Cranach throughout his career. There are more than sixteen painted depictions of this subject and a drawing (formerly Staatliche Kunstsammlungen, Kupferstich-Kabinett, Dresden) by Cranach and his shop.[12] Because of variations in the details of the setting and the pose of the nymph, no two works are exactly the same. The precise source for the pose of Cranach's nymph is not known, although several authors have called attention to the similarities to Giorgione's *Venus* (Staatliche Kunstsammlungen, Gemäldegalerie, Dresden) or suggested that Giorgione might have painted a version, now lost, of the Nymph of the Spring.[13] Furthermore, Cranach might have been influenced by the woodcut depiction of a sleeping fountain nymph and satyr

in Francesco Colonna's *Hypnerotomachia Poliphili*, or Italian prints such as Girolamo Mocetto's engraving of *Amymone*, c. 1500/1514, or the drawing attributed to Dürer of *The Nymph of the Spring*, c. 1514. It is possible that Cranach might have known an antique source for the reclining figure, perhaps through a drawing or a print.[14]

The earliest versions of the theme, the paintings in the Staatliche Schlösser und Gärten, Jagdschloss Grunewald, Berlin, dated c. 1515/1516, and in the Museum der bildenden Künste, Leipzig, dated 1518, simply show the nymph lying in front of the fountain.[15] The drawing formerly in Dresden, usually dated c. 1525, is probably the first image to include what might be called the secondary attributes—the bow, arrows in a quiver, and partridges—that are found in the National Gallery's panel.[16] Somewhat later than the drawing are paintings containing these objects in the Thyssen-Bornemisza collection, Lugano, dated between c. 1526/1530 and c. 1530/1535, and the Walker Art Gallery, Liverpool, dated 1534.[17]

Because of the folded wings of the serpent in the artist's device, the Washington version of *The Nymph of the Spring* is dated after 1537. Koepplin and Falk find stylistic similarities with the version in the Musée des Beaux-Arts, Besançon, which they date c. 1540/1550.[18] Comparison can also be

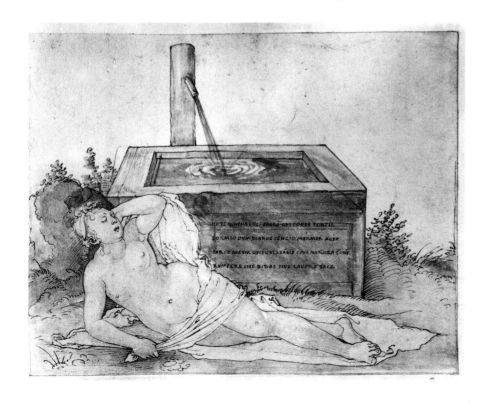

Fig. 2. Albrecht Dürer, *The Nymph of the Spring*, pen and brown ink and brush with watercolor, 15.2 × 20.0 cm., Kunsthistorisches Museum, Vienna [photo: Kunsthistorisches Museum]

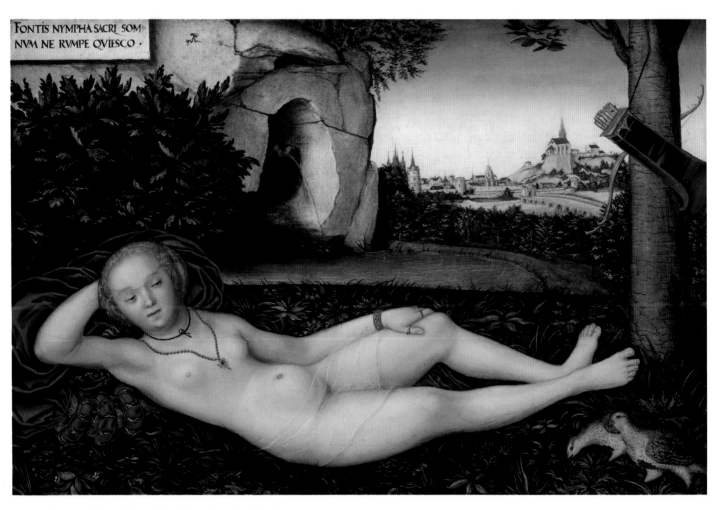

Lucas Cranach the Elder, *The Nymph of the Spring*, 1957.12.1

made to the version in the Nasjonalgalleriet, Oslo, dated 1550.[19]

Even though late in date, the National Gallery's painting is to be grouped with the works of Lucas Cranach the Elder and is different in style and execution from those versions in Kassel and New York that are likely to be by Lucas the Younger.[20]

Notes

1. The wood was identified as linden by Peter Klein, examination report, 29 September 1987, in NGA curatorial files, and by the National Gallery's scientific research department.

2. Not verified, but Friedländer and Rosenberg 1932 (see Biography), 89, no. 324, cite the painting as being formerly in the von Schenck collection.

3. Information from a copy of the Böhler stock records in the Getty Provenance Index, Santa Monica; Martha Hepworth to Sally E. Mansfield, 18 August 1988, in NGA curatorial files. The painting is listed as being on consignment from "Sarasota." It has not been possible to verify Hepworth's suggestion that this might refer to John Ringling. A notation in the stock records suggests that the painting passed to the dealer Paul Cassirer, but it has not been possible to confirm this. Böhler and Steinmeyer was the firm created by Julius Böhler, Munich, and Fritz Steinmeyer, Lucerne, and operated from the 1920s on; see Julius Böhler to the author, 29 August 1988, in NGA curatorial files.

4. Listed as being in Palitz' collection in exh. cat. New York, 1939, no. 54.

5. John Walker, letter to Clarence Y. Palitz, 16 January 1946, in NGA curatorial files.

6. See Otto Kurz, "*Huius nympha loci*: A Pseudo-Classical Inscription and a Drawing by Dürer," *JWCI* 16 (1953), 171–177; Elisabeth B. MacDougall, "The Sleeping Nymph: Origins of a Humanist Fountain Type," *AB* 57 (1975), 357–365. The poem appears in a manuscript compilation of inscriptions dated between 1477 and 1484 by Michael Fabricius Ferrarinus, prior at the Carmelite monastery at Reggio Emilia. The Latin poem reads: "Huius nympha loci, sacri custodia fontis / Dormio, dum blandae sentio murmur aquae / Parce meum, quisquis tangis cava marmora somnum / Rumpere: sive bibas, sive lavere tace," or, as charmingly translated in 1725 by Alexander Pope: "Nymph of the grot, these sacred springs I keep, And to the murmur of these waters sleep; Ah, spare my slumbers, gently tread the cave! And drink in silence, or in silence lave!" MacDougall 1975, 359, notes that images of Ariadne on sarcophagi were available in the late fifteenth and early sixteenth centuries but feels that it is unlikely that ancient depictions of water nymphs or river gods were known until at least the 1530s.

7. Dieter Wuttke, "Zu *Huius nympha loci*," *Arcadia* 3 (1968), 305–307.

8. Pen and brown ink and brush with watercolor, 152 × 200 mm. The attribution to Dürer is not fully accepted by all authorities; for a brief discussion and references to earlier literature see Walter L. Strauss, *The Complete Drawings of Albrecht Dürer*, 6 vols. (New York, 1974), 3: 1462, no. 1514/36.

9. Talbot 1967, 81. Liebmann 1968, 437, while noting the combination of two motives—that of Nymph of the Spring with Venus-Luxuria in Cranach's later works—stresses that Luxuria should be interpreted not as voluptuousness, but as "luxuriant growth" or "powerful increase." For the iconography of partridges see Talbot 1967, 87 n. 35; and Herbert Friedmann, *A Bestiary for Saint Jerome: Animal Symbolism in European Religious Art* (Washington, 1980), 282, 284, 131–132. Two gray partridges (*Perdix cinerea*) similar to those in the National Gallery's painting occur in Cranach's *Saint Jerome in His Study*, dated 1526 (John and Mable Ringling Museum of Art, Sarasota); Friedmann 1980, figs. 104–105. As pointed out by Friedmann 1980, 131–132, although Jerome considered the birds satanic, partridges could also refer to the eventual triumph of truth and hence are not easily interpreted within the context of depictions of Saint Jerome.

10. Talbot 1967, 81, 83–84. Schade 1974 (see Biography), 69–71, without referring specifically to the National Gallery's panel, sees a connection between the bow and arrow of Diana and the legendary spring of the alchemist Bernardus Trevisanus. The theme of the Nymph of the Spring is discussed at some length in Koepplin and Falk 1974–1976 (see Biography), vol. 1, with Dieter Koepplin, "Cranachs vor-manieristische Formeln," 421–432, and vol. 2, 631–641, nos. 543–548, and related images, nos. 549–554. See also Bonicatti and Cieri 1974, 272–285.

11. Talbot 1967, 81–84, discusses and reproduces Cranach's *Venus and Cupid* of 1509 (Hermitage, St. Petersburg) and *Venus with Cupid as the Honey Thief*, dated 1531 (Galleria Borghese, Rome). In this regard it is perhaps significant that Dürer's drawing of *Venus with Cupid as the Honey Thief*, monogrammed and dated 1514 (Kunsthistorisches Museum, Vienna), is associated with the drawing of the Nymph of the Spring attributed to Dürer; see Kurz 1953, 171. The drawing is reproduced in Bonicatti and Cieri 1974, fig. 19.

12. Unless otherwise noted the paintings are on wood:

1. Staatliche Schlösser und Gärten, Jagdschloss Grunewald, Berlin, 58.2 × 87 cm.; Friedländer and Rosenberg 1978 (see Biography), 93, no. 119A; Koepplin and Falk 1974–1976 (see Biography), vol. 1, fig. 236.

2. Museum der bildenden Künste, Leipzig, 1518, 59 × 92 cm.; Friedländer and Rosenberg 1978 (see Biography), 93, no. 119, repro.

3. Formerly Staatliche Kunstsammlungen, Kupferstich-Kabinett, Dresden, pen and brown ink and gray wash, 116 × 206 mm.; Jakob Rosenberg, *Die Zeichnungen Lucas Cranach d.Ä.* (Berlin, 1960), 22,

no. 40, repro., dated the drawing c. 1525.

4. Thyssen-Bornemisza collection, Lugano, 77 × 21.5 cm.; Friedländer and Rosenberg 1978 (see Biography), 94, no. 120, repro.

5. Private collection, 36.5 × 25 cm.; Friedländer and Rosenberg 1978 (see Biography), 94, no. 120A; Koepplin and Falk 1974–1976 (see Biography), vol. 2, fig. 317.

6. Walker Art Gallery, Liverpool, 1534, 50.8 × 76.2 cm.; Friedländer and Rosenberg 1978 (see Biography), 121, no. 259, repro.

7. Kunstsammlungen, Veste Coburg, diameter 14.7 cm.; Friedländer and Rosenberg 1978 (see Biography), 116, no. 232C; Koepplin and Falk 1974–1976, vol. 1, fig. 146.

8. Present location unknown (in a private collection, Paris, in 1932), 50 × 75 cm.; Friedländer and Rosenberg 1978 (see Biography), 150, no. 402, repro.

9. Art market, Switzerland, in 1963, 48 × 72.5 cm.; Friedländer and Rosenberg 1978 (see Biography), 150, no. 402A.

10. Staatliche Kunstsammlungen, Kassel, 14.8 × 20.6 cm.; Friedländer and Rosenberg 1978 (see Biography), 150, no. 403A, as likely to be by Lucas Cranach the Younger; Anja Schneckenburger-Broschek, *Die altdeutsche Malerei* (Kassel, 1982), 95, as workshop of Lucas Cranach the Younger.

11. Metropolitan Museum of Art, New York, Robert Lehman Collection, 16 × 20 cm.; Friedländer and Rosenberg 1978 (see Biography), 150, no. 403B, as likely to be by Lucas Cranach the Younger; George Szabó, *The Robert Lehman Collection* (New York, 1975), pl. 72.

12. Musée des Beaux-Arts, Besançon, 48 × 73 cm.; Friedländer and Rosenberg 1978 (see Biography), 150, no. 403C; *Le XVIᵉ siècle européen. Peintures et dessins dans les collections publiques françaises* [exh. cat., Petit Palais] (Paris, 1965), no. 95.

13. Private collection, Switzerland, in 1969, 48 × 72.5 cm. (same as no. 8?); Friedländer and Rosenberg 1978 (see Biography), 150, no. 404, repro.

14. Hessisches Landesmuseum, Darmstadt, 1533, 37 × 24 cm.; Koepplin and Falk 1974–1976 (see Biography), vol. 2, fig. 316, no. 546.

15. Nasjonalgalleriet, Oslo, 1550, 71.5 × 122 cm.; *Nasjonalgalleriet. Katalog over Utenlandsk Malerkunst* (Oslo, 1973), 376, no. 832.

16. Kunsthalle, Bremen, 34.5 × 56 cm. Photograph in NGA curatorial files.

17. Earl of Crawford and Balcarres collection in 1958, 35.6 × 24.1 cm. Photograph in NGA photographic archives.

18. Art market, Switzerland, in 1970, 46.5 × 72 cm.; *Pantheon* 28 (1970), 271.

13. Curt Glaser, *Lukas Cranach* (Leipzig, 1921), 100–101, in discussing the Leipzig version of 1518, was apparently the first to see the influence of Giorgione's *Venus* on *The Nymph of the Spring*. This view was accepted by several subsequent authors, among them Friedländer and Rosenberg 1932 (see Biography), 49, no. 100. Kurz 1953, 176, however, suggested that the prototype might have been a lost painting by Giorgione depicting Venus resting after the hunt with a herd of deer in the background. Bonicatti and Cieri 1974, fig. 15, reproduce a Giorgionesque drawing of a nymph and faun with a deer in the background. And as noted by Kurz, deer appear in the background of Cranach's drawing in Dresden.

14. Liebmann 1968, 435–437, emphasizes the importance of the *Hypnerotomachia Poliphili*, published in Venice in 1499. For Mocetto's engraving of *Amymone* as a possible allegory of Mantua see Wolfgang Kemp, "Eine mantegneske Allegorie für Mantua," *Pantheon* 27 (1969), 12–17. For discussions of the complicated questions of the sources and interpretation of Cranach's depictions of the Nymph of the Spring and their relation to other images see Harry Murutes, "Personifications of Laughter and Drunken Sleep in Titian's 'Andrians,'" *BurlM* 115 (1973), 518–525; Koepplin and Falk 1974–1976 (see Biography), vol. 1, 426–432; vol. 2, 631–641; Schade 1974 (see Biography), 69–70; Bonicatti and Cieri 1974, 272–285; Katrin Wernli, "Die schlafende Nymphe," *Der Mensch um 1500. Werke aus Kirchen und Kunstkammern* [exh. cat., Gemäldegalerie] (Berlin, 1977), 134–137, no. 23.

15. See note 12, nos. 1, 2.

16. See note 12, no. 3.

17. See note 12, nos. 4, 6. Helmut Börsch-Supan, "Cranachs Quellnymphen und sein Gestaltungsprinzip der Variation," *Akten des Kolloquiums zur Basler Cranach-Ausstellung 1974* (Basel, 1977), 21–22, sees the Thyssen-Bornemisza collection painting as the point of departure for later versions, and this was discussed in light of Cranach's workshop practice by Löcher and Koepplin in an addendum.

18. Koepplin and Falk 1974–1976 (see Biography), 638, under no. 547.

19. See note 12, no. 15.

20. See note 12, nos. 10, 11. Werner Schade, conversation with the author, 31 October 1990, expressed his belief that the National Gallery's panel might be by Lucas the Younger.

References

1932 Friedländer and Rosenberg (see Biography): 89, no. 324, repro. Rev. ed. 1978: 150, no. 403, repro.

1959 Rosten, Leo. "Cranach: The Impish Nude." *Look* 20 January: repro. (Reprinted in *The Story Behind the Painting*. New York, 1962: 52, repro. 53.)

1967 Talbot, Charles W., Jr. "An Interpretation of Two Paintings by Cranach in the Artist's Late Style." *National Gallery of Art, Report and Studies in the History of Art*: 68, 78–85, repro. 79.

1968 Liebmann, Michael. "On the Iconography of the *Nymph of the Fountain*." *JWCI* 31: 436.

1974 Bonicatti, Maurizio, and Claudia Cieri. "Lucas Cranach alle soglie dell'Umanesimo italiano." *Journal of Medieval and Renaissance Studies* 4: 280 n. 42.

1975 NGA: 86, repro. 87.

1976 Koepplin and Falk (see Biography), 2: 638, under no. 547.

1976 Walker: 165, no. 189, repro.

1983 Wolff: unpaginated, repro.

1985 NGA: 105, repro.

1959.9.1 (1371)

Portrait of a Man

1522
Beech, 58.7 × 41 (23⅛ × 16⅛);
 painted surface: 57.6 × 39.9 (22⅝ × 15¾)
Samuel H. Kress Collection

Inscription
At top left corner, above a serpent with upright wings holding a ring in its mouth, facing right: *1522* (fig. 1)

Technical Notes: The painting is composed of two boards with grain running horizontally. Dendrochronological examination by Peter Klein provided dates of 1356–1516 and 1398–1514 for the boards.[1] A barbe is present along all four edges, suggesting that the panel was painted in an engaged frame. The panel has been thinned and an auxiliary support, estimated to be mahogany, was added prior to the addition of the cradle. Examination with infrared reflectography did not disclose underdrawing. The background is built up in layers and consequently is thicker than other areas of the painting. It appears that a brown layer was applied over the ground throughout, visible in the upper left under the artist's serpent device. The background consists of additional green-yellow and green-blue layers as well as a glaze layer to create areas of shadow.

The painting is in very good condition, with only small areas of retouching scattered throughout.

Provenance: Possibly Dr. Friedrich Campe, Nuremberg, by 1844.[2] Bernhard von Lindenau, Altenburg; by inheritance to his niece, Mrs. von Watzdorf-Bachoff, Altenburg.[3] (Paul Cassirer, Berlin, by 1921).[4] Private collection, possibly von der Heydt.[5] August Lederer, Vienna, probably by 1923.[6] (Rosenberg & Stiebel, Inc., New York, by 1954); purchased January 1954 by the Samuel H. Kress Foundation, New York.[7]

Exhibitions: Berlin, Paul Cassirer Gallery, 1921.

1959.9.2 (1372)

Portrait of a Woman

1522
Beech, 58.7 × 40.5 (23⅛ × 16);
 painted surface: 58 × 39.8 (22⅞ × 15⅝)
Samuel H. Kress Collection

Technical Notes: The panel is composed of two boards with grain running horizontally. Dendrochronological examination by Peter Klein provided dates of 1346–1475 and 1365–1516 for the boards.[8] A barbe is present along all four sides. The panel has been thinned and an auxiliary support, estimated to be mahogany, was added prior to cradling. Examination with infrared reflectography did not reveal underdrawing. As in the companion portrait, the background is applied in a sequence of layers: light brown to light green to dark green glazes.

The painting is in good condition, with scattered retouching throughout, noticeably on the edges and along the join line.

Provenance: Same as 1959.9.1.

Exhibitions: Same as 1959.9.1.

SET AGAINST bright green backgrounds, this unidentified young couple is dressed in clothing of understated elegance and severity. The man wears a soft black cap with black aiglets and a dark brown robe. The only decorative elements

Fig. 1. Detail of *Portrait of a Man*, 1959.9.1

are the white slashings of the black sleeves and the finely embroidered knot pattern in his shirt. The woman wears an elaborate black hat with what appears to be an enamel pin attached at the top. The color combination of her dress is the same as her husband's, but reversed; the bodice is black and the sleeves are brown. Notes of brighter color are provided by the red belt and band of embroidered fabric beneath it. The costumes suggest that the man and woman are either patricians or members of the wealthy middle class.

There is a clear physical disparity between the two figures, which has the effect of affirming the dominance of the man. His body occupies a greater area of the picture and his shoulders extend beyond the edges of the panel. The woman is smaller and more slender, and her pale ivory complexion contrasts with the ruddier skin tones of her husband. By eliminating the hands and reducing the details of the costumes, the artist has focused the viewer's attention on the sitters' faces, which are sensitively delineated and thinly but subtly modeled.

An interesting feature of these portraits is the shadows cast on the background behind the figures and along the top and side edges. In addition to noting that the shadows related the figures spatially to the background, Talbot observed that the portraits were probably intended to be hung on either side of a window.[9] The pattern of the shadows indicates that the light source is between the two pictures. The window panes reflected in the sitters' eyes also allude to an interior.[10] Cast shadows appear in Cranach's portraits with some regularity but were a device that was enthusiastically adopted and made more emphatic by his son Lucas the Younger and followers.[11]

Although not often discussed, these portraits have been recognized since first published in 1921 as excellent examples of Cranach's portraiture in the 1520s. Talbot compared their sober mood with that found in the depictions of Martin Luther and his wife, first produced around 1525 but existing in nearly countless replicas.[12] The same format is used: dark figures set against a featureless monochrome background that emphasizes the silhouettes and the differences in figure size. As in the Washington portraits, Martin Luther's figure extends beyond the frame while

Katharina von Bora's is contained within its boundaries. Only Koepplin, in a verbal opinion recorded by Eisler, raised the possibility that the pictures were by one of Cranach's sons or by another artist not necessarily in the studio, finding the somewhat grainy paint and unusually flat surfaces not characteristic of Cranach at this time.[13] More importantly, Koepplin noted the influence of Netherlandish portraiture, such as that of Joos van Cleve. There are some points of comparison, for instance, with van Cleve's portraits of Joris Vezeleer and Margaretha Boghe in the National Gallery (1962.9.1–2), probably painted in 1518, in which the figures are set against a green background with cast shadows.[14]

Notes

1. The wood was identified by Peter Klein, examination report, 10 April 1987, in NGA curatorial files, and by the National Gallery's scientific research department.

2. Joseph Heller, *Das Leben und die Werke Lucas Cranach's* (Bamberg, 1844), 89, lists "Ein männliches und ein weibliches Brustbild, bezeichnet mit 1522 und der Schlange" as belonging to the art and book dealer Dr. Friedrich Campe of Nuremberg. Unfortunately, it is not possible to determine whether these are the National Gallery's paintings, and they are not mentioned in other descriptions of the collection, such as Ritter C. Heideloff, *Verzeichniss der Friedrich Campe'schen Sammlung von Oelgemälden und geschmeltzen Glasmalereien* (Nuremberg, 1847).

3. H.-C. v. d. Gabelentz, director, Staatliches Lindenau-Museum, Altenburg, letter to Dr. Ilse Franke, Munich, 19 July 1968, in NGA curatorial files. As Gabelentz notes in his letter, Bernhard von Lindenau ordered all his papers destroyed after his death, so it is not possible to determine, for example, when he acquired the paintings.

4. Scheffler 1921, 298, cites the painting as being with Cassirer. Gabelentz to Franke, 19 July 1968, says that Mrs. von Watzdorf-Bachoff sold the portraits to Cassirer.

5. Not verified. Gabelentz to Franke, 19 July 1968, says that the portraits were in the von der Heydt collection, but it has not been possible to locate them in any catalogues associated with the name von der Heydt.

6. Glaser 1923, 179, reproduces the portraits as being in a private collection, Vienna; this is not included in the 1921 edition. Scheffler 1921, 298, reports only that the portraits went from Cassirer into a private collection, so it is possible, although not verified, that Lederer owned them as early as 1921. Friedländer and Rosenberg 1932 (see Biography), 53–54, nos. 123–124, are the first to mention Lederer as owner.

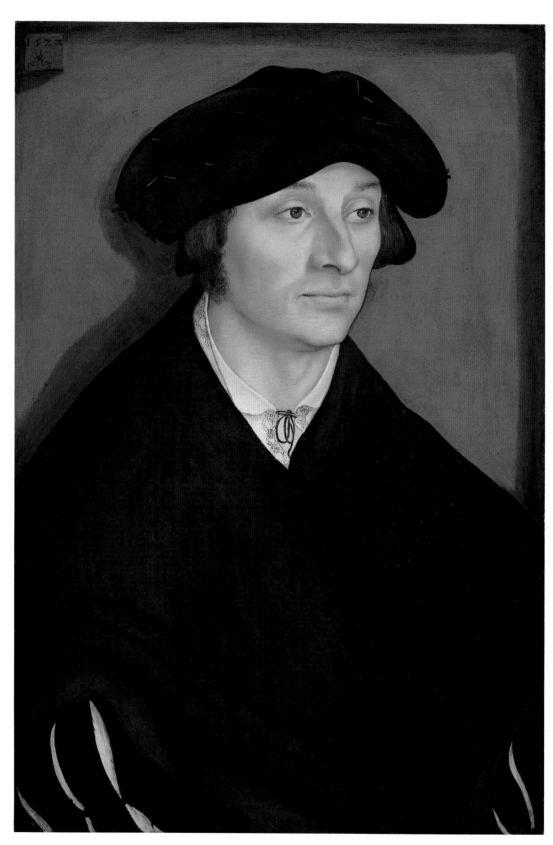

Lucas Cranach the Elder, *Portrait of a Man*, 1959.9.1

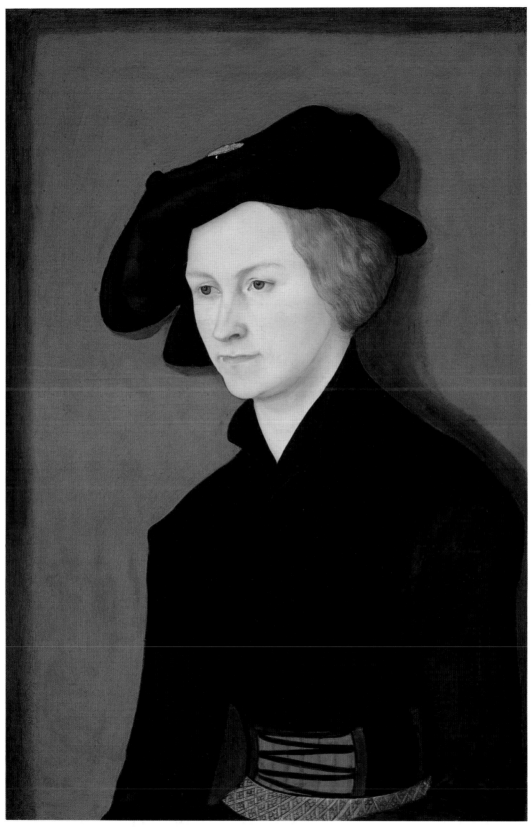

Lucas Cranach the Elder, *Portrait of a Woman*, 1959.9.2

7. Invoice, 29 January 1954; and Saemy Rosenberg to John Walker, 30 January 1954, in NGA curatorial files. I am grateful to Gerald G. Stiebel for his assistance (letter to the author, 10 April 1987, in NGA curatorial files).

8. Klein, examination report, 10 April 1987, in NGA curatorial files.

9. Charles Talbot, draft catalogue entry, 1966, in NGA curatorial files.

10. For Talbot the indistinctness with which the panes were represented is indicative of how much this had become a convention. For a discussion of window reflections in eyes see Albrecht Dürer, *Portrait of a Clergyman* (1952.2.17) (pp. 62–64 in the present volume), and Jan Białostocki, "The Eye and the Window: Realism and Symbolism of Light-Reflections in the Art of Albrecht Dürer and His Predecessors," *Festschrift für Gert von der Osten* (Cologne, 1970).

11. A cast shadow is found as early as c. 1511/1512, for example, in Cranach's portrait of Margrave Albrecht of Brandenburg-Ansbach (private collection, Riechen); Friedländer and Rosenberg 1978 (see Biography), 73, no. 26, repro. For portraits by Lucas Cranach the Younger see Schade 1974 (see Biography), pls. 216–217, 234–245.

12. Talbot, draft catalogue entry, 1966, in NGA curatorial files. For the portraits of Luther and his wife that are closest in type to the National Gallery's panels see Friedländer and Rosenberg 1978 (see Biography), 107, nos. 189–190, repro. The panel depicting Luther is dated 1526, and numerous other versions of the pair are dated 1525 or 1526 and were done on the occasion of Luther's marriage.

13. Eisler 1977, 24; the verbal communication took place in spring 1968.

14. John Oliver Hand and Martha Wolff, *Early Netherlandish Painting*, The Collections of the National Gallery of Art, Systematic Catalogue (Washington, 1986), 57–62, repro.

References

1921 Scheffler, Karl. "Kunstausstellungen." *Kunst und Künstler* 19: 298, repro. 270.

1923 Glaser, Curt. *Lukas Cranach.* Leipzig: repro. 179.

1932 Friedländer and Rosenberg (see Biography): 53–54, nos. 123–124, repro. English rev. ed., 1978: 99, nos. 145–146, repro.

1933 Mayer, August L. "Lukas Cranach D.Ä." *Pantheon* 11/12: repro. 108.

1944 Winkler, Friedrich. *Altdeutsche Tafelmalerei.* Munich: 244, repro. 151.

1956 Kress: 56–59, nos. 18–19, repro.

1960 Broadley: 30, repro. 31.

1975 NGA: 86, repro. 87.

1976 Walker: 165, nos. 184–185, repro. 164.

1977 Eisler: 23–24, figs. 24–25.

1985 NGA: 105, repro.

1961.9.69 (1621)

The Crucifixion with the Converted Centurion

1536
Beech, 50.8 × 34.6 (20 × 13⅝)
Samuel H. Kress Collection

Inscriptions
At top: *VATER IN DEIN HET BEFIL ICH MEIN GAIST*
 At top of cross: I ♦ N ♦ R ♦ I
At center, below Christ's feet: *WARLICH DIESER MENSCH IST GOTES SVN GEWEST*
At bottom right, above serpent with folded wings: *1536* (fig. 1)

Technical Notes: The panel is composed of two boards with vertically oriented grain. Dendrochronological examination by Peter Klein provided dates of 1486–1531 and 1439–1530 for the individual boards and also indicated that both boards were from the same tree.[1] At the top and bottom there are narrow, unpainted edges that have been apparently filled and overpainted at a later date. The left and right edges of the panel have been trimmed and a cradle attached. On the reverse strips of oak 0.38 cm. wide have been set into the panel.

The painting is in good condition. There is a network of small cracks in the paint layer, which extends into the ground; this is most prominent in the front portion of the horse and extends upward into the area of Christ's drapery. There are some shallow scratches to the right of the horse and near Christ's torso. Areas of abrasion exist near the knees of the crucified figure at the left and in the hindquarters of the horse.

Provenance: Dr. Demiani, Leipzig, by 1899;[2] (sale, Rudolph Lepke, Berlin, 11 November 1913, no. 40). Probably Mrs. Jenö Hubay. Probably Mathias Salamon; Aladar Feigel, Budapest, 1947.[3] (Dominion Gallery, Montreal); (M. Knoedler & Co., New York, January, 1952);[4] purchased February 1952 by the Samuel H. Kress Foundation, New York.

Fig. 1. Detail of *The Crucifixion with the Converted Centurion,* 1961.9.69

Exhibitions: Dresden, 1899, *Cranach-Ausstellung*, no. 65. National Gallery of Art, Washington, from June 1953.

CHRIST'S DEATH on the cross here occurs in a setting that has rightly been called frozen and timeless.[5] The bodies of Christ and the two criminals crucified with him are brightly lit and silhouetted against the inky darkness of the turbulent sky. Below are bands of yellow, orange, pink, and blue light that call to mind such eerie atmospheric phenomena as the aurora borealis. The barren foreground is strewn with pebbles and rocks, and the contour of the horizon suggests the curvature of the earth, reinforcing both the isolation and the universality of the event.

Inscribed at the top of the painting are the words spoken by Christ just before his death, "Father, into thy hands I commit my spirit!" (Luke 23:46). Flanking Christ are the two criminals, traditionally called the Good Thief and the Bad Thief. While the Bad Thief on the right turns away, the Good Thief on the viewer's left, hence at Christ's right hand, recognizes Jesus' divinity and according to the biblical account (Luke 23:39–43) will join him in paradise. At the foot of the cross is the centurion, clad in armor and wearing a fashionable hat trimmed with ostrich feathers. To the right are inscribed the words spoken by the centurion after Christ's death, "Truly this man was the Son of God!" (Mark 15:39). Along with Longinus the spear bearer, with whom he is sometimes confused, this anonymous soldier was among the first Gentiles to recognize the Savior's divinity.[6]

Painted in 1536, when the Protestant Reformation was well established in many regions of Germany, the National Gallery's panel and related versions have been interpreted as reflecting one of the central tenets of Lutheran doctrine, salvation through faith alone. The prominently displayed centurion may be seen as a personification of the idea that salvation is achieved through the gift of God's grace, and his conversion to Christianity as evinced by his words constitutes an individual statement of faith.[7] Talbot also noted associations between the centurion, mounted on a white charger, and Saint George, the almost archetypal Christian knight, and, further, the images of the militant Christian soldier found in Erasmus of Rotterdam's *Enchiridion Militis Christiani* or Dürer's engraving *Knight, Death, and the Devil*.[8] Although secondary in importance, the Good Thief may also be seen as an example of salvation through faith. Moreover, the use of the vernacular rather than Latin in the inscriptions is in line with the Lutheran belief that the word of God should be directly accessible to all believers.

At the time of its exhibition in Dresden in 1899 *The Crucifixion with the Converted Centurion* was considered by Friedländer to be "probably autograph," while Flechsig thought it was by Hans Cranach but that Lucas Cranach the Younger should also be considered.[9] Subsequent authors, however, have confirmed the attribution to Lucas Cranach the Elder, and whether the panel was painted entirely by Cranach himself or contains workshop participation, the quality of execution is, in fact, quite high.

Although Cranach produced numerous images of the Crucifixion throughout his career, *The Crucifixion with the Converted Centurion* is apparently the earliest of a relatively small number of versions of this type. Closest to the National Gallery's picture, but smoother and blander in appearance, is the panel in the Staatsgalerie, Aschaffenburg (fig. 2), which is monogrammed and dated 1539.[10] Two other versions, each dated 1538 (Museo de Bellas Artes, Seville,[11] and Yale University Art Gallery, New Haven[12]), repeat the composition but alter details such as the pose of the Bad Thief or the costume of the centurion. Friedländer and Rosenberg list another version containing a bust-length donor portrait that in 1931 was in a private collection in Paris.[13] A close replica of the National Gallery's panel is in a private collection in Basel.[14]

Notes

1. The wood was identified as beech (sp. *Fagus*) by Peter Klein, examination report, 10 April 1987, and by the National Gallery's scientific research department, report, 15 July 1988, both in NGA curatorial files. The wood was erroneously identified as linden in exh. cat. Dresden 1899, which was repeated in Eisler 1977, 24.

2. Listed as owner in exh. cat. Dresden 1899.

3. Max Stern, Dominion Gallery, letter to Charles Henschel, M. Knoedler & Co., 8 January 1952, in Knoedler files, stating that Feigel acquired the painting from Salamon in 1947 and that it had been previously owned by Mrs. Jenö Hubay, born Countess Cebrian

Fig. 2. Lucas Cranach the Elder, *The Crucifixion with the Converted Centurion*, panel, 1539, Staatsgalerie, Aschaffenburg [photo: Bayerische Staatsgemälde-sammlungen]

Rosa, who sold it after the death of her husband. I am grateful to Nancy C. Little, M. Knoedler & Co., for her assistance.

4. Nancy C. Little, M. Knoedler & Co., letter to the author, 2 March 1988, in NGA curatorial files. A report of the Getty Provenance Index, in NGA curatorial files, states that the painting was jointly owned by Pinakos, Inc. (Rudolf Heinemann).

5. Talbot 1967, 78.

6. See Réau, *Iconographie*, vol. 2, pt. 2 (1957), 496–497. Prior to 1980 the painting had been entitled *The Crucifixion with Longinus*.

7. Talbot 1967, 71; Eisler 1977, 24–25; Koepplin and Falk 1976 (see Biography), 486, and for further

"Protestant" subjects, 498–522. See also Laurinda S. Dixon, "The *Crucifixion* by Lucas Cranach the Elder: A Study in Lutheran Reform Iconography," *Perceptions* 1 (1981), 35–42, and Christiane D. Andersson, "Religiöse Bilder Cranachs im Dienste der Reformation," *Humanismus und Reformation als kulturelle Kräfte in der deutschen Geschichte. Ein Tagungsbericht* (Berlin, 1981), 43–79.

8. Talbot 1967, 71–72, citing and reproducing Cranach's *Saint George*, formerly Staatliche Kunstsammlungen, Dessau. For a discussion of Dürer's engraving in relation to Erasmus' writings see Panofsky 1943, 151–154. For the possible influence on Dürer of Cranach's woodcut of 1506, *Knight in Armor Riding*

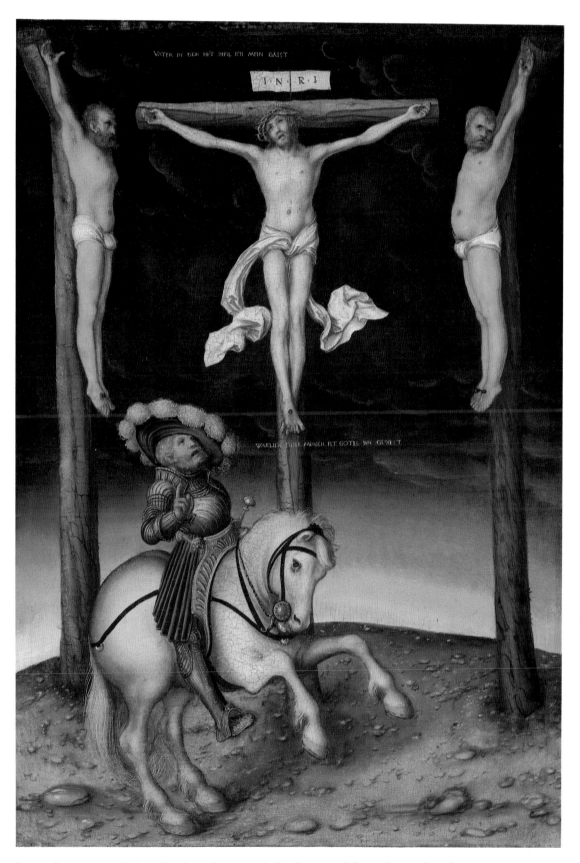

Lucas Cranach the Elder, *The Crucifixion with the Converted Centurion*, 1961.9.69

toward the Right, see Lynda S. White, "A New Source for Dürer's *Knight, Death and the Devil*," *Source* 2 (1982), 5–9.

9. Friedländer 1899, 242; Flechsig 1900, 275.

10. No. 13255, wood, 51.5 × 34 cm.; see *Galerie Aschaffenburg. Katalog* (Munich, 1975), 46. Friedländer and Rosenberg 1932 (see Biography), 85, no. 303, include exhibition and provenance information that pertains to the National Gallery's picture, not this one; this conflation continues in the revised edition of 1978, 145, no. 378.

11. Wood, 85 × 56 cm. Angulo Iñiguez 1972, 1–7, repro.; Koepplin and Falk 1976 (see Biography), 485–486, fig. 267.

12. No. 1959.15.23, wood, 60 × 40.6 cm. Charles Seymour, Jr., *The Rabinowitz Collection of European Paintings* (New Haven, 1961), 40, repro. 41, states that the centurion is a portrait of Johann Friedrich, elector of Saxony. This is repeated in Andrew Carnduff Ritchie and Katharine B. Neilson, *Selected Paintings and Sculpture from the Yale University Art Gallery* (New Haven and London, 1972), no. 6. Talbot 1967, 86 n. 15, did not find the comparison with known portraits of Johann Friedrich convincing but noted that the centurion's face was more individualized than in other versions, including the National Gallery's panel.

13. Friedländer and Rosenberg 1932 (see Biography), 85–86, under no. 303; rev. ed. 1978 (see Biography), 145, no. 378D; the painting apparently bore the artist's devise and was dated 153[8].

14. Wood, 51.3 × 33.2 cm., photograph in NGA curatorial files. The painting was examined by Martha Wolff, 13 May 1985, memorandum in NGA curatorial files; see also letter from Dieter Koepplin, 20 April 1985, in NGA curatorial files.

References

1899 Friedländer, Max J. "Die Cranach-Ausstellung in Dresden." *RfK* 22: 242.

1900 Flechsig, Eduard. *Cranachstudien*. Leipzig: 275, no. 65, 282, under no. 1'15.

1932 Friedländer and Rosenberg (see Biography): 85, under no. 303. Rev. ed. 1978: 145, no. 378c.

1956 Kress: 60, no. 20, repro. 61.

1967 Talbot, Charles W., Jr. "An Interpretation of Two Paintings by Cranach in the Artist's Late Style." *National Gallery of Art, Report and Studies in the History of Art*: 68, 71–78, repro. 69.

1972 Angulo Iñiguez, Diego. "Lucas Cranach: el Calvario de 1538 del Museo de Sevilla." *Archivo Español de Arte* 45: 6.

1974 Schade (see Biography): 86.

1975 NGA: 86, repro. 87.

1976 Walker: 165, no. 187, repro. 164.

1976 Koepplin and Falk (see Biography) 2: 486, under no. 334.

1977 Eisler: 24–25, fig. 15.

1983 Wolff: unpaginated, repro.

1985 NGA: 106, repro.

Albrecht Dürer

1471–1528

WE are quite well informed about the artist's life, and many of his works are dated. Albrecht Dürer was born in Nuremberg on 21 May 1471. His first training was as a goldsmith in his father's shop. Dürer's talent manifested itself early, and both his skill as a draftsman and a self-awareness highly unusual for the time can be seen in the silverpoint *Self-Portrait* made in 1484 when he was thirteen years old (Graphische Sammlung Albertina, Vienna). In 1486 Dürer became an apprentice in the workshop of the painter Michael Wolgemut, where he would remain for almost four years. Toward the end of his apprenticeship he produced his first dated painting, the portrait of his father, Albrecht Dürer the Elder, of 1490 (Galleria degli Uffizi, Florence), and the recently discovered pendant of his mother (Germanisches Nationalmuseum, Nuremberg). In April of 1490 Dürer departed Nuremberg; it is not known exactly what cities he visited, but it is possible that this trip included the Netherlands, Cologne, and parts of Austria. He arrived in Colmar in the summer of 1492, and although Martin Schongauer was no longer alive, the influence of Schongauer's engravings as well as the work of the Housebook Master is evident in Dürer's early work. From Colmar he went to Basel, where he made designs for woodcut illustrations for books (such as Sebastian Brant's *The Ship of Fools*), and then to Strasbourg, arriving probably in the autumn of 1493. Returning to Nuremberg in late May 1494, he married Agnes Frey on 7 July.

The outbreak of plague in Nuremberg in August 1494 provided the impetus for Dürer to leave town. He traveled across the Alps to Venice by way of Augsburg, Innsbruck, the Brenner pass, the Eisack valley, and Trent. His stay in Venice, which lasted until spring 1495, was of incalculable importance. He became acquainted with artists such as Gentile and Giovanni Bellini and absorbed, often by copying, the work of Andrea Mantegna, Antonio Pollaiuolo, and Lorenzo di Credi. His awareness of and lifelong interest in the theory of human proportions also began in Venice, quite possibly because of Jacopo de' Barbari.

Upon his return to Nuremberg in 1495 Dürer embarked on a career as a printmaker and a painter. He was immediately successful, receiving in 1496 commissions for paintings from Frederick the Wise, elector of Saxony. His woodcut series, the *Apocalypse*, published in 1498, by reason of its innovative format, technical mastery, and the forcefulness of its imagery, made Dürer famous throughout Europe. In the works of his early maturity, from 1500 to about 1505, the Northern love of the particular coexists with Italian-inspired concerns for perspective and proportion. The *Large Piece of Turf* of 1503 (Graphische Sammlung Albertina, Vienna) meticulously explores the minutiae of nature, while the *Adam and Eve* engraving of 1504 and related drawings are an attempt to depict ideal, classically proportioned nudes. The *Adoration of the Magi*, 1504 (Galleria degli Uffizi, Florence), painted for Frederick the Wise, is a masterpiece of spatial and compositional coherence and equilibrium.

In the summer of 1505 the plague reappeared in Nuremberg and Dürer again set out for Venice. This time, however, he arrived as a well-known artist with a reputation based on his woodcuts and engravings. In fact, his graphics were being copied, and he went to court in an attempt to prevent Marcantonio Raimondi from reproducing his compositions and his monogram. His major commission of this period was the *Feast of the Rose Garlands*, 1506 (Národní Galerie, Prague), painted for the Fondaco dei Tedeschi, the association of German merchants, to be installed in the Church of San Bartolommeo—a work that in its

solemnity and use of Venetian color and motifs silenced any criticism of Dürer's abilities as a painter. From Venice, Dürer apparently went to the university city of Bologna to learn about perspective and then journeyed farther south to Florence—where he saw the work of Leonardo da Vinci and the young Raphael—and to Rome. *Christ among the Doctors*, 1506 (Thyssen-Bornemisza Collection, Lugano), was painted in Rome in five days and reflects the influence of Leonardo's grotesques. Dürer was back in Venice early in 1507 before returning to Nuremberg in the same year.

Except for a few short journeys, Dürer remained in Nuremberg from 1507 until 1520. His work alternated between periods when painting predominated and periods when graphic work received more attention. The *All Saints* altarpiece, completed in 1511 (Kunsthistorisches Museum, Vienna), was commissioned by Matthäus Landauer, and the presentation drawing of 1508 (Musée Condé, Chantilly) shows that Dürer designed the frame as well. This was followed by several print cycles, the *Small Passion* woodcuts of 1509 to 1511 and the engraved *Passion* of 1512. Dürer attracted the attention of Emperor Maximilian I, who visited Nuremberg in February 1512 and subsequently gave Dürer several commissions, including the marginal drawings for Maximilian's prayerbook (Bayerische Staatsbibliothek, Munich), to which other artists also contributed. The three so-called "Master Engravings"— *Knight, Death, and the Devil* of 1513 and *Saint Jerome in His Study* and *Melencolia I*, both of 1514— raised the engraving technique to new heights and reflect Dürer's ongoing assimilation of Italian art, theory, and in the case of *Melencolia I*, Neoplatonic philosophy. From about 1518 on Dürer seemed to be striving for a greater simplicity and solidity of form, as can be seen in the *Madonna and Child with Saint Anne* of 1519 (Metropolitan Museum of Art, New York).

Following the death of Maximilian I, Dürer's need to have his pension confirmed by Charles V prompted him to travel to the Netherlands, ac-companied by his wife and a maid. He arrived in Antwerp on 3 August 1520 and visited Mechelen and Brussels, where he was received by Margaret of Austria. His diary, kept during his journey, is an invaluable source of information and reveals that the artist was highly esteemed and often entertained by his Netherlandish colleagues. In October he attended the coronation of Charles in Aachen and then spent several weeks in Cologne before returning to Antwerp for the winter. The impact of his art can be seen, in part, in the numerous Netherlandish copies of the *Saint Jerome* painted in Antwerp in 1521 (Museo Nacional de Arte Antiga, Lisbon). He, in turn, was influenced by the engravings of Lucas van Leyden. Leaving Brussels and traveling by way of Louvain, Aachen, and Cologne, Dürer arrived back in Nuremberg early in August 1521.

In his last years Dürer became increasingly involved in his theoretical writings. The *Teaching of Measurements* was completed in 1525 and followed by *Various Instructions of the Fortification of Towns, Castles, and Large Villages* of 1527. His last and most important treatise, *Four Books on Human Proportion*, was published posthumously on 31 October 1528. A number of painted and engraved portraits were produced in these years, but the major work is the *Four Apostles*, dated 1526 (Alte Pinakothek, Munich), presented to the city council in Nuremberg. The Apostles John, Peter, and Paul, and the Evangelist Mark are accompanied by inscriptions warning against false prophets. It is generally agreed that the apostles personify the Four Temperaments, but there is less consensus on the degree to which the panels reflect Dürer's Lutheranism or his concern over the excesses of the Reformation.

Dürer died on 6 April 1528, possibly as a result of a malarial infection contracted in 1521 when he went to Zeeland in the hopes of seeing a stranded whale. He is the best-known and arguably the greatest German artist of the Renaissance, whose work was admired and influential throughout Europe.

Bibliography
Panofsky 1943.
Anzelewsky 1971.
Mende, Matthias. *Dürer-Bibliographie*. Wiesbaden, 1971.
Anzelewsky, Fedja. *Dürer: His Art and Life*. Translated by Heide Grieve. London, 1982.

1952.2.16a–b (1099)

Madonna and Child
reverse: *Lot and His Daughters*

c. 1496/1499
Wood, 52.4 × 42.2 (20⅝ × 16⅝)[1]
Samuel H. Kress Collection

Inscriptions
Coat-of-arms at lower left: *Gules, a chapé emanating from the dexter flank argent, charged with a dexter gyron sable.* Crest: *out of a wreath of the liveries the torso of an armless Moorish woman proper, habited gules, crined and braided sable, earringed Or,* wearing a "flying head band" (*fliegende Binde*) *twisted gules and argent.* Mantling: *gules, lined argent*[2]
Coat-of-arms at lower right: rendered heraldically indescribable by later alterations (see Technical Notes)
On reverse, on rock at left center: 朮

Technical Notes: Examination of the panel and the x-radiograph show that the support is comprised of four boards with vertically oriented grain. Unsmoothed adz marks are visible on the reverse, indicating that the panel was thinned and smoothed after joining. The edges are obscured by the picture frame, although it is possible to see that the bottom edge has been cut. Thin strips of wood are nailed to each picture edge.

Underdrawing in what appears to be a liquid material, possibly iron gall ink, can be seen in the Child's body with the unaided eye. Examination with infrared reflectography reveals diagonally hatched underdrawing in the face of the Madonna (fig. 1), and elsewhere a few contour lines. The Child's left foot was changed slightly from its underdrawn position. The coat-of-arms at the lower right has been heavily altered. The original arms are painted out, and both the x-radiograph and infrared reflectogram show only a single dark form against a light background. On the surface is a design of vertical and diagonal bars and three balls. Optical microscopy of the blue paint in this design disclosed synthetic ultramarine, a pigment that was not

Fig. 1. Infrared reflectogram assembly of a detail of *Madonna and Child*, 1952.2.16a

commercially produced until around 1828.[3] The *Madonna and Child* is in excellent condition. There is a scratch and a retouched loss in the window at the left. There is light abrasion in the flesh tones and in the glazes of the greens. The blue paint of the Madonna's robe is deeply cracked and has accumulated dark accretions in the thickest areas.

Lot and His Daughters is quite different from the obverse in both its manner of execution and state of preservation. A ground or preparation layer is either not present or not readily discernible; it is possible that there is a layer of glue or glue with a very small admixture of calcium carbonate that has become transparent. There is no underdrawing visible either to the naked eye or under infrared reflectography. The monogram (fig. 2) rendered in brown paint is not visible under infrared reflectography, whereas the dark lines defining the surrounding rock formations are vis-

Fig. 2. Detail of *Lot and His Daughters*, 1952.2.16b

ible, indicating the presence of black pigment in the latter. If the monogram were very recent, it is likely that it would be made visible with infrared reflectography. Numerous small losses are scattered throughout and reflect worm damage, abrasion, impacts to the surface, and flaking due to movement of the unprimed wood. The joins of the panel have opened in the past and have visible inpainting.

Provenance: Probably a member of the Haller family, Nuremberg. Possibly Paul von Praun [d. 1616] and descendants, Nuremberg, until at least 1778.[4] Charles à Court Repington [d. 1925], Amington Hall, Warwickshire; sold to Mrs. Phyllis Loder, London[5] (sale, Christie, Manson & Woods, London, 29 April 1932, no. 51, as by Bellini); (Vaz Dias).[6] Baron Heinrich Thyssen-Bornemisza, Villa Favorita, Lugano, by 1934; (Pinakos, Inc. [Rudolf Heinemann], on consignment to M. Knoedler & Co., New York, 1950);[7] purchased 1950 by the Samuel H. Kress Foundation, New York.

Exhibitions: New York, Metropolitan Museum of Art; Nuremberg, Germanisches Nationalmuseum, 1986, *Gothic and Renaissance Art in Nuremberg 1300–1550*, no. 109 (shown only in New York).

THIS PANEL was unknown until 1932 when it was sold, as a Bellini, at auction in London. Following its cleaning[8] and the disclosure of an image on the reverse, it was acquired by Baron Heinrich Thyssen-Bornemisza and first published as by Dürer in Friedländer 1934. The picture has emerged as one of the most important paintings from the artist's early maturity. The attribution to Dürer is ac-

cepted by virtually all of the major authorities, and isolated attempts to give the panel to Hans Baldung Grien, Hans Sebald Beham, or even Albrecht Altdorfer have proven untenable.[9]

On the obverse the Virgin in half length supports a naked Christ Child who stands with one foot on a cushion and holds in his proper left hand a fruit, probably an apple. These figures are set in a shallow marble interior, and at the left a window opens onto a mountainous landscape in which a winding trail leads upward to a castle tower. Northern and Italian compositional elements are combined. As observed by Panofsky, the placement of figures in the corner of a room with a window containing a landscape view is an essentially Netherlandish device and may be said to begin with Dirck Bouts' *Portrait of a Man* of 1462 (National Gallery, London).[10] The Tietzes also saw the influence of Martin Schongauer's engraving, the *Madonna and Child with a Parrot* (Bartsch, 29), which shows both a corner of a domestic interior with a window and the Christ Child seated on a large cushion.[11]

It is, however, Dürer's admiring absorption of Venetian art that is most striking and most commented upon. Although the Tietzes mentioned Antonello da Messina, it is the impact of Giovanni Bellini that is immediately apparent. One can find close comparisons to Bellini's paintings of the late 1480s, both stylistically and in the general arrangement of half-length Madonna, standing Child, and foreground parapet, specifically the *Madonna degli Alberetti*, dated 1487 (Gallerie dell'Accademia, Venice) and the center panel of the Frari altarpiece, dated 1488 (Church of the Frari, Venice).[12] While retaining the proportions of Bellini's poised, self-aware *bambino*, Dürer transformed him into a fidgety, awkward infant. The solidly modeled oval of the Madonna's head, her serious expression, and distant gaze also derive from Bellini, as can be seen in the faces of the Virgin in the *Pala di San Giobbe* of 1487 and the *Madonna and Child with Saint Catherine and the Magdalene*, c. 1490 (both Gallerie dell'Accademia, Venice).[13]

In contrast to the finely rendered details and finished surfaces of the *Madonna and Child*, the representation of *Lot and His Daughters* on the reverse is handled in a broad, fluid, and some-

Albrecht Dürer, *Madonna and Child*, 1952.2.16a

Albrecht Dürer, *Lot and His Daughters*, 1952.2.16b

what summary manner that has been compared to watercolor technique. The image is based on the account in Genesis 19: 24–29. In the foreground Lot, wearing a hat of Turkish, probably Ottoman, design[14] and followed by his two daughters, who carry a few possessions, departs the cities of Sodom and Gomorrah. The destruction of these cities in a cataclysmic explosion of fire and billowing smoke takes place in the background. On the path at the upper left is Lot's wife, who has been turned into a pillar of salt after defying the Lord's injunction against looking back. Unlike the obverse, there is nothing overtly Italianate about the style or composition.

The juxtaposition of the Madonna and Child with a representation of Lot and his daughters is highly unusual, if not unique, and according to Anzelewsky is the first depiction of the story of Lot in panel painting. Anzelewsky and Eisler arrived at similar interpretations of the possible iconographic relationship between obverse and reverse. Both authors noted that in the typological writings of the later Middle Ages, such as the *Speculum Humanae Salvationis* and the *Biblia Pauperum*, the theme of Lot in Sodom and Gomorrah is an Old Testament typology, or prefiguration of Christ in Limbo.[15] Both are demonstrations of God's redemption of mankind. The motif of redemption is found on the obverse, for Christ is born, assumes human form, and dies on the cross in order to save man from sin. By carrying an apple, the Child is marked as the "new Adam," while the Virgin, perhaps in a moment of premonition, looks outward with an expression of great seriousness. Eisler in particular stressed the passional aspect of the Virgin's demeanor and found in the marble setting overtones of the Entombment. The destruction of Sodom and Gomorrah is also a typology for the destruction of the world predicted in Revelation and, as noted by Seymour and Benesch, may reflect the chiliasm and fears that the world would end that gripped Germany as the year 1500 approached.[16]

While some have credited Dürer with the choice of subjects, it is perhaps more likely that they reflect the wishes of the patron. Unfortunately there are no documents, and the physical evidence for the commission is incomplete and inconclusive. From the coat-of-arms at the lower left there would seem to be little doubt that the National Gallery's panel was first owned and probably executed for a member of the Haller family of Nuremberg.[17] The Hallers were one of Nuremberg's largest and most influential patrician families. But our inability to identify the coat-of-arms at the lower right renders it all but impossible to find a candidate. Notwithstanding, Anzelewsky raised the possibility that the panel was painted for Wilhelm Haller (d. 1534), whose second marriage to Dorothea Landauer took place in 1497, while Mansfield has suggested Hieronymus II Haller (d. 1519), who married Catharina Wolf von Wolfstal in 1491.[18]

It is not clear whether the panel in its present form is complete or not. Anzelewsky and Strieder believe that it was originally the left wing of a diptych and that a donor portrait would have been on the right wing.[19] Among Dürer's extant portraits there are no viable candidates. Noting that neither Madonna nor Child faces in the direction of the donor, Löcher argues against the idea of a diptych and suggests instead that the obverse had a sliding cover that most likely bore a coat-of-arms.[20] The fact that the obverse is in much better condition than the reverse may be seen as an indication that it was protected in some manner, whether by a cover or a portrait.

It is generally agreed that the National Gallery's panel dates after Dürer's first trip to Venice of 1494–1495 and, as suggested by the Haller arms, was probably executed in Nuremberg. There has been, nevertheless, a divergence of opinion. The question is complicated by the differences in style, finish, and subject matter between obverse and reverse, which have prompted several authors to propose different dates for each side, with *Lot and His Daughters* generally seen as being earlier. Friedländer dated the *Madonna and Child* to 1498/1502 and the reverse to 1497 or a little later.[21] Buchner also dated the reverse to 1496/1497 but saw a connection between the backward-bent wrist of the Child's arm and Eve's left arm in Dürer's 1504 engraving of *Adam and Eve*, which suggested a date of c. 1504 for the *Madonna and Child*.[22] Panofsky, who had not seen the original, dated the obverse to c. 1498/1499 and the reverse to c. 1497.[23] Winkler put forward 1495 for the reverse and c. 1496/1499 for the

obverse, while Strieder suggested that *Lot and His Daughters*, c. 1498, was slightly later than the *Madonna and Child* of 1496/1497.[24] Eisler dated the reverse to the mid-1490s and the obverse to c. 1500 but allowed that the *Madonna and Child* could be as late as c. 1505.[25]

The Tietzes, Suida, Seymour, Anzelewsky, and Stechow believe that both sides were painted simultaneously and more or less agree on a date of 1496/1498. Influenced by Buchner's observations, Shapley dated the panel c. 1505, and this dating is preserved in subsequent National Gallery publications.[26] Waetzoldt put the picture at the time of the second Venetian journey, 1505/1507, while Longhi placed it before the second trip.[27]

In order to arrive at a viable date, it is necessary to consider Dürer's two-sided paintings as well as the relation of the *Madonna and Child* and *Lot and His Daughters* to his work in all media. Excluding the Washington panel, only four of Dürer's paintings bear images on both sides. Two of these have coats-of-arms on the reverse: the portrait of Albrecht Dürer the Elder of 1490 (Galleria degli Uffizi, Florence) and that of Hans Tucher, dated 1499 (Schlossmuseum, Weimar).[28] The other two are the *Saint Jerome Penitent*, c. 1494/1497 (Fitzwilliam Museum, Cambridge, on loan from the Edmund Bacon collection), which has on the reverse an unidentified celestial or cosmic event, and the *Portrait of a Man*, dated 1507 (Kunsthistorisches Museum, Vienna), on the back of which is depicted an old woman holding a sack of money, which is possibly an allegory of avarice or vanity.[29] In the latter two instances the subjects on the reverse and the relationship of front to back are unusual; the reverse of the portrait probably reflects the wishes of the sitter, but the back of the Saint Jerome may have been the artist's choice. Although it is perhaps more apparent in these two instances, it should be noted that in all four panels the obverse is more carefully painted than the reverse. In his writings Dürer seems to differentiate between degrees of finish; careful "fiddling" (*kläubeln*) is distinguished from looser "common painting" (*gemeine gemäl*). And as suggested by Anzelewsky with specific reference to *Lot and His Daughters*, the broader manner was considered more appropriate for the reverse.[30] A difference in style or speed of execution does not necessarily mean a difference in date.

A comparison of the *Madonna and Child* and *Lot and His Daughters* with Dürer's other works affirms, I believe, the views of those who think that both sides are contemporaneous and date from c. 1496/1499. For the *Madonna and Child* the closest comparisons are with the *Madonna and Child* (Magnani Rocca Collection, Parma) and the *Madonna and Child before a Landscape* (Georg Schäfer Collection, Schweinfurt).[31] The National Gallery's picture shares with these the direct influence of Giovanni Bellini, visible in the stable triangular arrangement of the half-length figures and the large-headed, Italianate, and somewhat ungainly infants. In the Parma panel the surrounding marble architecture and the modeling of the Virgin's face are especially close, while the proportions of the Christ Child and the manner of rendering trees are more like those in the Schweinfurt picture. Both paintings are dated 1494/1495 by Anzelewsky but put closer to 1506 by a few authors.[32] The change in style effected by the first trip to Italy can be seen in the differences between the *Christ Child with the World Globe*, monogrammed and dated 1493 (Graphische Sammlung Albertina, Vienna), and the Infant in the *Holy Family*, c. 1495 (Museum Boymans-van Beuningen, Rotterdam, on loan from the Rijksdienst Beeldende Kunst, The Hague);[33] the former is more delicate and gothic, while the latter is larger and more active.

The concern for the solidity and volume of the human figure that one sees in the Washington *Madonna and Child* is also evident in certain of Dürer's drawings of the mid-1490s, such as the *Nude Woman Seen from Behind* (Musée du Louvre, Paris),[34] the sheet of studies including a nude man and a Christ Child (Galleria degli Uffizi, Florence), or the *Madonna and Child in a Niche* (Wallraf-Richartz-Museum, Cologne).[35] Compare also the *Angel with a Lute*, dated 1497 (Kupferstichkabinett, Berlin), the *Women's Bath*, dated 1496 (formerly Kunsthalle, Bremen), and the *Woman Standing in a Niche*, dated 1498 (?) (Metropolitan Museum of Art, Robert Lehman Collection, New York).[36]

Further comparisons are to be found in Dürer's

portraits of the late 1490s. In the portraits of Hans and Felicitas Tucher, dated 1499 (Schlossmuseum, Weimar), and the portrait of Elsbeth Tucher from the same year (Gemäldegalerie, Kassel), the placement of the figure next to a window and the way in which the landscape foliage is painted are quite similar.[37] Dürer also used this arrangement for his 1497 portrait of a female member of the Fürleger family (Gemäldegalerie, Berlin)[38] and for his *Self-Portrait* of 1498 (Museo del Prado, Madrid),[39] although in these instances the landscape is not particularly close in style. The portrait of Oswald Krell, however, dated 1499 (Alte Pinakothek, Munich), is related in the manner in which the trees at Krell's left are painted and in the use of "wild men" to support coats-of-arms.[40]

Turning to *Lot and His Daughters*, perhaps the most important parallel, initially observed by Friedländer, is that the destruction of the cities of Sodom and Gomorrah appears, in reverse, in the woodcut of the *Whore of Babylon* from Dürer's *Apocalypse* series of 1498.[41] Note also the comparable explosion that occurs in the lower left of the *Seven Trumpets* woodcut in the same series.[42] The Turkish garb of Lot and the sturdy proportions of all three figures are echoed in Dürer's pen and watercolor studies of 'orientals from c. 1495 as well as in engravings such as the *Turkish Family* and the *Three Peasants in Conversation*, both c. 1496/1497.[43] Moreover, as has been observed on several occasions, the thin, fluid, and somewhat cursory rendering of the landscape corresponds to that found in Dürer's watercolors, c. 1494/1497, done in Italy and after his return to Germany.[44] In the small painting of *Saint Jerome Penitent* mentioned earlier, the rocks are similarly constructed, but as one might expect for an obverse, the overall landscape is more finished and nuanced.

The particular mixture and character of stylistic elements seen in the *Madonna and Child* and *Lot and His Daughters* are not discernible in the works generally dated around or after 1500. There are admittedly very few Madonna paintings by Dürer until the time of his second Venetian trip—and these are very different—but in the picture closest in date, the *Madonna and Child* of 1503 (Kunsthistorisches Museum, Vienna), the

face of the Virgin is fundamentally different in type, less symmetrical, more particularized, and, one might say, more "Germanic."[45] Further, in two paintings of the *Lamentation*, one produced for the Holzschuher family (Germanisches Nationalmuseum, Nuremberg), the other for Albrecht Glimm (Alte Pinakothek, Munich), both dated c. 1500, the elaborate, extensive landscape is not so much differently executed as it is differently conceived.[46] Lastly, and with regard to Buchner's date of c. 1504, accepted by Shapley and others, it should be noted that the backward-bent wrist of the Christ Child appears in embryo in Giovanni Bellini's *Madonna degli Alberetti* and could easily have been appropriated by Dürer.

As noted by Eisler, it is highly unusual for Dürer to place his monogram on the reverse of a painting,[47] and the particular form of this monogram is apparently unique. Nonetheless, the monogram is consistent with our suggested dating of c. 1496/1499. In the late 1490s Dürer seems to have experimented with various arrangements of his initials before settling, around 1497, on the famous monogram of a capital *D* set under the crossbar of a larger capital *A*.[48] As first observed by Buchner, the monogram in the Washington painting is closest to that found in Dürer's engraving of *The Virgin with the Dragonfly*, c. 1495 (Bartsch, 44).[49] Technical examination does not seem to indicate that the monogram has been altered or that it is not original, despite Anzelewsky's claims.[50]

Winkler cited a chiaroscuro woodcut of the *Madonna and Child* by Hans Wechtlin, active in Strasbourg between 1506 and 1526, as directly inspired by Dürer's *Madonna and Child*.[51] Eisler saw the influence of Dürer's Madonna in the woodcut of *The Holy Family* by Hans Schäufelein, dated c. 1508 (Bartsch, 13), indicating its availability in the workshop.[52]

Notes

1. Since it was not possible to disengage the panel from its frame, these measurements derive from an analysis of x-radiographs and include thin strips of wood added to all four sides. Kress 1951, 192, gives as measurements: 52.6 × 42.9 (20⅞ × 16⅞); painted surface, obverse, 50.5 × 40 (19⅞ × 15¾); painted surface, reverse, 50.2 × 40 (19¾ × 15¾). The panel thickness is estimated to be 0.3 cm. in notes in NGA conservation department files.

2. I am indebted to Walter Angst for the heraldic description.

3. Rutherford J. Gettens and George L. Stout, *Painting Materials: A Short Encyclopedia* (rev. ed., New York, 1966), 163.

4. Christophe Gottlieb von Murr, *Beschreibung der vornehmsten Merkwürdigkeiten in des H. R. Reichs freyen Stadt Nürnberg und auf der hohen Schule zu Altdorf* (Nuremberg, 1778), 476: "Von einem unbekannten sehr alten Meister. N. 239 Lot eilet mit seinen Töchtern aus Sodom. Man siehet unter andern auch ein Marienbild angebracht. Auf Holz." Listed as belonging to the "Praunisches Museum." The suggestion, which remains unverified, that this refers to the National Gallery's painting was first made by Erika Tietze, letter to Fern Rusk Shapley, 4 February 1953, in NGA curatorial files. In Murr's later catalogue of the collection, however, the painting is given to Joachim Patinir. See Christophe Theophile de Murr, *Description du Cabinet de Monsieur Paul de Praun à Nuremberg* (Nuremberg, 1797), 31: "Joachim Patenier, 239. Lot et ses deux Filles sortans de Sodome. Les figures sont comme decoupées, sans justes ombres. Sur bois. Albert Dürer reçut ce petit Tableau en 1521 à Anvers par le Secrétaire de cette Ville ... haut 8 p. larg. 8 p." The dimensions in *pouces*, approximately 8 × 8 in., do not correspond to those of the Washington panel, and a verso is not described, suggesting that a different painting had been assigned the same catalogue number. The Praun collection was dispersed in sales of 1797 and 1802; see Th. Hampe, "Kunstfreunde im alten Nürnberg und ihre Sammlungen," *Festschrift des Vereins für Geschichte der Stadt Nürnberg zur Feier seines 25 jähr. Bestehens* (Nuremberg, 1903), 82–87.

Eisler 1977, 14, listed Willibald Imhoff the Elder (d. 1580) of Nuremberg as a possible owner. Although there are several images of the Madonna or of the burning of Sodom and Gomorrah listed in the Imhoff inventories, they are not conjoined or described in enough detail to permit identification with the National Gallery's picture. By the same token, it is not possible to verify the interesting suggestion in Eisler 1977, 16 n. 46, that the Washington panel might be the "Marienbild von Albrecht Dürer" belonging to both the Imhoff and Praun collections. See Joseph Heller, *Das Leben und die Werke Albrecht Dürer's* (Bamberg, 1827), vol. 2, pt. 1, 78, no. 1 (Imhoff), 230–231, no. y (Praun). There is also some question as to whether the many works listed as by Dürer in the Imhoff collections were autograph or deliberate falsifications; see Moriz Thausing, *Dürer, Geschichte seines Lebens und seiner Kunst* (Leipzig, 1876), 141–144 (English trans., *Albert Dürer: His Life and Works*, ed. Fred A. Eaton, 2 vols. [London, 1882], 1: 184–188).

5. This and the preceding are unverified but are first cited in Friedländer 1934, 322, which states that Loder purchased the painting from à Court Repington; repeated in Heinemann 1937, 47, no. 127, and accepted by later authors. For Charles à Court Repington see J. E. Edmonds in *The Dictionary of National Biography*, supplement (Oxford and London, 1922–1930), 717–718. That he dealt in pictures on occasion is stated in Mary Repington, *Thanks for the Memory* (London, 1938), 223, 278. No information has come to light concerning Phyllis Loder. There is no justification for the assertion in Sutton 1979, 205, that the picture was once owned by Robert Langton Douglas.

6. *Art Prices Current* 11, pt. A (London, 1933), A154, no. 2445; see also the handwritten annotation in the copy of the Christie's sales catalogue in the Frick Art Reference Library, New York, as cited by Eisler 1977, 14. A note in the provenance section of the card file in the NGA curatorial records office suggests that the panel passed from Vaz Dias to the dealer Bottenwieser in Berlin, but it has not been possible to verify this.

7. M. Knoedler & Co. stockbook; I am grateful to Nancy C. Little for making this information available.

8. A photograph of the painting before cleaning is in the NGA curatorial files.

9. Lanckorońska 1971, 57, 59, attributed the painting to Hans Baldung Grien and dated it c. 1502/1503; Oehler 1973, 72, gave the picture to Hans Sebald Beham and dated it after 1504; Walter Strauss, letter to Perry Cott, 28 June 1968, in NGA curatorial files, attributed it to Albrecht Altdorfer, primarily on the basis of the monogram.

10. Panofsky 1943, 1: 41–42.

11. Tietze 1937, 2:15; Schonguaer's engraving as reproduced in Jane C. Hutchison, ed., *The Illustrated Bartsch: Early German Artists* (New York, 1980), 8:243.

12. Reproduced in color and catalogued in Renato Ghiotto and Terisio Pignatti, *L'opera completa di Giovanni Bellini* (Milan, 1969), 98, no. 106; 100–101, no. 134; pls. 31 and 41, respectively.

13. Ghiotto and Pignatti 1969, pls. 33–34, 36–37; 97–98, no. 101; 101, no. 138.

14. Eisler 1977, 13, notes that Lot's costume was regarded as Near Eastern, specifically Turkish. Julian Raby, *Venice, Dürer, and the Oriental Mode* (London, 1982), 22–30, discussed Dürer's use of the "Ottoman mode" in works made during and just after his first trip to Venice. Lot's hat in particular corresponds to the type of headdress called Ottoman by Raby.

15. Anzelewsky 1971, 56–57; Eisler 1977, 13–14. See Réau, *Iconographie*, vol. 2, pt. 1 (1956), 115–118.

16. Seymour 1961 (Kress), 83; Benesch 1966, 20.

17. For the Haller arms see Otto Titan von Hefner and Gustav Adelbert Seyler, *Die Wappen des bayerischen Adels. J. Siebmacher's grosses Wappenbuch*, 34 vols. (Neustadt an der Aisch, 1971), 22:38, pl. 36. An extant example of the arms in the National Gallery painting is the Memorial Shield of Erhart Haller, c. 1457 (Germanisches Nationalmuseum, Nuremberg, on loan from the Freiherrn Haller von Hallerstein), reproduced and discussed in exh. cat. New York and Nuremberg

1986, 203–204, no. 61. The direction of the Haller arms in the National Gallery's painting is reversed so that it may "respect" the arms of what is presumed to be the wife's family at the lower right; see Gustav A. Seyler, "Die Orientirung der Wappen," *Geschichte der Heraldik. J. Siebmacher's grosses Wappenbuch*, vols. A–G (Neustadt an der Aisch, 1970), A:454–487; Walter Angst, letter to the author, 16 April 1988, in NGA curatorial files.

18. Anzelewsky 1971, 142. Wilhelm Haller was acquainted with Dürer and, as the son-in-law of Matthäus Landauer, appears in Dürer's *All Saints* altarpiece of 1511 (Kunsthistorisches Museum, Vienna); see Anzelewsky 1971, 228, no. 118, pl. 141; and Ernst Waller, "Haller v. Hallerstein," *Neue Deutsche Biographie* 17 (1966), 556. Hieronymus II Haller was a Nuremberg humanist who commissioned paintings from Lucas Cranach the Elder and Bernhard Strigel; see Sally E. Mansfield, report, in NGA curatorial files.

19. Anzelewsky 1971, 141; Strieder 1982, 318. Anzelewsky noted that while the *Portrait of a Man in a Red Cloak* (Accademia Carrara, Bergamo) is the same size, the painting in its present state is so heavily reworked that no compositional parallels exist; Anzelewsky 1971, 161–163, no. 59, pl. 60.

20. Kurt Löcher in exh. cat. New York and Nuremberg 1986, 276, no. 109.

21. Friedländer 1934, 322, 324.

22. Buchner 1934, 262, 268.

23. Panofsky 1943, 2: 10, no. 25.

24. Winkler 1957, 73, 77–78; Strieder 1976, 40, 42; Strieder 1982, 318, dated the *Madonna and Child* c. 1498.

25. Eisler 1977, 13–14.

26. Shapley 1956, no. 5.

27. Waetzoldt 1935, 210; Longhi 1961, 5–7.

28. Anzelewsky 1971, 114, no. 2, pls. 1–3; 163, nos. 60–61, pls. 61, 63.

29. Anzelewsky 1971, 122–123, nos. 14–15, pls. 12–14; 205–207, nos. 99–101V, pls. 125–127.

30. Anzelewsky 1982 (see Biography), 70. Dürer's remarks about finish are contained in his letter to Jakob Heller, 26 August 1509; see Hans Rupprich, *Dürer. Schriftlicher Nachlass*, 3 vols. (Berlin, 1956–1969), 1:72.

31. Anzelewsky 1971, 123–124, no. 16, pl. 15, color pl. 2; 124–125, no. 17, pls. 16–24.

32. Longhi 1961, 3–9; Musper 1965(?), 24.

33. Anzelewsky 1971, 120, no. 11, pl. 10; 125, no. 18, pl. 25.

34. Walter L. Strauss, *The Complete Drawings of Albrecht Dürer*, 6 vols. (New York, 1974), 1:280, no. 1495/10, repro. 281.

35. Strauss 1974, 1: 292, no. 1495/17, repro. 293; 196, no. 1494/1, repro. 197.

36. Strauss 1974, 1:430, no. 1497/1, repro. 431; 142, no. 1493/4, repro. 143 (Strauss does not accept the date, 1496, that appears on the drawing); 274, no. 1495/7, repro. 275 (Strauss believes the date is a later addition and that the drawing is before 1497).

37. Anzelewsky 1971, 163–164, nos. 60–63, pls. 61–64.

38. Anzelewsky 1982 (see Biography), 77, repro. 76, pl. 63, considers this version, which entered the Berlin museum from a private collection in Paris in 1977, to be the original. The version in the Museum der bildenden Künste, Leipzig, however, contains a landscape that is much closer to that in the National Gallery's *Madonna and Child*; see Anzelewsky 1971, 146–148, no. 46, pl. 47.

39. Anzelewsky 1971, 152–155, no. 49, pl. 49, color pl. 4.

40. Anzelewsky 1971, 160–161, no. 56, pls. 58–59.

41. Willi Kurth, *The Complete Woodcuts of Albrecht Dürer* (New York, 1963), fig. 119.

42. Kurth 1963, fig. 112.

43. Strauss 1974, 1: 284–291, nos. 1495/12–1495/16; Walter L. Strauss, *The Complete Engravings, Etchings, and Drypoints of Albrecht Dürer* (New York, 1972), 28, no. 14, repro. 29; 34, no. 17, repro. 35.

44. Kress 1951, 192; Anzelewsky 1971, 141; Anzelewsky 1982 (see Biography), 82. Benesch 1966, 19, mistakenly says that *Lot and His Daughters* is painted in watercolor. For comparisons see Walter Koschatzky, *Albrecht Dürer: The Landscape Water-Colours* (New York, 1973), especially nos. 8, 10–12, 15–16, 19–22. The concordance of datings given by Koschatzky 1973, 106, indicates that for modern scholars the watercolors—with the exception of nos. 31–32, both views of Kalcreuth—date between c. 1489 and 1497.

45. Anzelewsky 1971, 174–175, no. 71, pl. 85.

46. Anzelewsky 1971, 159–160, no. 55, pl. 57; 173–174, no. 70, pls. 69–72, color pl. 5.

47. Eisler 1977, 14.

48. For a succinct discussion see Gustav Pauli, "Dürers Monogramm," *Festschrift für Max J. Friedländer zum 60. Geburtstage* (Leipzig, 1927), 34–40.

49. Buchner 1934, 262; Strauss 1972, 9.

50. Anzelewsky, 1971, 141, thought that he could make out traces of an original signature underneath the present monogram. The examination by Catherine A. Metzger of the National Gallery's conservation staff did not substantiate this (see Technical Notes), but her report notes that the area of the monogram is somewhat less abraded than other areas and appears slightly dark in ultraviolet light, which may reflect greater care taken in cleaning around the monogram. The author believes that what seems to be a double *A* is an attempt by Dürer to adjust the proportions of the letter.

51. Winkler 1951, 9–11.

52. Eisler 1977, 14; Max Geisberg, *The German Single-Leaf Woodcut: 1500–1550* (rev. ed. by Walter L. Strauss, New York, 1974), no. G. 1048.

References

1934 Buchner, Ernst. "Die sieben Schmerzen Mariä. Eine Tafel aus der Werkstatt des jungen Dürer."

Münchner Jahrbuch der bildenden Kunst, n.s., 11: 262, 265, 268, 270, figs. 10–11, 14.

1934 Friedländer, Max J. "Eine unbekannte Dürer-Madonna." *Pantheon* 14: 321–324, repro.

1935 Deusch, Werner R. *Deutsche Malerei des sechzehnten Jahrhunderts*. Berlin: 25, pls. 4–5.

1935 Waetzoldt, Wilhelm. *Dürer und seine Zeit*. Vienna: 210, 331.

1936–1939 Pilz, Kurt. "Der Totenschild in Nürnberg und seine deutschen Vorstufen. Das 14.–15. Jahrhundert." *AdGM* 49: 72.

1937 Heinemann, Rudolf. *Stiftung Sammlung Schloss Rohoncz. I. Teil. Verzeichnis der Gemälde*. Lugano-Castagnola: 47, no. 127, pls. 30–31.

1937 Tietze, Hans, and Erika Tietze-Conrat. *Kritisches Verzeichnis der Werke Albrecht Dürers*. 3 vols. Basel and Leipzig, 2: 15–16, nos. 130a, 130b, repros. 173.

1943 Panofsky. 1: 41–42; 2: 10, no. 25.

1949 "Die Sammlung Thyssen der "Offentlichkeit zugänglich." *Die Weltkunst* 19 (1 September): 8.

1951 Kress: 190–193, no. 84, repros.

1951 Winkler, Friedrich. "Hans Wechtlins 'Schöne Maria.'" *Berliner Museen*, n.s., 1: 9–11, fig. 2.

1952 Frankfurter, Alfred M. "Interpreting Masterpieces: Twenty-four Paintings from the Kress Collection." *Art News Annual* 111–112, repro. 106.

1956 Shapley, Fern Rusk. *National Gallery of Art, Portfolio Number 5: Masterpieces from the Samuel H. Kress Collection*. Washington: no. 5, repro.

1957 Winkler, Friedrich. *Albrecht Dürer. Leben und Werk*. Berlin: 72–73, 77–78, 138, fig. 37.

1959 Stange, Alfred. "Ein Gemälde aus Dürers Wanderzeit?" *Studien zur Kunst des Oberrheins. Festschrift für Werner Noack*. Konstanz and Freiburg: 116.

1960 Broadley: 20, repro. 21.

1961 Longhi, Roberto. "Una Madonna del Dürer a Bagnacavallo." *Paragone* 139: 5–7.

1961 Seymour (Kress): 80, 83, 210, pls. 73–74.

1962 Cairns and Walker: 70, repro. 71.

1962 Lüdecke, Heinz. "Dürer und Italien." *Dezennium 1. Zehn Jahre VEB Verlag der Kunst*. Dresden: 292, repro. 293.

1962 Neugass, Fritz. "Die Auflösung der Sammlung Kress." *Die Weltkunst* 32 (1 January): 4.

1963 Walker: 116, repro. 117.

1964 Lüdecke, Heinz. "Albrecht Dürer und Italien." *Bildende Kunst*, no. 2: 77, repro. 75.

1965 Grote, Ludwig. *Dürer*. Geneva: 49, 51, repro. 50.

1965(?) Musper, Heinrich Theodor. *Albrecht Dürer*. New York: 24, 74, repro. 75.

1966 Benesch, Otto. *German Painting. From Dürer to Holbein*. Geneva: 19–20, repro. 18

1966 Cairns and Walker: 110, repro. 111.

1968 Zampa, Giorgio, and Angela Ottino della Chiesa. *L'opera completa di Dürer*. Milan: 95, no. 50 a–b, pls. 9–10.

1971 Anzelewsky 1971: 28–29, 56–57, 70–71, 90, 92–93, 140–142, nos. 43–44, fig. 20, pls. 39–46, color pl. 3 opposite 40.

1971 Hofmann, Walter Jürgen. *Über Dürers Farbe*. Nuremberg: 43 n. 105, 87.

1971 Lanckorońska, Maria Gräfin. *Neue Neithart-Studien. Neithart bei Dürer, zur Dokumentation und zum neu entdeckten Werk von Matthäus Gotthart Neithart*. Baden-Baden: 55–60, figs. 28–29.

1971 Mende, Matthias. "1471—Albrecht Dürer—1971." *Conn* 176: 165.

1972 Lüdecke, Heinz. *Albrecht Dürer*. New York: 14, fig. 2.

1973 Oehler, Lisa. "Das Dürermonogramm auf Werken der Dürerschule." *Städel-Jahrbuch*, n.s., 4: 72, fig. 63.

1974 Stechow, Wolfgang. "Recent Dürer Studies." *AB* 56: 260.

1975 NGA: 116, repro. 117.

1975 Paltrinieri, Marisa, and Franco De Poli. *I geni dell'arte. Dürer*. Milan: 34, 37, repro., 57, 59, 63, repro., 93, repro.

1976 Strieder, Peter. *Dürer*. Milan: 40–45, repro., 181, nos. 11–12.

1976 Walker: 148–151, nos. 160, 163, repro.

1976 Mende, Matthias. *Albrecht Dürer. Das Frühwerk bis 1500*. Herrsching: 68–69, pls. 30–31.

1977 Eisler: 12–16, figs. 11–14.

1979 Westrum, Geerd. *Altdeutsche Malerei*. Munich: 84, 86, repro. 85.

1979 Sutton, Denys. "Robert Langton Douglas. Part IV." *Apollo* 110 (July): 205, fig. 30.

1982 Anzelewsky (see Biography): 70, 82, figs. 70–71.

1982 Strieder, Peter. *Albrecht Dürer. Paintings. Prints. Drawings*. Translated by Nancy M. Gordon and Walter L. Strauss. New York: 318, figs. 417–418.

1983 Wolff: unpaginated, repro.

1984 Sgarbi, Vittorio. *Fondazione Magnani-Rocca. Capolavori della pittura antica*. Milan: 74.

1984 Walker, John. *National Gallery of Art, Washington*. Rev. ed. New York: 148, no. 154, repro. 149 (*Madonna and Child*); 151, no. 157, repro. 150 (*Lot and His Daughters*).

1985 NGA: 141, repro.

1986 Mulazzani, Germano. "Raphael and Venice: Giovanni Bellini, Dürer, and Bosch." *StHist* 17: 151, repro.

1990 Dülberg, Angelica. *Privatporträts. Geschichte und Ikonologie einer Gattung im 15. und 16. Jahrhundert*. Berlin: 297, no. 341, figs. 325–326.

1952.2.17 (1100)

Portrait of a Clergyman (*Johann Dorsch?*)

1516
Parchment, 43 × 33 (16⅞ x 13);
 painted surface: 41.7 × 32.5–32.7
 (16⅜ × 12¾–12⅞)
Samuel H. Kress Collection

Inscription

At top right: *1516*

🔲

Marks: On reverse, at top of stretcher, in pencil: *258*; at top of stretcher, in red crayon: *13*; on a paper sticker, handwritten in brown-black ink: *N° ii4J/Rom/119/Albrecht Durrers*; on a paper sticker: *No. 57737 Size 17×13/Port. of a Man/Albrecht Dürer.*

Technical Notes: There are scored lines at the junction of the painted surface and the unpainted edges, and these appear to be part of the preparation of the parchment. The unpainted area is not intact along the right edge. The parchment has been adhered to a single-thread, plain-weave fabric then mounted on a stretcher.[1] It is not known when the lining took place—although Eisler suggests the early nineteenth century[2]—or if there was, as seems likely, an original auxiliary support, probably wood. The paint surface is marred by weave interference that presumably occurred during the lining process. There is no evidence of a ground under the paint layer, and examination with infrared reflectography did not disclose underdrawing. The green background seems to have been put in first, with space left for the head and clothing. A significant design change occurs in the chin, which is larger than the space allotted for it.

There are several tears in the parchment along the bottom, left, and top edges. Areas of abrasion are visible, particularly in the neck and hair on the right of the face, and there are extensive pinpoint losses. There are small losses in the eyes and the mouth, possibly the result of vandalism that took place before 1934.[3]

Provenance: Paul von Praun [d. 1616] and descendents, Nuremberg, by 1719 until at least 1801.[4] Count Johann Rudolph Czernin von Chudenitz [d. 1845], Vienna, by 1821.[5] The Counts Czernin, Vienna. Count Eugen Czernin von Chudenitz, Vienna, until 1950; (Frederick Mont, New York, and Newhouse Galleries, New York);[6] purchased 1950 by the Samuel H. Kress Foundation, New York.

Exhibitions: Nuremberg, Germanisches Museum, 1928, *Albrecht Dürer Ausstellung*, no. 61. Zurich, Schweizerisches Landesmuseum, 1948–1949, loaned to a small exhibition of portraits of Huldrych Zwingli.[7]

THE SITTER, set against a green background, wears a black tunic and a black *pileus*, or cap, a type of costume appropriate to either an academic or an ecclesiastic.[8] A rigorous forthrightness and intensity permeate this portrait, and the simplified color scheme underscores the man's craggy features, heavy jaw, and straightforward gaze. Dürer's monogram and the date of 1516 have never been seriously questioned, and the painting is accepted by virtually all authors.[9]

The primary discussion, therefore, has centered on the identity of the sitter, and two principal candidates have been put forward: the Swiss reformer Huldrych (Ulrich) Zwingli (1484–1531), and Johann Dorsch, a cleric active mainly in Nuremberg. Eisler has also suggested the Augustinian Hans Link.[10] There are major impediments to the identification of the sitter as Zwingli, and these became apparent in 1948–1949 when the National Gallery's painting, then in the Czernin collection, was lent to the Schweizerisches Landesmuseum, Zurich, for comparison with known depictions of Zwingli. The evidence was inconclusive at best; not only was there a low degree of physiognomic similarity to Dürer's portrait, but other images on medals and paintings show Zwingli in profile.[11] Moreover, as far as we know, the earliest that Dürer could have met Zwingli was in April or May 1519 when the artist accompanied Wilibald Pirckheimer and Martin Tucher to Zurich.[12]

The biographical information about Johann Dorsch is incomplete, and especially scant for the period around 1516 that might relate him to this portrait.[13] The date and place of Johann Dorsch's birth are unknown. He was a hermit in the Augustinian cloister in Nuremberg, but there is no record of when he joined the order or how long he remained a hermit. He studied at the University of Wittenberg from at least the summer semester of 1506 and received his *baccalaurens artium* in December 1507. Kressel suggested, without documentation, that Dorsch took over the duties of Johannes Werner, head pastor of the Church of

Fig. 1. Detail of *Portrait of a Clergyman*, 1952.2.17

Saint John in Nuremberg, who died in May 1522. We next hear of Dorsch in 1524 when he was called to preach in the nearby town of Schwabach. In the interim he had apparently joined the cause of the Reformation, and on 14 February his first sermon was delivered with such stormy fervor that it was also his last, and he was forced to return to Nuremberg. In 1525 he appears as a member of the Augustinian cloister in that city and is possibly mentioned on 18 March as a father confessor for the women's cloister of Saint Clare. From 1528 until his death in 1541 he was the pastor (*Pfarrer*) of the reformed Church of Saint John in Nuremberg.

Strong evidence for the identification of Dorsch with Dürer's portrait is provided by the association in the earliest written record—the Praun family inventory of 1719—and in subsequent eighteenth- and early nineteenth-century catalogues.[14] As several authors have pointed out, these citations probably continue a traditional identification that goes back to the sixteenth century.[15] The 1719 inventory also contains the important information that the painting was then equipped with a cover (*Schüber*). If original, a cover such as that painted by Dürer for the 1526 portrait of Hieronymus Holzschuher (Gemäldegalerie, Berlin) might well have borne a coat-of-arms, which would explain the absence of identifying arms or inscriptions on the Washington portrait.[16]

Although perhaps less compelling as evidence, we must also consider that Dorsch, who resided in Nuremberg, could easily have been known to Dürer. The Church of Saint John was Augustinian before the Reformation; it was Dürer's parish church, and Johannes Werner, the scholarly and mathematically gifted pastor who preceded Dorsch, was a member of Dürer's close circle of humanist friends.[17] In this regard Mende has suggested that the National Gallery's painting belongs to a series of "friendship portraits" that Dürer made between c. 1516 and 1518.[18]

As already noted, the costume is so generalized as neither to confirm nor exclude the identification of the sitter as an Augustinian.[19] If the sitter was an academic, then the presence of a *pileus* means that he most probably possessed either a master's or a doctor's degree.[20]

In sum, Johann Dorsch is the strongest known candidate for the sitter in the Washington painting. The absence of confirming documentation or of another verifiable representation of Dorsch, however, means that the identification will remain uncertain.

It is not known if Dürer attached any special importance to the use of parchment as a support, but his paintings on parchment appear at three different periods. There are several small pictures from the 1490s, such as the *Christ Child with a World Globe*, monogrammed and dated 1493 (Graphische Sammlung Albertina, Vienna), the *Portrait of a Girl in a Red Beret*, dated 1507 (Gemäldegalerie, Berlin), and, in addition to the Washington portrait, two works from the year 1516, the *Madonna and Child with a Pink* (Alte Pinakothek, Munich) and the *Portrait of Michael Wolgemut* (private collection, southern Germany).[21] That these last three works have a wood base for the parchment possibly suggests that the support for the Washington picture was also originally wood.

The depiction of windows reflected in eyeballs is a device first used by Dürer around 1500 and can be seen in his famous *Self-Portrait* of 1500 (Alte Pinakothek, Munich).[22] In the case of the Washington picture there is actually a double reflection (fig. 1). The appearance of window reflections in Dürer's work is discussed by Białostocki as an illusionistic device, one facet of

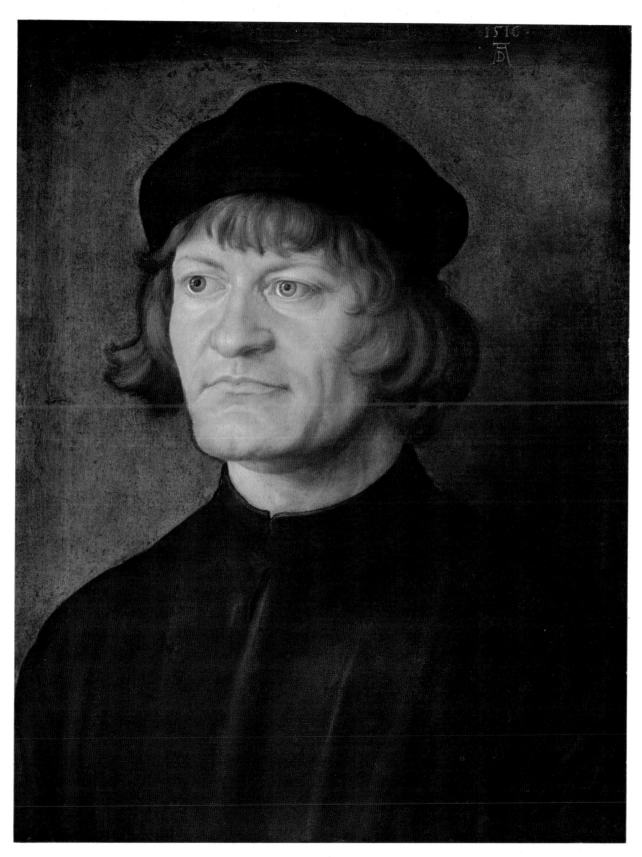

Albrecht Dürer, *Portrait of a Clergyman (Johann Dorsch?)*, 1952.2.17

the artist's realism; as an indication of Dürer's interest in optics, light, and perspective; and on a symbolic level, as a "window to the soul." Białostocki also touches on the mystical and religious overtones of the crosslike shape formed by the window mullions, ideas that would certainly seem to be relevant for the *Portrait of a Clergyman (Johann Dorsch?)*.[23]

Notes

1. Several authors, beginning with Tietze and Tietze-Conrat 1937 and including Panofsky 1943 and Anzelewsky 1971, have mistakenly listed wood as the auxiliary support for the parchment.

2. Eisler 1977, 16.

3. The hole in the lips is mentioned in Tietze 1934, 110.

4. Stadtarchiv, Nuremberg, Familienarchiv von Praun, E28, no. 1477, unpublished manuscript, "Inventar des Paulus von Praunschen Kunstkabinetts im Stiftungshaus am alten Weinmarkt. . ." (1719), 9: "N.119 Von Albr. Dürer Johann Dors gewesen Pfarrers beij St./Johañis contrefait auf Pergament von öel/farb gemahlt, mit ein Schüber, Das Gemähl/ist 18 [*sic*] S.[chuh] 4 Z[oll] hoch und i.8 S.[chuh] 1. Z[oll] breit." I am extremely grateful to Dr. Max Nüchterlein, Nuremberg, for this citation (letter to the author, 9 April 1977, in NGA curatorial files). A photocopy of the inventory entry and a transcription by Dr. G. Hirschmann, Stadtarchiv, Nuremberg, included in a letter to Nüchterlein, 2 February 1977, are also in NGA curatorial files. The transcription above is based on my examination of the manuscript on 10 September 1988; I am grateful to Mr. Reichmacher of the Stadtarchiv for his assistance.

A *Schuh* is a unit of measurement equal to approximately one foot, while a *Zoll* equals approximately one inch. See John Henry Alexander, *Universal Dictionary of Weights and Measures, Ancient and Modern: Reduced to the Standards of the United States of America* (Baltimore, 1850), 103–104, 124–125. In the cemetery of the Sankt Johannis church in Nuremberg, the author found a label accompanying an iron "Grabsteinmass," used for measuring graves, which indicated that a "Nürnberger Werkschuh" equaled 27.84 cm. The dimensions given in Murr 1797, 14, are: "Haut. 1 Pied, 4 Pouces; Larg. 1 Pied, 1 Pouce." Heller 1827, 231, gives the German equivalent as: "1 Sch[uh] 4 Z[oll] hoch, 1 Sch[uh] 1 Z[oll] breit."

5. Heller 1827, 260, cites the painting as being in the Czernin collection in 1821 but seems unaware that this is the same painting he noted earlier in the Praun collection. His description, however, is clearly that of the National Gallery's picture: "Brustbild eines Mannes, welcher nach Rechts gewendet ist, mit dem Zeichen und der Jahrszahl AD 1516. Grüner hinter-grund auf Leinwand; ohnegefähr 15Z. hoch, 10Z. breit." The mention of *Leinwand* suggests but does not confirm that the backing with fabric took place before 1827.

6. Frederick Mont, letter to the Samuel H. Kress Foundation, 6 February 1950, in NGA curatorial files. Nancy Marshall, Newhouse Galleries, letter to the author, 3 May 1988, in NGA curatorial files, noted that from the extant records it was unclear whether the painting was owned jointly or given on consignment. Marshall did confirm that the number 57737 on a paper sticker on the reverse was a Newhouse Gallery number, as indicated by Eisler 1977, 16.

7. According to Dr. Lucas Wüthrich, Schweizerisches Landesmuseum, Zurich, letter to the author, 8 April 1988, in NGA curatorial files, there was no catalogue.

8. Denna Jones Anderson, letter and accompanying bibliography to the author, 17 August 1988, in NGA curatorial files; Anderson notes the development of university garb out of clerical dress. Stella Mary Newton, letter to Colin Eisler, 23 July 1968, in NGA curatorial files, also observes that the costume could be worn by either a cleric or an academic.

9. Oehler 1973, 70–71, on the basis of the monogram gave the painting to Hans Sebald Beham, an attribution followed by no one else. Waagen 1866, 298, thought the portrait might be by Hans Süss von Kulmbach; Weixlgärtner 1905, 69, also doubted the attribution to Dürer.

10. Eisler 1977, 17.

11. Favoring the identification of the sitter as Zwingli are Hoffmann 1948, the anonymous author in *Atlantis* 1948, and Farner 1972, 146–152. As noted by Hoffmann 1948, 497, the known depictions of Zwingli, a medal by Jakob Stampfer (Schweizerisches Landesmuseum, Zurich) and paintings by Hans Asper (Kunstmuseum, Winterthur, and Zentralbibliothek, Zurich), were done either at the time of his death, 1531, or posthumously.

12. Noted by Braune 1948, 13, and many subsequent authors, including Winkler 1957, 268, and Anzelewsky 1971, 242.

13. The following account is based on the transcription of a lecture given by Hans Kressel, former *Kirchenrat* of the Church of Saint John, Nuremberg, 1971. It was kindly brought to my attention by Max Nüchterlein of Nuremberg, letter to the author, 12 May 1974, in NGA curatorial files. Thanks to Kurt Löcher, who facilitated my research in the outstanding library of the Germanisches Nationalmuseum, Nuremberg, I was able to verify the following references cited by Kressel: Andreas Würfel, *Verzeichnis und Lebensbeschreibungen der Herren Prediger* (Nuremberg, 1757), 302; Hermann Clauss, *Die Einführung der Reformation in Schwabach 1521–1530* (Leipzig, 1917), 59–60; Julie Rosenthal-Metzger, "Das Augustinerkloster in Nürnberg," *Mitteilungen des Vereins für Geschichte der Stadt*

Nürnberg 30 (1931), 102; Johannes Kist, *Die Matrikel der Geistlichkeit des Bistums Bamberg 1400–1556* (Würzburg, 1965), 79, no. 1125; Matthias Simon, *Nürnbergisches Pfarrerbuch. Die evangelisch-Lutherische Geistlichkeit der Reichsstadt Nürnberg und ihres Gebietes 1524–1806* (Nuremberg, 1965), 49; and Gerhard Pfeiffer, *Quellen zur Nürnberger Reformationsgeschichte. Von der Duldung liturgischer Änderungen bis zur Ausübung des Kirchenregiments durch den Rat (Juni 1524–Juni 1525)* (Nuremberg, 1968), 5, no. 21, 59, no. 401, 365, no. 153. The exact date of Dorsch's death is unclear; Würfel 1757 and Simon 1965 give 19 January 1541, but Dr. von Andrian-Werburg of the Staatsarchiv, Nuremberg, letter to Kurt Löcher, 26 July 1988, in NGA curatorial files, notes that Johann Dorsch's name appears in the *Totengeläutbuch* of Saint Sebald for the period 8 June–21 September 1541. I am extremely grateful to Kurt Löcher, who made additional inquiries to the Landeskirchliches Archiv and the Stadtarchiv of Nuremberg in search of documents mentioning Dorsch; unfortunately no new material came to light.

14. See note 5; Schöber 1769, 162; Murr 1778, 470, no. 119; Murr 1797, 14, no. 119; Heller 1827, 231, no. 6.

15. Flechsig 1928, 411–412, was probably the first.

16. For the Holzschuher portrait and cover see Anzelewsky 1971, 271, nos. 179–180, pls. 182–183. It is worth noting that in the 1719 Praun inventory, no. 120, Dürer's portrait of Michael Wolgemut is also listed as having a cover. This is almost certainly the same painting now in the Germanisches Nationalmuseum, Nuremberg; see Anzelewsky 1971, 241–242, no. 132, pl. 162.

17. See Hans Kressel, "Hans Werner. Der gelehrte Pfarrherr von St. Johannis. Der Freund und wissenschaftliche Lehrmeister Albrecht Dürers, "*Mitteilungen des Vereins für Geschichte der Stadt Nürnberg* 52 (1963–1964), 287–304; and Siegfried Bachmann, "Johannes Werner, kaiserlicher Hofkaplan, Mathematiker und Astronom zu Nürnberg, als Chronist der Jahre 1506 bis 1521," *102. Bericht des historischen Vereins für die Pflege der Geschichte des ehemaligen Fürstbistums Bamberg* (1966), 315–337. As noted by Eisler 1977, 17, it is quite possible that Dorsch presided at Dürer's funeral in 1528. For the church and cemetery of Saint John see Otto Glossner, *Der St. Johannisfriedhof zu Nürnberg* (Munich and Berlin, 1984); and Hans Kressel, *Führer durch die evangelischen Kirchen von Nürnberg-St. Johannis* (Nuremberg, 1977).

18. Mende 1982 included in this group portraits of Kaspar Nützel (original lost, but known through a copy in Jagdschloss Grunewald, Berlin), Lazarus Spengler (original of 1518 lost, known through an engraving), and Michael Wolgemut (Germanisches Nationalmuseum, Nuremberg).

19. Eisler 1977, 17, noted that, unlike Augustinian hermits, Augustinian canons were not tonsured and did not wear monastic garb. Close to the costume worn by the sitter in the National Gallery's picture is Hans

Sebald Beham's woodcut of a *Pfaffen standt* from a series of representations of the attire of clerics and members of orders, reproduced by Max Geisberg, *The German Single-leaf Woodcut: 1500–1550*, ed. Walter L. Strauss (New York, 1974), 209, no. G. 228. This costume is not connected with a specific order.

20. See note 9.

21. Anzelewsky 1971, 120, no. 11, pl. 10; 207–208, no. 102, pl. 128; 240–241, nos. 130, 131, pls. 159, 160–161.

22. Anzelewsky 1971, 164–168, no. 66, pls. 67–68.

23. Białostocki 1970, esp. 172–174.

References

1769 Schöber, David Gottfried. *Albrecht Dürers, eines der grössesten Meister und Künstler seiner Zeit, Leben, Schriften u. Kunstwerke.* Leipzig and Schleiz: 162.

1778 Murr, Christophe Gottlieb von. *Beschreibung der vornehmsten Merkwürdigkeiten in des H. R. Reichs freyen Stadt Nürnberg und auf der hohen Schule zu Altdorf.* Nuremberg: 470, no. 119.

1797 Murr, Christophe Theophile de. *Description du Cabinet de Monsieur Paul de Praun à Nuremberg.* Nuremberg: 14, no. 119.

1823 Böckh, Franz Heinrich. *Merkwürdigkeiten der Haupt- und Residenz-Stadt Wien und ihrer nächsten Umgebungen. Ein Handbuch für Einheimische und Fremde.* 2 vols. Vienna, 1: 296.

1827 Heller, Joseph. *Das Leben und die Werke Albrecht Dürer's.* Bamberg, 2: 231, no. 6, 260, no. e.

1866 Waagen, Gustav Friedrich. *Die vornehmsten Kunstdenkmäler in Wien.* 2 vols. Vienna, 1: 298, no. 28.

1876 Thausing, Moriz. *Dürer, Geschichte seines Lebens und seiner Kunst.* Leipzig: 384. English ed. *Albert Dürer. His Life and Works.* 2 vols. London, 1882, 2: 132.

1891 *Katalog der Gemälde-Gallerie seiner Excellenz des Grafen Jaromir Czernin von Chudenitz.* Vienna: 17, no. 164 (also subsequent catalogues, 1903, 1908, 1936).

1893 Thode, Henry. "Drei Porträts von Albrecht Dürer." *JbBerlin* 14: 210.

1905 Weixlgärtner, Arpad. Review of Valentin Scherer, *Dürer. Des Meisters Gemälde, Kupferstiche und Holzschnitte.* Klassiker der Kunst, vol. 4. In *Die Graphischen Künste*, supplement, *Mitteilungen der Gesellschaft für vervielfältigende Kunst* 28, nos. 3/4: 69.

1908 Scherer, Valentin. *Dürer. Des Meisters Gemälde, Kupferstiche und Holzschnitte.* Klassiker der Kunst, vol. 4. 3d ed. Stuttgart and Leipzig: 393, repro. 55.

1914 Friedländer, Max J. "Dürer, Albrecht." In Thieme-Becker, 10: 70.

1916 Waldmann, Emil. *Albrecht Dürer.* Leipzig: 89, no. 57, repro.

1928 Flechsig, Eduard. *Albrecht Dürer. Sein Leben*

und seine künstlerische Entwicklung. 2 vols. Berlin, 1: 411–412.

1928 Winkler, Friedrich. *Dürer. Des Meisters Gemälde, Kupferstiche und Holzschnitte.* Klassiker der Kunst, vol. 4. 4th ed. Berlin and Leipzig: 416, repro. 59.

1934 "Ein neuer Dürer." [Kleine Mitteilungen] *Technische Mitteilungen für Malerei* 50: 115–116.

1934 Tietze, Hans. "Das Dürerbild der Sammlung Czernin." *Pantheon* 13–14: 110, repro.

1937 Tietze, Hans, and Erika Tietze-Conrat. *Kritisches Verzeichnis der Werke Albrecht Dürers.* 3 vols. Basel and Leipzig, 2: 119, no. 663, repro. 278.

1943 Panofsky. 1:192; 2:18, no. 81.

1946 Hoffman, Hans. "Zu Dürers Bildnis eines jungen Mannes in der Galerie Czernin in Wien." In Oskar Farner, *Huldrych Zwingli. Seine Entwicklung zum Reformator 1506–1520.* 3 vols. Zurich, 2: 425–436, frontispiece.

1948 Braune, Heinz. "Zu Dürers 'Zwinglibildnis' im Landesmuseum." *Neue Zürcher Zeitung* (6 December): 13.

1948 "Ein Zwingli-Bildnis von Dürer?" *Atlantis* 20: 27–29, repro.

1948 Hoffmann, Hans. "Ein mutmassliches Bildnis Huldrych Zwinglis." *Zwingliana. Beiträge zur Geschichte Zwinglis* 7: 497–501, repro.

1949 "Ausstellungen." *Schweizerisches Landesmuseum in Zürich. Siebenundfünfzigster Jahresbericht 1948.* Zurich: 12.

1951 "Ausstellungen." *Schweizerisches Landesmuseum in Zürich. Achtundfünfzigster und Neunundfünfzigster Jahresbericht 1949/50.* Zurich: 17.

1951 "Dürers 'Zwingli' ging nach USA." *Die Weltkunst* 21 (1 January): 4, repro.

1951 Kress: 194, no. 85, repro. 195.

1955 Shapley, Fern Rusk. "The National Gallery of Art at Washington: Acquisitions 1945–1955." *The Studio* 150 (July): 6, repro. 3.

1957 Winkler, Friedrich. *Albrecht Dürer. Leben und Werk.* Berlin: 268, repro. fig. 138.

1960 Broadley: 24, repro. 25.

1962 Neugass, Fritz. "Die Auflösung der Sammlung Kress." *Die Weltkunst* 32 (1 January): 4.

1963 Walker: 118, repro. 119.

1965(?) Musper, Heinrich Theodor. *Albrecht Dürer.* New York: 26.

1966 Cairns and Walker: 112, repro. 113.

1968 Zampa, Giorgio, and Angela Ottino della Chiesa. *L'opera completa di Dürer.* Milan: 110, no. 148, repro.

1970 Białostocki, Jan. "The Eye and the Window. Realism and Symbolism of Light-Reflections in the Art of Albrecht Dürer and His Predecessors." *Festschrift für Gert von der Osten.* Cologne: 159, 164, 161, fig. 4.

1971 Anzelewsky 1971: 242, no. 133, pls. 163–165.

1972 Farner, Konrad. "Hat Dürer Zwingli gemalt?" *Zürich-Aspekte eines Kantons.* Zürich: 146–152, repro.

1973 Oehler, Lisa. "Das Dürermonogramm auf Werken der Dürerschule," *Städel Jahrbuch,* n.s., 4: 70–71, 63, fig. 27.

1975 NGA: 116, repro. 117.

1976 Strieder, Peter. *Dürer.* Milan: 139, repro., 186, no. 52.

1977 Eisler: 16–19, fig. 17.

1979 Hadley, Rollin van N. "What Might Have Been: Pictures Mrs. Gardner Did Not Acquire." *Fenway Court:* 44, repro.

1979 Watson, Ross. *National Gallery of Art Washington.* New York: pl. 39.

1982 Anzelewsky (see Biography): 182–183, 187, repro. 188.

1982 Mende, Matthias. "Dürers Bildnis des Kaspar Nützel." *Mitteilungen des Vereins für Geschichte der Stadt Nürnberg* 69: 130, 132, 136, 138–139, fig. 8.

1982 Strieder, Peter. *Albrecht Dürer. Paintings, Prints, Drawings.* New York: 242, repro. 245.

1985 NGA: 141, repro.

1987 Hadley, Rollin van N. *The Letters of Bernard Berenson and Isabella Stewart Gardner 1887–1924.* Boston: 138–144.

German

1942.16.3 (700)

Portrait of a Lady

1532
Oak, 44.2 × 31.7 (17⅜ × 12½)
Chester Dale Collection

Inscriptions
At top: *Bloes bin ich aūß mutter leib komē. Bloes werd
 ich wider hingnoe/Anno 1532 Aetatis sūæ-45*
At lower left: coat-of-arms, *argent, a horse salient
 forcené gules*[1]

Technical Notes: The painting is comprised of three boards with vertical grain, and each board is cut somewhat differently, varying from radial to tangential. The painting support was thinned, and a cradle was attached. A dendrochronological examination by Peter Klein suggested that the earliest possible felling date was 1529.[2] Since a barbe is visible at each edge of the panel, the panel may have been painted in an engaged frame. During the 1989 laboratory examination the medium was estimated to be egg tempera applied over a white ground. Examination with infrared reflectography did not disclose underdrawing. There are scattered losses and retouchings and abrasion throughout, but losses are particularly evident along the join lines. Until the present varnish and extensive retouchings are removed, the full extent of loss and abrasion cannot be accurately determined. It is possible that the coat-of-arms at the lower left has been reinforced.

Provenance: Possibly Prince Demidoff, San Donato, near Florence.[3] Probably the family of Count Filicaja (or Filicaia), Arezzo, until 1902;[4] purchased by Henry Osborne Havemeyer [d. 1907], New York, 1902;[5] by inheritance to his wife, Mrs. Henry Osborne Havemeyer [née Louisine Waldron Elder, d. 1929], New York; (sale, American Art Association, Anderson Galleries, New York, 10 April 1930, no. 54, as Ludger tom Ring); purchased by Chester Dale, New York.[6]

Exhibitions: New York, Museum of French Art, 1931, *Degas and His Tradition* (not in catalogue).[7]

THE UNKNOWN SITTER, shown in half length, wears a costume that is at once austere and rich. Set against the simplicity of her white kerchief and black dress are the elaborate design in gold

on her belt and the rings on her fingers. She holds a small book, handsomely bound and tooled in gold. The inscription at the top of the painting is from Job 1:21, "Naked I came from my mother's womb, and naked shall I return." The severity of this sentiment is in marked contrast to the woman's material wealth, and its use as a personal motto may reflect the increased popularity of the Book of Job in the sixteenth century in northern Europe.[8] The second line of the inscription gives the date as 1532 and the sitter's age as forty-five. The coat-of-arms cannot be identified with certainty.[9]

Any attempt to investigate this painting is seriously hampered by the fact that its pendant, a *Portrait of a Man*, was separated from its mate in 1930 and its present location is unknown. Although it is known that the male portrait is also dated 1532, vital information such as the content of the inscription or the coat-of-arms is not discernible in the poor reproduction in the sales catalogue.[10]

The traditional attribution of the *Portrait of a Lady* and its companion to the Westphalian artist Ludger tom Ring the Elder (1496–1547) was rejected by Riewerts and Pieper, who declared that the panels were scarcely by any member of the tom Ring family.[11] Subsequent authorities have affirmed this opinion on both stylistic and linguistic grounds; the inscription is written in a High German dialect that effectively excludes Münster in Westphalia, where Low German was spoken.[12]

Thus far it has not been possible to assign the *Portrait of a Lady* to an artist or school, and there is no consensus as to whether it should be localized in northern or southern Germany. Löcher believed the painting was produced in north Germany, in a coastal city such as Hamburg or Bremen, or possibly in Lüneburg or Friesland, while noting that this area was not much studied and few artists were known.[13] He also observed that 1532 was rather early for a half-length portrait. Pieper commented that from the inscription one could surmise that the artist was "Oberdeutsch," that is, south German, but that the painting could

have been painted in northern Germany as well.[14] Luckhardt also called the inscription "Oberdeutsch" but found the woman's headdress closer to types found in the Netherlands or Low Germany than in south Germany and suggested that the portrait could have originated in a border region such as Hessen or Saxony-Thuringia.[15] On a later occasion Luckhardt thought that a southern origin, perhaps around Freiburg, was also possible.[16] Given the absence of confirming visual evidence, especially for northern Germany at this time, the question of where the *Portrait of a Lady* was painted must remain open.

Notes

1. The heraldic description was provided by Walter Angst.

2. Examination report, 2 April 1987, in NGA curatorial files.

3. Unverified, but mentioned by Helena A. Dillingham, for the estate of Louisine W. Havemeyer, letter to Mary Bullard, 21 April 1930, in NGA curatorial files, and in the American Art Association sale catalogue, 10 April 1930.

4. Mary Bullard, Chester Dale's secretary, letter to John Walker, 29 March 1943, in NGA curatorial files; Dillingham to Bullard, 21 April 1930.

5. Dillingham to Bullard, 21 April 1930.

6. Handwritten annotation in NGA copy of the American Art Association sale catalogue.

7. Bullard to Walker, 29 March 1943; the painting was mentioned in a review of the exhibition by Edward Alden Jewell in the *New York Times*, 22 March 1931, 12x.

8. See the comments in Hand 1980, 38–41.

9. The only three examples of corresponding coats-of-arms are from Saxony, Nuremberg, and Switzerland; see *Johann Siebmachers Wappen-Buch. Faksimilie-Nachdruck der 1701/05 bei Rudolph Johann Helmers in Nürnberg erschienenen Ausgabe* (Munich, 1975), fig. 1, dukes of Saxony, fig. 155, Keypper of Nuremberg, and fig. 208, Frick of Switzerland.

10. Last recorded and reproduced in the sale catalogue, American Art Association, Anderson Galleries, New York, 10 April 1930, no. 55, wood (cradled), 43.2 ×

31.7 (17 × 12½). The painting is given as pendant to the National Gallery's portrait, and the catalogue states that it is dated 1532 and bears an inscription in German. A handwritten annotation in the NGA copy of the catalogue indicates that it was purchased by Böhler and Steinmeyer, New York.

11. Riewerts and Pieper 1955, 68–69, nos. 19–20.

12. Charles Talbot, draft catalogue entry, 1966, in NGA curatorial files, rejected the attribution to Ludger tom Ring the Elder but thought the artist might be Westphalian. The attribution to Ludger tom Ring the Elder and to Münster is rejected by Jochen Luckhardt, letter to the author, 15 August 1989, in NGA curatorial files, and by Paul Pieper, letter to the author, 4 August 1989, in NGA curatorial files; both note that the dialect in the inscription does not correspond to the Low German (Niederdeutsche) spoken in Münster. In addition to Luckhardt and Pieper, Möhring of the Staatsarchiv, Hamburg, identifies the inscription as "Oberdeutsch," letter to the author, 6 July 1989, in NGA curatorial files.

13. Kurt Löcher, letter to the author, 20 August 1979, in NGA curatorial files, and in conversation, 15 September 1988. Lars Olof Larsson, letter to the author, 13 July 1989, in NGA curatorial files, tentatively suggested Jacob Binck (c. 1500–1569), who was active in northern Germany, Denmark, and Sweden. Unfortunately, most of Binck's few surviving paintings were court portraits done in Scandinavia, and he was in Copenhagen by the early 1530s. See Thieme-Becker, 4 (1910): 36–37.

14. Pieper, letter to the author, 4 August 1989, in NGA curatorial files.

15. Luckhardt, letter to the author, 15 August 1989, in NGA curatorial files.

16. In conversation, 20 October 1989.

References

1930 "Havemeyer Sale Brings $296,699 For Parts I and III." *ArtN* 28 (19 April): 4.

1955 Riewerts, Theodor, and Paul Pieper, *Die Maler tom Ring. Ludger der Ältere, Hermann, Ludger der Jüngere.* Munich: 69, no. 20.

1975 NGA: 306, repro. 307.

1980 Hand, John Oliver. "The Portrait of Sir Brian Tuke by Hans Holbein the Younger." *StHist* 9: 39–40, repro. 44.

1985 NGA: 352, repro.

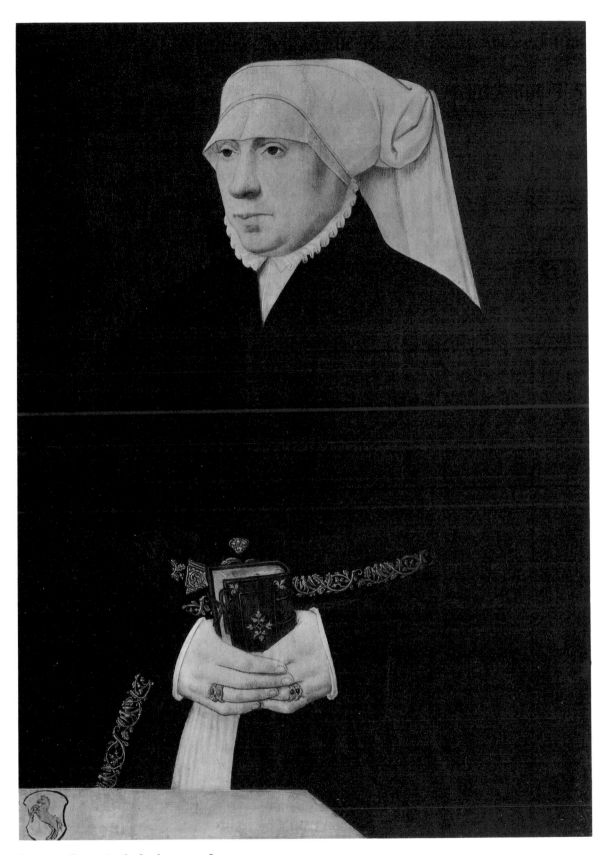

German, *Portrait of a Lady*, 1942.16.3

Matthias Grünewald

c. 1475/1480–1528

IT is generally but not universally agreed that the artist called "Matthaeus Grünewald" or "Matthaeus von Aschaffenburg" in Joachim von Sandrart's *Teutsche Academie der edlen Bau-, Bild- und Mahlerey-Künste* (1675) is the same person referred to in sixteenth-century documents as Mathis Gothart (Gothardt) Neithart (Nithart or Neithardt) or simply as "Meister Mathis." The artist continues to be known, however, by the traditional name of Matthias Grünewald.

Grünewald was probably born in Würzburg around 1475/1480. Nothing is known about his training or early career, although some authors have seen connections with the work of Hans Holbein the Elder. "Meister Mathis" is first documented in 1505 when he was commissioned to paint and inscribe the epitaph of Johann Reitzmann, vicar of the collegiate church of Aschaffenburg. His first dated painting is the *Mocking of Christ* of 1503 (Alte Pinakothek, Munich), which was probably part of an epitaph for Apollonia von Cronberg who died in 1503; the picture was painted shortly thereafter, c. 1504/1506.

In addition to being a painter, Grünewald was also a hydraulic engineer and is first mentioned in this regard in 1510 when he was called to Bingen to repair a fountain. It was around this time, perhaps in 1511, that he entered the service of Uriel von Gemmingen, archbishop of Mainz. The artist worked for the archbishop in Aschaffenburg, where he designed and supervised the construction of a chimneypiece in the castle. Grünewald also executed commissions for the Dominican church in Frankfurt; grisaille representations of saints (now in the Städelsches Kunstinstitut, Frankfurt, and the Staatliche Kunsthalle, Karlsruhe) were seen there by Joachim von Sandrart as part of Albrecht Dürer's Heller altarpiece. It is not clear whether the panels were originally part of Dürer's altarpiece or belonged to a now lost *Transfiguration of Christ*.

The Isenheim altarpiece (Musée d'Unterlinden, Colmar), Grünewald's masterpiece, was commissioned for the high altar of the church of the monastery of Saint Anthony, near Isenheim, in Alsace. Grünewald created three sets of wings to accompany Nicolas Hagenau's altarpiece of c. 1505. The wings are usually dated between c. 1512 and 1516, the death date of Guido Guersi, the Antonite preceptor who commissioned the paintings. The *Crucifixion* on the outermost wings may bear a date of 1515 on the Magdalene's ointment jar. In terms of its emotional power, expressive, often radiant color, and gruesome depictions of suffering, the Isenheim altarpiece is without parallel in northern European art.

No longer intact, the *Miracle of the Snows* altarpiece was commissioned by Canon Heinrich Reitzmann for a chapel of the collegiate church at Aschaffenburg. In 1517, a year after the chapel was consecrated, payment to *magistrum Matheum pinctorem* is recorded. The original frame, still in the church in Aschaffenburg, bears both a date of 1519 and a monogram of *MG* (in ligature) below an N, important evidence for identifying "master Matthew the painter" with Mathis Gothart Neithart. Surviving are depictions of the *Miracle of the Snows* (Augustinermuseum, Freiburg im Breisgau) and the *Madonna and Child* (Pfarrkirche, Stuppach).

Sometime around 1516 Grünewald began working for Cardinal Albrecht von Brandenburg, archbishop of Mainz. In the *Saint Erasmus and Saint Maurice*, completed before 1525 (Alte Pinakothek, Munich), the portrait of Albrecht as Saint Erasmus is based on Dürer's 1519 engraving, the so-called *Little Cardinal*. While in Aachen for the coronation of Charles V, Dürer recorded in his diary that he gave examples of his prints to "Mathes," usually assumed to be Grünewald. Grünewald seems to have remained in service to Cardinal Albrecht until 1526, and it has been sug-

gested that he was dismissed because of his participation in the Peasant Rebellion of 1525. Around this time he moved to Frankfurt, where he stayed in the home of Hans von Saarbrucken, a silk embroiderer.

In 1527 Grünewald moved to Halle, where he worked as a hydraulic engineer for the city. He died in late August of 1528. The inventory of his possessions is a fascinating document, listing what appears to be expensive clothing for court use, artist's materials, pigments in particular, coins and medals, two paintings, copies of Luther's sermons, and a New Testament (the latter described as "Lutheran trash").

Grünewald is one of the greatest German artists of the sixteenth century. Only about twenty-two individual paintings and approximately thirty-seven drawings have been attributed to him. Unlike Dürer and Cranach, he seems not to have had a school or pupils, although his work influenced his contemporaries and was in demand into the late sixteenth century. He was rediscovered, after a long period of obscurity, in the early twentieth century and was particularly admired by the German expressionists.

Bibliography

Zülch, Walter Karl. *Der historische Grünewald. Mathis Gothardt-Neithardt*. Munich, 1938.

Fraundorfer, Paul. "Altes und Neues zur Grünewald-Forschung." *Herbipolis Jubilans* 14/15 (1952/1953): 373–431.

Schädler, Alfred. "Zu den Urkunden über Mathis Gothart Neithart." *Münchner Jahrbuch der bildenden Kunst* 13, III.F. (1962): 69–74.

Sitzmann, Karl, and Eugenio Battisti, "Grünewald, Matthias." *Encyclopedia of World Art*. 16 vols. New York, Toronto, and London, 1959–1983. Vol. 7 (1963): cols. 182–191.

1961.9.19 (1379)

The Small Crucifixion

c. 1511/1520
Linden, 61.3 × 46 (24⅛ × 18⅛)
Samuel H. Kress Collection

Inscription
On placard at top of cross: *I·N·R·I*

Technical Notes: The painting is composed of three vertical boards.[1] As viewed from the recto, the widths of the boards are approximately 11.8 cm., 11.5 cm., and 21.6 cm. wide, from right to left. There is a shallow sawdust fill on the verso along the right-hand join. The left board contains two rectangular inserts that are probably replacements for knotholes. The panel is warped in a continuous convex curve and has suffered worm infestation. On the verso, which has been thinned, a series of shallow saw kerfs form a diamond pattern. Original paint extends to the edges of the support, and earlier reports of an unpainted border approximately 1 cm. wide suggest that the panel edges may have been trimmed.[2] Examination with infrared reflectography did not disclose underdrawing. X-radiography (fig. 1) reveals that the undermodeling in John's robes originally described different folds and contours. The little finger of the Virgin's proper left hand has been shortened, and the right contour of Christ's loincloth has been altered.

Most of the figures are intact despite damage and numerous areas of retouching and abrasion. There are four roughly circular losses in John's robe and a large irregular loss in the sky to the left of Christ's torso. There are small scattered losses throughout and abrasion of the paint surface, particularly in the background landscape.

The painting was restored in 1922 (fig. 2).[3] In 1936 the letters *mg* were revealed at the top of the cross as a result of restoration; these are in all likelihood a composite of an old and a more recent retouching.[4]

Provenance: Wilhelm V, duke of Bavaria [d. 1597], Munich. Maximilian I, duke of Bavaria [d. 1651], Munich.[5] Private collection, western Germany, possibly Westfalia.[6] Dr. Friedrich Schöne, Essen and Stettin (now Szczecin), by 1922; Franz Wilhelm Koenigs [d. 1941], Haarlem, purchased 27 September 1927;[7] heirs of Franz Wilhelm Koenigs; purchased 1953 by the Samuel H. Kress Foundation, New York.

Exhibitions: Berlin, Staatliches Museum, Kupferstichkabinett, December 1928–1929, *Grünewald-Ausstellung*.[8] Düsseldorf, Kunstmuseum, 1929, *Ausstellung alter Malerei aus Privatbesitz*, no. 27. Lent by Franz Koenigs to the Wallraf-Richartz-Museum, Cologne, for

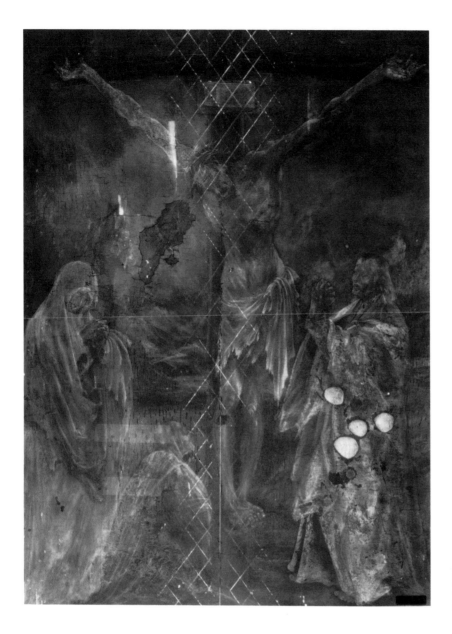

Fig. 1. X-radiograph of
The Small Crucifixion,
1961.9.19

six months in 1935.[9] Lent by Franz Koenigs to the Kaiser-Friedrich-Museum, Berlin, 1936.[10] Rotterdam, Museum Boymans, 1938, *Meesterwerken uit vier Eeuwen 1400–1800*, no. 31. Deposited by Franz Koenigs and heirs with the Rijksmuseum, Amsterdam, from c. 1940–1953, with the exception of 1952, when the painting was lent to the Kunsthistorisches Museum, Vienna.[11]

THE EARLIEST and perhaps most important written source for *The Small Crucifixion* is Sandrart's account, published in 1675. When Sandrart saw the painting around 1640/1650, it was in the col-lection of Maximilian I of Bavaria, but Sandrart noted that it had belonged to Duke Wilhelm V and was engraved in 1605 by Raphael Sadeler. There is no question that the engraving (fig. 3) reproduces the National Gallery's painting, and a portion of the inscription further confirms Wilhelm's possession of it.[12] It is not known where *The Small Crucifixion* was between the time Sandrart saw it and around 1922, but since its rediscovery, there has been unanimous consent that it is a major autograph work by Grünewald.

In the National Gallery's painting, Christ's

death on the cross is witnessed by the Virgin, Saint John the Evangelist, and the Magdalene, who kneels at the foot of the cross. In accordance with the Gospel accounts, especially Luke 23:45, a solar eclipse is depicted and a few stars are visible against the darkness. Set against this inky sky is the ravaged body of the crucified Christ; the emphasis here is on Christ's physical suffering. His body is covered with wounds and blood, and its weight bends down the ends of the crossbar.[13] Hands and feet are contorted into gestures of agony. Grünewald's expressive power is equally evident in the strident harmonies of the Virgin's blue-green robe set against the red and purple of the Magdalene's costume, in the ragged edges of John's voluminous cloak, which echo those of Christ's loincloth, and in the gesture of John's hands clasped together and bent backward at the wrist at a painful angle.

A framework for Grünewald's extraordinary depictions of Christ's Passion is found in several northern European visual and religious traditions. Of particular importance are aspects of German mystical practices from the thirteenth and fourteenth centuries onward, the intense monastic contemplation of the sorrows of Christ, and the devotion to the Five Wounds of Christ. In the fifteenth century the *Imitatio Christi* urged the lay Christian to identify with Christ's life and to experience his suffering personally. Visual antecedents can be found in painting and sculpture of the fourteenth and early fifteenth centuries that present the Crucifixion with gruesome realism.[14] There is also the example of theatrical performances, such as the Frankfurt Passion Play of 1493, cited by Zülch,[15] that graphically describe Christ's physical torment.

Feurstein was probably the first to recognize

Fig. 2. *The Small Crucifixion*, 1961.9.19, under restoration in 1922 [photo: *Städel-Jahrbuch 2*]

Fig. 3. Raphael Sadeler after Matthias Grünewald, *The Small Crucifixion*, 1605, engraving, National Gallery of Art, Washington, Gift of the Samuel H. Kress Foundation, 1974.90.2

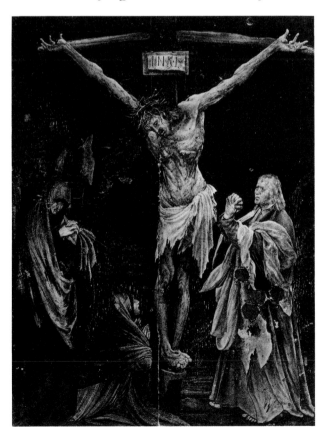

that one of the most important influences on Grünewald was the writings of the fourteenth-century mystic, Saint Bridget of Sweden.[16] In her *Revelations*, available by the early sixteenth century in both Latin and German,[17] the Virgin relates to Bridget an eye-witness account of the Crucifixion. This reads, in part: "Then the color of death came on wherever he could be seen for the blood; his cheeks clung to his jaws, ... his belly, exhausted of all its humors, collapsed on his back. ... Then his whole body quivered, and his beard sank on his breast. ... His mouth being open, as he had expired, his tongue, teeth, and the blood in his mouth could be seen by those looking on ...; and his body, now dead, hung heavily, the knees inclining to one side, the feet to the other, on the nails as on hinges."[18] Although not corresponding in every detail, the National Gallery's painting as well as others by Grünewald were clearly influenced by Bridget's description of the horrors of Christ's death.

The title, *The Small Crucifixion*, first appearing in Sandrart, has continued to be used primarily to distinguish this painting from the larger representation of the same theme in the Isenheim altarpiece. Given the relatively modest size of the Washington panel, it is likely that it functioned as a private devotional image, either in a domestic or an intimate ecclesiastical setting, such as a side chapel. There is no confirming evidence for the suggestion first made by Feurstein that *The Small Crucifixion* belonged successively to Caspar Schantz, Heinrich Reitzmann, and Georg Schantz, canons of the collegiate church in Aschaffenburg, and was mentioned in the 1528 inventory of Reitzmann's possessions.[19]

The area of greatest disagreement concerns the date of the *Small Crucifixion*, for the painting has been placed in every phase of Grünewald's career, from early to late. At first glance this is somewhat surprising since Grünewald's other depictions of the same theme would seem to provide a framework for comparison. The *Crucifixion* in the Kunstmuseum, Basel, is dated early, c. 1505/1506,[20] as is a drawing in the Staatliche Kunsthalle, Karlsruhe.[21] The *Crucifixion* on the outer wings of the Isenheim altarpiece in Colmar (fig. 4) is dated between c. 1512 and 1516,[22] while a

Crucifixion panel at Karlsruhe (fig. 5) is generally assigned a late date, c. 1520/1524.[23]

The various dates proposed for *The Small Crucifixion* may be clustered in certain groups. Weixlgärtner, Lüdecke, and Saran believe that the panel records a solar eclipse that took place on 1 October 1502 and must have been painted very shortly thereafter.[24] Stylistic comparison with Grünewald's *Mocking of Christ*, dated 1503 (Alte Pinakothek, Munich),[25] however, quickly eliminates this proposal from serious consideration. Following the lead of Friedländer, a second group places the National Gallery's painting between the Basel and Colmar *Crucifixions*.[26] Panofsky saw the influence of Grünewald, and *The Small Crucifixion* in particular, on Dürer's engraved *Crucifixion* of 1508, thus implying an early date for the Washington panel.[27] Anzelewsky, however, reversed the direction of influence.[28] Zülch's dating of c. 1511 places *The Small Crucifixion* just before the Isenheim altarpiece and is accepted by numerous authors, including Vogt, Lanckorońska, Lauts, Behling, and Müller.[29] National Gallery catalogues have dated the painting c. 1510.[30] A final group of critics favor a relatively late date, around or a little before the Karlsruhe *Crucifixion* panel; Feurstein, Burkhard, Ruhmer, and Rieckenberg date *The Small Crucifixion* c. 1519, the date of the *Miracle of the Snows* altarpiece (Augustinermuseum, Freiburg im Breisgau), while Eisler suggests that it could be placed well into the 1520s.[31]

An examination of the Basel, Colmar, and Karlsruhe *Crucifixion*s in chronological sequence reveals a movement toward greater simplification and monumentality coupled with increased emphasis on corporeal physicality and textural palpability.[32] In the Basel *Crucifixion* the figure of Christ is frontally and symmetrically displayed; the horizontal bar of the cross is straight. The foreground is densely filled by the Three Marys, John the Evangelist, and the centurion. In the Karlsruhe *Crucifixion* the number of figures has been reduced to three and there is ample space around them. Even making allowances for the greatly increased size of the Karlsruhe panel, the figures are thicker and stockier in their proportions. We are made conscious of the physical

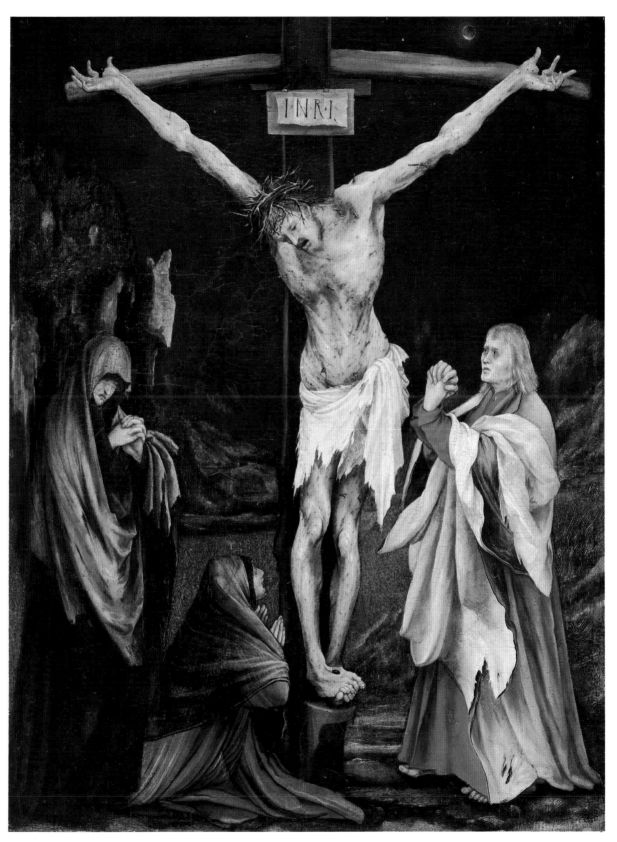

Matthias Grünewald, *The Small Crucifixion*, 1961.9.19

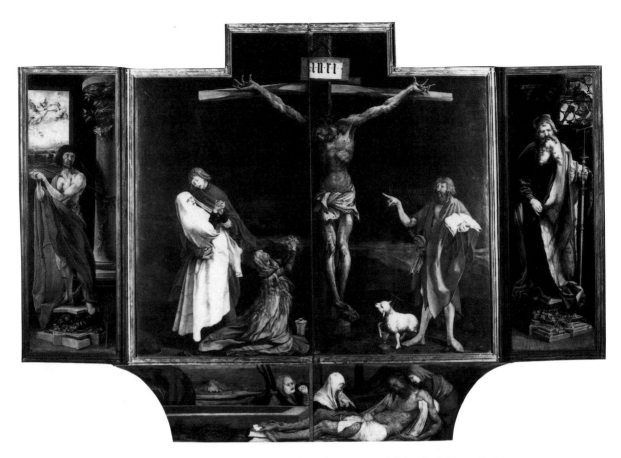

Fig. 4. Matthias Grünewald, *The Crucifixion*, panel, Musée d'Unterlinden, Colmar [photo: Musée d'Unterlinden, O. Zimmerman]

presence of Christ's body, whose weight bends down the ends of the cross. In relation to the vertical member of the cross, the body is off center; the *suppedaneum* under Christ's feet is seen at an angle, the torso is twisted toward the left while the feet, bent around the nail "as on hinges," point in an agonized gesture toward the right. Between the Basel and Karlsruhe panels is the Isenheim *Crucifixion* in Colmar. Here the torso of Christ is more symmetrical and frontal and the horizontal crossbar of the cross less bent than in the Karlsruhe picture. In the Isenheim *Crucifixion* the gestures and emotions of the Virgin, John the Evangelist, and the Magdalene are more externalized and histrionic, although in this and other instances the differences may reflect the specific function and requirements of the Isenheim commission.

The Small Crucifixion, then, seems to be least like the Basel *Crucifixion* and cannot be dated as early as c. 1505. The relationship of the Washing-

ton panel to the Colmar and Karlsruhe *Crucifixions* is not as easily defined, in part because of the differences in scale and function. On the one hand, the somatic type of Christ in the Washington picture is like that of the Isenheim Christ, although the musculature is less clearly defined. On the other hand, there are elements that ally themselves more with the Karlsruhe panel: greater torsion in the hips and torso of Christ, greater emphasis on the ragged edges of Christ's loincloth and John's robes, and a greater emphasis on texture and volume in John's robes. Other indications that *The Small Crucifixion* is closer to the Karlsruhe *Crucifixion* are the similar rendering of long, curving drapery folds in the costume of the Magdalene and in that of the Karlsruhe Virgin and the somewhat more self-contained emotional states of the onlookers in the Washington and Karlsruhe panels as compared to those in the Basel and Colmar *Crucifixion*s.

Ruhmer perceives stylistic similarities be-

tween *The Small Crucifixion* and the *Miracle of the Snows* of 1519.[33] The facial types of Mary and John are echoed in the two kneeling figures at the left in the Freiburg panel, and the broad areas of the red robes worn by Pope Liberius and his attendants are akin in handling to John's cloak and robes.

The foregoing comparisons suggest that while *The Small Crucifixion* may date slightly before the Isenheim altarpiece, the Washington painting is more likely to be contemporary with or later than it, and shows somewhat greater stylistic affinities with the *Miracle of the Snows* and the Karlsruhe *Crucifixion*. I would suggest a date for it between 1511 and 1520.

The image of *The Small Crucifixion*, transmitted through Sadeler's 1605 engraving, had a potent life of its own. An accurate copy, possibly from the late sixteenth century (Kunstsammlungen des Klosters, Einsiedeln), is virtually the same size as the National Gallery's painting.[34] At least ten other copies are known, all based on the engraving and dating from the seventeenth century.[35] What has been called the "Grünewald-Renaissance" parallels the "Dürer-Renaissance" at the turn of the century and in this instance may also testify to the needs of the Counter Reformation for emotionally gripping depictions of Christ's death.[36]

Notes

1. The wood was identified as linden by Peter Klein, examination report, 29 September 1987, in NGA curatorial files.

2. Schoenberger 1922, 36, and Zülch 1938 (see Bi-

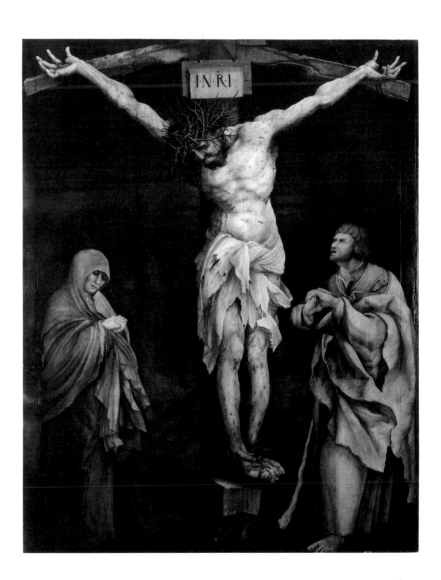

Fig. 5. Matthias Grünewald, *The Crucifixion*, panel, Staatliche Kunsthalle, Karlsruhe [photo: Staatliche Kunsthalle, Karlsruhe]

ography), 325, mention unpainted edges; Schoenberger states that a chalk ground extended over the unpainted edges.

3. Schoenberger 1922, 35–36, describes the painting's condition.

4. According to Zülch 1938 (see Biography), 325, the painting was treated twice before it was restored by Otto Klein in 1936. See also the memorandum recording a conversation between William P. Campbell and Otto Klein, 8 May 1970, in NGA curatorial files; and Saran and Schmeidler 1974, 212–213, based on an interview with Klein in 1965.

The letters *mg* were accepted as autograph by Zülch 1938 (see Biography), 325, and many subsequent authors. Kress 1956, 100, suggested that the letters were from the seventeenth century and stood for "Mathis Grünewald." I am grateful to Laetitia Yeandle, curator of manuscripts, Folger Shakespeare Library, for her paleographic observations.

5. Sandrart 1675, 236; Peltzer 1925, 82: "Ferner haben ihre Fürstl. Durchl. Herzog Wilhelm in Bayern hochseligsten Andenkens als vernünftiger Urtheiler und Liebhaber der edlen Kunst ein klein Crucifix mit unser Lieben Frauen und S. Johann samt einer niederknienden und andächtig betenden Maria Magdalena so fleissig gemahlt von dieser Hand gehabt, auch sehr geliebt, ohne dass sie gewust, von wem es sey. Selbiges ist wegen des verwunderlichen Christus am Creutz, so ganz abhenkend auf den Füssen ruhet, sehr seltsam, dass es das wahre Leben nicht anderst thun könte, und gewiss über alle Crucifix natürlich wahr und eigentlich ist, wann ihm mit vernünftiger Gedult lang nachgesonnen wird, solches ist deswegen halb-Bogen gross auf gnädigen Befehl hochgedachten Herzogs Anno 1605 von Raphael Sadler in Kupfer gestochen worden, und erfreute ich hernachmalen Ihre Churfürstl. Durchl. Maximilian seligster Gedächtnis höchlich, da ich des Meisters Namen geoffenbaret."

6. Friedländer 1922, 60; Scharf 1929, 370.

7. Mrs. Christie van der Waals, daughter of Franz Koenigs, statement, in NGA curatorial files.

8. Scharf 1929, 370; see also "Eine Grünewald-Ausstellung in Berlin," *Der Cicerone* 20 (1928), 716.

9. *Pantheon* 16 (1935), 380.

10. Troche 1936, 306.

11. Van der Waals, statement, in NGA curatorial files; Ernst Buschbeck, director of the Kunsthistorisches Museum, Vienna, letter to John Walker, 8 November 1952.

12. F. W. H. Hollstein, *Dutch and Flemish Etchings, Engravings, and Woodcuts ca. 1450–1700.* 32 vols. (Amsterdam 1949–1988), 21: 220, no. 32. The inscription reads in part: SERENISSIMO PRINCIPI GVILIELMO COMITI PALATINO, RHENI, VTRIVSQVE BAVARIAE DVCI. As noted by Eisler 1977, 21 n. 9, the engraving also carries papal privilege.

13. Zülch 1938 (see Biography), 124, compares the bent crossbar to a bow and the body of Christ to an arrow about to be shot heavenward. The imagery was used by Joris-Karl Huysmans in *Là-bas* (Paris, 1891) to describe Grünewald's *Crucifixion* in Karlsruhe; English translation of Huysmans in Ruhmer 1958, 7. Compare also Osten and Vey 1969, 93.

14. Otto Benesch, *The Art of the Renaissance in Northern Europe* (Cambridge, Mass., 1945), 26–28; Müller 1984, 20–27, reproduces in his fig. 10 a carved crucifix dated 1304 (Sankt Maria im Kapitol, Cologne) as a visual and emotional antecedent. For devotion to the wounds of Christ see John Oliver Hand, "The Portrait of Sir Brian Tuke by Hans Holbein the Younger," *StHist* 9 (1980), 41–47. The exact relationship between mysticism and art is often difficult to explain, but see Ernst Benz, "Christliche Mystik und christliche Kunst," *Deutsche Vierteljahrsschrift für Literaturwissenschaft und Geistesgeschichte* 12 (1934), 22–48; J. Sauer, "Mystik und Kunst unter besonderer Berücksichtigung des Oberrheins," *Kunstwissenschaftliches Jahrbuch der Görresgesellschaft* 1 (1928), 3–28.

15. Zülch 1938 (see Biography), 128.

16. Feurstein 1924, especially 140–161. For Bridget see Thurston and Attwater, 4: 54–59.

17. The *Revelationes* were first printed in Lübeck in 1492, as noted by Weixlgärtner 1962, 30. A Latin edition was published in Nuremberg by Anton Koberger in 1500, and a German edition appeared in 1502.

18. *Revelations of St. Bridget, on the Life and Passion of Our Lord, and the Life of His Blessed Mother* (New York, 1862), 67; see also Benesch 1945, 30.

19. Feurstein 1930, 116–117, citing the research of Josef Hohbach, who believed that the National Gallery's painting was probably identical with the "tefflin mit einem crucifix" in the estate of Heinrich Reitzmann (d. 1527) and, further, that the panel was probably bequeathed to Reitzmann by Caspar Schantz and in turn passed from Reitzmann to Caspar's brother Georg. Zülch 1938 (see Biography), 325, and 420 n. 39, cautiously mentions Feurstein's and Hohbach's proposal and then notes that Caspar Schantz died in 1525 and that Georg died between 1528 and 1531.

This provenance, accepted by many subsequent authors, is unverified. I have been unable to locate any publications by Joseph Hohbach concerning this material. However, the information is provided in Paul Fraundorfer, "Quellen zur Begründung der Maria-Schnee-Verehrung in Aschaffenburg," *Aschaffenburger Jahrbuch für Geschichte Landeskunde und Kunst des Untermaingebietes* 7 (1981), 119–221. In the inventory of Reitzmann's goods, 22 April 1528, appears "item 1 tefflin mit einem crucifix" (Fraundorfer 1981, 210); in Reitzmann's will, 5 August 1527, appears a provision that the goods inherited from Caspar Schantz are bequeathed to his brother Georg (Fraundorfer 1981, 179). There is nothing to connect the Crucifixion panel of the Reitzmann inventory with Grünewald or the National Gallery's painting, and nothing to connect it with either member of the Schantz family.

Equally unsubstantiated is the proposal in Troescher 1973, 85, that the painting came to Duke Wilhelm V from the dukes of Lorraine (Lotharingia) and was originally in the Order of Saint Anthony in France, or the assertion in Rieckenberg 1976, 10, that it was painted for Cardinal Albrecht of Brandenburg.

20. Zülch 1938 (see Biography), 106–114, 324, no. 6; Ruhmer 1958, 117, no. 3.

21. Ruhmer 1970, 79, no. 1, pls. 1–2. Kress 1956, 100, associated the drawing with the National Gallery's painting on the basis of Christ's right thumb being bent against the palm, a detail visible in the x-radiograph of the painting. See also Borries 1974.

22. Not all authors accept the markings on the Magdalene's ointment jar as containing a date of 1515; see Christian Heck, *Grünewald et le retable d'Issenheim* (Colmar, 1982), 19.

23. Müller 1984, 31; Ruhmer 1958, 126–127, no. 9. Ewald M. Vetter, "Matthias Grünewalds Tauberbischofsheimer Kreuztragung. Rekonstrukion und Deutung," *Pantheon* 43 (1985), 45, 48, fig. 10; Vetter sees the artist's first name and 1524 on the *Christ Carrying the Cross*, the now separated verso of the *Crucifixion*. My examination of the picture did not confirm this date.

24. Weixlgärtner 1949, 28–29; Weixlgärtner 1962, 30; Lüdecke 1971, 25; Geissler and Saran 1973, 218–219; Saran and Schmeidler 1974, 213–220.

25. Ruhmer 1958, 115, no. 1, pls. 1–3. As noted in the Biography, 1503 is probably the death date of the donor; the picture was painted shortly thereafter.

26. Friedländer 1922, 61; Schoenberger 1922, 42; Hagen 1923, 80, 235; Kress 1956, 98; Seymour (Kress) 1961, 211; Benesch 1966, 84; Sterling 1974, 130.

27. Panofsky 1943, 1:146.

28. Anzelewsky 1955, 294.

29. Zülch 1938 (see Biography), 324, no. 9; Vogt 1957, 158, no. 7; Lanckorońska 1963, 66; Lauts 1968, unpaginated; Behling 1969, 31; Müller 1984, 31.

30. NGA 1975, 166; NGA 1985, 192.

31. Feurstein 1930, 118; Knapp 1935, 39; Burkhard 1936, 50; Ruhmer 1958, 120–121; Ruhmer 1970, 93; Rieckenberg 1976, 10; Eisler 1977, 21. Christian Heck, former curator of the Musée d'Unterlinden, Colmar, in conversation with Martha Wolff, inclined toward a date c. 1519/1520 (memorandum, 26 August 1981, in NGA curatorial files). Schmid 1909, 413, and Schmid 1911, 226–228, placed the painting c. 1512/1517, between the Colmar and Karlsruhe *Crucifixions*; Josten 1913, 68, proposed a date of c. 1519; at this time only the engraving and the later copies were known.

32. I am grateful to Paul Boerlin in Basel, Christian Heck in Colmar, and Dietmar Lüdke and Babette Hartwieg in Karlsruhe for facilitating my examination of the paintings in their care.

33. Ruhmer 1958, 121, pls. 67–69 (Freiburg painting); Eisler 1977, 21, also observes similarities with the *Madonna and Child* (Pfarrkirche, Stuppach), which presumably was part of the *Miracle of the Snows* altarpiece. The altarpiece was commissioned by Heinrich Reitzmann for the chapel of the brothers Caspar and Georg Schantz in the collegiate church of Aschaffenburg, a fact that undoubtedly influenced several authors to accept the same origin for the National Gallery's panel; see note 19.

34. Linden, 61.5 × 46 cm. See Meyenberg 1933, 104–107; Goldberg 1980, 161 n. 139; Grimm and Konrad 1990, 252. I am extremely grateful to Bernd Konrad for bringing this painting to my attention and for a photograph of it; letter to the author, 11 June 1988, in NGA curatorial files.

35. These copies include:
1. Formerly Dr. von Pauer, Munich; wood, 62.5 × 47 cm.; Schoenberger 1922, pl. 14b.
2. Formerly Baron von Cramer-Klett, Hohenaschau; probably identical with the painting sold at Adolph Weinmüller, Munich, 15–16 April 1953, no. 771; wood, 70 × 52 cm.; Schoenberger 1922, pl. 14a.
3. Fürstenberg Sammlungen, Donaueschingen; wood, 33.5 × 22 cm.; Schoenberger 1922, fig. 13; Grimm and Konrad 1990, 252, no. 73, repro. 253.
4. Bodemuseum, Berlin, no. 1694; copper, 20 × 15 cm.; photograph in NGA curatorial files.
5. Kunstmuseum, Basel, no. 1480; wood, 29 × 20.7 cm.; Schoenberger 1922, pl. 14c; photograph in NGA curatorial files. The figure of the Magdalene is missing.
6. Wetterau-Museum, Friedberg; wood, 97 × 71 cm., including frame; Schoenberger 1922, 35, no. 8; color transparency in NGA curatorial files.
7. Kunstsammlung Lorenzkapelle, Rottweil, wood, 94.5 × 70 cm.; Schoenberger 1922, pl. 14d; photograph in NGA curatorial files. Only the figure of Christ is taken from Grünewald.
8. Historisches Museum, Basel, no. 1870.950; wood, low-relief sculpture, 59 × 29 cm.; Schoenberger 1922, fig. 14; photograph in NGA curatorial files.
9. Kupferstichkabinett, Berlin, no. 7934; pen, brown ink, and wash on paper, 27.9 × 20.9 cm.; Schoenberger 1922, fig. 15; photograph in NGA curatorial files.
10. Formerly Schlesisches Museum, Breslau (Wrocław), no. 1341; copper, 61 × 41 cm.; see Mariusz Hermansdorfer, director, Muzeum Narodowe, Wrocław, letter, 3 June 1987, in NGA curatorial files; Zülch 1938 (see Biography), 325, partial copy.
11. Private collection or museum, Walldürn? Unverified, see Knapp 1935, 39.

36. For Grünewald's influence see Ruhmer 1974 and Hausenberg 1927, especially 15–46. Virch 1958, 224, cites Sadeler's engraving as an influence on Hendrick Terbrugghen's *Crucifixion* (Metropolitan Museum of Art, New York). Compare also Gisela Goldberg, "Dürer-Renaissance am Münchner Hof," in *Um Glauben und Reich. Kurfürst Maximilian I. Wittelsbach*

und Bayern [exh. cat., Residenz] (Munich, 1980), vol. 2, pt. 1, 318–322.

References

1675 Sandrart, Joachim von. *Teutsche Academie der edlen Bau-, Bild-, und Mahlerey-Künste* (Der Teutschen Academie. Zwenter theil/von der alt/ und neu-beröhmten egyptischen/griechischen/römischen/italiänischen/hoch- und niederteutschen Bau-, Bild-, und Mahlerey Künstlere Lob und Leben). Nuremberg: 236.

1884 Niedermayer, Friedrich. "Mathias Grünewald." *RfK* 7: 249–251.

1894 Reber, Franz von. *Geschichte der Malerei vom Anfang des 14. bis zum Ende des 18. Jahrhunderts.* Munich: 247.

1909 Schmid, Heinrich Alfred. "Die Chronologie der Werke Grünewalds." *RfK* 32: 413.

1911 Schmid, Heinrich Alfred. *Die Gemälde und Zeichnungen von Matthias Grünewald.* Strasbourg: 226–228.

1913 Josten, H. H. *Matthias Grünewald.* Bielefeld and Leipzig: 66–68.

1920 Mayer, August L. *Matthias Grünewald.* Munich: 42–43, 82, no. 20.

1922 Friedländer, Max J. "Grünewalds einst beim Bayernherzog bewahrte Kreuzigung." *JbBerlin* 43: 60–62, repro.

1922 Schmid, Heinrich Alfred. "Grünewald, Matthias." Thieme-Becker. 15: 137.

1922 Schoenberger, Guido. "Matthias Grünewalds 'Klein Crucifix.'" *Städel-Jahrbuch* 2: 33–52, repro., pls. 9–13.

1923 Hagen, Oskar. *Matthias Grünewald.* Munich: 80–81, 89–91, 234–235, no. 2a, figs. 20a–c.

1924 Feurstein, Heinrich. "Zur Deutung des Bildgehaltes bei Grünewald." *Oberdeutsche Kunst der Spätgotik und Reformationszeit.* Edited by Ernst Buchner and Karl Feuchtmayr. Augsburg: 144 n. 3.

1925 Peltzer, Alfred R. *Joachim von Sandrarts Academie der Bau-, Bild-, und Mahlerey-Künste von 1675.* Munich: 82, 389 n. 261.

1927 Hausenberg, Margarethe. *Matthias Grünewald im Wandel der deutschen Kunstanschauung.* Leipzig: 19, 39–44.

1929 Scharf, Alfred. "Alte Malerei aus Rheinisch-Westfälischem Privatbesitz. Die Jubiläumsausstellung des Kunstvereins für die Rheinlande und Westfalen in Düsseldorf." *Der Cicerone* 21: 370, repro.

1930 Feurstein, Heinrich. *Matthias Grünewald.* Bonn: 73, 114–118, fig. 45.

1932 Feulner, Adolf. "Ein Zinnkruzifix nach Grünewald." *Städel-Jahrbuch* 7–8: 172.

1933 Meyenberg, Clemens. "Ein echter 'Grünewald'?" *St. Meinrads Raben* 22: 104–107.

1935 Deusch, Werner R. *Deutsche Malerei des sechzehnten Jahrhunderts.* Berlin: 26, pl. 38. English ed., New York, 1973: 28, pl. 38.

1935 Knapp, Fritz. *Grünewald.* Bielefeld and Leipzig: 39, 46, no. ix, repro. 41.

1935 "Köln, Wallraf-Richartz-Museum." *Pantheon* 16: 380.

1936 Burkhard, Arthur. *Matthias Grünewald: Personality and Accomplishment.* Cambridge, Mass.: 10–11, 49–52, pl. 50.

1936 Fraenger, Wilhelm. *Matthias Grünewald in seinen Werken.* Berlin: 12, repro. 11.

1936 Troche, E. G. "Deutsche Zeichnungen aus der Sammlung Koenigs-Haarlem." *Pantheon* 18: 306.

1938 Zülch (see Biography): 123–131, 324–326, no. 9, figs. 63–67a.

1939 Hürlimann, Martin, and Werner R. Deusch, *Grünewald. Das Werk des Meisters Mathis Gothardt Neithardt.* Berlin and Zurich: n.p., no. 49, repro.

1943 Panofsky. 1: 146; 2: fig. 197.

1948 Schoenberger, Guido. *The Drawings of Mathis Gothart Nithart called Gruenewald.* New York: 25–26, under no. 2; 45, under A4, fig. A6.

1949 Weixlgärtner, Arpad. *Dürer und Grünewald. Ein Versuch, die beiden Künstler zusammen—in ihren Besonderheiten, ihrem Gegenspiel, ihrer Zeitgebundenheit—zu Verstehen.* Göteborg: 28–29, 38–39, 42, 52–53, 58–59, 62–63, 72, 90–91, 152.

1949 Zülch, Walter Karl. *Grünewald. Mathis Gothardt-Neithardt.* Munich: 21–22, 61, no. 6, figs. 22–23.

1953 "Das Klein-Kruzifix des Bayern-Herzogs." *Die Weltkunst* 23 (15 January): 4, repro.

1954 Tietze, Hans. *Treasures of the Great National Galleries.* New York: 117–118, 123, pl. 200.

1955 Anzelewsky, Fedja. "Albrecht Dürer und Mathis Gothardt Nithardt." *Edwin Redslob zum 70. Geburtstag.* Berlin: 294.

1955 Dittmann, Lorenz. *Die Farbe bei Grünewald.* Munich: 120.

1955 "Famous Venetian, French and German Paintings for America: Acquisitions for the Washington, D.C., National Gallery." *The Illustrated London News* 227 (16 July): 115, repro.

1956 Frankfurter, Alfred. "Crystal Anniversary in the Capital." *ArtN* 55: 35, repro. 26, 27.

1956 Kress: 98–103, no. 36, repros.

1956 "New Kress Gift at Washington." *The Studio* 151: 80, repro.

1956 Shapley, Fern Rusk. *National Gallery of Art, Portfolio Number 5: Masterpieces from the Samuel H. Kress Collection.* Washington: no. 6, repro.

1956 Walker: 9, repro.

1957 Vogt, Adolf Max. *Grünewald. Mathis Gothart Nithart, Meister gegenklassischer Malerei.* Zurich and Stuttgart: 43–45, 158–159, no. 7, fig. 14.

1958 Pevsner, Nikolaus, and Michael Meier. *Grünewald.* New York: 36, no. 59, repro.

1958 Ruhmer, Eberhard. *Grünewald: The Paintings.* London: 120–121, pls. 60–61.

1958 Virch, Claus. "The Crucifixion by Hendrick

Terbrugghen." *BMMA* 16: 224.

1959 "Grünewald." *Sele Arte* 43: 11.

1959 Kress: 304, repro.

1960 Broadley: 42, repro. on cover.

1961 Seymour (Kress): 83, 85, 211, pls. 75–77.

1962 Cairns and Walker: 68, repro. 69.

1962 Weixlgärtner, Arpad. *Grünewald.* Vienna and Munich: 14, 21, 28–30, pl. 2.

1963 Lanckorońska, Maria. *Matthäus Gotthart Neithart. Sinngehalt und Historischer Untergrund der Gemälde.* Darmstadt: 65–69, fig. 38.

1963 Sitzmann, Karl. "Grünewald, Matthias." *Encyclopedia of World Art.* 16 vols. New York, Toronto, and London, 1959–1983, 7: col. 183.

1963 Walker: 114, repro. 115.

1965 Winzinger, Franz. "Grünewald Mathis Gotthart mit Beinamen Neithart oder Nithart, genannt." *Kindlers.* 2: 790, 802, no. 18, repro. 800.

1966 Benesch, Otto. *German Painting: From Dürer to Holbein.* Geneva: 84, 86.

1966 Cairns and Walker: 108, repro. 109.

1968 Cuttler. *Northern Painting.* 361–362, fig. 470.

1968 Lauts, Jan. *Grünewald. Kreuztragung und Kreuzigung.* Karlsruhe: unpaginated, pl. 13.

1969 Behling, Lottlisa. *Matthias Grünewald.* Königstein im Taunus: 9–10, repro. 31.

1969 Osten, Gert von der, and Horst Vey. *Painting and Sculpture in Germany and the Netherlands 1500 to 1600.* Harmondsworth: 94.

1970 Ruhmer, Eberhard. *Grünewald Drawings.* London: 12, 93, under no. 29.

1971 Lüdecke, Heinz. *Grünewald.* Dresden: 5–6, 25, pl. 2.

1973 Geissler, Heinrich, Bernhard Saran, et al. *Mathis Gothart Nithart. Grünewald. Der Isenheimer Altar.* Stuttgart: 23, 218–219.

1973 Troescher, Georg. "Die Entstehung des Hochaltars der Antoniter-Praeceptorei zu Isenheim." *Giessener Beiträge zur Kunstgeschichte* 2: 84–89, fig. 19.

1974 Blum, Henri. "Le Problème des signatures de Grünewald." *Grünewald et son oeuvre.* Actes de la table ronde organisée par le Centre national de la recherche scientifique à Strasbourg et Colmar du 18 au 21 octobre: 97 n. 11, 99–100, repro. 101, fig. 11.

1974 Borries, Johann Eckart von. "Bemerkungen zu der Karlsruher Grünewald-Zeichnung." *Grünewald et son oeuvre.* Actes de la table ronde organisée par le Centre national de la recherche scientifique à Strasbourg et Colmar du 18 au 21 octobre: 192–194, fig. 4.

1974 Ruhmer, Eberhard. "Grünewalds Ausstrahlung im 16. und 17. Jahrhundert." *Grünewald et son oeuvre.* Actes de la table ronde organisée par le Centre national de la recherche scientifique à Strasbourg et Colmar du 18 au 21 octobre: 182–184.

1974 Saran, Bernhard, and Felix Schmeidler, "Grünewalds 'Klein-Kruzifix' und die Sonnenfinsternis vom 1. Oktober 1502." *Maltechnik* 80: 210–220, repro.

1974 Sterling, Charles. "Grünewald vers 1500–1505." *Grünewald et son oeuvre.* Actes de la table ronde organisée par le Centre national de la recherche scientifique à Strasbourg et Colmar du 18 au 21 octobre: 130, 142, 144.

1975 Cinotti, Mia, ed. *The National Gallery of Art of Washington and Its Paintings.* Edinburgh: unpaginated, no. 93, repro.

1975 NGA: 166, repro. 167.

1976 Bodino, Maristella, and Franco De Poli. *Grünewald.* Milan: 34, repro., 92–93, repro.

1976 *Grünewald, with an Essay by J.-K. Huysmans.* Oxford and New York: 14, pl. 7.

1976 Rieckenberg, Hans Jürgen. *Matthias Grünewald.* Herrsching: 10, 76, no. 9, pl. 12.

1976 Walker: 144, no. 152, repro. 145.

1977 Eisler: 19–23, figs. 20, 21.

1977 Vetter, Ewald M. "Wer war Matthias Grünewald?" *Pantheon* 35: 189.

1979 Watson, Ross. *National Gallery of Art, Washington.* New York: 54, pl. 37.

1980 Diemer, Peter. "Wilhelm V. als Mäzen." *Um Glauben und Reich. Kurfürst Maximilian I. Wittelsbach und Bayern.* Exh. cat., Residenz. Munich: vol. 2, pt. 2, p. 76, under no. 112.

1980 Goldberg, Gisela. "Zur Ausprägung der Dürer-Renaissance in München." *München Jahrbuch der bildenden Kunst* 31: 140, 160–161 n. 139.

1981 Winzinger, Franz. "Zu Dürers Kaiserbildnissen." *Pantheon* 39: 206–207, fig. 6.

1983 Wolff: unpaginated, repro.

1984 Müller, Christian. *Grünewalds Werke in Karlsruhe.* Karlsruhe: 31, repro. 33.

1984 Walker, John. *National Gallery of Art, Washington.* Rev. ed. New York: 144, repro. 145.

1985 NGA: 192, repro.

1990 Grimm, Claus, and Bernd Konrad. *Die Fürstenberg Sammlungen Donaueschingen. Altdeutsche und schweizerische Malerei des 15. und 16. Jahrhunderts.* Munich: 252.

Hans Holbein the Younger

1497/1498–1543

HANS HOLBEIN THE YOUNGER WAS born in Augsburg into a family of artists. His father, Hans Holbein the Elder (c. 1465–1524), was an artist, as was his uncle, Sigismund Holbein (active 1501–died 1540), and his older brother Ambrosius (probably 1494–1519?). The date of Hans Holbein the Younger's birth is not documented but can be deduced from a silverpoint drawing of Hans and Ambrosius by their father (Kupferstichkabinett, Berlin), which is dated 1511 and gives Hans' age as fourteen and his brother's as seventeen. There is also a miniature portrait dated 1543 (Wallace collection, London), which gives the artist's age as forty-five. It is most likely that Hans was first trained by his father.

It is not known exactly when Holbein left Augsburg, but he was in Basel in 1515 and was joined there by Ambrosius, who had been working in Stein-am-Rhein. One of Holbein's earliest commissions was the marginal pen illustrations to an edition of *The Praise of Folly* by Erasmus, published in Basel in 1515 (Kunstmuseum, Kupferstichkabinett, Basel). The book belonged to the humanist schoolmaster Oswald Geisshüsler, known as Myconius or Molitor, for whom Hans and Ambrosius each painted one side of a signboard, dated 1516, advertising Geisshüsler's profession (Kunstmuseum, Basel). The side depicting *A Schoolmaster Teaching Two Adults to Write* is attributed to Hans. In the same year he painted a double portrait of the burgomaster of Basel, Jacob Meyer, and his wife (Kunstmuseum, Basel), which was influenced by the design of a woodcut portrait by Hans Burgkmair.

For much of the time between 1517 and 1519 Holbein worked in Lucerne, where his father had settled in 1517. Whether or not he journeyed to Italy is unknown, but he was back in Basel sometime after May 1519, and on 25 September became a master in the painters' guild. He married Elsbeth Binzenstock, the widow of Ulrich Schmidt, a tanner, and became a citizen of Basel on 3 July. His success was virtually immediate, and he received both municipal and private commissions. Two of the most important works from this period are the *Enthroned Madonna and Child with Saints Nicholas and George*, dated 1522 and done for Hans Gerster, the town clerk (Museum der Stadt, Solothurn), and the powerfully realistic and immediate *Dead Christ in the Tomb*, dated 1521, although a date of 1522 is visible in the x-radiograph (Kunstmuseum, Basel). The renowned humanist Erasmus of Rotterdam returned to Basel in November 1521 and was portrayed by Holbein several times; the version in the collection of the earl of Radnor, Longford Castle, Wiltshire, is dated 1523, and the equally fine portrait in the Musée du Louvre, Paris, was painted around the same time.

In 1524 Holbein journeyed to France. His exact itinerary is unknown, but he may have visited Lyons or possibly the courts of Francis I at Amboise and Fontainebleau. His presence in Bourges is indicated by his drawings of the tomb sculptures of Jean, duc de Berry, and his wife, which were in the ducal palace. As a result of this trip the influence of Jean Clouet's portrait drawings and of French and Italian art becomes evident in Holbein's work. Probably in 1526 Holbein began his last and perhaps greatest altarpiece, the *Madonna and Child with Jacob Meyer and His Family* (Schlossmuseum, Darmstadt).

As the Reformation gained an increasing foothold in Basel, it became more difficult for artists to earn a living. In late August 1526 Holbein left Basel for Antwerp, furnished by Erasmus with a letter of introduction to Pieter Gillis, the town clerk. He did not stay long in Antwerp, for in a letter of 18 December 1526 Sir Thomas More informed Erasmus that the artist was in England. Here Holbein worked primarily as a portraitist, often depicting intellectuals and humanists from

the circle of Sir Thomas More. Unfortunately the major work of this period, the *Family of. Sir Thomas More*, was destroyed and is known only through a drawing by Holbein (Kunstmuseum, Kupferstichkabinett, Basel) and later copies.

Holbein returned to Basel in the summer of 1528 and purchased a house on 29 August. He completed a mural for the council chamber of the town hall and revised the *Madonna and Child with Jacob Meyer and His Family* begun earlier. He also painted a portrait of his wife and two eldest children (Kunstmuseum, Basel), which is imbued with a haunting sadness and was possibly influenced by Leonardo da Vinci's late compositions.

As demonstrated by an outbreak of iconoclasm in 1529, the religious and political climate of Basel was still "freezing," to use Erasmus' word, and by early September 1532 Holbein was back in England. There, too, the situation had altered with the death of Archbishop Wareham and the removal from power of Sir Thomas More, and Holbein's first portraits were of the German merchants of the Hanseatic League housed in the steelyard in London. His circle of clients quickly broadened, however, and one of his largest and most complex works, *The Ambassadors*, dated 1533 (National Gallery, London), is a double portrait of the French envoys to England, Jean de Dintville and Georges de Selve.

Because the account books are missing, it is not known exactly when Holbein began working for Henry VIII, but it was no later than 1536. The most important commission from the king was for the fresco in Whitehall Palace depicting Henry VIII, Queen Jane Seymour, and his parents, Henry VII and Elizabeth of York, accompanied by Latin verses praising Henry VIII for suppressing the popes and thus restoring religion. The wall painting was destroyed by fire in 1698, but part of Holbein's cartoon is preserved (National Portrait Gallery, London), as are later copies of the entire composition.

In addition to depicting the king and members of the nobility, Holbein was called upon to travel to Europe to make portraits of potential brides for Henry. It was on one of these trips in 1538 that the artist returned to Basel, where a banquet was held in his honor and the city council attempted without success to persuade him to stay. He died of the plague in London sometime between 7 October, the date of his testament and will, and 29 November 1543.

Although he was a skillful and inventive draftsman, printmaker, miniaturist, and jewelry designer, Holbein is best known as a painter, in particular as a portraitist. An assured, meticulous technician, his insights into the character of his sitters are achieved, somewhat paradoxically, through his cool, emotional detachment and objective, astonishing realism. Working primarily in Switzerland and England, he is nonetheless one of the greatest German artists of the sixteenth century.

Bibliography

Die Malerfamilie Holbein in Basel. Exh. cat., Kunstmuseum. Basel, 1960.
Strong, Roy. *Holbein and Henry VIII*. London and New York, 1967.
Rowlands, John. *Holbein: The Paintings of Hans Holbein the Younger*. Oxford, 1985.

1937.1.64 (64)

Edward VI as a Child

Probably 1538
Oak, 56.8 × 44 (22⅜ x 17⅜)
Andrew W. Mellon Collection

Inscription

At bottom:
PARVVLE PATRISSA, PATRIÆ VIRTVTIS ET HÆRES / ESTO, NIHIL MAIVS MAXIMVS ORBIS HABET. / GNATVM VIX POSSVNT COELVM ET NATVRA DEDISSE, / HVIVS QVEM PATRIS, VICTVS HONORET HONOS. / ÆQVATO TANTVM, TANTI TV FACTA PARENTIS, / VOTA HOMINVM, VIX QVO PROGREDIANTVR, HABENT / VINCITO, VICISTI. QVOT REGES PRISCVS ADORAT / ORBIS, NEC TE QVI VINCERE POSSIT, ERIT. Ricard: Morysini. Car :

Labels

On reverse, inscribed in black ink on paper: *Edward*

VI, Sohn König Heinrich VIII/von England, geb. 1537 gest. 1553 gemalt/als Kind von Holbein. (Holbein wurde/geboren 1495 und starb 1554 zu London; inscribed in brownish black ink on paper: *Pömyinn H[]bind /nr.13*; printed on paper: *446*.

Technical Notes: The painting comprises two boards with vertical grain. From the x-radiograph it appears that the panel may once have been split along the join line and reglued. The dendrochronological examination conducted by Peter Klein did not produce data that matched the existing master chronologies for Europe and thus yielded neither a date nor confirmation of an earlier examination made by John Fletcher.[1] The panel has been thinned and cradled, and strips of wood approximately 0.95 cm. wide have been added to the sides and the top. There is no barbe, and the panel was not painted in an engaged frame. There is nothing to suggest the panel has been cut down. Rather, the fact that the ground is either very thin or nonexistent for a width of approximately 1 cm. along the top and bottom edges and that there is a raised lip of ground along the right end of the bottom edge suggest that the panel was held in a clamp or on some sort of easel when the ground was applied. Over the smooth, thick, white ground there is a salmon-pink imprimatura of medium thickness. Examination with infrared reflectography discloses a fine, delicate underdrawing lying over the imprimatura, probably done with a brush and also visible to the naked eye. There are slight changes in the eyelids, which in the underdrawing were somewhat higher, and in the hand holding the rattle, where the middle finger once was parallel to the index finger and both extended farther to the lower left.

Various techniques were used in this picture. The paint has been very precisely and smoothly applied; glazes and layering have been used in several areas. The paint layers extend to the edges of the panel on all sides. A thick, white layer underlies much of the green drapery, possibly to counter any effect of the pink imprimatura below. The fine, gold lines found in the brocade and decorative details appear to be shell gold brushed over a warm brown or yellow base. In the hat thick, light ocher-toned areas under the gold act as a bole or mordant to provide a warm color base for the gold. The gray-brown portions of the cap are silver leaf, which originally may have been covered by a red glaze.

Except for the hat, many or nearly all of the uppermost layers of the red paint are missing. The remaining reds have a cracked and crizzled appearance. Optical microscopy indicates that the pigment used for the background is smalt, which has discolored to gray and, as indicated by the edges under the frame rabbet, would originally have been closer to a brighter slate blue. Apart from the aforementioned damage, the painting is secure and in reasonably good condition. There is damage and a large abraded loss in the background at the left above the child's arm. There are tiny scattered losses in the left cheek and a thin series of old losses along the join line.

Provenance: Gift of the artist to Henry VIII, king of England [d. 1547], 1 January 1539.[2] Thomas Howard, earl of Arundel and Surrey [d. 1646], Arundel Castle, Sussex, and Arundel House, London, by 1639, in Amsterdam from 1643;[3] by inheritance to his wife, Alathea Howard [d. 1654], Antwerp and Amsterdam.[4] Probably William III, king of England and Stadholder-king of the Netherlands [d. 1702], Het Loo, Apeldoorn, possibly by c. 1700.[5] Ernest Augustus, duke of Cumberland and king of Hannover [d. 1851], Royal Castle, Georgengarten, Hannover, by 1844;[6] by descent to his son, George V, king of Hannover [d. 1878]; by descent to his son, Ernest Augustus, duke of Cumberland and crown prince of Hannover [d. 1923]. (P. & D. Colnaghi & Co., London, by 1924/1925). (M. Knoedler & Co., London and New York, 1925);[7] purchased July 1925 by Andrew W. Mellon, Washington; deeded 30 March 1932 to The Andrew W. Mellon Educational and Charitable Trust, Pittsburgh.

Exhibitions: On loan to Hannover, Royal Welfen Museum, by 1863 until the 1870s; Royal Collection housed at Landschaftstrasse 3, Hannover, by 1876; Hannover, Provinzial Museum, Fidei-Kommiss Galerie des Gesamthaus Braunschweig-Lüneberg, 1891–1924. New York, M. Knoedler & Co., 1928, *A Loan Exhibition of Twelve Masterpieces of Painting*, no. 6.

EDWARD VI, the future king of England, is shown in half length behind a parapet draped with a dark green cloth. He is regally dressed in a red tunic, trimmed in gold with cloth-of-gold sleeves, worn over a white shirt that itself is trimmed in gold around the neck. On his head is a tight-fitting cap and a flat red hat ornamented with gold aiglets and an ostrich feather. He holds a gold rattle in his left hand and raises his right hand in a declamatory gesture.

The Latin inscription at the bottom of the panel was composed by Sir Richard Morison (d. 1556), an author and ambassador associated with Henry's court.[8] Morison's name in Latinized form appears at the end of the text followed by *Car.*, an abbreviation of *carminum auctor*, or poet. The inscription may be translated, "Little one, emulate thy father and be the heir of his virtue; the world contains nothing greater. Heaven and earth could scarcely produce a son whose glory would surpass that of such a father. Do thou but equal the deeds of thy parent and men can ask no more. Shouldst thou surpass him, thou hast outstript all

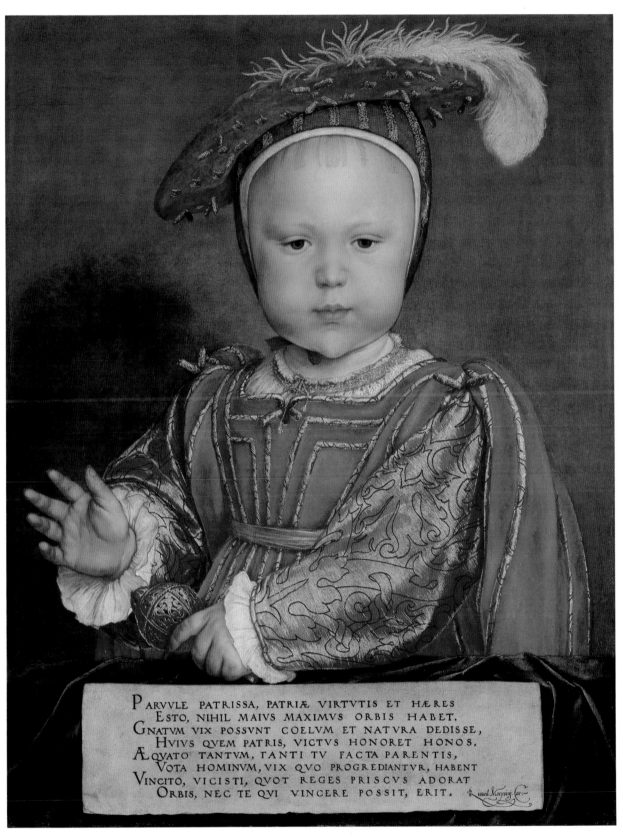

PARVVLE PATRISSA, PATRIÆ VIRTVTIS ET HÆRES
ESTO, NIHIL MAIVS MAXIMVS ORBIS HABET.
GNATVM VIX POSSVNT COELVM ET NATVRA DEDISSE,
HVIVS QVEM PATRIS, VICTVS HONORET HONOS.
ÆQVATO TANTVM, TANTI TV FACTA PARENTIS,
VOTA HOMINVM, VIX QVO PROGREDIANTVR, HABENT
VINCITO, VICISTI, QVOT REGES PRISCVS ADORAT
ORBIS, NEC TE QVI VINCERE POSSIT, ERIT. Ricard Morysini. Car:

Hans Holbein the Younger, *Edward VI as a Child*, 1937.1.64

kings the world has revered in ages past."[9]

Born at Hampton Court on 12 October 1537, Edward VI was the only child of Henry VIII and his third wife, Jane Seymour, who died shortly after on 24 October.[10] He was apparently a frail child and throughout his short life suffered from weak eyesight and periodic deafness. His education, however, was strenuous, and he distinguished himself as a scholar of Latin, Greek, and French and was also a lutenist and amateur astronomer. On 25 February 1547, following the death of Henry VIII, Edward VI was crowned king of England and Ireland in Westminster Abbey. His serious nature and religious piety manifested themselves at an early age, and his reign was notable for its full support of the doctrines and ceremonies of Protestantism, for which he was praised by European proponents of the Protestant Reformation. Edward VI died at Greenwich on 6 July 1553, three months before his sixteenth birthday.

Although it is not absolutely certain, it is gener-

Fig. 2. Peter Oliver after Hans Holbein the Younger, *Edward VI as a Child*, miniature, The Duke of Devonshire and the Chatsworth Settlement Trustees [photo: Devonshire Collection, Chatsworth. Reproduced by permission of the Chatsworth Trustees]

Fig. 1. Hans Holbein the Younger, *Edward VI as a Child*, black and colored chalk on pink prepared paper, reinforced in ink, 26.2 × 22.3 cm., Her Majesty Queen Elizabeth II, Royal Library, Windsor Castle [photo: Windsor Castle, Royal Library. © 1992 Her Majesty Queen Elizabeth II]

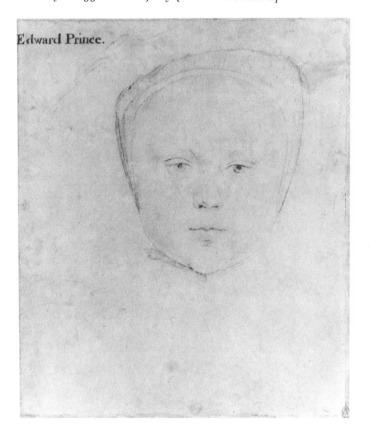

ally agreed that *Edward VI as a Child* is the painting that was presented by Holbein as a gift to Henry VIII on 1 January 1539 and is so recorded on a roll of New Year's gifts as "By hanse holbyne a table of the pictour of the p[ri]nce grace."[11] The king was apparently pleased with the painting, for the same document indicates a gift to the artist of a golden vessel weighing 10¼ ounces made by Cornelius Hayes, the king's goldsmith.[12] The National Gallery's panel is the only autograph version of this type of depiction of Edward VI either extant or known. It is most likely that Holbein painted the portrait in 1538, following his return in late autumn or early winter from Burgundy, Nancy, and Basel. The work must have proceeded rather quickly in order for it to have been finished and ready for the king by 1 January.

Even though it has suffered some damage, the

Fig. 3. Wenceslaus Hollar after Hans Holbein the Younger, *Edward VI as a Child*, pen and ink and brown wash, 23.6 × 17.9 cm. Pepys Library, Magdalene College, Cambridge [photo: Masters and Fellows of Magdalene College, Cambridge]

Fig. 4. Wenceslaus Hollar after Hans Holbein the Younger, *Edward VI as a Child*, 1650, etching, Her Majesty Queen Elizabeth II, Royal Library, Windsor Castle [photo: Windsor Castle, Royal Library. © 1992 Her Majesty Queen Elizabeth II]

portrait of *Edward VI as a Child* is one of the most important works by Holbein in the United States and amply demonstrates Holbein's superb control of his technique and means of expression. Particularly striking is the splendidly rendered detail in the cloth-of-gold sleeves and the careful draftsmanship and subtle modeling of the child's face. Some critics have argued for a later date for the panel on the grounds that the child appears older than his age in 1538 of approximately fourteen months.[13] This ignores a central contradiction that relates to the function of the painting. Taken by itself, Edward's face is that of an infant who is perhaps a little more than a year old, but who is given the posture and serious demeanor of an adult. Although there is a slight twist to the torso, the pose is basically frontal and hieratic. Separated from the viewer by the parapet, the child appears to look down upon the spectator, his

hand raised in a speaking gesture.[14] As befits a royal effigy, the image has an imposing, iconic dignity and rigidity. Even though his features are astutely observed, Edward is depicted by Holbein as a sturdy child, free from any physical frailty. This image of the king's only male heir and successor to the throne was intended to flatter Henry VIII and to bolster and consolidate his authority and power. Underscoring this aspect of the painting's function is Sir Richard Morison's inscription at the bottom of the panel, which challenges Edward to equal the achievements of his father and adds that should he surpass Henry he would have bettered all the kings in history.

Strong discussed the National Gallery's portrait in the larger context of Reformation politics and propaganda in England. In particular he noted a connection between Hans Holbein, Thomas Cromwell, a counselor to the king who

was made lord chancellor and earl of Essex in 1539, and Sir Richard Morison, who was employed by Cromwell and brought to court by him as a pamphleteer. According to Strong, Holbein's portrait of Edward VI and its accompanying verses by Morison is one of the last manifestations of Cromwell's campaign to assert the supremacy of the king in matters both temporal and ecclesiastical and to unify support for the crown in the face of rebellion growing out of Henry's divorce from Catherine of Aragon and his acceptance of Protestantism. Earlier instances include the woodcut designed by Holbein for the frontispiece of Coverdale's 1535 translation of the Bible into English, an important Reformation document that was published under Cromwell's guidance and patronage, and the strong anticlerical tenor of a woodcut series designed perhaps around 1536 by Holbein but not published until 1548 when it appeared in Thomas Cranmer's *Catechism*.[15]

A preparatory drawing by Holbein for *Edward VI as a Child* (fig. 1) is in the Royal Library at Windsor Castle.[16] The drawing is rubbed, and the outlines have been partially reinforced by a later hand. It has been suggested that the drawing was never fully finished, possibly owing to the difficulties of trying to capture the features of an active child. The dimensions of the face do not match those of the face in the painting, and thus, in contrast to other Holbein drawings, the Windsor sheet was not directly transferred to the painting.[17]

Images of the Washington painting made in the seventeenth century are very important in helping to establish ownership by Thomas Howard, earl of Arundel. Peter Oliver's miniature (fig. 2) was catalogued in 1539 as reproducing the Holbein portrait belonging to Arundel, and Wenceslaus Hollar's drawing and the resulting etching, dated 1650 (figs. 3, 4), identify the owner as Arundel.[18] Both drawing and etching date from the period when Hollar had left England, perhaps because of religious turbulence, and was living in Antwerp. We can only speculate, however, on how the painted portrait passed from the royal collection into Arundel's hands, or how it later entered the collection in Hannover.

A copy of good quality, virtually the same size

as the Washington panel, was in the collection of the earl of Yarborough until 1929 and was at times confused with the National Gallery's portrait.[19] Its present location is unknown. A panel showing Edward in full length (Duke of Northumberland, Syon House) is based on Holbein's portrait and includes Morison's verses.[20] As might be expected for a royal effigy, Holbein's portrait was undoubtedly copied numerous times, and depictions of Edward VI attributed to Holbein are to be found in inventories and elsewhere in the literature. It is not always clear, however, whether or not they reproduce the composition of the Washington portrait.[21]

Notes

1. See Appendix and Peter Klein's examination report, 24 September 1987, in NGA curatorial files. John Fletcher examined the painting on 3–4 October 1979 and put forward a date of 1533/1545 for the earliest likely use of the panel (report, 7–8 November 1979, in NGA curatorial files).

2. New Year's Gift Roll, Folger Shakespeare Library, Washington, MS. Z. d. 11, dated "First daie of January anno XXX" of the reign of Henry VIII. I am very grateful to Laetitia Yeandle, curator of manuscripts, for assistance in transcribing the citation. A photocopy is in NGA curatorial files. Regnal year 30 of Henry VIII ran from 22 April 1538 to 21 April 1539, hence the manuscript dates from 1539; see Christopher R. Cheney, *Handbook of Dates for Students of English History* (London, 1978), 24.

3. The earl of Arundel's portrait of Edward VI was copied in miniature by Peter Oliver (fig. 2); the miniature was catalogued by Abraham van der Doort in 1639 as part of the collection of Charles I, king of England, and added to the description are the words, "Coppied by Peter Olliver after Hanc Holbin whereof my Lord of Arrundell-hath ye Principall"; see Millar 1958–1960, 108, no. 22. The earl of Arundel left England in 1641 and his collection was in Amsterdam in 1643; see Mary L. Cox, "Notes on the Collections Formed by Thomas Howard," *BurlM* 19 (1911), 282.

Two other images identify what is evidently the National Gallery's painting with the Arundel collection: the preparatory drawing and etching by Wenceslaus Hollar (figs. 3, 4). The latter is inscribed: "H Holbein pinxit. Wenceslaus Hollar fecit. ex Collectione Arundeliana. An. 1650." Horace Walpole added the handwritten emendation, "There is a print from this by Hollar," to the printed version of van der Doort's catalogue (George Vertue, *A Catalogue and Description of King Charles the First's Capital Collection . . .* [London, 1757], 39–40, no. 22).

4. Thomas Howard, earl of Arundel, died in Padua

in 1646. His will of 3 September 1640 left his possessions to his wife; see Charles Howard, *Historical Anecdotes of Some of the Howard Family* (London, 1817), 93–96. Alathea Howard died in Amsterdam in 1654; an inventory in the Rijksarchief, Utrecht, of the Arundel collection made in Amersfoort in 1655 lists two portraits of Edward VI by Holbein; see F.H.C. Weijtens, *De Arundel-Collectie. Commencement de la fin Amersfoort 1655* (Utrecht, 1971), 30, no. 19; and 31, no. 49, "Eduwart de seste, Holben"; and "Eduwardus den sesten, Holben." These correspond to an inventory in Italian in the Public Record Office, London; Cox 1911, 323. It is assumed that the painting copied by Oliver and Hollar corresponds to one of the works listed. It is not clear what happened next to the collection. At the time of Alathea Howard's death, her only surviving son, William Viscount Stafford (d. 1680), claimed that a nuncupative will entitled him to her personal possessions, including the art collection, but this was disputed by his nephew, Henry, who succeeded his father, Henry Frederick (d. 1652), as earl of Arundel and Surrey; see Hervey 1921, 473; Weijtens 1971, 18–24. Weijtens 1971, pl. 14, published a document of 11 October 1662 signed by the painter Herman Saftleven indicating that Lord Stafford's collection was probably sold in Utrecht in that year.

5. Drossaers and Lunsingh Scheurleer 1974, "Inventaris van de inboedel van het Huis Het Loo, het Oude Loo en Het Huis Merwell, 1713," 679, no. 886; and 700, no. 10, "Een koning Eduard van denselven [i.e., Holbein] met een descriptie van Richard Morosini" and "Schilderijen die volgens het zeggen van den kunstbewaerder Du Val door Hare Majt. de coninginne van Groot-Brittanniën zijn gereclameert geworden als tot de croon behorende"; and "Koning Eduart van dito [i.e., Holbein]" (in the margin, "Staet niet aengeteekent"). As observed by Broos in Brenninkmeyer-de Rooij et al. 1988, 117, Du Val's marginal notation of "not listed" (*Staet niet aengeteekent*) may be taken as an indication that the portrait was not on the list of works requested for return to the English royal collection because it was acquired from a private collection, that of Arundel. Broos 1988, 118, suggested, without verification, that the portrait was in Het Loo by about 1700 and that it hung next to a portrait of Henry VIII by Holbein as indicated in the 1713 inventory in Drossaers and Lunsingh Scheurleer 1974, 679, no. 885, "Een Hendrick de Achtste van Holbeen." The portrait was in Het Loo in 1711, for in that year it was described by Zacharias Conrad von Uffenbach; see Uffenbach 1753, 376–377, who transcribed the inscription at the bottom of the painting but believed that it represented Henry VIII as a child.

6. It is not known exactly when and by what means the painting entered Germany's royal collections. Broos 1988, 117–118, suggested that the portrait came to Germany from Het Loo as a result of the marriage in 1734 of William IV, king of the Netherlands, to Anna of Hannover, duchess of Braunschweig-Lüneberg; this is unverified but intriguing. No portrait of Edward VI by Holbein appears in the royal collection inventories of 1709, 1754, 1781, or 1803; I am extremely grateful to Hans Georg Gmelin for this information, letter to the author, 16 December 1977, in NGA curatorial files. The earliest published mention of the picture is Molthan 1844, 65, no. 12, and conceivably it thus could have entered the collection sometime after 1803 and before 1844.

7. Nancy C. Little, M. Knoedler & Co., letter to the author, 2 March 1988, in NGA curatorial files, states that the painting came to Knoedler's from Colnaghi in 1925. I am also indebted to Ms. Little for access to stockbooks and files at M. Knoedler & Co., New York, on 15 March 1988. A rather sensational but unverified account of how the painting passed from the duke of Cumberland's collection to Colnaghi's to a representative of Knoedler's was given by A. Martin de Wilde in Betty Beale, "Will of Billionaire Deprives U.S. of Art," *Buffalo Evening News* (6 June 1960), clipping in NGA curatorial files.

8. See W.A.J.A., "Morison, Sir Richard," *DNB* 39 (1894), 60–61.

9. This translation appears in the M. Knoedler & Co. brochure, in NGA curatorial files, and is used in several NGA publications, including Cairns and Walker 1966, 120, and NGA 1985, 204. Wornum 1867, 324, translates the inscription, "Little one! Imitate your father and be the heir of his virtue, the world contains nothing greater—Heaven and Nature could scarcely give a son whose glory should surpass that of such a father. You only equal the acts of your parent, the wishes of men cannot go beyond this. Surpass him, and you have surpassed all the kings the world ever worshipped, and none will ever surpass you."

10. See S.L.L., "Edward VI," *DNB* 17 (1889), 84–90; *Encyclopaedia Britannica*, 8th ed. (1945), s.v. "Edward VI," 9–10.

11. See note 2. Caution is expressed by Ganz 1950, 251, no. 105, and Strong 1969, 91–92.

12. Folger Shakespeare Library, Washington, MS. Z. d. 11: "to hanse holbyne paynter a gilte cruse wt a couer Cornelis weing Xoz qu[ar]t[er]." A photocopy is in NGA curatorial files.

13. Parker 1945, 49, and Roberts 1987, 86. Strong 1969, 91–92, is in error when he states that year 30 of Henry's reign began on 21 April 1539; see note 2.

14. Louchheim 1948, 56, and Joan A. Holladay, memorandum, August 1977, in NGA curatorial files, interpret the gesture as one of blessing, which associates Edward with Christ as Ruler and King.

15. Strong 1967 (see Biography), 14, 17–18; the title page of the Coverdale Bible is reproduced 15, pl. 8, and the woodcuts, 17, pls. 12–14.

16. Parker 1945, 49, no. 46.

17. Roberts 1987, 86; and Ainsworth 1990, 182–183, who notes that perhaps the circumstances of the commission "did not require the working methods that had

been established for other portraits produced in multiple versions." The discrepancy in sizes between the painted and drawn faces is discussed in a series of letters between the author and Susan Foister, 12 August 1980–11 February 1982, in NGA curatorial files. See also Martha Wolff, letter to Maryan Ainsworth, 20 June 1985, in NGA curatorial files, which discusses the adjustments in contour between painting and drawing and includes a photocopy of the drawing superimposed on the painted face. This image shows that the drawing is smaller than the painting, the contours varying in width from 6 mm. to 20 mm.

18. Peter Oliver's miniature is reproduced and discussed in Daphne Foskett, *British Portrait Miniatures* (London, 1963), 57, fig. 6; there are brief remarks on Oliver in Roy Strong, *The English Renaissance Miniature* (London, 1983), 186–187. For the drawing and etching by Hollar see Franz Sprinzels, *Hollar Handzeichnungen* (Vienna, Leipzig, Prague, 1938), 16, 59, no. 2; Richard Pennington, *A Descriptive Catalogue of the Etched Work of Wenceslaus Hollar 1607–1677* Cambridge, 1982), 239–240, no. 1395.

19. Wood, 57.2 × 43.2 (22½ × 17); sale, Christie, Manson and Woods, London, 12 July 1929, no. 40, repro., purchased by Francis Harvey, as reported, for example, in "Notes from Abroad," *International Studio* 94 (1929), 65. Although this version is often described in the earlier literature as an excellent copy (Woltmann 1866, 334, Ganz 1912, 242), the provenance was confused with that of the National Gallery's portrait, for example by Wornum 1867, 324, and Ganz 1950, 251, who believed that Hollar's etching reproduced the earl of Yarborough's painting. Grossmann 1951, 21, emphasized that it was the National Gallery's portrait that was in the Arundel collection and hence the subject of Hollar's etching.

20. See *Kings & Queens AD 653–1953* [exh. cat., Diploma Gallery] (London, 1953), 19, no. 80, repro. 22. Grossmann 1951, 21, suggests that Holbein's original full-length painting was the second portrait of Edward VI owned by the earl of Arundel and that it passed into the collections of Everhard Jabach and, later, of L. F. Crozat.

21. Of the several depictions of Edward VI associated with Holbein, a panel, 52 × 36.6 cm., sold at Christie, Manson and Woods, London, 21 January 1977, no. 22, might from its size and description be a copy of the Washington painting. Unfortunately I have been unable to find a reproduction. A drawing, 203 × 254 mm., attributed to Hollar and reproducing the National Gallery's painting in reverse, was sold at Sotheby's, London, 30 June 1920, no. 437. Grossmann 1951, 21 n. 83, observed that the drawing was done after the painting and suggested that it might be by Vorsterman. A portrait of Edward VI accompanied by Morison's inscription was seen in Whitehall Palace, London, in 1600 by a traveler, Baron Waldstein, who, however, described the sitter as about twelve years old; see Groos 1981, 46–47.

References

1753 Uffenbach, Zacharias Conrad von. *Merkwürdige Reisen durch Niedersachsen Holland und Engelland.* 3 vols. Ulm, 2: 376–377.

1844 Molthan, Justus. *Verzeichniss der Bildhauerwerke und Gemälde welche sich in den königlich hannoverschen Schlössern und Gebäuden befinden.* Hannover: 65, no. 12.

1854 Waagen, Gustav Friedrich. *Treasures of Art in Great Britain.* . . . 4 vols. London, 2: 448.

1859 Nichols, John Gough. *A Catalogue of the Portraits of King Edward the Sixth, Both Painted and Engraved.* n.p.: 3, no. 2.

1863 Franks, Augustus W. "Remarks on the Discovery of the Will of Hans Holbein." *Archaeologia* 39: 8–9.

1863 Nichols, John Gough. "Notices of the Contemporaries and Successors of Holbein." *Archaeologia* 39: 20.

1863 Parthey, Gustav Friedrich. *Deutscher Bildersaal. Verzeichniss der in Deutschland vorhandenen Oelbilder verstorbener Maler aller Schulen.* 2 vols. Berlin, 1: 600, no. 29.

1864 *Das königlich Welfen-Museum zu Hannover im Jahre 1863.* Hannover: 93, no. 239.

1866 Woltmann, Alfred. *Holbein und seine Zeit.* Leipzig: 333–334. English ed., London, 1872: 431–433.

1867 Wornum, Ralph Nicholson. *Some Account of the Life and Works of Hans Holbein, Painter, of Augsburg.* London: 322–324.

1897 Knackfuss, Hermann. *Holbein der jüngere.* Bielefeld and Leipzig: 136, 138, repro. 132. English ed., Bielefeld and Leipzig, 1899: 147, repro. 138.

1903 Davies, Gerald S. *Hans Holbein the Younger.* London: 177.

1912 Ganz, Paul. *Hans Holbein D. J. Des Meisters Gemälde in 252 Abbildungen.* Klassiker der Kunst, vol. 20. Stuttgart and Leipzig: 242, repro. 122.

1912 Cust, Lionel. "Notes on the Collections Formed by Thomas Howard, Earl of Arundel and Surrey, K. G.-V." *BurlM* 21: 258, no. 30.

1913 Chamberlain, Arthur B. *Hans Holbein the Younger.* 2 vols. London, 2: 164–165.

1921 Hervey, Mary F. S. *The Life, Correspondence, & Collections of Thomas Howard, Earl of Arundel.* Cambridge: 482.

1924 Schmid, Heinrich Alfred. "Holbein, Hans, d. J." Thieme-Becker, 17: 351.

1927 Vaughan, Malcolm. "Holbein Portraits in America. Part II." *International Studio* 88: 63–64, repro. 66.

1928 "Amerika." *Pantheon* 1: 270, repro. 273.

1929 Stein, Wilhelm. *Holbein.* Berlin: 308, 310.

1931 Frankfurter, Alfred M. "Thirty-five Portraits from American Collections." *ArtN* 29, no. 33: 4, repro. 27.

1936 Kuhn: 83, no. 370, pl. 80.

1937 Christoffel, Ulrich. "Das Kinderbildnis." *Die*

Kunst 75: 226, repro.

1937 Cortissoz, Royal. *An Introduction to the Mellon Collection.* n.p.: 43.

1937 Jewell, Edward Alden. "Mellon's Gift." *Magazine of Art* 30: 82, repro. 79.

1937 "Trends." *American Architect and Architecture* 150 (March): 4, repro.

1938 Waetzoldt, Wilhelm. *Hans Holbein der Jüngere. Werk und Welt.* Berlin: 197–198, repro. pl. 93.

1941 Held, Julius S. "Masters of Northern Europe, 1430–1660, in the National Gallery." *ArtN* 40: 12, repro. 15.

1941 NGA: 98–99, no. 64.

1943 Ganz, Paul. "Holbein and Henry VIII." *BurlM* 83: 272, pl. A.

1945 Parker, Karl Theodore. *The Drawings of Hans Holbein in the Collection of His Majesty the King at Windsor Castle.* London and New York: 49, under no. 46, repro.

1948 Louchheim, Aline B. "Children Should Be Seen." *Art News Annual* 46: 55–56, repro.

1948 Schmid, Heinrich Alfred. *Hans Holbein der Jüngere. Sein Aufstieg zur Meisterschaft und sein englischer Stil.* 3 vols. Basel, 2: 376.

1950 Ganz, Paul. *The Paintings of Hans Holbein: First Complete Edition.* London: 251, no. 105, pl. 146. German ed., Basel: 235, no. 105, pl. 146.

1950 Goldblatt, Maurice H. "Leonardo da Vinci and Andrea Salai." *Conn* 125: 73–74, repro.

1951 Grossmann, Fritz. "Holbein, Flemish Paintings, and Everhard Jabach." *BurlM* 93: 21.

1958 Cauman, Samuel. *The Living Museum. Experiences of an Art Historian and Museum Director—Alexander Dorner.* New York: 30–31, 47.

1958 Waetzoldt, Wilhelm. *Hans Holbein der Jüngere.* Königstein im Taunus: 24, 80, repro. 71.

1960 Broadley: 40, repro. 41.

1958–1960 Millar, Oliver. "Abraham van der Doort's Catalogue of the Collections of Charles I." *Walpole Society* 37: 108, no. 22, 233.

1963 Walker: 120, repro. 121.

1966 Cairns and Walker: 120, repro. 121.

1967 Strong (see Biography): 14, 17–18, repro.

1968 Cuttler. *Northern Painting:* 415, repro.

1969 Strong, Roy. *Tudor & Jacobean Portraits. National Portrait Gallery.* London: 91–92, pl. 164.

1971 Salvini, Roberto, and Hans Werner Grohn. *L'opera pittorica completa di Holbein il giovane.* Milan: 106, no. 115, pl. 50.

1974 Drossaers, S.W.A., and Th. H. Lunsingh Scheurleer. *Inventarissen van de inboedels in de verblijven an de Oranjes en daarmede gelijk te stellen stukken 1567–1795.* 3 vols. The Hague, 1: 679, no. 886, 700, no. 10.

1975 NGA: 176, repro. 177.

1976 Walker: 160, repro. 161.

1978 King, Marian. *Adventures in Art.* New York: 33, pl. 11.

1979 Gelder, Jan Gerrit van. "The Stadholder-King William III as Collector and 'Man of Taste.'" In *William & Mary and Their House.* Exh. cat., Pierpont Morgan Library. New York: 35–36.

1979 Hadley, Rollin van N. "What Might Have Been: Pictures Mrs. Gardner Did Not Acquire." *Fenway Court:* 37, 42.

1979 Roberts, Jane. *Holbein.* London: 85, repro. 84.

1979 Watson, Ross. *National Gallery of Art, Washington.* New York: 56, pl. 40.

1981 Groos, G. W. *The Diary of Baron Waldstein: A Traveller in Elizabethan England.* London: 46–47, repro. 14.

1983 Foister, Susan. *Drawings by Holbein from the Royal Library Windsor Castle.* London: 2, 21, 32, 43, under no. 46, fig. 44.

1983 Wolff: unpaginated, repro.

1985 NGA: 204, repro.

1985 Rowlands (see Biography): 116, 146–147, no. 70, color pl. 32, pl. 110.

1987 Roberts, Jane. *Drawings by Holbein from the Court of Henry VIII: Fifty Drawings from the Collection of Her Majesty Queen Elizabeth II, Windsor Castle.* Exh. cat., Museum of Fine Arts. Houston: 86, under no. 25.

1988 Brenninkmeyer-de Rooij, Beatrijs, et al. *Paintings from England: William III and the Royal Collections.* Exh. cat., Koninklijk Kabinet van Schilderijen "Mauritshuis." The Hague: 39, 60, 117–118, no. XIII, repro. 11b.

1990 Ainsworth, Maryan. "'Paternes for phiosioneamyes': Holbein's Portraiture Reconsidered." *BurlM* 132: 182–183.

1990 Campbell, Lorne. *Renaissance Portraits: European Portrait-Painting in the 14th, 15th, and 16th Centuries.* New Haven and London: 104, repro.

1937.1.65 (65)

Sir Brian Tuke

c. 1527/1528 or c. 1532/1534
Oak, 49.1 × 38.5 (19⅜ x 15⅛)
Andrew W. Mellon Collection

Inscriptions
On back wall, top: *BRIANVS TVKE, MILES, AN°
ETATIS SVÆ, LVII*
On back wall, center: *.DROIT ET AVANT.*
On paper, lower left: *NVNQVID NON PAVCITAS
DIERVM / MEORVM FINIETVR BREVI?*[1]
At top of cross: *INRI*

Technical Notes: The painting is composed of two boards with vertical grain. The panel has been thinned very slightly; this is indicated by the presence on the

reverse, at the upper right, of a red resinous seal that sits about 2mm. above the surface of the panel.[2] The picture has been cradled. Peter Klein's dendrochronological examination indicated that the wood was from the Baltic/Polish region and provided felling dates of 1525^{+4}_{-2} and 1530^{+4}_{-2} for the two boards.[3] Examination with infrared reflectography did not disclose underdrawing. While there are no major alterations, infrared reflectography and x-radiography indicated very minor alterations in the outline of the figure, such as the reduction in size of the outer edge of the left elbow and changes in the position of the thumb.

In general the painting is in very good condition. There are two checks at the left. There is retouching along the left and right edges and scattered retouching in the face and hands. The painting exhibits an unusual craquelure pattern with localized areas of wide drying cracks.

Provenance: Probably Sir Paul Methuen [d. 1757], London; by bequest to his cousin and godson, Paul Methuen [d. 1795], Corsham Court, Wiltshire;[4] by inheritance to his son, Paul Cobb Methuen [d. 1816], Corsham House, Wiltshire; by inheritance to his son, Paul, first Lord Methuen [d. 1849], Corsham House, Wiltshire. Richard Sanderson, London and Edinburgh (sale, Christie & Manson, London, 17 June 1848, no. 7); possibly to Seguier(?), London.[5] Richard Grosvenor [d. 1869], second marquis of Westminster, Eaton Hall, Cheshire, by 1867;[6] his daughter, Lady Theodora Guest, Inwood, Somerset, probably by inheritance in 1869, until 1913; (Robert Langton Douglas, London, 1913, held jointly with P. & D. Colnaghi & Co., London);[7] (M. Knoedler & Co., London and New York, 20 May 1913);[8] Watson B. Dickerman [d. 1923], New York, April 1914; his widow Mrs. Watson B. Dickerman, New York, probably 1923–1929/1930; consigned to (M. Knoedler & Co., New York, 1929–1930);[9] purchased April 1930 by Andrew W. Mellon, Washington; deeded 30 March 1932 to The Andrew W. Mellon Educational and Charitable Trust, Pittsburgh.

Exhibitions: London, South Kensington Museum, 1868, *Third Special Exhibition of National Portraits*, no. 625. London, Royal Academy, 1880, *Exhibition of Works by the Old Masters and by Deceased Masters of the British School*, no. 188. London, Burlington Fine Arts Club, 1909, *Exhibition Illustrative of Early English Portraiture*, no. 43. New York, M. Knoedler & Co., 1915, *Loan Exhibition of Masterpieces by Old and Modern Painters*, no. 4.

THIS SPLENDID PORTRAIT depicts Sir Brian Tuke in half length, wearing a soft black cap with ear flaps, a black mantle with a fur collar, and meticulously rendered cloth-of-gold sleeves. Hanging from the gold chain around his shoulders is a cross decorated with black pearls and bearing the Five Wounds of Christ. The inscription at the top of the mottled green-brown background identifies the sitter as Brian Tuke, knight, and gives his age as fifty-seven. Inscribed below is what is almost certainly a personal motto, DROIT ET AVANT, which may be translated "upright and forward." At the lower left, on a piece of folded paper, is a quotation from Job 10:20, "Are not the days of my life few?" Tuke appears to be shyly pointing at this inscription with his index finger.

Tuke was a figure of considerable importance to English court and intellectual life in the first half of the sixteenth century.[10] Unfortunately his exact date of birth is unknown, although the early 1470s have been suggested. He was probably the son of Richard and Agnes Tuke. Richard Tuke is said to have been tutor to the duke of Norfolk, and it is possibly because of this connection that Brian Tuke obtained, in 1508, his first public position, that of king's bailiff in Sandwich. Other appointments followed rapidly; in 1509 he was clerk of the signet and also was appointed feodary, that is, an officer authorized to collect rents, for Wallingford and Saint Walric. In the following year he was made clerk of the Council of Calais and was a member of the commission for peace in Kent in 1512 and for Essex in 1513.

In 1516 Tuke was made a Knight of the King's Body and in the next year was named Governor of the King's Posts, a position he retained throughout his career. As Britain's first postmaster general, he was charged with ensuring that domestic letters were delivered promptly and safely, and he seems to have been responsible for arranging payment for messengers and couriers operating on the king's business in Europe. Sometime after 1517 he became secretary to Cardinal Wolsey. He was French secretary to Henry VIII in 1522, and in April of the following year he was granted the clerkship of Parliament. Henry VIII was obviously impressed by his abilities, for in 1528 Tuke was made treasurer of the royal household and was one of the commissioners appointed to treat for peace with France. In addition to his skills as postmaster, treasurer, and secretary, he was in demand as a skilled cryptographer.[11] During this period he was a member of the circle of intellectu-

Hans Holbein the Younger, *Sir Brian Tuke*, 1937.1.65

als gathered around Sir Thomas More and seems to have been regarded as a speaker and writer of great eloquence.[12]

In the 1530s Tuke not only survived the dramatic changes that took place in Henry's court but apparently prospered. In 1533 he served as the sheriff of Essex and Hertfordshire. He wrote the preface to the edition of *The Workes of Geffray Chaucer* published in 1532 by William Thynne.[13] It was as treasurer of the royal household that he was mentioned in 1538 as paying the salary of Hans Holbein, "Paynter."[14] As rewards for his service to the king he was presented with the manors of Southweald, Layer Marney, Thorpe, and East Lee in Essex. It was at Layer Marney that he died on 16 October 1545. He was buried in the church of Saint Margaret Lothbury, London, with his wife Grissel, who predeceased him.

Holbein's portrait of Tuke does not bear a date, and it has not been possible to date the painting through documentary means. As observed by Roberts, it is often difficult to situate Holbein's undated paintings,[15] and consequently various dates have been put forward for the National Gallery's picture. Beginning with Ganz in 1912, most authors have placed the portrait in Holbein's first English period, c. 1527/1528.[16] Others, including Cust and Schmid, date the picture between 1539 and 1541, well into the second English period.[17] Schmid proposed a date between 1532 and 1536, while Rowlands placed it between 1538 and 1540.[18] Ganz, followed by the present author, later suggested that the portrait could have been painted either in the first English period or at the beginning of the second.[19]

Close stylistic comparisons for *Sir Brian Tuke* are to be found in Holbein's first English period. The modeling of Tuke's face and hands is similar to the rendering of skin tones in such works as *Sir Henry Guildford*, dated 1527 (Royal Collection, Windsor Castle), *Nicholas Kratzer*, dated 1528 (Musée du Louvre, Paris), *Thomas Godsalve with His Son, John*, dated 1528 (Gemäldegalerie Alte Meister, Dresden), and *Sir Thomas More*, 1527 (Frick Collection, New York).[20] The possibility that the Washington portrait dates from the early years of Holbein's second English period should also be considered. Particularly comparable in terms of pose and expression is the portrait of *Sir Henry Wyatt* (Musée du Louvre, Paris), which is undated but usually placed 1527/1528, until recently when, primarily on the basis of dendrochronological evidence, a date of 1535/1537 was proposed.[21] Moreover, as noted by Ganz, the use of gold letters on either side of the sitter—perhaps the earliest use of this device by the artist—relates the National Gallery's panel to Holbein's portraits of the German steelyard merchants, painted on his return to England, such as that of *Hermann Wedigh*, dated 1532 (Metropolitan Museum of Art, New York).[22] While not decisive in itself, the dendrochronological evidence tends to favor a dating in the first part of the second English period.[23]

Although there is not a great change in the portraits during the period 1539 to 1541, Holbein's late works often appear to have harder, more enamel-like surfaces and slightly finer, more linear rendering of detail. The modeling of faces is sometimes at once flatter and more subtle.

The author has discussed elsewhere the iconography of the cross worn by Tuke and inscriptions from the Book of Job in the foreground as possibly shedding light on the private, emotional life of the sitter.[24] The cross, which is possibly unique, depicts the Five Wounds of Christ; the red stone at its center encircled by the Crown of Thorns signifies the wound in the Lord's heart, while the hands and feet of the crucified Christ are rendered in what is apparently flesh-colored enamel. From the early fifteenth century onward there was increasing veneration of the Five Wounds in England, and a major reason for the popular devotion to the Five Wounds lay in their supposed restorative powers. Depictions of the Five Wounds of Christ as well as prayers and talismanic phrases are found on gold rings of English manufacture from the late fifteenth and early sixteenth century and were intended as protection against various kinds of illnesses, evil, and even death.

The prophylactic qualities of the cross may be associated with the pessimism of the words "Are not the days of my life few?" spoken by Job in the midst of his afflictions. In addition to being an exemplar of patient suffering in his own right, Job typologically prefigures the torment, death, and resurrection of Christ.

As observed by several authors, there is an un-

dercurrent of pain and melancholy in Tuke's faint smile and unfocused gaze. His own correspondence and the writings of others indicate that from early June to mid-July of 1528 Tuke was gravely ill with a plague that took the form of a sweating sickness. I have elsewhere suggested that the National Gallery's portrait was produced at the time of or after Tuke's illness and thus that the cross bearing the Five Wounds might have been worn specifically to protect against the sweating sickness. This is only a hypothesis, and it is possible that the cross does not allude to any specific incident. There is a certain irony in the quotation from Job, for while Tuke may have felt that death was imminent, he survived Wolsey, Wareham, More, and even Holbein.

The portrait of Sir Brian Tuke was copied several times. Four of the five extant versions are virtually the same size as the Washington panel: Bayerische Staatsgemäldesammlungen, Munich (distinguished by a skeleton in the background);[25] Norton Simon Foundation, Los Angeles;[26] formerly the art market, Konstanz;[27] Sir Anthony Tuke, Wherwell, near Andover;[28] and Nicholas Toke, Hastings, East Sussex.[29] Other versions appear in the literature.[30]

Notes

1. Examination by the NGA conservation department does not confirm the assertion of Ganz 1950, 234, that the top line of the background inscription and the quotation from Job are later additions.

2. Also on the reverse is a paper sticker that reads: *93007D/40 x 56/Knoedler/pour ce soir/5 heures.*

3. Peter Klein, examination report, 3 December 1986, and letter to the author, 28 March 1990, in NGA curatorial files; see Appendix.

4. The first published reference to the painting is Passavant 1836, 87. For the history of the collection see *Corsham Court* (Wiltshire, 1985), 23–31. There is no way of knowing if the portrait of Tuke belonging to Robert Sidney, Lord Lisle, and seen by John Evelyn on 27 August 1678, is the National Gallery's panel or another version, although this is sometimes given as part of the provenance; see E. S. de Beer, ed., *The Diary of John Evelyn*, 6 vols. (Oxford, 1955), 4, 143.

5. The copy of the Christie & Manson sale catalogue of the Sanderson collection (Provenance Index, J. Paul Getty Trust, Santa Monica) has a handwritten inscription in the margin, of "Seguier" or possibly "Leguin." Martha Hepworth, letter to Susan E. Davis, 2 August 1988, in NGA curatorial files, notes that this is a later annotation by Frank Simpson, librarian at the Bar-

ber Institute, Birmingham. The person has not been identified; William Seguier, the dealer, restorer, and first keeper of the National Gallery, London, died in 1843.

6. Wornum 1867, 294, is the first mention of the painting as being in the possession of the marquis of Westminster but notes that it was bought for the marquis at the Sanderson sale of 1848. This is not independently verified, but if it is the case, the name in the margin of the catalogue could refer to the agent.

7. Sutton 1979, 423–425, and Provenance Index, J. Paul Getty Trust, Santa Monica. Robert Langton Douglas, letter to John G. Johnson, 6 May 1913, in Archive of the John G. Johnson Collection, Philadelphia Museum of Art. I am indebted to Lawrence W. Nichols for his assistance (letter to the author, 29 March 1990, in NGA curatorial files). I have not been able to confirm Douglas' joint ownership with Colnaghi; see Jeremy Howard, letter to the author, 29 August 1989, in NGA curatorial files.

8. Nancy C. Little, M. Knoedler & Co., letter to the author, 4 December 1978, in NGA curatorial files, states that the painting was purchased from Colnaghi's on 20 May 1913 and sold to W. B. Dickerman in April 1914.

9. Little to author, 4 December 1978.

10. The biography that follows is based primarily on that given in *DNB* 57 (1899), 295–296; the family name was spelled Tuke, Toke, and Tooke.

11. In J. S. Brewer, ed., *Letters and Papers, Foreign and Domestic, of the Reign of Henry VIII* (London, 1862–1910), Tuke's name appears in hundreds of documents. To cite one example of his reputation as a cryptographer, Gardiner and Foxe writing from Orvieto on 27 March 1528 request Tuke "to take some trouble in deciphering their ciphers, as they know his skill" (vol. 4, pt. 1, no. 4103).

12. Some indication of Tuke's fame can be inferred from the praise given him by a contemporary, the antiquarian John Leland (d. 1552), in *Principum, Ac illustrium aliquot & eruditorum in Anglia virorum, Encomia, Trophaea, Genethliaca, & Epithalamia* (London, 1589), 4, 15–16, 22–23, 31, 34, 41, 47–48, 77. Originally presented to Henry VIII, these verses and epigrams were not published until after Leland's death.

13. The full title is *The Workes of Geffray Chaucer Newly Printed, with Dyvers Workes Which Were Never in Print Before* (London, 1532). The preface is dedicated to Henry VIII and appears to be by Thynne. Tuke's authorship is confirmed, however, by the inscription in his own hand in the copy of the book in Clare College, Cambridge, which reads, "This preface I Sir Brian Tuke knight wrot at the request of Mr. Clarke of the kechyn then being tarying for the tyde at Grenewich." See "Thynne, William," *DNB* 56 (1898), 374; and E. P. Hammand, *Chaucer. A Bibliographical Manual* (New York, 1933), 116.

14. See "Vertue Note Books. Volume 1," *The Walpole Society* 18 (1930), 59–60.

15. Jane Roberts, *Holbein* (London, 1979), 5.

16. Ganz 1912, 238, included the painting in a section on "Undated Pictures 1526–1528"; see also Chamberlain 1913, 331; Tatlock 1923, 251; Vaughan 1927, 23; Kuhn 1936, 79–80; Christoffel 1950, 38; Cuttler 1968, 411; NGA 1941, 99; NGA 1975, 178; and NGA 1985, 205. Wilhelm Stein, *Holbein* (Berlin, 1929), 159, mentions three versions of the portrait of Sir Brian Tuke as dating from Holbein's first English period, and while the National Gallery's painting is probably one of the three, it is not identified specifically.

17. Cust 1910, 194; Schmid 1924, 352; Salvini and Grohn 1971, 107, no. 120; Ford 1989, 230.

18. Schmid 1948, 386; Rowlands 1985 (see Biography), 144–145, no. 64.

19. Ganz 1950, 234, no. 51; Hand 1980, 49.

20. Rowlands 1985 (see Biography), 133, no. 25, pl. 53; 134–135, no. 30, pl. 59, color pl. 19; 135, no. 31, pl. 61, color pl. 23; and 132–133, no. 24, pl. 55, respectively.

21. Rowlands 1985 (see Biography), 134, no. 29, pl. 58; the later date is found in *Les peintures de Hans Holbein le jeune au Louvre* [exh. cat., Musée du Louvre] (Paris, 1985), 48–52, 67, 68–69. The late date is supported somewhat by Wyatt's aged and feeble appearance; he died in 1537.

22. Ganz 1950, 11, 234, no. 51. For the portrait of Hermann Wedigh see Rowlands 1985 (see Biography), 137, no. 37, pl. 71; see also Thomas S. Holman, "Holbein's Portraits of the Steelyard Merchants: An Investigation," *JMMA* 14 (1979), 139–158.

23. Peter Klein, examination report, 3 December 1986, and letter to the author, 28 March 1990, both in NGA curatorial files. With the earliest felling date being 1524 and a minimum storage time of 2 years, a date of 1526 for the earliest first use of the panel is possible, but a more statistically realistic dating, allowing for more missing sapwood rings, would be 1530^{+4}_{-2}. John Fletcher examined the panel in early October 1979 and put forward a date of 1532–1542 for the earliest likely use of the panel (report, 5 November 1979, in NGA curatorial files). Fletcher's results, however, are sometimes compromised by a tendency toward art historical interpretation. See also Fletcher 1983, 87–93.

24. The remarks that follow are a condensation of Hand 1980, 38–49. In 1991 a gold cross bearing the Five Wounds was found in Milton Keynes, north of London, and acquired by the Buckinghamshire County Museum; see Cherry 1992, 34–36. The cross is strikingly similar to that worn by Tuke.

25. Inv. no. 737, oak, 48 × 38 cm.; Hand 1980, fig. 4; Rowlands 1985, 145, under 64c cites Gisela Goldberg as stating that the figure of Death is not a later addition and therefore unlikely to be the version listed in the Fickler inventory of the Wittelsbach collection of 1598. See also *Um Glauben und Reich. Kurfürst Maximilian I. Wittelsbach und Bayern* [exh. cat., Residenz] (Munich, 1980), vol. 2, pt. 2, 501–502, no. 805.

26. Inv. no. F.65.1.30.P, oak, 49.5 × 38.5 cm.; Hand 1980, fig. 5; a dendrochronological examination of the panel by John Fletcher, October 1979, at the National Gallery yielded a felling date of 1616 and a date of 1620–1635 for the earliest likely use of the panel.

27. With Atelier Helvetica, Konstanz, in 1980, oak, 49 × 39.5 cm.; Hand 1980, fig. 6.

28. Canvas, 48.3 × 36.9 cm.; photograph in NGA curatorial files; Sir Anthony Tuke, letter to the author, 5 September 1989, in NGA curatorial files.

29. Mahogany, 94 × 63.5 cm.; Nicholas Toke, letter to the author, 5 April 1990, in NGA curatorial files.

30. Rowlands 1985 (see Biography), 145, cites versions formerly at Burton Constable, Yorkshire, and formerly in the collection of Mrs. Eileen A. Craufurd, sale, Sotheby & Co., London, 29 November 1950, no. 147, wood, 49.5 x 39.4 cm. The portrait of Tuke belonging to Lieutenant-Colonel Raleigh Chichester-Constable, Burton Constable, was sold at Christie, Manson and Woods, London, 8 July 1927, wood, 74.9 × 62.2 cm.; see *Art Prices Current*, n.s., 6 (1927), 436, no. 9468. In addition, T.H.D. 1869, 376, mentions a version on canvas in the possession of William M. Tuke, Saffron Walden, and a version belonging in 1864 to the Reverend Nicholas Toke, Godington Park, Kent. It is likely that the former is the painting now in the possession of Sir Anthony Tuke (see note 28), while Nicholas Toke confirms ownership of the latter (see note 29), which belonged to his great-great grandfather. J. R. Haig, *Notes and Queries*, 4th ser., vol. 5 (26 March 1870), 313, writes that he owns a portrait by Holbein of Sir Brian Tuke, but the dimensions and location of the picture are not given.

References

1836 Passavant, Johann David. *Tour of a German Artist in England.* 2 vols. London, 2: 87.

1838 Waagen, Gustav Friedrich. *Kunstwerke und Künstler in England.* 2 vols. Berlin, 2: 304–305. English ed. 3 vols. London, 3: 93–94.

1867 Wornum, Ralph Nicholson. *Some Account of the Life and Works of Hans Holbein, Painter, of Augsburg.* London: 294–295.

1869 T. H. D. "Holbein's Portrait of Sir Brian Tuke." *The Athenaeum* 2186 (18 September): 376.

1872 Woltmann, Alfred. *Holbein and His Time.* London: 315–317.

1876 Walpole, Horace. *Anecdotes of Painting in England; with Some Account of the Principal Artists.* 3 vols. London, 1: 82.

1879 Crowe, J. A., ed. *Handbook of Painting: The German, Flemish, and Dutch Schools, Based on the Handbook of Kugler.* 2 vols. London, 1: 208–209.

1903 Davies, Gerald S. *Hans Holbein the Younger.* London: 219.

1909 Fry, Roger E. "Early English Portraiture at the Burlington Fine Arts Club." *BurlM* 15: 74.

1910 Cust, Lionel. "A Portrait of Queen Catherine Howard, by Hans Holbein the Younger." *BurlM* 17: 194.

1912 Ganz, Paul. *Hans Holbein d.J. des Meisters Gemälde in 252 Abbildungen.* Klassiker der Kunst, vol. 20. Stuttgart and Leipzig: 238, repro. 79.

1913 Chamberlain, Arthur B. *Hans Holbein the Younger.* 2 vols. London, 1: 331–333.

1923 Tatlock, R. R. "Sir Bryan Tuke, by Holbein." *BurlM* 42: 246, 251.

1924 Schmid, Heinrich Alfred. "Holbein, Hans, d.J." Thieme-Becker, 17: 352.

1927 Vaughan, Malcolm. "Holbein Portraits in America." *International Studio* 88: 23, repro. 25.

1936 Kuhn: 79–80, no. 351.

1937 Cortissoz, Royal. *An Introduction to the Mellon Collection*: 43.

1941 NGA: 99, no. 65.

1948 Schmid, Heinrich Alfred. *Hans Holbein der Jüngere. Sein Aufstieg zur Meisterschaft und sein englischer Stil.* 3 vols. Basel, 2: 386.

1950 Christoffel, Ulrich. *Hans Holbein d.J.* Berlin: 38.

1950 Ganz, Paul. *The Paintings of Hans Holbein: First Complete Edition.* London: 11, 234, no. 51, pl. 88. German ed., Basel: 217, 219, pl. 88.

1959 Frankfurter, Alfred. "Midas on Parnassus." *Art News Annual* 28: 53, repro.

1960 Broadley: 38, repro. 39.

1963 Walker: 122, repro. 123.

1966 Cairns and Walker, 1: 118, repro. 119.

1968 Christensen, Erwin O. *A Guide to Art Museums in the United States.* New York: 131, repro.

1968 Cuttler. *Northern Painting*: 411, repro.

1971 Salvini, Roberto, and Hans Werner Grohn. *L'opera pittorica completa di Holbein il giovane.* Milan: 107, no. 120, repro.

1975 NGA: 178, repro. 179.

1976 Walker: 156, no. 174, repro. 157.

1979 Sutton, Denys. "Robert Langton Douglas. Part III." *Apollo* 109: 423–425, repro.

1980 Hand, John Oliver. "The Portrait of Sir Brian Tuke by Hans Holbein the Younger." *StHist* 9: 33–49, repros.

1981 Sutton, Denys. "British Collecting. I. Early Patrons and Collectors." *Apollo* 114: 286, repro. 284.

1983 Fletcher, John, and Margaret Cholmondeley Tapper. "Hans Holbein the Younger at Antwerp and in England, 1526–28." *Apollo* 117: 93.

1985 Rowlands (see Biography): 144–145, no. 64, pl. 102.

1985 NGA: 205, repro.

1988 Rowlands, John. *The Age of Dürer and Holbein: German Drawings 1400–1550.* Exh. cat., British Museum. London: 238, under no. 206.

1989 Ford, Boris, ed. *The Cambridge Guide to the Arts in Britain.* Vol. 3. *Renaissance and Reformation.* Cambridge: 230, repro. 231.

1992 Cherry, John. "The Milton Keynes Gold Cross." *Minerva* 3 (May/June): 34–36, repro.

Attributed to Hans Holbein the Younger

1961.9.21 (1381)

Portrait of a Young Man

c.1520/1530
Linden, 23.2 × 18.3 (9⅛ × 7¼);
 painted surface: 22 × 17 (8⅝ × 6¾)
Samuel H. Kress Collection

Technical Notes: The portrait is painted on a single piece of linden[1] with vertically oriented grain, and it has been cradled. The panel has been thinned and scored on the reverse in a diamond-shaped pattern. The presence of a barbe along all four edges strongly suggests that the panel was painted in an engaged frame. Over the smooth white ground there is a thin layer of a warm pink paint that is visible under the blue background and seems to have been deliberately used to moderate the background color. It is likely, although not verified, that the pink imprimatura is under the figure as well. Underdrawing in the face and hat, apparently executed with a brush, is visible with both the naked eye and infrared reflectography (fig. 1).

A curving crack traverses the length of the panel. There is an associated straight crack, which merges with the curved crack just above the sitter's eyes. There are minor damages to the unpainted borders, including a small loss in the lower right corner. As a result of movement in the panel, there are losses in the ground and the pink imprimatura and corresponding losses in the paint layer. These losses are skillfully inpainted. There is scattered abrasion throughout, and the background has been lightly retouched.

Provenance: Possibly a member of the de Rothschild family, Vienna, from about 1850.[2] Baron Louis de Rothschild, Vienna, probably by inheritance, by 1931–1947;[3] (Rosenberg & Stiebel, New York, put on consignment with M. Knoedler & Co., New York, May, 1947; transferred to Knoedler's regular stock, June 1947, with a portion owned by Rosenberg & Stiebel);[4] purchased 1952 by the Samuel H. Kress Foundation, New York.

Exhibitions: Houston, Museum of Fine Arts, 1950, *Seventeen Masters of Painting*, no. 20, as by Hans Holbein the Younger. Basel, Kunstmuseum, 1960, *Die Malerfamilie Holbein in Basel*, no. 92, as by Ambrosius Holbein.

THE UNIDENTIFIED SITTER, shown in bust length, is fashionably but somewhat casually dressed. Over his pleated shirt he wears a robe of a pinkish orange *couleur changeant* that is untied and open at the front. The young man wears a bright red-orange cap with a brim that is notched

Fig. 1. Infrared reflectogram assembly of a detail of *Portrait of a Young Man*, 1961.9.21 [infrared reflectography: Molly Faries]

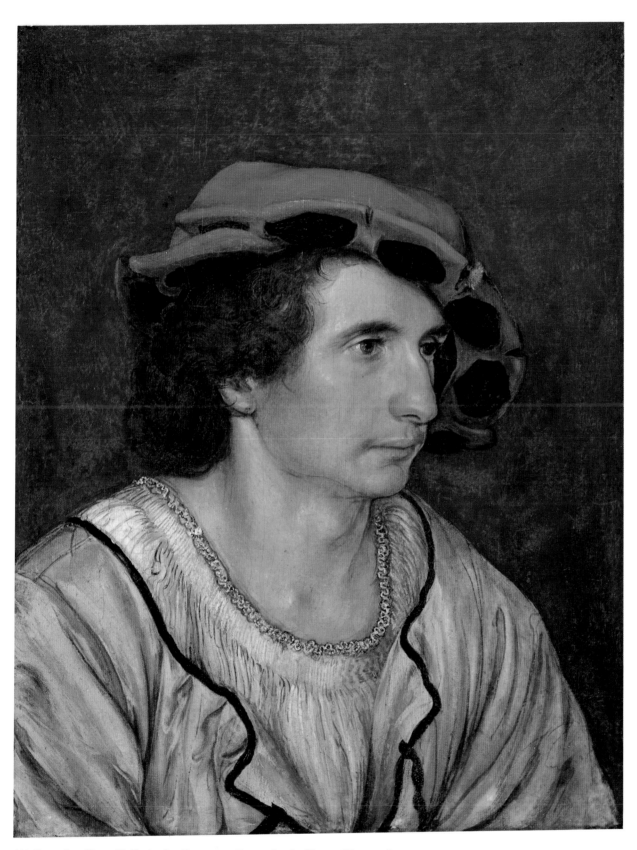

Attributed to Hans Holbein the Younger, *Portrait of a Young Man*, 1961.9.21

and enlivened by a black fabric passed through the slashings. There is also a small pink flower in the hat. A skillful technician, the artist also demonstrates great sensitivity to private emotional states in capturing the young man's alert yet pensive expression. As indicated by its unpainted edges, the painting has not been altered, and its relatively small size and informality suggest that it might have functioned as a kind of "friendship portrait" or might even indicate that the artist and sitter were well acquainted.

The attribution and, to a lesser degree, the date of the *Portrait of a Young Man* have been the subject of discussion and disagreement. When the painting was in the de Rothschild collection, it was apparently attributed to Ambrosius Holbein but first published by Baldass as an early work by Hans Holbein the Younger, dating to 1516.[5] While noting some affinities to Ambrosius, Schmid concurred with Baldass' attribution but placed the picture later in date.[6] About the same time Friedländer and Hugelshofer also gave the painting to Hans the Younger and dated it c. 1520.[7] This was the attribution and date adopted by the National Gallery from 1956 on.[8]

For some critics the idea that the portrait might be by Hans' older brother, Ambrosius, continued to be a viable possibility.[9] In 1960 the *Portrait of a Young Man* was exhibited in Basel as by Ambrosius, though in the text of the catalogue entry Paul-Henry Boerlin discounted the authorship of either Hans or Ambrosius and instead dated the picture around the middle of the sixteenth century.[10] Eisler cites Boerlin as later believing the portrait to be contemporaneous with the work of Swiss artist Tobias Stimmer (1539–1584).[11]

Ganz rejected the attribution to Hans Holbein the Younger, and more recently Eisler, Rowlands, and Falk have raised serious doubts about this ascription.[12] For Eisler, the *Portrait of a Young Man* had affinities to both Hans and Ambrosius but was not wholly compatible with either. He suggested instead that the portrait was produced by an anonymous artist working in a style close to that of Hans Holbein the Younger, probably active in Basel in the first third of the sixteenth century, but also linked to the Danube School. Noting that superficially the painting had the look of a Hans Holbein around 1520, Rowlands found Eisler's as-

sessment to be plausible. Falk also did not find the attribution to Hans convincing and suggested that the style was influenced by Hans Holbein the Younger but that the portrait was painted by an artist from Basel or the Upper Rhine.

On the basis of costume and style there would appear to be no justification for the date around mid-century proposed by Boerlin. Instead, it seems more likely that the picture was painted c. 1520/1530, as suggested by Hugelshofer, Eisler, and others.[13] Moreover, the attribution of the *Portrait of a Young Man* to Ambrosius Holbein can be eliminated on stylistic grounds. Comparison with Ambrosius' one secure portrait, the depiction of a young man in an architectural setting, monogrammed and dated 1518 (Hermitage, St. Petersburg), as well as with other portraits attributed to him, reveals a very different temperament.[14] Ambrosius' forms tend to be softer and rounder, his color harmonies warmer, and his sitters imbued with an almost dreamlike calm. As noted by Baldass, the National Gallery's portrait lacks Ambrosius' "schläfrige Haltung."[15]

At first glance there would seem to be much to recommend the attribution of the *Portrait of a Young Man* to Hans Holbein the Younger. There are parallels to works from Holbein's first Basel period, including the portraits of *Jacob Meyer zum Hasen* and his wife, *Dorothea Kannengiesser*, dated 1516, or the portrait of *Bonifacius Amerbach*, dated 1519 (all Kunstmuseum, Basel).[16] For many authors, as initially stated by Baldass, the painting is so masterful that it must be by Hans, especially if Ambrosius is eliminated as a candidate.

On closer examination, however, the arguments and observations of Eisler, Rowlands, and Falk become more convincing. What Falk aptly termed the "unclassical liveliness" of the portrait, the direct emotional engagement with the sitter, is alien to Hans Holbein's detached objectivity. The exception is the 1528 portrait of the artist's wife and two children (Kunstmuseum, Basel).[17] Moreover, both the plain background, devoid of landscape or architecture, and the bright orange *couleur changeant* of the robe are unusual for Holbein at this time. The first secure portrait by Holbein with a neutral background is the portrait of *Erasmus of Rotterdam*, c. 1523 (Kunstmuseum,

Basel).[18] Admittedly, a *couleur changeant* fabric appears as part of the robe in Holbein's portrait of *Johannes Zimmermann (Xylotectus)*, dated 1520 (Germanisches Nationalmuseum, Nuremberg), but the picture's color scheme is much more sober and the attribution to Hans questioned by Rowlands, who believes the portrait was begun by Ambrosius and finished by someone else.[19] Moreover, in neither instance is the manner of painting the same as in the Washington portrait, which is distinguished from the others not only by mood but also by the very fine strokes of dark paint made with a nearly dry brush seen in the robe and the sitter's hair.

Although the attribution of the *Portrait of a Young Man* to Hans Holbein the Younger is questionable, there are no known followers of Holbein in Basel in the 1520s to whom the painting might be assigned. One can only note the existence in Basel of earlier portraits with the same format, specifically the depictions of *Jakob Meyer zum Pfeil(?)* and *Bernhard Meyer zum Pfeil(?)*, dated 1511 and 1513, respectively (Kunstmuseum, Basel).[20] Given the high quality of the painting, the proximity to Holbein, and the dearth of comparative material, the likelihood that the National Gallery's portrait is by Hans Holbein the Younger must be retained along with the possibility that it is by an anonymous artist working under his influence.

Notes

1. The wood was identified by the National Gallery's scientific research department.

2. Not verified, but likely; stated in Baldass 1931, 61, and in M. Knoedler & Co. invoice, 6 February 1952, in NGA curatorial files.

3. As reported in the *Illustrated London News* (7 July 1945), 24–25, the painting was to be sent to a museum of German art in Linz, but it is not clear whether Hitler was in physical possession of this and other paintings from the Louis de Rothschild collection.

4. Gerald G. Stiebel, Rosenberg & Stiebel, letter to the author, 10 April 1987, in NGA curatorial files; Nancy C. Little, M. Knoedler & Co., letter to the author, 2 March 1988, in NGA curatorial files; I am grateful to Ms. Little for access to stockbooks and files; report of the Provenance Index, J. Paul Getty Trust, Santa Monica, in NGA curatorial files.

5. Baldass 1931, 61–62.

6. Schmid 1948, 69.

7. Max J. Friedländer, certificate on the reverse of a photograph, 13 February 1947, in NGA curatorial files; Hugelshofer 1949, 67–70.

8. Kress 1956, 106, cites the unpublished opinions of Paul Ganz, Georg Swarzenski, and Jakob Rosenberg as favoring the attribution to Hans Holbein.

9. Although Grohn 1966, 260, is the only one to publish the painting as by Ambrosius, others have commented with varying degrees of confidence; J. Nieuwstraten, memorandum of conversation with Charles Parkhurst, 1973, in NGA curatorial files, thought the portrait certainly was by Ambrosius; John Rowlands, letter to the author, 10 June 1976, in NGA curatorial files, cautiously favored Ambrosius; and Gisela Goldberg, conversation with the author, 10 May 1988, suggested that the portrait might be by Ambrosius.

10. Exh. cat. Basel 1960, 134, no. 92.

11. Eisler 1977, 33.

12. Ganz 1950, v; Eisler 1977, 32–33; Rowlands 1985 (see Biography), 237; Tilman Falk, letter to the author, 31 January 1990, in NGA curatorial files. Moreover, in reviewing Eisler's catalogue, Blunt 1977, 392, termed the painting a "border-line Holbein," while Young 1977, 153, thought it was probably by a later imitator.

13. Hugelshofer 1949, 69, proposed a date around 1520; Falk, letter to the author, 31 January 1990, thought it could not be earlier than 1520/1525; Christiane Andersson, conversation with the author, 29 December 1989, dated the painting in the 1520s, comparing the stylish costume to that found in the works of the fashion-conscious Swiss artist Urs Graf (c. 1485–1528/1529).

14. Nikolai N. Nikulin, *German and Austrian Painting Fifteenth to Eighteenth Centuries: The Hermitage Catalogue of Western European Painting* (Moscow and Florence, 1987), 79–80, repro.; Nikolai Nikulin and Boris Asvarishch, *The Hermitage: German and Austrian Painting* (Leningrad, 1986), color pls. 13–14. Other portraits generally attributed to Ambrosius include pendant portraits of *A Boy with Brown Hair* and *A Boy with Blonde Hair*; *Hans Herbster*, dated 1516; *Jörg Schweiger(?)* (all Kunstmuseum, Basel). *The Portrait of a Man in a Red Hat* (Hessisches Landesmuseum, Darmstadt) has been attributed to both Hans and Ambrosius; Rowlands 1985 (see Biography), 228–229, no. R6, gives it to Ambrosius. Several portrait drawings are attributed to Ambrosius. For Ambrosius Holbein see Willy Hes, *Ambrosius Holbein* (Strasbourg, 1911); Otto Fischer, "Ambrosius Holbein," *Pantheon* 20 (1937): 306–313; *Die Malerfamilie Holbein in Basel* [exh. cat., Kunstmuseum] (Basel, 1960), 115–164, nos. 80–130; Grohn 1966, 257–260.

15. Baldass 1931, 61.

16. Rowlands 1985 (see Biography), 125, no. 2, color pls. 12–13, pls. 2–3; 126, no. 7, color pl. 11, pl. 8.

17. Rowlands 1985 (see Biography), 135, no. 32, color pl. 18, pls. 62–64.

18. Rowlands 1985 (see Biography), 130, no. 16, pl. 29.

19. Rowlands 1985 (see Biography), 229, no. R.8, pl. 212, noting that while most authorities attribute the portrait to Hans they do so with doubts and reservations. The association between the Nuremberg portrait and the National Gallery's, particularly in the coloristic effects, was noted by Hugelshofer 1949, 69.

20. See *Kunstmuseum Basel. Katalog. 1. Die Kunst bis 1800* (Basel, 1966), 70–71, inv. nos. 21–22, repros. For a history of Swiss painting see Paul Ganz, *Malerei der Frührenaissance in der Schweiz* (Zurich, 1924), although the attributions are often outdated.

References

1931 Baldass, Ludwig. "Ein Frühwerk Hans Holbeins des Jüngeren." *Kunstchronik und Kunstliteratur. Beilage zur Zeitschrift für bildende Kunst*, 7/8: 61–62, repro.

1945 "A Plan for Loot: Blue-Prints for a New 'House of German Art.' " *Illustrated London News* (7 July): 25, repro.

1948 Schmid, Heinrich Alfred. *Hans Holbein der Jüngere. Sein Aufstieg zur Meisterschaft und sein englischer Stil.* 3 vols. Basel, 1: 69.

1949 Hugelshofer, Walter. "Die Anfänge Hans Holbeins des Jüngeren als Bildnismaler." *Phoebus* 2: 60, 67–70, repro.

1950 Ganz, Paul. *The Paintings of Hans Holbein: First Complete Edition.* London: v.

1956 Kress: 106, no. 38, repro. 107.

1960 Broadley: 36, repro. 37.

1961 Baldass, Ludwig. "Offene Fragen auf der Basler Holbein Ausstellung von 1960." *Zeitschrift für Kunstwissenschaft* 15: 87, repro. 88.

1961 Seymour (Kress): 90, repro., 212.

1966 Grohn, Hans Werner. "Holbein, Ambrosius." *Kindlers.* 3: 260.

1971 Salvini, Roberto, and Hans Werner Grohn. *L'opera pittorica completa di Holbein il giovane.* Milan: 87–88, no. 15, repro.

1975 NGA: 178, repro. 179.

1976 Walker: 158, no. 176, repro.

1977 Blunt, Anthony. Review of Eisler 1977. In *Apollo* 105: 392.

1977 Eisler: 32–33, fig. 16.

1977 Young, Eric. Review of Eisler 1977. In *Conn* 195: 153.

1985 NGA: 205, repro.

1985 Rowlands (see Biography): 237, no. R.42, pl. 250.

Johann Koerbecke

c.1420–1491

JOHANN KOERBECKE is first documented in 1443 when he and his wife purchased his father's house in the northwestern German city of Münster. It has been suggested that Johann was born around 1420 and first studied with his father, Hinrick Koerbecke, or with another local artist in the 1430s before taking over the workshop when his father died around 1442. Unfortunately nothing is known of Hinrick's work; he may have come from the nearby town of Coesfeld and was in the house in Münster by 1435.

Between 1453 and 1484 Johann Koerbecke is mentioned several times in Münster documents. He often acted as a witness, as, for example, in a 1471 marriage contract or the 1484 sale of land involving the Cistercian cloister at Marienfeld. Around 1460 "Joannes Koerbecke, de meler," was listed as a member of the Confraternity of Our Lady of the Church of Saint Aegidius. Koerbecke died in Münster on 13 June 1491; his necrology stated that he came from Coesfeld, a reference to either his birthplace or his family's origins. He was survived by his wife, Else, and two sons, Hinrick and Hermann. His widow apparently maintained the house and workshop until at least 1495. Hermann followed in his father's profession, while Hinrick became a cleric.

Koerbecke's magnum opus, the Marienfeld altarpiece, is documented to 1456/1457 and is the starting point for the analysis of the artist's style. Other works mentioned as having been done for the Cistercian cloister, such as a painting of Saints Philip and James, have not survived. Dated early, c. 1445, is the series of eight panels depicting the Passion of Christ (Westfälisches Landesmuseum für Kunst und Kulturgeschichte, Münster) that came from the church of the Augustinian nuns in Langenhorst. The artist's style c. 1470/1480 is represented by *John the Baptist and Saint George* and *Saint Christopher* (Westfälisches Landesmuseum für Kunst und Kulturgeschichte, Münster),

portions of an altarpiece formerly in a church in Freckenhorst. Several paintings in the style of, but not wholly from the hand of the master, such as the *Crucifixion* altarpiece, also in the museum in Münster, are evidence of the activity of Koerbecke's workshop.

Koerbecke is the outstanding painter in Westphalia at mid-fifteenth century. What sets him and his compatriots, the Master of Schöppingen and the Master of Iserlohn, apart from the "soft" style of the preceding generation is the hard-edged realism of their figures and landscape settings as well as the influence of neighboring schools of painting in Cologne and the Netherlands, in particular that of Stefan Lochner and Robert Campin.

Bibliography

Sommer, Johannes. *Johann Koerbecke. Der Meister des Marienfelder Altares von 1457*. Münster, 1937.
Prinz, Joseph. "Urkundliches zur Geschichte der Malerfamilie Koerbecke." *Westfalen* 26 (1941), 99–102.
Kirchhoff, Karl-Heinz. "Maler und Malerfamilien in Münster zwischen 1350 und 1534." *Westfalen* 55 (1977), 98–110.

1959.9.5 (1528)

The Ascension

1456/1457
Oak, 92.7 × 64.8 (36½ × 25½)
Samuel H. Kress Collection

Technical Notes: The painting is composed of three boards with vertically oriented grain. Reading from left to right, the boards measure 32.4, 21.65, and 12.5 cm. across. The boards have been thinned. The painting has been cradled, and a wax coating applied. A dendrochronological examination conducted by Peter Klein indicated that the boards came from the same tree, which was probably felled 1410^{+6}_{-4}. The gold background was applied over a red bole, and various punches were used to form halos, rays, and what seem

Fig. 1. Infrared reflectogram assembly of a detail of *The Ascension*, 1959.9.5 [infrared reflectography: Molly Faries]

to be tongues of flame. A faint incised line defines the major contours and the rocks. The figures' draperies were apparently painted before their hands, and there is a certain amount of overlapping paint in these areas. Examination with infrared reflectography reveals underdrawing in what appears to be a liquid medium. In the draperies there are changes between the underdrawn outlines and the paint layer (fig. 1) and alterations in the placement of Saint Peter's eye and nose (fig. 2). A painted edge approximately 1 cm. wide on the left, top, and right is reddish brown or orange in color; similar edges are found in other panels from the altarpiece.[1]

In general the painting is in very good condition. The gilding has a fine overall craquelure and some restoration at the extreme left. Only a few discrete losses and retouchings are apparent in the painted areas, with the greatest amount of inpainting occurring in the robes of Christ, the Virgin, and Saint Peter. Unspecified restorations of the altarpiece are recorded as having taken place in 1516/1517 and 1533/1534, but there is no indication as to what degree the National Gallery's panel was affected, if at all.[2]

Provenance: Part of the high altar in the abbey church of the Cistercian cloister at Marienfeld, near Münster, completed in 1456/1457, installed 6 February 1457, until 1803.[3] Charles Léon Cardon, Brussels, by 1912.[4] Rudolph Chillingworth, Lucerne, Brussels, and Nuremberg (sale, Galeries Fischer and Frederik Muller & Cie., Lucerne, 5 September 1922, no. 47). Possibly private collection, Basel.[5] (Julius Böhler, Munich, by 1934). Jacob Walter Zwicky, Freiburg and Arlesheim-Basel, by 1937(?);[6] (M. Knoedler & Co., New York, 1955, owned with Pinakos [Rudolf Heinemann]);[7] purchased 1957 by the Samuel H. Kress Foundation, New York.

Exhibitions: Brussels, Palais Goffinet, 1912, *Exposition de la miniature*, no. 2051, as "Anonyme (Ecole de Souabe, XV siècle)." Zurich, Kunsthaus, 1921, *Gemälde und Skulpturen 1430–1530. Schweiz und angrenzende Gebiete*, no. 46. Munich, Julius Böhler, 1934, *Ausstellung. Altdeutsche Kunst*, no. 38. Bern, Kunstmuseum, 1944–1945, *Gemälde und Zeichnungen alter Meister. Kunsthandwerk aus Privatbesitz*, no. 11. Münster, Landesmuseum, 1952, *Westfälische Maler der Spätgotik 1440–1490*, no. 57.

THE *Ascension* was originally part of one of the major monuments of painting in Westphalia, Johann Koerbecke's Marienfeld altarpiece. The work was commissioned for the high altar of the church of the Cistercian abbey at Marienfeld, near Münster, by Arnold von Bevern, abbot between 1443 and 1478. The coats-of-arms of von

Bevern, the Cistercian Order, and the bishopric of Münster appear on *The Annunciation* panel (Art Institute of Chicago). A partial but apparently final payment to Koerbecke for the panels of the altarpiece occurs on the reverse of a list of goods, dated 1456, at Marienfeld.[8] The chronicle completed in 1715 by Pater Hermann Hartmann (d. 1719) provides important information about the history and appearance of the altarpiece: it was installed on 6 February 1457 and consecrated on the day after the feast of the birthday of John the Baptist, that is, 25 June 1458.[9]

The Cistercian Order placed special emphasis on the veneration of the Virgin, thus it is not surprising to learn that the center of the high altar at Marienfeld was a reliquary screen containing at its center a statue of a seated *Madonna and Child* (still in the parish church at Marienfeld),[10] surrounded by twenty-four reliquaries of the virgin companions of Saint Ursula. Arranged in two zones, in two groups of six per zone, these reliquaries have not survived but seem to have been busts with skulls in niches. On the exterior wings were a series of eight panels depicting the Passion of Christ, while the eight panels on the inner wings represented scenes from the life of the Virgin. When open, the original altarpiece is estimated to have measured 2.2 by 6.4 meters. The altar would have been opened only on Sundays and feast days but would have presented the celebrants of the Mass with a dazzling display of light and color. The shimmering gold backgrounds of the inner panels and the gilding of the center panel, the statue, and the reliquaries were, as reported by Hartmann, still brilliant in 1715.

The altarpiece was not intact when it was seen by Hartmann, however, for during the rule of Abbot Johannes Stades (1661–1681) the altar was

Fig. 2. Infrared reflectogram assembly of a detail of *The Ascension*, 1959.9.5 [infrared reflectography: Molly Faries]

dismantled and put into a baroque frame, the empty altar screen hung in the choir, and the fronts and backs of the painted panels separated and hung in a room of the cloister.[11] In 1803 the cloister at Marienfeld was secularized, and by February of the following year a group of paintings had been selected for auction. On 25 February 1804 the Münster artist Johann Christian Rincklake (1764–1813) wrote a certificate of valuation requesting that the sixteen panels of the Marienfeld altarpiece, along with other works, be exempted from auction.[12] The panels were to be sent to the Akademie der bildenden Künste, Berlin, but never arrived and were mysteriously dispersed; by 1836 one of them was in the possession of a dealer in Avignon.[13]

The sequence of the panels has been reconstructed as follows:

Inner left wing (page 108):

The Presentation of the Virgin	The Annunciation
The Nativity	The Adoration of the Magi[14]

Inner right wing (page 109):

The Presentation in the Temple	Christ and the Virgin Enthroned in Heaven
The Ascension	The Assumption of the Virgin

Outer left wing (p. 110):

Christ Carrying the Cross	The Crucifixion
The Arrest of Christ	Christ before Pilate

Outer right wing (p. 111):

The Entombment	The Resurrection
The Mocking of Christ	Christ at the Column

In its combination of carved and painted sections, the Marienfeld altarpiece was typical of many fifteenth-century northern European altarpieces, and while the iconographic program is far from unique, it is interesting that the work most often compared to it, the *Seven Joys of the Virgin* altarpiece, c. 1480 (Musée du Louvre, Paris, and Germanisches Nationalmuseum, Nuremberg), by the Master of the Holy Kindred, came from a Benedictine cloister in Cologne.[15]

The National Gallery's panel, depicting the As-

cension, would have occupied the lower left portion of the inner wing. Christ's last appearance on earth and ascent into heaven is mentioned only briefly in the Bible, in Luke 24:50–51, where Christ blesses his disciples, and Acts 1:9–12, which locates the event on the Mount of Olives and states that Christ was carried out of sight on a cloud. Later, apocryphal recountings of the life of Christ elaborated on these terse accounts.[16]

The bottom half of the Washington painting is occupied by the Virgin, the only figure with a halo, and the apostles. Although strictly speaking Matthias had yet to be chosen to replace Judas, the apostles are twelve in number here. The youthful John the Evangelist kneels next to the Virgin and holds her;[17] the kneeling figure in the right foreground is usually identified as Peter with Paul immediately behind him. The remaining apostles are undifferentiated. The motif of Christ's footprints indelibly impressed into the rock appears in late medieval representations of the Ascension and, as noted by Broadley, may refer to the prophecy in Zechariah 14:4: "On that day his feet shall stand on the Mount of Olives which lies before Jerusalem on the east."[18]

In the center of the upper zone Christ, seated on a cloud, raises one hand in blessing and holds the red banner of Resurrection with the other. The gold background is arched at the top, and in the

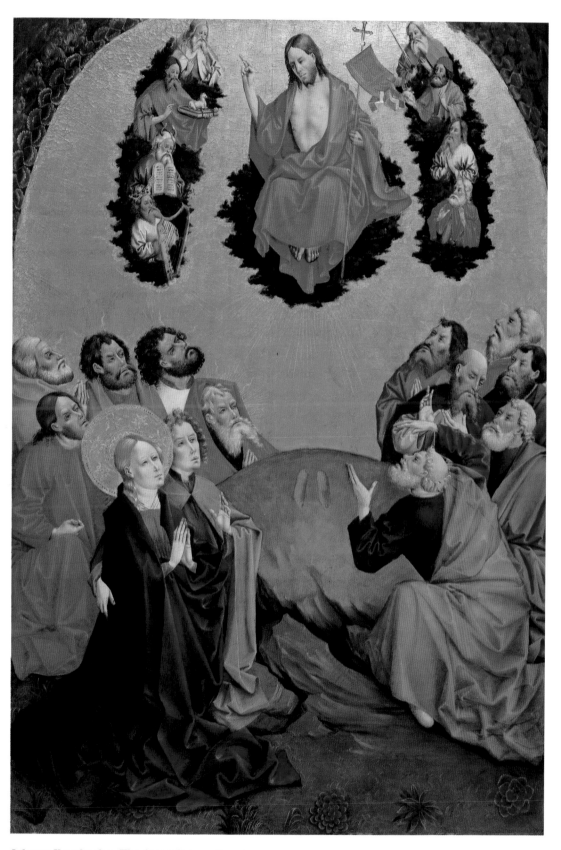

Johann Koerbecke, *The Ascension*, 1959.9.5

*Inner
left wing*

The Presentation of the Virgin, panel, Muzeum
Narodowe w Krakowie [photo: Muzeum
Narodowe w Krakowie]

The Annunciation, canvas transferred from panel,
The Art Institute of Chicago, Mr. and Mrs. Martin A.
Ryerson Collection [photo: The Art Institute of
Chicago]

The Nativity, panel, Germanisches
Nationalmuseum, Nuremberg [photo:
Germanisches Nationalmuseum]

The Adoration of the Magi (lost)

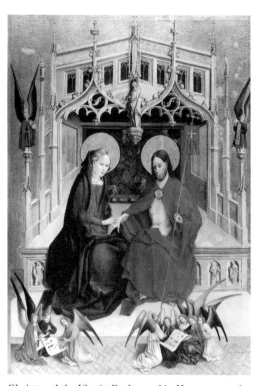

The Presentation in the Temple, panel,
Westfälisches Landesmuseum für Kunst und
Kulturgeschichte, Münster [photo: Westfälisches
Landesmuseum für Kunst und Kulturgeschichte]

Christ and the Virgin Enthroned in Heaven, panel,
Westfälisches Landesmuseum für Kunst und
Kulturgeschichte, Münster [photo: Westfälisches
Landesmuseum für Kunst und Kulturgeschichte]

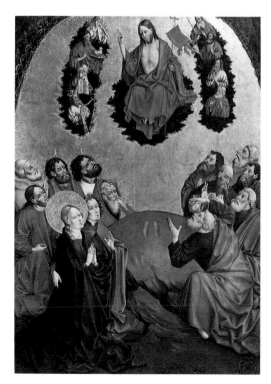

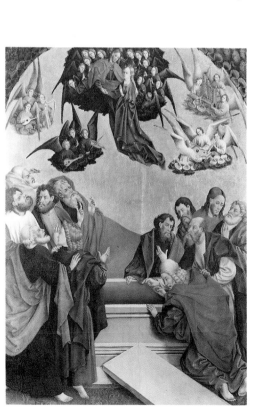

The Ascension, 1959.9.5

The Assumption of the Virgin, canvas over panel,
Thyssen-Bornemisza Collection, Lugano [photo:
Thyssen-Bornemisza Collection]

*Outer
left wing*

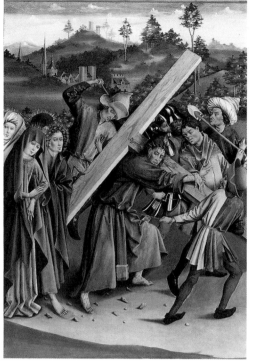

Christ Carrying the Cross, canvas over panel,
Gemäldegalerie, Berlin [photo: Jörg P. Anders]

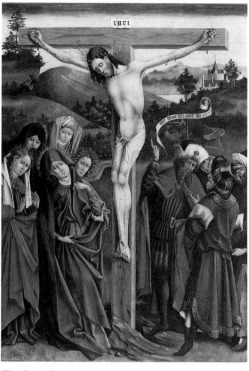

The Crucifixion, canvas over panel,
Gemäldegalerie, Berlin [photo: Jörg P. Anders]

The Arrest of Christ, panel, Westfälisches
Landesmuseum für Kunst und Kulturgeschichte,
Münster [photo: Westfälisches Landesmuseum für
Kunst und Kulturgeschichte]

Christ before Pilate, panel, Westfälisches
Landesmuseum für Kunst und Kulturgeschichte,
Münster [photo: Westfälisches Landesmuseum für
Kunst und Kulturgeschichte]

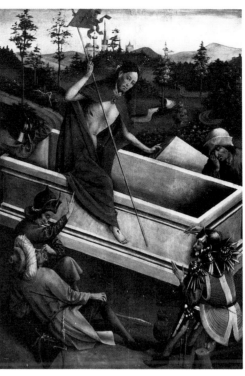

The Entombment, panel, Westfälisches
Landesmuseum für Kunst und Kulturgeschichte,
Münster [photo: Westfälisches Landesmuseum für
Kunst und Kulturgeschichte]

The Resurrection, panel, Musée Calvert, Avignon
[photo: Musée Calvert, Avignon]

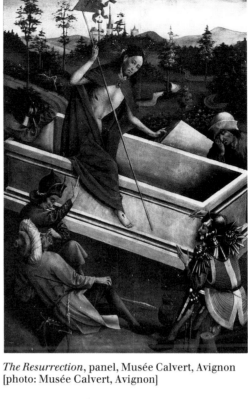

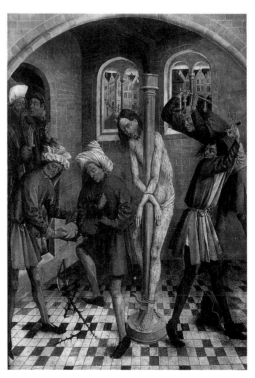

The Mocking of Christ, panel, Westfälisches
Landesmuseum für Kunst und Kulturgeschichte,
Münster [photo: Westfälisches Landesmuseum für
Kunst und Kulturgeschichte]

Christ at the Column, panel, Pushkin Museum of
Fine Arts, Moscow [photo: Pushkin Museum of
Fine Arts]

spandrels cloud motifs and welcoming angels are delicately painted in white on the blue sky. The bust-length figures on either side of Christ are thought to represent those persons that he took out of Limbo and brought with him into heaven. At the left, starting at the top, are: Aaron with a flowering branch; John the Baptist holding a lamb on a book; Moses with the tablets of the Law; and David wearing a crown and holding a harp. The figures on the right are less easily identified: the figure at the top holding a sword is usually considered to be Joshua, but might also be Paul;[19] below him is Gideon holding a fleece. The bottom two figures lack identifying attributes, but it has been plausibly suggested that they are Enoch and Elijah, both of whom were miraculously translated into heaven and both appear as typological prefigurations of the Ascension of Christ.[20] Other possibilities suggested by Eisler are Jeremiah, Jacob, and Zechariah.[21]

As observed by Luckhardt, the arrangement of the inner panels, with the exception of the *Annunciation*, follows the sequence of the liturgical calendar.[22] The Ascension is celebrated forty days after Easter and ten days before Pentecost. Eisler suggested that what appear to be tongues of flame tooled into the gold over the heads of the apostles refer to Pentecost and the descent of the Holy Spirit.[23] It must also be kept in mind that the inner wings of the Marienfeld altarpiece constitute a Marian cycle, and the prominent place given to the Virgin in *The Ascension* directly relates to the next and final panel in the series, *The Assumption of the Virgin*. Luckhardt has demonstrated how, in paralleling the Ascension and the Assumption, popular devotional texts such as the *Vita Christi* of Ludolphus of Saxony or the *Meditations on the Life of Christ* by Pseudo-Bonaventura underscored the identification of Christ with the Bridegroom allied with Mary as Bride and as Ecclesia.[24]

It doubtless took several years to paint all the panels of the Marienfeld altarpiece, and Sommer put the beginning of the work at c. 1450.[25] Stange saw a process of stylistic development within the inner panels that seemed to follow the narrative sequence; *The Presentation of the Virgin* is rather tentatively painted and is close to trecento models, while *The Ascension* and *The Assumption of the Virgin* achieve greater monumentality and

expressiveness.[26] As a mature work, *The Ascension* exemplifies the new, more realistic style that typifies both Koerbecke and Westphalian painting around mid-century. Colors are clear, of medium value, and limited to red, blue, yellow-green, and light red; outlines are firm, and details such as hair and facial features are crisp and linear. Both the composition and individual figures are endowed with clarity and solidity.

Notes

1. As, for example, on *The Presentation in the Temple* and *Christ and the Virgin Enthroned in Heaven* (both Westfälisches Landesmuseum für Kunst und Kulturgeschichte, Münster), which are also from the inner wing of the altarpiece. The outer wings have orange painted edges with gold floral motifs on the bottom edges.

2. Sommer 1937 (see Biography), 14, citing the documents in the Staatsarchiv, Münster, Marienfelder Akten, I, 15b, 15d.

3. See notes 11–12.

4. Exhibited with the Cardon collection in Brussels, 1912 (see Exhibitions).

5. Unverified, but listed as such by Hugelshofer 1926/1927, 179; Lippe 1927, 175; and Hugelshofer 1930, 373.

6. Sommer 1937 (see Biography), 16, no. 7, listed the painting as being in a private collection in Basel.

7. Joint ownership confirmed by Melissa De Medeiros, librarian, M. Knoedler & Co., letter to the author, 7 March 1989, in NGA curatorial files.

8. Staatsarchiv, Münster, Urkunde Marienfeld, no. 1040, the notice written by Johannes Alen, bursar, on the reverse of p. 6 of a *Güterverzeichnis* for the year 1456 also includes mention of a payment to Koerbecke for a window, but the relevant portion reads: "Sunder do de tafele uppe unsen oversten altare reyde was" (cited in full in Sommer 1937 [see Biography], 9–10). See also Rensing 1933, 262, 264.

9. J. B. Nordhoff, "Kunstzustände eines reichen Klosters um 1700," *RfK* 5 (1882), 305–310. Hartmann was a monk at the Marienfeld cloister for eighteen years, and his chronicle covers the years 1610–1715; see J. B. Nordhoff, "Der Churfürst Friedrich III. erwirbt ein Tafelgemälde," *Zeitschrift für preussische Geschichte und Landeskunde* 18 (1881), 576–577; see also Jos. Wigger, *Antiquitates et inscriptiones Campi Sanctae Mariae. Eine Handschrift über das Kloster Marienfeld aus dem Jahre 1715* (Warendorf, 1898), 14.

10. Reproduced in Luckhardt 1987, 7.

11. Sommer 1937 (see Biography), 17–18, cites Hartmann's description in Latin and provides a German translation. Luckhardt 1987, 24, 34, notes the tradition of reliquary altars in the Cistercian Order and reproduces two examples from the fourteenth century.

12. Alb. Wormstall, "Zur Geschichte der Liesborner und Marienfelder Altargemälde," *Zeitschrift für vaterländische Geschichte und Alterthumskunde* 55 (1897), 90–92, with Rincklake's "Gutachten" cited, 99–102; see also Sommer 1937 (see Biography), 11–12.

13. The painting in question, *The Resurrection*, was with the dealer Guérin and acquired in the same year by Musée Calvet, Avignon; see Sommer 1937 (see Biography), 16, no. 8.

14. Pieper 1952, 93, under no. 54, suggested that this was the panel listed by Rincklake as broken through the middle; see Wormstall 1897, 100.

15. Stange *DMG*, 5 (1952): 75–77, figs. 151–153; Stange 1967, 1: 90, no. 262; the center panel in Paris from the *Seven Joys of the Virgin* altarpiece contains scenes of *The Adoration of the Magi, The Presentation in the Temple*, and *Christ and the Virgin Enthroned in Heaven*. The inner wings in Nuremberg depict *The Annunciation* and *The Nativity* (left), and *The Ascension* and *The Assumption of the Virgin* (right). The outer wings, two of which are destroyed, depict scenes from the Passion of Christ. This altarpiece and the Marienfeld panels are often discussed together, not only because of their iconographic programs but also in terms of a joint dependency on Stefan Lochner, in particular Lochner's *Presentation in the Temple* (Hessisches Landesmuseum, Darmstadt). See Brand 1938, 26–35; Pieper 1952, 94–95; Stange *DMG*, 6 (1954), 17–18; Pieper 1986, 167, 173–175; and a cautious discussion by Luckhardt 1987, 15–18, who notes both the hypothetical nature of Brand's reconstruction and the theological and monastic connection between Cologne and Marienfeld.

16. See Ernest T. Dewald, "The Iconography of the Ascension," *American Journal of Archaeology* 19 (1915), 277–319; Sophie Helena Gutberlet, *Die Himmelfahrt Christi in der bildenden Kunst von den Anfängen bis ins hohe Mittelalter* (Strasbourg, 1935), especially 243–257; Réau, *Iconographie*, vol. 2, pt. 2 (1957), 582–590; A. A. Schmid, "Himmelfahrt Christi," *LexChrI*, 2: cols. 268–276.

17. Eisler 1977, 4, sees this gesture as reflecting Christ's admonition to John and the Virgin in John 19: 26–27 to care for each other as mother and son.

18. Broadley 1960, 16.

19. Paul is tentatively suggested by Adelheid Heimann, Warburg Institute, London, letter to Colin Eisler, 26 December 1968, in NGA curatorial files.

20. Broadley 1960, 16; Enoch and Elijah are specifically mentioned in Pseudo-Bonaventura's account of the Ascension: see Isa Ragusa and Rosalie B. Green, *Meditations on the Life of Christ: An Illustrated Manuscript of the Fourteenth Century* (Princeton, 1961), 375; for the typology of the Ascension see Schmid, "Himmelfahrt Christi," col. 276.

21. Eisler 1977, 5 n. 4; both Eisler 1977, 4, and Pieper 1953, 94, note compositional and thematic similarities to representations of the Last Judgment.

22. Luckhardt 1987, 23–24, suggests that the chronological sequence can be maintained if *The Annunciation* is associated with the Immaculate Conception, even though the feast day of 8 December was not officially sanctioned until much later.

23. Eisler 1977, 4–5, notes that in German cycles of the Life of Christ a depiction of Pentecost often follows that of the Ascension, and for Marian cycles the two events may be conflated.

24. Luckhardt 1987, 18–24; the connection with the writings of Ludolphus of Saxony was put forward by Sommer 1937 (see Biography), 26. In addition to Ragusa and Green 1961, see Albert Lecoy de la Marche, ed., *Vie de Jésus-Christ composée au XVᵉ siècle d'après Ludolphe le Chartreux* (Paris, 1870), especially 189–195; and C. C. de Bruin, ed., *Tleven Ons Heren Ihesu Christi. Het Pseudo-Bonaventura-Ludolfiaanse leven van Jesus* (Leiden, 1980), especially 211–217. For the image of the Bride and Bridegroom and Mary as the Church see O. Gillen, "Bräutigam u. Braut," *LexChrI*, 1: cols. 318–324; and Gertrud Schiller, *Ikonographie der christlichen Kunst*, 4 vols. (Gütersloh, 1966–1980), vol. 4, pt. 1, "Mater Ecclesia," 84–89, "Eva-Ekklesia-Typologie," 89–92, and "Braut-Bräutigam (Sponsa-Sponsus)," 94–102.

25. Sommer 1937 (see Biography), 36.

26. Stange *DMG*, 6 (1954), 18–19; he also sees the Passion of Christ on the exterior as falling stylistically between the beginning and the end of the inner wings.

References

1922 Biermann. "Die Sammlung Chillingworth. Versteigerung am 5. September in Luzern." *Der Cicerone* 14: 663.

1926/1927 Hugelshofer, Walter. "Der Hochaltar von 1457 des Klosters Marienfeld in Westfalen." *Zeitschrift für bildende Kunst* 60: 179, repro. 181.

1927 Lippe, M. "Koerbecke, Johann." Thieme-Becker, 21: 175.

1930 Hugelshofer, Walter. "Koerbecke und der Marienfelder Altar von 1457. Ein Beitrag zur Westfälischen Malerei." *Der Cicerone* 22: 373.

1933 Rensing, Theodor. "Ein Beitrag zur Koerbecke-Frage." *Westfalen* 18: 264, repro. 265.

1937 Sommer (see Biography): 16 (no. 7), 20–21, 26, 31–32, pl. x, fig. 16.

1938 Brand, Lotte. *Stephan Lochners Hochaltar von St. Katharinen zu Köln*. Hamburg: 26–28, 40–43, 65, fig. 6.

1940 Busch, Harald. *Meister des Nordens. Die altniederdeutsche Malerei 1450–1550*. Hamburg: 68.

1945 Quensel, P. "Ausstellung alter Meister in Berner Kunstmuseum," *Pro Arte* 4, no. 35 (March): 84, repro. 88.

1952 Pieper, Paul. "Westfälische Maler der Spätgotik 1440–1490. Katalog der Ausstellung des Landesmuseums." *Westfalen* 30: 92–93, no. 57, 94, pl. 17.

1954 Stange *DMG*, 6: 16, 18–19.

1960 Broadley: 16, repro. 17.

1967 Stange, Alfred. *Kritisches Verzeichnis der deutschen Tafelbilder vor Dürer.* 3 vols. Munich, 1: 153, no. 498f.

1975 NGA: 186, repro. 187.

1976 Walker: 147, no. 159, repro.

1977 Eisler: 4–6, fig. 6.

1985 NGA: 217, repro.

1986 Pieper, Paul. *Die deutschen, niederländischen, und italienischen Tafelbilder bis um 1530.* Westfälisches Landesmuseum für Kunst und Kulturgeschichte, Münster. Landschaftsverband Westfalen-Lippe, Bestandskatalogue. Münster: 166, repro. 169.

1987 Luckhardt, Jochen. *Der Hochaltar der Zisterzienserklosterkirche Marienfeld.* Bildhefte des Westfälischen Landesmuseums für Kunst und Kulturgeschichte, no. 25. Münster: 8–9, 21–23, repro. 11.

Nicolaus Kremer

c. 1500–1553

RELATIVELY little is known about Nicolaus Kremer. He married Christina zum Han, a brewer's daughter, in Strasbourg in 1521, acquiring citizenship in that city and joining the artists' guild. Between 1521 and 1547 he is mentioned several times in Strasbourg documents. In 1523 Jost Krieg is listed as a pupil in Kremer's workshop, and in 1531/1532 the artist was paid by the city for two sundials. After the death of his first wife, Kremer in 1538 married Dorothea Büheler, the daughter of a Nuremberg artist living in Strasbourg. Kremer is documented as acquiring in 1545 the artistic estate of Hans Baldung Grien, which included a lock of Albrecht Dürer's hair. It has been suggested that, as a consequence of the Reformation, Kremer left Strasbourg sometime after 1547 and moved to the nearby city of Baden-Baden. He died in 1553, and his gravestone in the town of Ottersweier (Bühl) identifies him as a citizen.

The starting point for Kremer's activity as an artist is a group of six portrait drawings of men, in the print room of the Kunsthalle, Hamburg. One of the drawings bears the artist's name, and others are inscribed with the monogram *NK*, in ligature, and a date. Based on the purchase of Baldung's artistic goods and the attribution to Kremer of a drawing of the *Madonna Adoring the Child*, monogrammed and dated 1519 (Staatsgalerie, Stuttgart) which is clearly derived from Baldung in style and chiaroscuro technique, it is assumed that Kremer was a member of Hans Baldung Grien's workshop. The Stuttgart drawing is, however, quite different from the Hamburg portrait drawings. For painting, the National Gallery's *Portrait of a Nobleman* occupies a position of primary importance. Although Nicolaus Kremer was a figure of some standing in Strasbourg, his oeuvre is imperfectly and incompletely known.

Bibliography

"Kremer (Kraemer), Nicolaus." Thieme-Becker, 21: 494.

Rott, Hans. *Quellen und Forschungen zur südwestdeutschen und schweizerischen Kunstgeschichte im XV. und XVI. Jahrhundert.* 3 vols. Stuttgart, 1933–1938. Vol. 3 (1938). *Der Oberrhein*, 89–100.

Hans Baldung Grien. Exh. cat., Staatliche Kunsthalle. Karlsruhe, 1959.

1947.6.3 (898)

Portrait of a Nobleman

1529
Oak, 59.7 × 44.1 (23½ × 17⅜)
Ralph and Mary Booth Collection

Inscription
At upper left: *1529*
 ⸱NK⸱

Labels
On reverse, inscribed on paper: *Nicolaus Kremer 1529 / certified by Dr. Friedlaender, Wescher/Antique gothic frame 23″ XII/CETT/$12000.*

Marks
On reverse, a resinous seal bearing a coat-of-arms (fig. 1).

Fig. 1. Seal on the reverse of
Portrait of a Nobleman, 1947.6.3

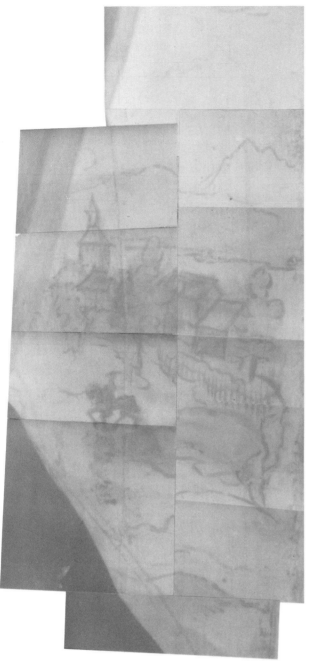

Fig. 2. Infrared reflectogram assembly of a detail of *Portrait of a Nobleman*, 1947.6.3

Technical Notes: The panel is composed of three boards with vertically oriented grain. The dendrochronological examination by Peter Klein yielded information only from the center board and provided a felling date of 1493^{+6}_{-4}. Examination with infrared reflectography revealed underdrawing, probably applied with a brush in a liquid medium, in the curtain folds and the landscape (fig. 2) and in the hands. Several changes are visible in the x-radiograph; the sitter's right hand was originally slightly more to the left, and the left hand was placed parallel to it as if both were holding an object, such as a piece of paper. The right side of the face along the cheek and chin has been enlarged very slightly. Examination of the date and monogram did not disclose adulteration or inpainting. There are several checks in the wooden support running from the top edge along the vertical grain, and the panel has been attacked by worms in several locations, notably the left and right edges. There is retouching throughout, but the greatest concentration of loss and subsequent retouching occurs in the sitter's face and along the checks. An edge of white ground has been left around the sides, presumably to accommodate the frame, but the two vertical edges and the top left and right corners have been reworked using a material denser than the original ground.

Provenance: Madame de L. de L., Paris (sale, Théodore Fischer, Lucerne [with A. Mak, Amsterdam], 27 July 1926, no. 139, as Nicolas Kirberger).[1] Otto B. Schuster, Amsterdam (sale, Sotheby & Co., London, 15 July 1931, no. 109, as Master N. K.); to Means. Mrs. Jacob H. Schiff (sale, American Art Association, Anderson Galleries, New York, 7–9 December 1933, no. 77, as Hans Kirberger[?], bought in?).[2] Dr. Siegfried F. Aram, New York.[3] Ralph Harman and Mary B. Booth, Detroit, by 1938.

THE SITTER, shown in bust length, wears a broad-brimmed hat and a fur-trimmed cloak over a pleated shirt. Behind him is the somewhat unusual device of a curtain that has been pulled aside at the right to reveal a landscape containing a few buildings and a horse and rider. There are no clues to the sitter's identity, such as inscriptions or coats-of-arms, neither is there any way of knowing whether the painting had a female pendant or existed as an independent portrait.[4]

The picture was first attributed by Friedländer to Nicolaus Kirberger, primarily on the basis of the same monogram found on a drawing of the *Beheading of John the Baptist* (Graphische Sammlung Albertina, Vienna) and on a painting, *The Feast of Herod* (Stiftsmuseum, Klosterneuburg). Kirberger, however, was a member of Albrecht Altdorfer's workshop, and his works are stylistically unrelated to the National Gallery's portrait.[5]

The attribution to Nicolaus Kremer was made by Wescher in a certificate of 1936 and an article of 1938 and has been accepted in the few subsequent discussions of the painting.[6] As observed by

Nicolas Kremer, *Portrait of a Nobleman*, 1947.6.3

Wescher, *Portrait of a Nobleman* can be immediately related to a group of portrait drawings in Hamburg, Paris, and Vienna; one of the drawings in Hamburg is inscribed "Nicolaus Kremer,"[7] and several others bear the same monogram as the Washington painting as well as dates.[8] Wescher found the painting closest, both in style and type of person represented, to the drawing of *Count Friedrich von Kriehlingen*, monogrammed and dated 1541 (Musée du Louvre, Cabinet des Dessins, Paris).[9] The use of a three-quarter profile in several of the drawings and the broad planes and shadings of the heads are quite similar to the face of the sitter in the National Gallery's painting. In this regard, the absence of discernible underdrawing in the head of the sitter suggests that the artist might have worked from a portrait drawing.

Portrait of a Nobleman is stylistically related to the work of Hans Baldung Grien, in particular to the portraits of the mid-1520s such as that of *Hans Jacob von Morsperg*, dated 1525 (Staatsgalerie, Stuttgart), or the portrait of an unknown man at age twenty-nine, dated 1526 (Germanisches Nationalmuseum, Nuremberg).[10] The stylistic similarities accord both with the belief that Kremer was a pupil of Baldung Grien in Strasbourg or Freiburg and with his own activity in Strasbourg. Evident in the National Gallery's painting are the observations of Wescher and others that Kremer lacks the tension and complexity of Hans Baldung Grien.[11] Surfaces are not as polished, contrasts of light and shade are reduced, and the characterization of personality is less intense.

In addition, the influence of Albrecht Dürer can be seen both in the landscape, painted in thin washes reminiscent of Dürer's watercolors,[12] and, as noted by Talbot, in the inclusion of both hands, a format used by Dürer in emulation of Netherlandish portrait types.[13]

At present the *Portrait of a Nobleman* is one of two paintings that can be attributed to Nicolaus Kremer with some degree of assurance. The second picture is the posthumous *Portrait of Margrave Bernhard III of Baden-Baden*, monogrammed and dated 1542 (Freiherr von Ow-Wachendorf, Wachendorf). The treatment of the face in three-quarter view, the thinly painted watery landscape, and the form of the date and monogram are in accord with the Washington painting.[14] Other proposals made by Rott, Wescher, and Butts are often intriguing but are neither stylistically consistent nor wholly convincing.[15] The topic of Kremer as a painter awaits further study.

Notes

1. It has not been possible to verify the earliest, apparently traditional portion of the provenance that puts the picture first in the possession of a Baron Rechberg, Hohenlöwen, then with a Count von Leutzner. These names may have been derived from the coat-of-arms on the seal on the reverse of the panel, and they appear in the NGA curatorial records provenance card file. The arms on the seal are unidentified; Walter Angst, letter to the author, 27 May 1989, in NGA curatorial files, states that it is not Rechberg or Leutzner, although it could be a collector's seal.

2. Handwritten annotation probably by Fern Rusk Shapley of "no buyer" on the card for this sale in the NGA curatorial records provenance card file.

3. It is not entirely clear whether Aram was a collector or a dealer or both; the NGA curatorial records provenance card file indicates that at least two Italian paintings passed through his hands.

4. The possibility that the portrait had a pendant was suggested by Kurt Martin, memorandum to Charles Seymour, Jr., 24 August 1948, in NGA curatorial files, but subsequent correspondence between Charles Talbot and Martin, 22 April and 6 May 1966, in NGA curatorial files, brought forward no confirming information.

5. Max Friedländer's opinion is cited in the 1926 sales catalogue of the collection of Madame L. de L., no. 139. For a discussion of Kirberger and reproduction of the Albertina drawing, the Klosterneuberg painting, and other works see Alfred Stange, *Malerei der Donauschule* (Munich, 1964), 86–87, figs. 129–132.

6. Wescher's original certificate of 16 March 1936 is not extant but is cited, in an English translation, in *A Portrait of a Nobleman by Niclaus Kremer* (New York, n.d.), brochure, in NGA curatorial files.

7. Hamburger Kunsthalle, Kupferstichkabinett, Hamburg, no. 22883b, black and red chalk, 350 × 260 mm. Photograph in NGA photographic archives; discussed in exh. cat. Karlsruhe 1959, 123, no. 293.

8. Hamburger Kunsthalle, Kupferstichkabinett, Hamburg, no. 22883d, black and red chalk, 271 × 295 mm., dated 1526; no. 22883e, black and red chalk, 353 × 296 mm., monogrammed and dated 1542; photographs in NGA photographic archives; discussed in exh. cat. Karlsruhe 1959, 123–124, nos. 294, 296. Graphische Sammlung Albertina, Vienna, no. 3203, chalk and colored pencil, dated 1543 on now separated paper; see Hans Tietze and E. Tietze-Conrat et al., *Die Zeichnungen der deutschen Schulen bis zum Beginn des*

Klassizismus, Beschreibender Katalog der Handzeich-nungen in der Graphische Sammlung Albertina (Vi-enna, 1933), 41, no. 329, pl. 116.

9. Wescher 1938, 208, fig. 4. See Louis Demonts, *Musée du Louvre. Inventaire général des dessins des écoles du nord. Ecoles allemande et suisse.* 2 vols. (Paris, 1936), 1:51, no. 247 (18.715), pl. 85, black and red chalk, 238 × 290 mm.

10. The comparison to the portrait of Hans Jacob von Morsperg was made by Charles Talbot, draft cata-logue entry, 1966, in NGA curatorial files. For the two portraits see Gert von der Osten, *Hans Baldung Grien. Gemälde und Dokumente* (Berlin, 1983), 173–175, no. 58, 177, no. 60, repros.

11. Wescher 1938, 208, repeated by Talbot, draft catalogue entry, 1966, in NGA curatorial files.

12. Wescher 1938, 204.

13. Talbot, draft catalogue entry, 1966, in NGA cura-torial files, noting that Dürer's early portraits and those produced in 1521, the time of his Netherlandish jour-ney, include hands. See Panofsky 1943, 1:211.

14. Reproduced in color in *Die Renaissance im deutschen Südwesten zwischen Reformation und Dreissigjährigem Krieg,* 2 vols. [exh. cat., Badisches Landesmuseum] (Karlsruhe, 1986), 1:172, no. C7. I am grateful to Dr. Heinrich Geissler for this reference.

15. It is an open question as to whether paintings from the circle of Hans Baldung Grien might be by Nicolaus Kremer. Many of the works attributed to Kremer by Rott 1938 (see Biography), 90–97, are now given to Baldung and his followers; see Osten 1983, 92, 126–128, 281, nos. 34, X131, and for further discussion of Kremer and Baldung, 129, 144, 146, 272, nos. 35, 45, N 109A.

Rott 1938 (see Biography), 94, 97, attributed to Kre-mer the *Votive Painting of Sebastian Metzger,* dated 1534 (Kloster Lichtenthal, Baden-Baden); judging solely from the reproduction in exh. cat. Karlsruhe 1986, 1:171, no. C6, I would question the attribution. Butts 1985, 200–204, on the basis of comparison with the National Gallery's painting, attributed to Kremer a *Portrait of a Nobleman with a Red Hat* (Fürstlich Für-stenbergische Sammlungen, Donaueschingen) and, more tenuously, an *Ill-Matched Lovers* (present loca-tion unknown), published as Hans Süss von Kulmbach by Paul Wescher, "Ein 'Ungleiches Liebespaar' von Hans von Kulmbach," *Pantheon* 22 (1938), 376–379, and apparently based on a Baldung drawing of the same theme. The Donaueschingen portrait is attrib-uted to Andreas Haider in Grimm and Konrad 1990, 200. See also Bernd Konrad, letter to the author, 8 May 1989, in NGA curatorial files.

References

1936 Kuhn: 94, no. 449.

n.d. *Portrait of a Nobleman by Niclaus Kremer.* New York: unpaginated brochure, repro.

1938 Wescher, Paul. "Nicolas Kremer of Strass-burg." *Art Quarterly* 1: 204–209, figs. 1–2.

1948 *Recent Additions to the Ralph and Mary Booth Collection.* Washington: unpaginated, repro.

1959 Exh. cat. Karlsruhe (see Biography): 123.

1975 NGA: 186, repro. 187.

1976 Walker: 155, no. 172, repro.

1985 NGA: 217, repro.

1985 Butts, Barbara Rosalyn. "'Dürerschüler' Hans Süss von Kulmbach." Ph.D. diss., Harvard Univer-sity: 147, 200–204, fig. 146.

1990 Grimm, Claus, and Bernd Konrad. *Die Für-stenberg Sammlungen Donaueschingen. Altdeutsche und schweizerische Malerei des 15. und 16. Jahrhun-derts.* Munich: 200, repro.

Johann Liss

c. 1597–1631

AS BEFITS his peripatetic career, the artist is known variously as Johann Liss (or Lis), Jan Lys, or Giovanni Lys. His works remained unknown until relatively recently and were often attributed to other artists. The most important source of information remains the account given in Joachim von Sandrart's *Teutsche Academie der edlen Bau-, Bild- und Mahlerey-Künste*, published in 1675. Sandrart states that Johann Liss was from the north German city of Oldenburg, a region not known for its artists, and that from there he emigrated to Amsterdam where he painted in the manner of Hendrick Goltzius. According to Sandrart, Liss then went to Paris, Venice, and Rome, before returning to Venice where he died in the plague of 1629/1630. Sandrart was acquainted with Liss in Venice and comments on both his love of Venetian painting and his irregular work habits, with long absences, probably spent in riotous living, followed by days and nights of uninterrupted painting. It is now documented that Liss died not in Venice but in Verona on 5 December 1631.

Establishing an exact chronology of the artist's extant works has proved to be a difficult task. It is usually assumed that Liss was born c. 1597 and thus died at a rather young age, but his paintings and drawings, produced in a little over a decade, underwent numerous stylistic transformations, and there are few fixed points of reference. There are, for example, no works that can securely be given to the early years in the Netherlands, and there is no evidence for Liss' activity in Paris. It seems that around or shortly after 1620 he went to Venice, where he was strongly influenced by Domenico Fetti, although his choice of subjects, such as the *Peasant Wedding* (Szépmüvészeti Múzeum, Budapest), is often quite Northern. A second group of paintings, including *The Death of Cleopatra* (Alte Pinakothek, Munich), *Judith* (National Gallery, London), and *Banquet of Soldiers and Courtesans* (Germanisches Nationalmuseum, Nuremberg), demonstrates the absorption of the art of Caravaggio and his followers during Liss' stay in Rome, c. 1623–c. 1626. In addition to the stylistic evidence, a drawing, *Allegory of Christian Faith* (Cleveland Museum of Art), is signed, indistinctly dated, and inscribed "Zu Rom." Influences of Titian, Veronese, and Fetti continued in Liss' final years in Venice, although in pictures such as *The Toilet of Venus* (Dr. Karl Graf von Schönborn-Wiesentheid, Schloss Pommersfelden), or *The Vision of Saint Jerome*, painted for the church of San Nicolò da Tolentino and seen there around 1628 by Sandrart, the brushwork is softer and brighter in tonality, with passages of pink and light blue. A drawing of *Fighting Gobbi Musicians* (Kunsthalle, Kupferstichkabinett, Hamburg), signed and identified as done in Venice, is now believed by Peter Amelung to be dated 1629—the only year that Liss appears on the list of the painters' guild—not 1621 as previously thought.

Along with Adam Elsheimer, Liss is the most important German artist of the seventeenth century. Interestingly, both found it desirable to work in Italy. If anything, Liss was somewhat more progressive than Elsheimer, and it is not surprising to find that his paintings were often copied by eighteenth-century artists.

Bibliography

Steinbart, Kurt. *Johann Liss*. Berlin, 1940.
Johann Liss. Exh. cat., Rathaus, Augsburg; and Cleveland Museum of Art. Augsburg, 1975.
Antoniazzi, Elisabetta. "Addenda: La data di morte di Johann Liss." *Arte Veneta* 29 (1975): 306.
Amelung, Peter. "Die Stammbücher des 16./17. Jahrhunderts als Quelle der Kultur-und Kunstgeschichte." *Zeichnung in Deutschland. Deutsche Zeichner 1540–1640*. 2 vols. Exh. cat., Staatsgalerie. Stuttgart, 1979–1980, 2: 221, n. 36.

1942.9.39 (635)

The Satyr and the Peasant

Possibly c. 1623/1626
Canvas, 133.3 × 167.4 (52½ × 65⅞)
Widener Collection

Technical Notes: The support is composed of six pieces of linen sewn together. The main body of the painting is formed by two pieces with a vertical seam just left of center, while four small pieces of fabric, 9 cm. in height, are joined in a narrow strip across the top of the painting. The plain-weave linen is of medium-fine threads, unevenly spun, and is moderately tightly woven. Although the original tacking margins are no longer extant, presumably only a very small amount was removed and the painting is close to its original size. The ground is made up of two layers, a thick red lower layer and a thin black upper one. The few pentimenti that are visible indicate minor adjustments in contours: the peasant's hair was extended farther out at the front, the bottom of the mother's right cheek was made fuller, and the lengths of one finger each on the satyr's left and child's right hand were altered. There are scattered losses in the ground and paint layers near the edges and along the tears, with a few along the top horizontal seam, and small losses elsewhere. There is extensive and disfiguring abrasion throughout. The impasto in the areas of white paint, such as in the infant's dress and the mother's sleeve, has been flattened by previous relinings. There are several long tears in the support: on the child's forehead, at the center of the satyr's chest, on the peasant's arm, and between the peasant's arm and body; these have been mended and are now aligned and in plane.

Provenance: Aron de Joseph de Pinto [d. 1785], Spain and the Netherlands, by 1780.[1] Lopes Leao de Laguna, the Netherlands.[2] (Leo Nardus, New York);[3] Peter A. B. Widener [d. 1915], Lynnewood Hall, Elkins Park, Pennsylvania, 1897. Inheritance from the Estate of Peter A. B. Widener by gift through power of appointment of Joseph E. Widener, Elkins Park.

Exhibitions: Augsburg, Rathaus; and Cleveland Museum of Art, 1975–1976, *Johann Liss*, no. A10.

THE SUBJECT depicted in Liss' painting is an adaptation of one of Aesop's *Fables*. Encountering a traveler or peasant outside in cold weather, a satyr inquires why the man is blowing on his hands and is told that he wishes to warm them. Later, in either the satyr's or the peasant's home—depending on the version—the satyr is astonished to find the peasant blowing on his soup, this time to cool it, and indignantly renounces their association. The moral of the tale is that one should avoid friendship with sycophants who can blow hot and cold with the same breath.[4]

In the late sixteenth and early seventeenth centuries painted and printed illustrations of this fable were quite popular in northern Europe, particularly in the Netherlands, but appeared rarely in Italy.[5] One of the most important editions of Aesop was published in Bruges in 1567 and contained etchings by Marcus Gheeraerts the Elder.[6] As in Gheeraert's etching of this scene, the National Gallery's painting is set in the peasant's home. Liss depicted a dark room dramatically lit from the upper left, with the peasant's wife holding an infant at the center and his young son at far left, possibly seated by a fire. As the peasant, seated at a rough table, blows on his soup or porridge, the satyr abruptly rises to leave.

As with other works by this artist, *The Satyr and the Peasant* was not immediately recognized as a work by Johann Liss. The picture entered the collection of Peter A. B. Widener as by Diego Velázquez and in 1915 was attributed to Bernardo Strozzi.[7] Verbal opinions recorded by Edith Standen ranged from "possibly Genoese" (Walter Friedländer) to "Spanish, possibly Velázquez" (Georg Richter) and "Piazzetta?" (Hans Swarzenski).[8] In 1916 Oldenbourg was the first to attribute the painting to Liss, and this was seconded by von Bode in 1920. The work was given to Liss in the 1923 catalogue of Joseph Widener's collection.[9] Steinbart, however, in his 1940 monograph on the artist, listed the painting under false attributions and suggested instead that it was by a Spanish or Neapolitan painter working in the first half of the sixteenth century. Steinbart later recanted and published the painting as by Liss in 1959.[10] Virtually all authorities accept *The Satyr and the Peasant* as autograph, and following its restoration and exhibition in Augsburg and Cleveland the canvas has been recognized as a qualitatively outstanding work by Johann Liss, in which vigorous, fluent brushwork creates strong effects of light and texture.

There are two major areas of discussion concerning *The Satyr and the Peasant* that reflect, in microcosm, larger issues in Liss' oeuvre that have

evolved in recent years. The first of these centers on the relation of the Washington painting to another depiction of the same subject, of almost identical dimensions, acquired in 1962 by the Gemäldegalerie, Berlin.[11] While the latter was still on the art market, Steinbart accepted both it and the Washington painting as autograph but thought that the Berlin version was several years later than the National Gallery's picture.[12] In 1966 Bloch cautiously expressed doubts about the Berlin painting, but for the most part it was accepted as an autograph replica and exhibited as such in 1975–1976.[13] In the aftermath of the exhibition, which had juxtaposed different renditions of the same subject, critics began to question the authenticity of many of the pictures. The strongest voice in this process of revision was that of Spear, who found the concept of autograph replicas both methodologically and stylistically unjustifiable and, further, found it unlikely that Liss even had a workshop. With regard to the Berlin painting, Spear asserted that, as evidenced by its hard, glossy finish and many awkward passages of drawing and brushwork, it was a copy, but one done by a Northern artist.[14] Although the nationality of the artist is undetermined, the Berlin version is now believed to be a contemporary replica of the Washington original.[15]

The second question of when and where *The Satyr and the Peasant* was painted is, if anything, less easily resolved, for although we have a general idea of the sequence of Liss' life and works, the exact chronology is highly problematic, with few certain points of reference. Beginning with Oldenbourg in 1916, however, critics unanimously agree that Liss was strongly influenced by Jacob Jordaens' numerous paintings and drawings of the satyr and the peasant, produced in the period c. 1616/1621. In paintings such as that of c. 1620/1621 (Musées Royaux des Beaux-Arts, Brussels), Jordaens, like Liss, sets the scene in the peasant's home.[16] Consequently, several authors put the National Gallery's painting into Liss' first Netherlandish period; Klessmann believed it was not much later than 1616/1619, and in the catalogue of the Augsburg and Cleveland exhibition Lurie suggested that either the Berlin or the Washington version was painted in Antwerp, while the other was a later repetition for an Italian

patron.[17] Yet in addition to its proximity to Jordaens, *The Satyr and the Peasant* was clearly influenced in some manner by Caravaggio. The dark tonality, the way in which the large figures are composed, the closeness of the subjects to the picture plane, the particular realism and emphasis on texture, and especially the dramatic lighting, all bespeak Liss' assimilation of the ideas of Caravaggio. Rowlands, Zucker, and Shapley therefore maintain that the picture was executed in Italy, quite possibly during or just following Liss' Roman sojourn, and that it reflects his direct contact with Caravaggesque painting.[18]

Supporting the later dating is the current belief that no paintings can be assigned to Liss' Netherlandish years and that depictions of scenes of peasant life were meant to satisfy an Italian taste for "Flemish" subjects.[19] It is not possible to establish precise dates for Liss' stay in Rome. His membership in the *Schildersbent*, a group only established in 1623,[20] would seem to put him in Rome around this time, and several critics have suggested dates of c. 1623–1626 for his Roman period.[21] It is difficult to place the National Gallery's painting in his first Venetian period, c. 1620–1623, when Domenico Fetti's influence is dominant, and the picture is certainly not from Liss' last years in Venice. With our present knowledge, however imprecise, a date of c. 1623/1626 for *The Satyr and the Peasant* seems most viable.

A handsome study in black chalk on blue paper of the head of a woman (fig. 1) is one of Liss' very few preparatory drawings from life for a known painting.[22]

The influence and importance of Johann Liss' *Satyr and the Peasant* can be inferred from the fact that, in addition to the Berlin version, there exist at least twelve copies of the composition.[23] According to Lurie, the copy by Antoine de Favray and the adaptations by Sebastiano Ricci support the notion of an early Italian provenance, if not the painting's actual origin in Italy.[24]

Notes

1. Widener 1885–1900, 270, no. 270. The painting is not listed in the catalogue of the de Pinto sale (Van der Schley & Yver, Amsterdam, 11 April 1785); Gerbrand Kotting, Rijksbureau voor Kunsthistorische Documentatie, The Hague, letter to the author, 16 December 1988.

Johann Liss, *The Satyr and the Peasant*, 1942.9.39

Fig. 1. Johann Liss, *Head of a Woman*, black chalk,
29.8 × 19.8 cm., Rijksprentenkabinet, Rijksmuseum-
Stichting, Amsterdam [photo: Rijksmuseum-
Stichting]

2. See note 1.

3. Notes by Edith Standen, secretary to Joseph Wi-
dener, in NGA curatorial files, indicate that a typewrit-
ten copy of the 1885–1900 catalogue of the Widener
Collection, dated 1 February 1908 on the binding, adds
the words "Nardus, 1897," to the entry on this painting.

4. The fable is usually numbered 74 and has the
traveler visiting the satyr's home; see, for example,
Francis Barlow, *Aesop's Fables with His Life: In Eng-
lish, French and Latin* (London, 1687), 148–149.

5. The greatest number of representations of this
theme, listed in Andor Pigler, *Barockthemen. Eine Aus-
wahl von Verzeichnissen zur Ikonographie des 17. und
18. Jahrhunderts*, 2 vols. (Budapest, 1956), 2: 324, 326,
are Netherlandish, with only three Italian paintings
listed.

6. See Edward Hodnett, *Marcus Gheeraerts the
Elder of Bruges, London, and Antwerp* (Utrecht, 1971),
31–34, fig. 11; and A. E. Popham, "The Etchings of Mar-

cus Gheeraerts the Elder," *Print Collector's Quarterly*
15 (1928), 191–197, pl. 4.

7. Widener 1885–1900, 270, no. 270; Mayer 1915,
316.

8. Undated handwritten notes by Edith Standen,
in NGA curatorial files.

9. Oldenbourg 1916, 53–58; Bode 1920, 172–173;
Valentiner 1923, unpaginated.

10. Steinbart 1940 (see Biography), 173–174; the
National Gallery's painting is not mentioned in
Steinbart's later book, *Johann Liss* (Vienna, 1946);
Steinbart 1959, 168–170, 204.

11. Inv. no. KFMV 245, canvas, 130.5 × 166.5 cm.

12. Steinbart 1959, 204.

13. Vitale Bloch, " 'German Painters and Draughts-
men of the Seventeenth Century' in Berlin," *BurlM* 108
(1966), 546; Klessmann 1965, especially 83; exh. cat.
Augsburg and Cleveland 1975 (see Biography), 68–70,
no. A9, repro., entry by Ann Tzeutschler Lurie.

14. Spear 1976, 583–586, 588, 591. The distance be-
tween the views at the time of the exhibition and subse-
quent opinion can be seen in Klessmann 1986, 191 n. 2,
who states that now only *The Toilet of Venus* (Galleria
degli Uffizi, Florence) can be considered an autograph
replica (of the painting lent to the exhibition [A28] by
Dr. Karl Graf von Schönborn-Wiesentheid, Schloss
Pommersfelden). At the time of the exhibition twenty-
four paintings were considered to be autograph repli-
cas by Liss.

15. Listed as such in Henning Bock et al., *Gemälde-
galerie Berlin. Gesamtverzeichnis der Gemälde. Com-
plete Catalogue of the Paintings* (London, 1986), 44,
cat. no. KFMV 245, fig. 241.

16. For Jordaens' versions see Roger-Adolf d'Hulst,
Jacob Jordaens (London, 1982), 60–61, 94, 96, 98–101,
367 (the Brussels painting is reproduced on p. 98).
D'Hulst 1982, 61, notes the likely influence of Marcus
Gheeraerts on Jordaens. See also Michael Jaffé, *Jacob
Jordaens 1593–1678* [exh. cat., National Gallery of Can-
ada] (Ottawa, 1968), 72, no. 6, who observes the impor-
tance of Jordaens for Liss; in addition, see nos. 142, 146,
220, 293, 296.

17. Klessmann in exh. cat. Augsburg and Cleveland
1975 (see Biography), 24–25, and entry by Lurie, 70–72,
no. A10. Klessmann 1965, 85, dated the Berlin painting
and by implication the National Gallery's picture to
shortly after c. 1618/1619.

18. Observation of the influence of Caravaggio be-
gan with Oldenbourg 1916, 53–58. Rowlands 1975, 835,
thought that both the Berlin and Washington versions
were painted in Italy and that the Berlin version was
later and close to c. 1622/1624. Mark J. Zucker, draft
catalogue entry, 1967, in NGA curatorial files, dates the
painting to the early 1620s. Shapley 1979 proposes a
date of c. 1622/1623, during Liss' Roman period or
shortly after the return to Venice.

19. Spear 1976, 590, believes that the only painting
possibly produced in the pre-Italian years is the *Diana*

and Actaeon (private collection, England); exh. cat. Augsburg and Cleveland 1975 (see Biography), no. A8. Klessmann 1986, 194, states that Liss' Netherlandish period is *terra incognita*.

20. Godefridus J. Hoogewerff, *De Bentvueghels* (The Hague, 1952), 54, says that the group became permanent apparently by April or May of 1623; elsewhere (p. 139) he puts Liss' stay in Rome around 1625.

21. In particular Spear 1976, 590; and Klessmann 1986, 192.

22. Discussed in exh. cat. Augsburg and Cleveland 1975 (see Biography), 137–138, no. B46.

23. These copies include:

1. Formerly Max Rothschild collection; destroyed by a fire in the Sackville Galleries, London, 1918; canvas, 133 × 165 cm.; see Tancred Borenius, "Jan Lys," *BurlM* 33 (1918), 115, repro. facing 115.

2. Muzeul Brukenthal, Sibiu; canvas(?), 41 × 52 cm.; *The Brukenthal Museum Fine Arts Gallery* (Bucharest, 1964), 20, no. 118, repro.

3. Present location unknown; sale, Phillips, Son & Neale, Inc., New York, 8 June 1983, no. 35; canvas, 57 × 73.5 cm.; copy of sale cat. in NGA curatorial files.

4. Present location unknown; formerly Dr. Otto A. Burchard, London; canvas, 130 × 156 cm.; photograph and correspondence between Fern Rusk Shapley and Burchard, 13 February 1959, 2 March 1959, in NGA curatorial files.

5. Present location unknown; sale, Vienna, 16 April 1918, no. 234, as by Jacob Jordaens; canvas, 94 × 112 cm.; cited by Lurie in exh. cat. Augsburg and Cleveland 1975 (see Biography), 72.

6. Present location unknown; formerly Prince Kaunitz collection; canvas, 92 × 116 cm.; cited by Lurie in exh. cat. Augsburg and Cleveland 1975 (see Biography), 72, as possibly the same as no. 5 because of similar measurements.

7. Present location unknown; sale, Fischer, Lucerne, 29 November 1969; canvas, 47 × 60.7 cm.; cited by Lurie in exh. cat. Augsburg and Cleveland 1975 (see Biography), 72.

8. Antoine de Favray (1706–1792), canvas, 167 × 124 cm., signed and dated 1741, Cathedral Museum, Medina, Malta; exh. cat. Augsburg and Cleveland 1975 (see Biography), fig. 151, no. E74.

9. Present location unknown; canvas, 47 × 52 cm.; cited by Lurie in exh. cat. Augsburg and Cleveland 1975 (see Biography), 72, as formerly Gilberto Algranti, Milan, and in a private collection in Germany.

10. Present location unknown; probably art market or private collection, France. Mentioned by Germain Bazin, Musée du Louvre, letter to John Walker, 28 June 1958, in NGA curatorial files.

11. Kupferstichkabinett, Berlin; chalk(?) on paper, 19 × 23.6 cm.; exh. cat. Augsburg and Cleveland 1975 (see Biography), fig. 153, no. E77.

12. Sale, Sotheby & Co., New York, 5 April 1990, no. 137; canvas, 114.5 × 123 cm.; I am grateful to Heidi Chin of Sotheby & Co. for the photograph, in NGA curatorial files.

13. Gemäldegalerie, Staatliche Museen zu Berlin, no. 2206; canvas, 128.5 × 186.5 cm.; Rainer Michaelis, *Deutsche Gemälde 14–18. Jahrhundert* (Berlin, 1989), 70, repro. 71.

In addition there are two paintings of the *Satyr and the Peasant* by Sebastiano Ricci (1659–1734), clearly inspired by Liss' composition: one was with Thos. Agnew & Sons, London, in 1969 (exh. cat. Augsburg and Cleveland 1975 [see Biography], fig. 152, no. E76); the other is in the Musée du Louvre, Paris, inv. no. 65 (exh. cat. Augsburg and Cleveland 1975 [see Biography], fig. 154, no. E75).

24. Exh. cat. Augsburg and Cleveland 1975 (see Biography), 71, observes that de Favray must have painted his copy in Rome, for he and Jean-François de Troy were there from 1738 to 1744; it also points out that Ricci's admiration for Liss led him to negotiate purchases of that artist's work for the Grand Duke Ferdinand of Tuscany.

References

1885–1900 *Catalogue of Paintings Forming the Private Collection of P. A. B. Widener, Ashbourne—Near Philadelphia, Part II: Early English and Ancient Painting* 270, no. 270, repro.

1907 Mather, F. J. "Art in America." *BurlM* 10: 269.

1915 Mayer, August L. "Notes on Spanish Pictures in American Collections." *Art in America* 3: 316.

1916 Berenson, Bernard, and W. Roberts. *Pictures in the Collection of P. A. B. Widener at Lynnewood Hall, Elkins Park, Pennsylvania: Early Italian & Spanish Schools.* Philadelphia: unpaginated, repro.

1916 F. "Aus der Sammlerwelt und vom Kunsthandel," *Der Cicerone* 8: 40.

1916 Oldenbourg, Rudolf. "An Unidentified Picture by Jan Lys." *Art in America* 4: 53–58, fig. 1.

1918 Oldenbourg, Rudolf. "Gemäldegalerie. Neues über Jan Lys." *Amtliche Berichte aus den Königliche Kunstsammlungen* 39: col. 114.

1920 Bode, Wilhelm von. "Johan Lys." *Oelhagen & Klasings Monatshefte* 33: 172–173, repro.

1921 Oldenbourg, Rudolf. *Sei e settecento straniero. Jan Lys.* Rome: 10, pl. 17.

1923 Valentiner, Wilhelm R. *Paintings in the Collection of Joseph Widener at Lynnewood Hall.* Elkins Park, Pa.: unpaginated, repro.

1929 Peltzer, R. A. "Liss." Thieme-Becker, 23: 286.

1935 Tietze, Hans. *Meisterwerke Europäischer Malerei in Amerika.* Vienna: 336, no. 160, repro. English ed., New York, 1939.

1938 Brimo, René. *L'évolution du goût aux Etats-Unis d'après l'histoire des collections.* Paris: 117.

1938 Waldmann, E. "Die Sammlung Widener." *Pantheon* 22: 340–341.

1939 Valentiner, Wilhelm R. "Willem Drost, Pupil of Rembrandt." *AQ* 2: 322.

1939 Waterhouse, Ellis K. Review of *L'évolution du goût aux Etats-Unis d'après l'histoire des collections* by René Brimo. *BurlM* 75: 86.

1940 Steinbart (see Biography): 173–174.

1941 Valentiner, Wilhelm R. "Jan van de Cappelle." *AQ* 4: 289.

1959 Steinbart, Kurt. "Das Werk des Johann Liss in alter und neuer Sicht." *Saggi e memorie di storia dell' arte* 2: 168–170, 204, fig. 13.

1965 Klessmann, Rüdiger. "Ein neues Werk des Johann Liss in der Berliner Gemäldegalerie." *Nordelbingen* 34: 83.

1967 "Rijksmuseum Amsterdam. Verschillende Verzamelingen." *Verslagen der Rijksverzamelingen van Geschiedenis en Kunst* 89: 98.

1975 Blankenagel, Gabriele. "Johann Liss." *Weltkunst* 45: 1361.

1975 Klessmann, Rüdiger. "Johann Liss—His Life and Work." In exh. cat. Augsburg and Cleveland (see Biography): 24–25.

1975 NGA: 206, repro. 207.

1975 Richards, Louise S. "Johann Liss—Drawings and Prints." In exh. cat. Augsburg and Cleveland: 39.

1975 Rowlands, John. "'Johann Liss' at Augsburg." *BurlM* 117: 835.

1975 Safarik, Eduard A. "La mostra di Johann Liss." *Arte Veneta* 29: 303, no. A10.

1976 Bean, Jacob. "Johann Liss (and Paolo Pagini)." *MD* 14: 64–65.

1976 Butler, Joseph T. "America." *Conn* 193: 147.

1976 Spear, Richard E. "Johann Liss Reconsidered." *AB* 58: 586, 588, 590–591.

1979 Shapley: 290–293, no. 635, pl. 206.

1981 Pallucchini, Rodolfo. *La pittura veneziana del seicento.* Milan: 144, fig. 397.

1985 NGA: 231, repro.

1986 Klessmann, Rüdiger. "Addenda to Johann Liss." *BurlM* 128: 192.

Master of Heiligenkreuz

active c. 1400

T HE ARTIST takes his name from a diptych in the Kunsthistorisches Museum, Vienna, that once belonged to the Cistercian abbey of Heiligenkreuz in southeastern Austria near the present-day border with Hungary. An *Annunciation* is on the left panel of this diptych, with a *Madonna and Child* on the reverse; the right panel depicts a *Mystic Marriage of Saint Catherine*, with *Saint Dorothy* on the reverse. Based on costume, iconography, and associations with the International Style, the panels are usually dated around 1400/1410.

Betty Kurth's initial publication of the Vienna pictures in 1922 proposed that the artist was French and associated with the Parisian court. Subsequent authors have challenged this idea, and the Master of Heiligenkreuz has been described variously as French, Austrian, German, or Bohemian, as well as an itinerant court artist, trained in France but active in Austria. The master's use of refined tooled decoration has been cited on the one hand as proof of his origins in Franco-Burgundian goldsmiths' work of the late fourteenth century and, on the other hand, as a link with panel painting at the court in Prague. This discussion serves mainly to underscore the difficulty of localizing late Gothic courtly art; it is unlikely that the artist's nationality will be established with certainty.

Paintings by the Master of Heiligenkreuz are extremely rare. In addition to the diptych in Vienna and the two panels discussed below, there is a fragmentary *Mystic Marriage of Saint Catherine*, formerly in the Becker collection in Dortmund and sold at auction in 1991 (Christie, Manson and Woods, London, 24 May 1991, no. 5). These few works are enough, however, to demonstrate that the master was a skillful, highly individual practitioner of the International Style.

Bibliography

Kurth, Betty. "Französische Tafelbilder aus der Wende des 14. Jahrhunderts in österreichischen Sammlungen." *Zeitschrift für bildende Kunst*, n.s., 33 (1922): 14–22.

Oettinger, Karl. "Zur Malerei um 1400 in Österreich." *Jahrbuch der kunsthistorischen Sammlungen in Wien*, n.s., 10 (1936): 59–87.

1952.5.83 (1162)

The Death of Saint Clare

c. 1400/1410
Fir, 67.5 × 55.3 (26¾ × 21¾);
 painted surface: 66.3 × 54 (26⅛ × 21¼)
Samuel H. Kress Collection

Inscription

On left-hand page of book held by nun at lower right:
 Dĩi labia[1]

Technical Notes: The support appears to consist of a three-member panel of fir with vertically oriented grain.[2] Direct examination was not possible because the edges of the panel have been enclosed with 0.5 cm. thick strips of mahogany and a wooden cradle has been attached to the reverse.[3] On the reverse of the panel is a moderately thick layer of wax.

The major design elements of the composition, including the outlines of the figures, the primary drapery folds, major architectural motifs, and numerous details, are incised into the smooth white ground layer that is estimated to be somewhat thickly applied. Sheets of gold leaf have been applied, over a layer of thin, fluid red bole, to the upper background, the halos of the standing saints, and the angels under the canopy at the right. A great variety of punches in a wide range of sizes has been used to create in the gold leaf elaborate designs and figures of angels. Examination with infrared reflectography did not reveal underdrawing.

Examination of the technically congruent pendant, *The Death of the Virgin*, in the Cleveland Museum of Art provided important information about the probable original state of the National Gallery's picture.[4] The Cleveland panel is 1.3 cm. thick, and the reverse covered with what appears to be an original layer of white ground; the panel has not been thinned or cradled. One can assume that the Washington panel, presently 1 cm.

thick, was in a similar state before cradling. In the Cleveland panel a fairly coarse and loosely woven plain-weave fabric is observable between the support and the overlying ground and paint layers. This helps to confirm the use of a fabric interlayer in the Washington painting, which is suggested by the weave pattern visible in the x-radiograph. The metal content pigments of both paintings were analyzed with x-ray fluorescence, and the results for the paintings were very similar.

The National Gallery's painting is structurally secure and is in very good condition. Small pinpoint losses are scattered throughout, and some of the paint surfaces are minutely abraded. Larger retouched areas of abrasion are located in paint next to the gilt areas of the canopy, along the left profile edge of the standing Virgin next to Saint Clare, and in the bottom of Christ's red robe. The gilt stars on Clare's bed are badly worn.

Provenance: Possibly the Convent of the Poor Clares, Eger (Cheb), Bohemia (now Czechoslovakia), or Eger (Erlau), Hungary.[5] (Karl Schäfer, Munich); (Walter Schnackenberg, Munich, 1921/1922–1951);[6] in 1943 a one-third share was acquired from Schnackenberg by Carl Langbehn, Munich, and passed by inheritance to his mother, Marta Langbehn.[7] (Owned jointly by Seiler & Co., Walter Schnackenberg, and Alfred Müller, Munich);[8] sold 1951 to (M. Knoedler & Co., New York, with Pinakos [Rudolf Heinemann]);[9] purchased 1951 by the Samuel H. Kress Foundation, New York.

Exhibitions: Lent by Walter Schnackenberg to the Alte Pinakothek, Munich, in 1926.[10]

REPRESENTED HERE is an episode from the death of Saint Clare (1194–1253), disciple of Saint Francis of Assisi and founder of the Poor Clares, the Second Order of Saint Francis. According to legend, Clare was visited on her deathbed by a group of sainted virgins led by the Virgin Mary.[11] It is generally accepted that it is Mary who stands on the far side of the bed holding Clare's head in her hands.[12] Next to Mary, from right to left, are Saint Catherine holding a miniature wheel, possibly Saint Helena[13] with a chaplet of roses, Saint Barbara with a tower, and probably Saint Dorothy[14] holding a spray of red flowers and a small basket. At the foot of the bed is Saint Margaret, identifiable by the minuscule dragon in her hand. All of these figures wear rich and elaborate garments, crowns, and headdresses. The woman on the viewer's side of the bed is probably Saint Agnes; she adjusts the "mantle of wondrous beauty" that was brought by the virgins to cover the dying

Clare.[15] Agnes was Clare's younger sister, who attended her in her last hours and survived her by only a few months. The lamb at Agnes' feet may be seen more as a symbol of her name than as an attribute, since it is usually associated with Saint Agnes of Rome.[16] Margaret's and Agnes' halos were probably omitted for compositional reasons, but for Agnes, who wears a plain blue robe, sainthood still lay in the future.

Also present at Saint Clare's death are four nuns, two in the foreground and two at the head of the bed, dressed like Clare herself in the habit of the Poor Clares. Two angels swinging censers are under the bed canopy. At the top of the panel Christ bears heavenward the embodiment of Clare's soul, a child dressed in white. Music-making angels with banners are delicately punched and tooled into the gold at the upper left, while three angels look on from above the canopy of the bed.

The pendant to *The Death of Saint Clare*, Cleveland's *Death of the Virgin* (fig. 1), is congruent in both size and technique.[17] The paintings probably formed a nonfolding diptych. Thematically and compositionally it seems most likely that *The Death of the Virgin* was on the left and *The Death of Saint Clare* on the right. As noted by Eisler, the subject matter of both panels suggests that they figured prominently in funereal or commemorative services.[18] The juxtaposition and association with the Virgin's death further underscores the purity and sanctity of Clare's life. In 1961 Stange suggested that the panels came from the Convent of the Poor Clares in Eger, Bohemia (now Cheb, Czechoslovakia), and later he expanded this idea to include Eger (Erlau) in Hungary.[19] The original location of the altarpiece remains unknown, but given what is known about the master's sphere of activity, either city is possible.

First observed by Levine, the singular design in Saint Margaret's dress (fig. 2) may simply be a decorative motif or the heraldic device known as a displaced potent-counter-potent.[20] A similar configuration appears in the Cleveland panel in the fabric on the Virgin's bed. If heraldic, this design might shed light on the location or patronage of the altarpiece, but for the moment it yields no precise information.

There can be little doubt that *The Death of Saint*

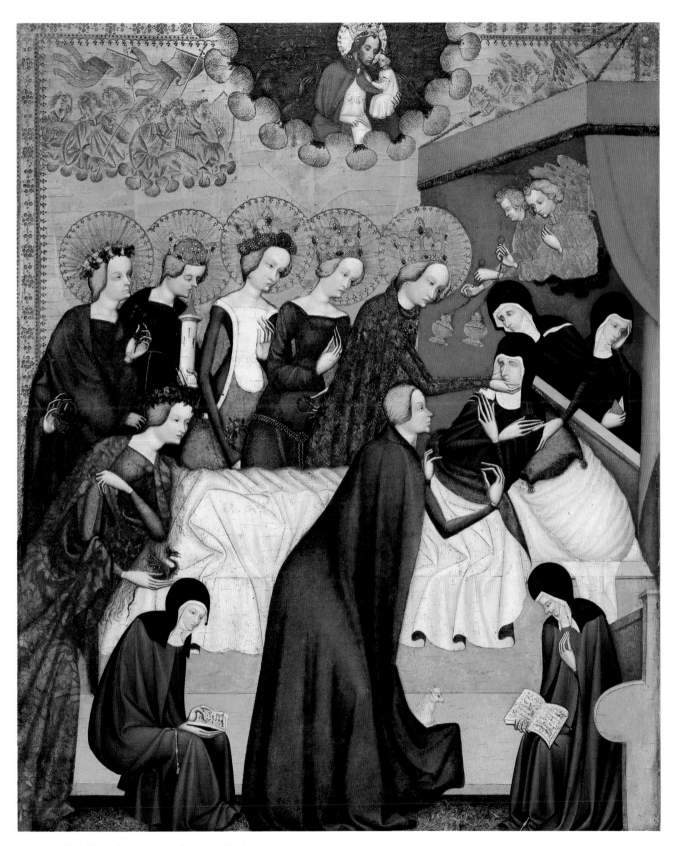

Master of Heiligenkreuz, *The Death of Saint Clare*, 1952.5.83

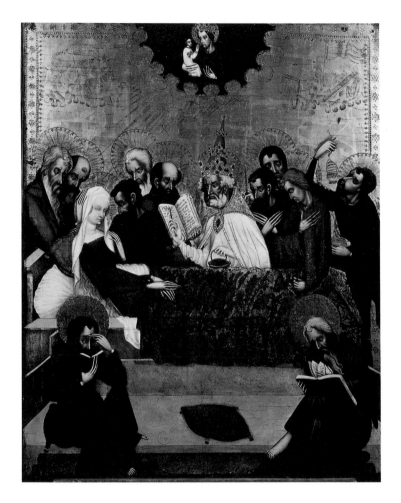

Fig. 1. Master of Heiligenkreuz, *The Death of the Virgin*, panel, The Cleveland Museum of Art, Gift of Friends of the Museum in memory of John Long Severance [photo: The Cleveland Museum of Art]

Clare and *The Death of the Virgin* are by the same hand as the Master of Heiligenkreuz's name pieces, his *Annunciation* and *Mystic Marriage of Saint Catherine* (Kunsthistorisches Museum, Vienna).[21] The artist's idiosyncratic style is quickly recognized in the figures' high bulbous foreheads, small pointed chins, triangular sloping noses, and thin, angular arms that end in extremely long, brittle, spidery fingers. At the same time, the combination of saturated color, richly patterned and embroidered fabrics, and gold leaf enlivened by delicate punch work creates an elegant and courtly effect. On the basis of period style, the National Gallery's painting and its companion in Cleveland are usually dated c. 1410, although Sterling and Eisler put forward a date in the 1420s.[22] The Vienna panels are sometimes considered slightly earlier in date.[23]

As noted in the Biography, there has been a lively but inconclusive debate over the origins and training of the Master of Heiligenkreuz. Whatever his artistic heritage, the master worked in Central Europe, and the visual precedents and parallels for his *Death of Saint Clare* can be found in Germanic painting, specifically in the pictures cited by Eisler in the Germanisches Nationalmuseum, Nuremberg, and formerly in the Deutsches Museum, Berlin.[24] The artistic situation at the beginning of the fifteenth century, however, was one of great fluidity. As a cosmopolitan center and possible source for the punch work and tooling that are found in *The Death of Saint Clare*, Prague is as viable as Paris.[25]

Fig. 2. Detail of *The Death of Saint Clare*, 1952.5.83

Notes

1. This is possibly "Domine Labia aperies" from Psalm 51:15, verses often found in Books of Hours.

2. The identification of the wood as fir (sp. *Abies*) was made by the National Gallery's scientific research department.

3. An x-radiograph made prior to cradling is in the National Gallery's conservation department.

4. The examination was conducted 7–8 April 1988 by the author and by Paula DeCristofaro, formerly associate conservator for the Systematic Catalogue, with Bruce F. Miller, conservator of paintings at the Cleveland Museum of Art. I am most grateful to Mr. Miller and his staff for their assistance in making the painting available to us.

5. Stange *DMG*, 11:4. In a letter to Fern Rusk Shapley, 13 February 1965, in NGA curatorial files, Stange gave Prince Joseph Clemens of Bavaria as the source but noted that while there was a convent of the Poor Clares in Bohemian Eger in the fourteenth and fifteenth centuries, Clemens did not specify Czechoslovakia or Hungary and so both were possible. There is no verification for the statement in Eisler 1977, 234, that the panel may have belonged to the kings of Saxony.

6. English translation of Walter Schnackenberg letter, 12 April 1951, in files of M. Knoedler & Co., New York, giving date of acquisition from Karl Schäfer. Stange's letter, 13 February 1965, also mentions Schäfer as handling the painting.

7. Schnackenberg letter, 12 April 1951. Carl and Marta Langbehn are listed as owners in an M. Knoedler & Co. brochure, in NGA curatorial files.

8. M. Knoedler & Co. account book. I am grateful to Nancy C. Little for access to the account book and files.

9. M. Knoedler & Co. account book.

10. Baldass 1926, 133–134, as "Tod einer heiliger Nonne"; Cleveland's *Death of the Virgin* was also lent. I have found no verification for the statement in Kress 1956, 122, and Eisler 1977, 234, that the picture was shown in *Exposition d'Art Autrichien*, Musée du Jeu de Paume, Paris, 1937; see Elisabeth Foucart-Walter, Musée du Louvre, letter to the author, 18 March 1987, in NGA curatorial files. Likewise there is no indication that the painting was exhibited in Munich in 1936, as per Kress 1956, 22; this may be a confusion with the 1926 loan. See also Eisler 1977, 236 n. 42.

11. In Kress 1956, 120, Wilhelm Suida is credited with the correct identification of the scene; in the preceding literature the saint is called Agnes of Montepulciano. For Saint Clare see Thurston and Attwater, 3: 309–313; Réau, *Iconographie*, vol. 3, pt. 1 (1958), 316–319. The vision of Clare's visitation by Mary and the virgins is recounted in the earliest biography, written shortly after her death, by Tommaso da Celano. See Guido Battelli, ed., *Tomaso da Celano. La leggenda di Santa Chiara d'Assisi cavata dal codice magliabechi ano XXXVIII, 55, della Biblioteca Nazionale di Firenze* (Milan, 1952), 72–75; and Ignatius Brady, ed., *The Legend and Writings of Saint Clare of Assisi* (St. Bonaventure, New York, 1953), 50.

12. Eisler 1977, 235 n. 21, cites Mary's deathbed presence in *Ars Moriendi* woodcuts as further confirmation that she is the person closest to Clare; see Stephan Beissel, *Geschichte der Verehrung Marias im 16. und 17. Jahrhundert* (Freiburg 1910; reprint, Nieuwkoop, 1970), 9–16. Seymour 1961, 18, interprets Mary's gesture as closing the mouth of the dead Clare.

13. Kress 1956, 122, identifies this figure as Saint Cecilia; the tentative identification as Saint Helena by Eisler 1977, 233, is based on the imperial eagle in her crown as well as the special devotion to the True Cross by Clare and the Franciscan Order.

14. Accepted by Kress 1956, the identification is questioned by Eisler 1977, 233. Saint Dorothy's traditional attributes are either a basket of fruit and flowers or a basket of roses, and even though the flowers in the painting are not identifiable, it seems likely that the saint is Dorothy, a virgin martyr.

15. Brady 1953, 50.

16. For Agnes of Assisi see Thurston and Attwater, 4: 358–359; for Agnes of Rome and her attribute the lamb see Réau, *Iconographie*, vol. 3, pt. 1 (1958), 33–38.

17. Acc. no. 36,496, fir, 71 × 54 cm.; painted surface, 66.9 × 54 cm. Full catalogue information is provided in Stechow 1974, 4–5; see also Technical Notes.

18. Eisler 1977, 233, notes a connection between diptychs and the reading of prayers for the dead in the liturgy.

19. Stange *DMG*, 4; see also note 5. Buchner 1924, 12, listed both the Cleveland and NGA panels as coming from an East Prussian castle; Henry S. Francis, letter to John Walker, 6 March 1961, in NGA curatorial files,

quotes Richard Zinser, who once owned the Cleveland panel, as believing that it belonged to the Radziwill family. Wilhelm Suida, undated memorandum, in NGA curatorial files, recording a conversation with Frederick Stern, 31 January 1952, gives a private collection in northeast Germany, possibly out of a monastery in the same region, as the source of the panels. This last is given as provenance in Kress 1956, 122.

20. Daniel Levine, NGA summer intern, department of northern Renaissance painting, memorandum, 1986, in NGA curatorial files. For the displaced potent-counter-potent (in German, *Verschobenes Gegensturzkrückenfeh*) see Arthur Charles Fox-Davies, *A Complete Guide to Heraldry* (London, 1929), 84–85, 80, fig. 39s. Interestingly, this device appears in the arms of the Cistercian Order of Clairvaux (*Johann Siebmacher's grosses Wappenbuch*, 34 vols. [1854; reprint, Neustadt an der Aisch, 1970–1984]; *Die Wappen der Bistümer und Klöster* 8 [1976], pl. 145), and of the city of Champagne (*Die Wappen und Flaggen der Herrscher und Staaten der Welt* 1 [1978], pl. 32). Levine also notes what may be a purely decorative appearance of the motif in the hem of the Virgin's robe in an early fifteenth-century Parisian panel of the *Enthroned Madonna and Child with Saints and a Donor*; discussed and reproduced in Michel Laclotte, "Tableaux de chevalet français vers 1400," *Art de France* 3 (1963), 220–222.

21. Inv. no. 6523; Wolfgang Prohaska, *Kunsthistorisches Museum Wien. II. Die Gemäldegalerie* (Munich and London, 1984), 91, color repro.

22. Sterling 1942, 15, c. 1420/1430; Eisler 1977, 234. Eisler considered as by the Heiligenkreuz master and close in date pendant panels of the *Man of Sorrows* and the *Madonna and Child* (Kunstmuseum Basel), catalogued as Bohemian, c. 1360; see *Kunstmuseum Basel. Katalog. 1. Die Kunst bis 1800*, 2d ed. (Basel, 1966), 5, repro.

23. Buchner 1924, 5. Baldass 1929, 66, and Ring 1949, 199, call the Cleveland and Washington panels "less French" than the Vienna pictures, perhaps implying a later date.

24. Eisler 1977, 233; the Nuremberg panel, representing the *Death and Coronation of Saint Clare*, fig. 51, is dated c. 1365. *The Death of Saint Clare* formerly in Berlin came from Augsburg and was dated 1430 on the reverse; see Stange *DMG*, 4 (1951): 121, fig. 186.

25. Steingräber 1969, 32–33, discusses the punch work in the National Gallery's painting as belonging to the French court and the Franco-Netherlandish tradition. On the other hand, there are equally legitimate comparisons with the punch work in Bohemian painting of the early fifteenth century; for examples see Antonin Matejcek and Jaroslav Pesina, *Gothic Painting in Bohemia 1350–1450* (Prague, n.d. [1956?]), pl. 194: *Madonna of Saint Thomas' Church* (Provincial Museum, Brno); pl. 203, *Madonna of Vyssí Brod* (Monastery Church of the Virgin, Vyssí Brod).

References

1924 Buchner, Ernst. "Eine Gruppe deutscher Tafelbilder vom Anfang des XV. Jahrhunderts." *Oberdeutsche Kunst der Spätgotik und Reformationszeit.* Edited by Ernst Buchner and Karl Feuchtmayr. Beiträge zur Geschichte der deutschen Kunst. Vol. 1. Augsburg: 1–13, fig. 2.

1926 Baldass, Ludwig. Review of *Oberdeutsche Kunst der Spätgotik und Reformationszeit. Belvedere* 9/10: 133–136.

1926 Suida, Wilhelm. *Österreichs Malerei in der Zeit Erzherzog Ernst des Eisernen und König Albrecht II.* Vienna: 25.

1929 Baldass, Ludwig. "Die Wiener Tafelmalerei von 1410–1460 (Neuerwerbungen des Wiener Kunsthistorischen Museums)." *Der Cicerone* 21: 65–67.

1936 Oettinger (see Biography): 78.

1938 Ring, Grete. "Primitifs français." *GBA* 19: 157–168.

1942 Sterling, Charles. *Les peintres du moyen age.* Paris: 15, no. 9.

1943 Larsen-Roman, Erik, and Lucy Larsen-Roman. "Les origines provençales du Maître de Heiligenkreuz." *Apollo. Chronique des Beaux-Arts* 18: 17–19.

1949 Ring, Grete. *A Century of French Painting 1400–1500.* London: 199, no. 59.

1950 "Meister von Heiligenkreuz." In Thieme-Becker, 37: 144–145.

1956 Frankfurter, Alfred. "Crystal Anniversary in the Capital." *ArtN* 55: 26, repro.

1956 Kress: 120–123, no. 46, repro.

1956 "The Kress Collection." *Arts* 30: 49, repro. 48.

1960 Broadley: 12, repro. 13.

1961 Musper, Heinrich Theodor. *Gotische Malerei nördlich der Alpen.* Cologne: 119, repro.

1961 Seymour (Kress): 18, 21, pl. 16.

1961 Stange *DMG*, 11: 4.

1963 Walker: 110, repro. 111.

1966 Cairns and Walker: 102, repro. 103.

1968 Cuttler. *Northern Painting*: 51.

1969 Steingräber, Erich. "Nachträge und Marginalien zur französisch-niederländischen Goldschmiedekunst des frühen 15. Jahrhunderts." *AdGM* 32, 34, fig. 6.

1970 Musper, Heinrich Theodor. *Altdeutsche Malerei.* Cologne: 28, 92, no. 18, repro. 93.

1974 Stechow, Wolfgang. "Master of Heiligenkreuz, ca. 1400." *European Paintings Before 1500.* Pt. 1. Cleveland Museum of Art Catalogue of Paintings. Cleveland: 4–5, repro.

1975 NGA: 222, repro. 223.

1976 Walker: 147, no. 154, repro. 146.

1977 Eisler: 232–236, figs. 225–226.

1984 Walker, John. *National Gallery of Art, Washington.* Rev. ed. New York: 5, repro. 3.

1985 NGA: 254, repro.

Master of the Saint Bartholomew Altar

active c. 1475–1510

T HE ARTIST takes his name from an altarpiece in the Alte Pinakothek, Munich, that depicts on the center panel Saint Bartholomew flanked by Saints Agnes and Cecilia. Although the painting is known to have been in the Church of Saint Columba in Cologne, the Carthusian monk kneeling next to Saint Bartholomew raises the possibility of associations with the Carthusian monastery in Cologne.

It is now generally believed that the master was born and first trained in the Netherlands, perhaps in Utrecht or in the Gelderland region, and that possibly around 1480 he emigrated to Cologne. Our knowledge of his early style proceeds from the miniatures in the *Hours of Sophia van Bylant* (Wallraf-Richartz-Museum, Cologne), one of which, *The Flagellation*, is dated 1475. The calendar of the manuscript is that of the diocese of Utrecht, but certain linguistic peculiarities of the text point to Arnhem, as does the fact that the donor lived in that region. Early works, dated to the 1480s, such as the *Adoration of the Kings* or the *Madonna and Child with Saint Anne* (both Alte Pinakothek, Munich), exhibit affinities with north Netherlandish art and were possibly created in the Netherlands.

The only documented works by the Bartholomew master are two altarpieces commissioned for the Carthusian monastery in Cologne by Dr. Peter Rinck, a lawyer. The *Saint Thomas* altarpiece (Wallraf-Richartz-Museum, Cologne) was donated before Rinck's death in 1501 and bears his housemark. The *Crucifixion* altarpiece (Wallraf-Richartz-Museum, Cologne) was probably not begun until after Peter Rinck's death and marks the transition from middle to late periods. Characteristic of the late period are the broader forms of the *Saint Bartholomew* altarpiece, which is generally dated c. 1505/1510.

Despite several attempts, the Master of the Saint Bartholomew Altar has resisted identifica-

tion. It has been suggested, however, because of the commissions for the Carthusian monastery, that the artist might himself have been a member of the order. The master is often spoken of as the last "Gothic" painter of the Cologne School. Approximately twenty-five paintings have been attributed to him and are highly individual in style. Abstraction and realism are often contrasted; retardataire elements are combined with a progressive rendering of volume and texture; and a mystical intensity of religious feeling is acted out by figures who have an almost childlike innocence and simplicity. Despite the fact that he was the leading painter in Cologne at the end of the century, the Bartholomew master seems to have had no direct followers or a school in the usual sense.

Bibliography

Rath, Karl vom. *Der Meister des Bartholomäusaltares.* Bonn, 1941.
Der Meister des Bartholomäus Altares, der Meister des Aachener Altares. Kölner Maler der Spätgotik. Exh. cat., Wallraf-Richartz-Museum. Cologne, 1961.

1961.9.78 (1630)

The Baptism of Christ

c. 1485/1500
Probably oak, 105.7 × 170.4 (41⅝ × 67⅛)
 painted surface: 104.3 × 169.7 (41 × 66¾)
Samuel H. Kress Collection

Inscriptions

On banderole: *HIC EST EILIVS MEVS DILECTV̑ IN QVO MICHI CONPLICVI* [1]
On heart held by Saint Augustine: *IH̑S*

Technical Notes: The painting is composed of four oak boards with horizontal grain, joined with a block and four-dowel system.[2] The boards have been thinned. There are unpainted edges at the top, bottom, and left sides. A backing board, also oak, and a cradle have been

attached. The smooth white ground is covered by a striated isolation coat containing lead-white. Examination with infrared reflectography reveals extensive densely hatched and crosshatched underdrawing in the figures, which appears to have been done with a brush (fig. 1). A good deal of this underdrawing is visible to the naked eye. Traces of gold leaf can be seen in the musical instruments held by the foreground angels and in the censer held by an angel. There are extensive flake losses throughout, most noticeably in the lower half of the angel playing a vielle. There are small, scattered losses in the figures of Christ and John the Baptist. In addition, the paint surface has suffered from abrasion, and it is likely that glazes are missing. What was originally gold leaf in the background has been largely replaced by gold-colored paint. In 1905 the painting bore a false Lucas van Leyden monogram, which was probably removed before 1941.

Provenance: Possibly a church in Arnhem.[3] Count Jacques de Bryas, Paris (sale, Hôtel Drouot, Paris, 6 February 1905, no. 20); (Galerie F. Kleinberger, Paris).[4] Richard von Kaufmann, Berlin (sale Paul Cassirer and Hugo Helbing, Berlin, 4 December 1917, no. 132). (Paul Graupe, Berlin).[5] Otto Henkell, Wiesbaden. (Rosenberg & Stiebel, New York); purchased February 1955 by the Samuel H. Kress Foundation, New York.

Exhibitions: Berlin, Königliche Akademie der Künste, 1914, *Ausstellung von Werken alter Kunst aus dem Privatbesitz von Mitgliedern des Kaiser-Friedrich-Museums-Vereins*, no. 92. Cologne, Messehalle, 1925, *Jahrtausend Ausstellung der Rheinlande in Köln*, no. 71.

DEPICTED at the center of this outstanding painting is the Baptism of Christ in the River Jordan. John the Baptist, wearing a camel skin, pours water over Christ's head. Also present in this foreground group are two music-making angels and a third angel in a brocaded cope who holds Christ's cloak. As recounted in the three synoptic Gospels, this event was accompanied by the descent of the Holy Spirit. Thus, appearing overhead are the dove of the Holy Spirit and God the Father, his hands raised in blessing, attended by two angels holding candles. On the banderole below are God's words from Matthew 3:17: "This is my beloved Son, with whom I am well pleased." As noted by Eisler, God the Father wears on his proper left wrist a maniple, used by priests when performing a rite associated with the Eucharist.[6] A further liturgical note is added by the censer held by the small naked angel.

A mystical and rather magical element is created by the fourteen saints, seven male and seven female, who emerge from a bank of luminous clouds and hover in a semicircle over the Baptism. The shimmering, otherworldly gold background is in deliberate contrast to the vigorous realism of the figures, as seen especially in the carefully rendered textures of fabric and metal or the drops of water on Christ's forehead. The saints are readily identifiable by their attributes. Starting from the left are depicted Dorothy, holding a basket of roses; Andrew, with the X-shaped cross; Christopher, carrying the Christ Child; Jerome, in cardinal's hat and robes; Catherine, holding a wheel and a sword; Augustine, dressed as a bishop and holding a heart; Agnes, holding a lamb; Francis, displaying the stigmata; Lucy, with a sword through her neck; Elizabeth, wearing a crown and holding another; Anthony Abbot, with a crozier; Apollonia, bearing a pair of tongs with a tooth; Mary Magdalene, with an ointment jar; and lastly, George, in armor and kneeling on a dragon.

Even though fourteen saints are depicted (excluding John the Baptist), there appears to be no direct relationship to the group known as the fourteen Holy Helpers, venerated in Germany especially from the fourteenth century onward. Of the standard fourteen Holy Helpers, only Saints Christopher, George, and Catherine appear in the National Gallery's painting.[7]

The relatively large size of *The Baptism of Christ* suggests that it probably functioned as an altarpiece. Although the horizontal shape is somewhat unusual, the possibility that there were originally shutters is not precluded.[8] As several authors have observed, the combination of the Baptism of Christ with fourteen saints is iconographically unique, and the choice of both subject and individual saints was determined by the terms of the commission.[9]

Unfortunately, nothing is known about the commission or the original location of the panel. Based on a note affixed to the back of the picture, the painting is traditionally thought to have been in a church in Arnhem, in the Gelderland region of the Netherlands. Eisler's assertion that the painting may have been done for the high altar of the Sint Janskerk in Arnhem is possible but awaits confirming evidence.[10] The Sint Janskerk was

Master of the Saint Bartholomew Altar, *The Baptism of Christ*, 1961.9.78

Fig. 1. Infrared reflectogram assembly of a detail of *The Baptism of Christ*, 1961.9.78 [infrared reflectography: Molly Faries]

demolished in 1817, and the first mention of the painting in connection with the "cathédrale" in Arnhem occurs in 1905.[11]

Although *The Baptism of Christ* is without visual or textual precedent, a few remarks about its general liturgical function are possible. Christ's Baptism by John marks his acceptance of and his cleansing of the sins of the world, and in this regard, it foreshadows his death on the cross. In addition, the descent of the Holy Spirit upon Christ is a critical indication of his status as the Messiah. The Christian who follows Christ through the first sacrament of baptism symbolically dies and is resurrected. It is only through rebirth by means of baptism that one enters the community of the Church.[12] Here, the opening of the heavens at the moment of Christ's Baptism and the witnessing of the event by numerous saints may, as suggested by Eisler, represent the Church and its congrega-

tion of baptized souls.[13] Levine emphasized the relationship between baptism and Pentecost— the descent of the Holy Spirit on the Christian community—whose celebration is the culmination of the paschal cycle.[14]

Many of the plants arrayed across the foreground strengthen the associations between baptism, the Passion of Christ, and the Trinity. The columbines prominently displayed below Christ can refer both to the dove of the Holy Spirit and to the Passion of Christ.[15] At the left are plantain, associated with Christ's death, and mint, a healing and purifying herb. At the far right are strawberries, whose leaves allude to the Trinity and whose petals symbolize the blood and wounds of Christ.[16]

The Baptism of Christ is solidly attributed to the Master of the Saint Bartholomew Altar and is unanimously praised as a work of importance and

high quality. Brockmann and, more importantly, Stange dated the painting to the 1480s, while Boon put it no later than c. 1490.[17] For Stange and Boon, the putative Arnhem provenance and the possibility that the painting was executed before the artist left the Utrecht-Arnhem region for Cologne were factors in the dating.[18] In view of the unverified provenance and the lack of precise information about the master's travels, these become moot points. While noting the possible Dutch origins of the Washington panel, Pieper saw its pictorial language as more typical of Cologne and suggested that *The Baptism of Christ* may have been one of the first works the master produced in Cologne.[19] The use of a gold background may also be more appropriate to Cologne than to the Netherlands, where, by the turn of the century, it might have seemed old-fashioned.

Stylistically, the most immediate comparisons are with the master's *Saint Thomas* altarpiece (fig. 2). The general arrangement of saints in clouds in a semicircle around the central figures of Christ and Thomas, with music-making angels in the foreground and God the Father overhead, is like that in *The Baptism of Christ*. Moreover, individual details, such as the faces of Saints Jerome[20] and Mary Magdalene, Christ, and even Thomas in comparison to John the Baptist, are remarkably similar in both paintings. One of the two paintings by the Bartholomew master donated to the Carthusian cloister in Cologne by Dr. Peter Rinck, the *Saint Thomas* altarpiece is usually dated between 1490 and 1500.[21] Somewhat more finished and spatially advanced, it is considered by several authors to be slightly later than his *Baptism of Christ*.[22] Also close in style is the *Madonna*

Fig. 2. Master of the Saint Bartholomew Altar, *The Saint Thomas Altar*, panel, Wallraf-Richartz-Museum, Cologne [photo: Rheinisches Bildarchiv]

and Child with Saints Augustine and Adrian, usually dated c. 1490/1500 (Hessisches Landesmuseum, Darmstadt).[23]

While the National Gallery's painting is closest to the *Saint Thomas* altarpiece, there is nothing to exclude a date as early as c. 1485/1490. *The Baptism of Christ* does not, however, fit among the early works, which include such pictures as the *Madonna and Child with Saint Anne* (Alte Pinakothek, Munich).[24] Pieper noted similarities to facial types used in the *Hours of Sophia van Bylant* of 1475.[25] Comparison with the heavier modeling found in the late works such as the artist's name piece, the *Saint Bartholomew* altar in Munich, excludes a late date for *The Baptism of Christ*.

Notes

1. As per Matthew 3:17, this should be HIC EST FILIUS MEUS DILECTUS IN QUO MICHI CONPLACUI. Examination with a microscope reveals that the P in CONPLACUI is obscured by repaint.

2. The wood was identified as oak by the National Gallery's scientific research department.

3. First mentioned in *Catalogue des tableaux anciens . . . provenant de la collection de M. le Comte Jacques de Bryas*, Hôtel Drouot (Paris, 1905), 11: "Cette oeuvre du plus grand caractère, et dans le plus admirable état de conservation, provient de la cathédrale d'Aarnheim, édifice gothique qui fut au XVIIᵉ siècle désaffecté du culte catholique." Friedländer in the Paul Cassirer and Hugo Helbing sales catalogue *Die Sammlung Richard von Kaufmann Berlin* (Berlin, 1917), no. 132, cites a "Notiz auf der Rückseite" as the basis for the Arnhem provenance. This notice was never described and had disappeared by 1941, as per Rath 1941 (see Biography), 125, no. 9.

4. Handwritten note in the margin of the copy of the 1905 sales catalogue in the NGA library.

5. Handwritten note in vol. 2 of the 1905 sales catalogue in the NGA library.

6. Eisler, 1977, 8.

7. The traditional fourteen Holy Helpers whose feast day is 8 August and who are invoked as a group in cases of dire need or distress are: Saints Achatius, Barbara, Blaise, Catherine, Christopher, Cyriacus, Denis, Erasmus, Eustace, George, Giles, Margaret, Pantaleon, and Vitus. In different localities substitutions occur and can include, for example, Saint Dorothy, who appears in the National Gallery's panel. See Joseph Braun, *Tracht und Attribute der Heiligen in der deutschen Kunst* (Stuttgart, 1943), cols. 561–566; F. Geldner, "Nothelferverehrung vor, neben und gegen Vierzehnheiligen," *Historischer Verein für die Pflege*

der Geschichte des ehemaligen Fürstbistums zu Bamberg 89 (1948–1949), 36–47; J. Dünninger, "Fourteen Holy Helpers," *NCathEnc* 5: 1045–1046.

8. The center panel of the *Saint Bartholomew* altarpiece in Munich is of similar shape and dimensions (128.6 × 161 cm.). See Gisela Goldberg and Gisela Scheffler, *Altdeutsche Gemälde. Köln und Nordwestdeutschland*, vol. 14 (Munich, 1972), 231–243.

9. The uniqueness of the iconography was probably first noticed by Pieper 1959, 155, who also observed (n. 46), that inclusion of John the Baptist would raise the number of saints to fifteen. I have been unable to find a common factor that would unify the fourteen saints depicted in the National Gallery's painting. All are well known, widely venerated, and popular.

10. Eisler 1977, 9, where he also suggests that the commission may have been given to Johan van Hatstein, commander of the Order of Saint John from 1486 to 1497.

11. See note 3.

12. Réau, *Iconographie*, vol. 2, pt. 2, 295–304; articles on baptism in *NCathEnc* 2: 54–69.

13. Eisler 1977, 8.

14. Daniel Levine, NGA summer intern, department of northern Renaissance painting, memorandum, 1986, in NGA curatorial files. Although Pentecost now falls on the seventh Sunday after Easter, it was originally a feast that occurred fifty days after Passover and was adapted to Christian usage. Levine sees a connection between the numerological significance of Pentecost (7 × 7 + 1) and the fourteen saints plus John the Baptist in the painting (7 + 7 + 1). If there is a connection between Pentecost and the paschal cycle, then the candles carried by the angels flanking God the Father might refer to the paschal candles, an important part of the celebration of baptism within the Easter Vigil. See B. F. Meyer, "Pentecost," and E. J. Johnson, "Pentecost Cycle," *NCathEnc* 11: 104–105, 109–111; R. van Doren, "Easter Vigil," *NCathEnc* 8: 918; and B. I. Mullahy, "Light, Liturgical Use of," *NCathEnc* 8: 753.

15. See Fritz 1952, 99–110; Ingo Krumbiegel, "Die Akelei (Aquilegia). Eine Studie aus der Geschichte der deutschen Pflanzen," *Janus. Archives internationales pour l'histoire de la médecine et la geographie médicale* 36 (1932), 71–92; Lottlisa Behling, *Die Pflanze in der mittelalterlichen Tafelmalerei*, 2d ed. (Cologne and Graz, 1967), 36–164.

16. These plants appear in Gerard David's *The Rest on the Flight into Egypt* (National Gallery of Art, 1937.1.43), and their symbolism is discussed in John Oliver Hand and Martha Wolff, *Early Netherlandish Painting*, Systematic Catalogue of the Collections of the National Gallery of Art (Washington, 1986), 64. I am grateful to Dianne Cina of the National Gallery's horticultural staff for assistance in identifying the plants. The small plants with white flowers on either side of the columbine are possibly some form of daisy (*Bellis*

perennis), a Marian flower, but they are too generalized for precise identification; see Behling 1967, 33, 39.

17. Brockmann 1924, 53; Stange 1952, 66; Boon 1940, 101.

18. Their comments may have been influenced by Max J. Friedländer, "Neues über den Meister des Bartholomäus Altars," *WRJ* 13/14 (1926/1927), 182, who proposed that the Master of the Saint Bartholomew Altar was born in Cologne around 1455, traveled to the Netherlands around 1475, and worked there for about ten years before returning to Cologne.

19. Pieper in exh. cat. Cologne 1961 (see Biography), 27.

20. Oswald 1961, 342–346, suggested that the facial features of both Saint Jeromes are those of Archbishop Antonino of Florence (1389–1459), who was canonized in 1521. A bust based on a death mask in Santa Maria Novella, Florence (Oswald 1961, fig. 230), offers several plausible points of comparison.

21. Exh. cat. Cologne 1961 (see Biography), 87–91, no. 22.

22. Pieper in exh. cat. Cologne 1961 (see Biography), 29; Wallrath 1961, 155; exh. cat. Cologne 1970, 48; Budde 1986, 143.

23. Exh. cat. Cologne 1961 (see Biography), 92, no. 23, fig. 45. Steingräber 1964, 224, n. 6, noted similarities between the Saint Agnes in the National Gallery's painting and the master's *Mystic Marriage of Saint Agnes* (Germanisches Nationalmuseum, Nuremberg), dated c. 1495/1500.

24. Exh. cat. Cologne 1961 (see Biography), color pl. IV.

25. Pieper 1953, 150, specifically compared the face of John the Baptist in the National Gallery's painting with that of the same saint in the miniature depicting Reynalt von Homoet, and compared Saint Andrew to Saint James in the illumination showing Sophia van Bylant.

References

1906 *Exhibition of Early German Art.* Exh. cat., Burlington Fine Arts Club. London: 55.

1913/1914 Plietzsch, E. "Die 'Ausstellung von Werken alter Kunst' in der Berliner Kgl. Akademie der Künste." *Zeitschrift für bildende Kunst*, n.s., 25: 228, repro. 225.

1917 Friedeberger, H. "Die Sammlung Richard von Kaufmann-Berlin." *Der Cicerone* 9: 377.

1918 "Die Versteigerung der Sammlung von Kaufmann." *Der Cicerone* 10: 26.

1923 Schaefer, Karl. *Geschichte der Kölner Malerschule.* Lübeck: 19.

1924 Brockmann, Harald. *Die Spätzeit der Kölner Malerschule. Der Meister von St. Severin und der Meister der Ursulalegende.* Bonn and Leipzig: 53.

1925 Reiners, Heribert. *Die Kölner Malerschule.* Munich, Gladbach, Bonn, and Leipzig: 182, 186–187, 190, pl. XXXVII.

1939 Ring, Grete. "Die Gruppe der heiligen Agnes." *Oud Holland* 56: 39.

1940 Boon, K. G. "Einige Opmerkingen naar aanleiding van Vroege Nederlandsche Schilders." *Oud Holland* 57: 101.

1941 Rath (see Biography): 52–57, 59–61, 125, no. 9, figs. 19–23.

1950 Stange, Alfred. *German Painting XIV–XVI Centuries.* New York, Paris, and London: 25.

1950 Rath, Karl vom. "Meister des Bartholomäus-Altares." In Thieme-Becker, 37: 35.

1952 Fritz, Rolf. "Aquilegia. Die symbolische Bedeutung der Akelei." *WRJ* 14: 101, 109, no. 58, fig. 93.

1952 Stange *DMG*, 5: 66, fig. 135.

1953 Pieper, Paul. "Miniaturen des Bartholomäus-Meisters." *WRJ* 15: 149–152, 154, fig. 133.

1956 Frankfurter, Alfred. "Crystal Anniversary in the Capital." *ArtN* 55: 35.

1956 Kress: 124, no. 47, repro. 125.

1959 Levey, Michael. *The German School.* National Gallery Catalogues. London: 92.

1959 Pieper, Paul. "Das Stundenbuch des Bartholomäus-Meisters." *WRJ* 21: 139, 155–157, figs. 75–76.

1960 Broadley: 18, repro. 19.

1961 Andree, Rolf, Helmut R. Leppien, and Horst Vey. "Nachlese der Ausstellung 'Kölner Maler der Spätgotik.'" *WRJ* 23: 331–332.

1961 Exh. cat. Cologne (see Biography): 27, 29, 91, no. 22, 92, no. 23.

1961 Oswald, Fritz. "Die Darstellungen des Hl. Hieronymus beim Meister des Bartholomäusaltares." *WRJ* 23: 342, fig. 229.

1961 Wallrath, Rolf. Exhibition review, "Kölner Maler der Spätgotik." *Kunstchronik* 14: 153, 155.

1962 Cairns and Walker: 66, repro. 67.

1963 Walker: 112–113, repro.

1964 Steingräber, Erich. "Ein neu entdecktes Werk vom Meister des Bartholomäus-Altares." *WRJ* 26: 224, n. 6.

1964 Malkon, K. "Meister des Bartholomäusaltars." *Kindlers* 1: 214–215.

1966 Cairns and Walker: 104, repro. 105.

1967 Stange, Alfred. *Kritisches Verzeichnis der deutschen Tafelbilder vor Dürer.* 3 vols. Munich, 1: 85, no. 252.

1969 Montebello, Philippe de. "Master of the St. Bartholomew Altarpiece." *Dictionary of Art.* 5 vols. Toronto, London, Sydney, and Johannesburg, 4: 13.

1969 Osten, Gert von der, and Horst Vey. *Painting and Sculpture in Germany and the Netherlands 1500 to 1600.* Harmondsworth: 138–139.

1970 *Herbst des Mittelalters. Spätgotik in Köln und am Niederrhein.* Exh. cat., Kunsthalle. Cologne: 48, under no. 34.

1970 Musper, Heinrich Theodor. *Altdeutsche Malerei*. Cologne: 11.

1975 NGA: 224, repro. 225.

1977 Eisler: 8–10, fig. 10.

1983 Wolff: unpaginated, repro.

1984 Walker, John. *National Gallery of Art, Washington*. Rev. ed. New York: no. 147, repro.

1985 NGA: 256, repro.

1986 Budde, Rainer. *Köln und seine Maler 1300–1500*. Cologne: 141–143, 258, no. 95, figs. 121, 122, color pl. 30.

The Master of Saint Veronica

active c. 1395-c.1420

THE ARTIST takes his name from the painting of *Saint Veronica Holding the Sudarium* (Alte Pinakothek, Munich). He was active in Cologne, and *Saint Veronica* and several other works ascribed to him were originally in religious institutions in that city. No dated or documented works by him are known, and previous attempts to identify him with known Cologne artists such as Herman Wynrich von Wesel have been unsuccessful. Although the master's oeuvre consists of only about eleven paintings, it has been possible, nonetheless, to establish a general chronological order. For example, his *Small Crucifixion* (Wallraf-Richartz-Museum, Cologne) is dated early, c. 1400, while the Munich *Saint Veronica* and the *Madonna of the Sweet Pea* (Germanisches Nationalmuseum, Nuremberg) are considered to be late, c. 1420.

The Master of Saint Veronica was the most important artist in Cologne before Stefan Lochner. He shares with other practitioners of the International Style around 1400 a gentle lyricism, decorative elegance, and delicacy of coloring. Although his origins and possible travels are unknown, associations with French and Burgundian art are evident.

The master's style was continued in Cologne by the Master of Saint Lawrence, who was probably part of the shop and, according to Zehnder, may have collaborated on such paintings as the *Madonna of the Sweet Pea* (Wallraf-Richartz-Museum, Cologne).

Bibliography
Stange *DMG*, 3: 56–67.
Zehnder, Frank Günter. "Der Meister der Hl. Veronika." Ph.D. diss., Rheinischen Friedrich-Wilhelms-Universität, Bonn. Sankt Augustin, 1981.

1961.9.29 (1390)

The Crucifixion

c. 1400/1410
Oak, 46.2 × 31.1 (18¼ × 12¼);
 design area, 40.7 × 25.2 (16 × 9⅞)
Samuel H. Kress Collection

Inscriptions
At top of cross: *J·N·R·I·*
In Mary's halo: possibly *salv* [illegible]
 m [?] *ar* [?]*ia:m* [?]*a*
In Christ's halo: [illegible]
In John's halo: *:s:Joha* [illegible]*:evia* [illegible][1]

Marks: On reverse, three National Gallery paper stickers; also, at top, a paper sticker: *A5322*; below, in black grease pencil or crayon: *A5322*; at bottom: illegible red and black circular stamps.

Technical Notes: The picture and its engaged frame are composed of a single piece of vertically grained wood; the frame is 2.3 cm. thick, and the design area is approximately 1.3 cm. thick. Dendrochronological examination by Peter Klein suggests a felling date of 1398^{+6}_{-4}.[2] Gold leaf over red bole covers both the frame and the background. Delicate punch work is used throughout the areas of gold leaf; small dots and circles decorate the frame, while the clouds, the angels' wings, and the outlines of the chalices are created out of tiny dots. Larger punched dots were used to create the halos and the lettering within them. Fine, shallow incised contours outline the figures. There is some overlapping of the major figures and the gold leaf, visible at the top of the Virgin's head, in the monk's left eye, and in areas of loss. The angels and Longinus' spear are painted over the gold. Examination with infrared reflectography reveals a small amount of underdrawing in the torso of Christ.

The panel is in good condition. The right half of the face of the bottom edge was damaged and has been reconstructed and regilded. In some areas of paint there is moderate abrasion, and tiny flake losses exist in paint over gold leaf. Damage and regilding in the halos greatly reduce the legibility of the inscriptions. A small amount of regilding occurs above the monk's head and above John's halo.

The reverse of the panel is covered with a layer of white ground, which is in turn covered with a thin, red, bolelike paint; both are possibly original.

Provenance: Possibly the Carthusian monastery of Saint Barbara, Cologne.[3] Richard von Schnitzler, Cologne, by 1917.[4] (M. Knoedler & Co., New York, owned with Pinakos [Rudolf Heinemann] by 1953);[5] purchased 1954 by the Samuel H. Kress Foundation, New York.

Exhibitions: Cologne, Kölnischer Kunstverein, 1922, *Alte Malerei aus kölnischem Privatbesitz*, no. 60, as by follower of Meister Wilhelm. Cologne, Wallraf-Richartz-Museum, 1961, *Der Meister des Bartholomäus-Altares, der Meister des Aachener Altares. Kölner Maler der Spätgotik*, catalogue insert, unpaginated, unnumbered.

STANDING on either side of the crucified Christ are the Virgin and Saint John the Evangelist. Four small angels, holding chalices to collect Christ's blood, hover around the wounds in the hands, feet, and side, while a fifth angel, perhaps added for symmetry, is at the right of Christ's chest. Kneeling at the foot of the cross at the left is an elegantly clad Saint Longinus, a spear held delicately between his fingers. Longinus is the name traditionally given to the unnamed soldier who pierced Christ's side with a spear (John 19:34–35), but it is also given to the equally anonymous centurion who was the first Gentile to recognize Christ's divinity (Matthew 27:54).[6] What appear to be drops of blood falling from the tip of the lance may refer to an incident recounted in *The Golden Legend*, whereby Longinus' eye malady is miraculously cured by a drop of Holy Blood.[7] The presence of Longinus at the Crucifixion carries with it associations of pardon, redemption, and conversion, as does the veneration of the Holy Blood and the wounds of Christ.

Kneeling to the right of the foot of the cross is the Carthusian monk for whose private devotion and meditation this panel was almost certainly intended. I agree with Eisler that the young monk's features are so generalized and so like those of Saint John the Evangelist that it is doubtful that they portray an individual.[8] Although unverified, it is possible, as Eisler first suggested, that the *Crucifixion* was originally located in the Charterhouse of Saint Barbara in Cologne, the city where the Master of Saint Veronica was active and where Saint Bruno, founder of the Carthusian Order, was born. The Charterhouse in Cologne was

a large and important institution that underwent a major building campaign between 1391 and 1405.[9] Given the order's emphasis on solitary contemplation and devotion, it would seem likely that the National Gallery's panel adorned the cell of a single monk. It is possible that it was originally part of a commission for multiple images, as was the case with the Crucifixions painted by Jean de Beaumetz and his shop for the Charterhouse at Champmol.[10]

This *Crucifixion* has always been recognized as an important work of the School of Cologne. It was first published in 1917 as by Hermann Wynrich von Wesel, an attribution that proved untenable since the artist is known only through documents.[11] By 1920 the National Gallery's panel was identified as the work of the artist known as the Master of Saint Veronica, and now it is virtually unanimously identified as such.

The question of what constitutes the oeuvre of the master, however, remains a matter of some discussion. Schweitzer believed that *The Crucifixion* was by an artist in the workshop of the Veronica master but also wondered whether the stillness and intensity he observed was typical of the representation of emotion in the Cologne School of painting.[12] Pieper expressed similar thoughts in his 1950 discussion of a related *Trinity* in the Landesmuseum, Münster, suggesting that both *The Crucifixion* and the panel in Münster were possibly by a Westphalian artist under the influence of the quieter style of Cologne and of the Veronica master in particular.[13] Pieper has since accepted both paintings as by the Master of Saint Veronica, but more recently Eisler, seeing in the National Gallery's panel a greater delicacy than in the master's other works, wondered if Schweitzer's doubts might not be correct.[14]

The overwhelming majority of authors have placed *The Crucifixion* among the core paintings by the Master of Saint Veronica. No work is dated earlier, and Zehnder listed it as perhaps the master's earliest picture.[15] Förster dated *The Crucifixion* in the 1380s, but most critics, following Stange, place it around or a little before 1400.[16] Dendrochronological examination suggests a date of c. 1410,[17] which is in accord with the date of c. 1407 proposed by Eisler on the basis of King Ruprecht's decision in 1407 to place the Char-

Master of Saint Veronica, *The Crucifixion*, 1961.9.29

terhouse in Cologne under the protection of the Holy Roman Empire.[18]

The National Gallery's painting fits easily into the group of works generally agreed to be early: the *Man of Sorrows* (Koninklijk Museum voor Schone Kunsten, Antwerp); the *Small Crucifixion* (Wallraf-Richartz-Museum, Cologne); the altarpiece of the *Madonna and Child with Saints and Angels* (Kisters Collection, Kreuzlingen);[19] and portions of the *Clara* altarpiece (Cathedral, Schnütgen-Museum, and Diözesan-Museum, Cologne). As Zehnder observed, the closest comparisons are with the Antwerp *Man of Sorrows* and the *Small Crucifixion* in Cologne, where the facial types, the soft delicate colors, the modeling, especially the brownish tones in Christ's face, and the highly symmetrical compositions are stylistically congruent.[20] There are, however, a few small differences; color is perhaps a bit more atmospheric and delicate in the Washington *Crucifixion*, particularly in the shot colors of John's robe. Stange, Pieper, Zehnder, and others have emphasized that the tenderness and elegant refinement of the Veronica master's art ally him with the International Style around 1400 and thus invite comparison with the paintings of Konrad von Soest in Westphalia, or with Franco-Burgundian manuscript illumination. These associations are particularly evident in *The Crucifixion*, perhaps because of its early date. Budde has seen the work as specifically influenced by André Beauneveu.[21]

Notes

1. Eisler 1977, 1, noted that the damage precluded secure transcription but suggested for Mary, Christ, and John, respectively: *SALVE REGI[N]A MA[TER]; JHSU; S. JOHANNES.*

2. See Appendix.

3. Unverified; see entry text.

4. Bombe 1917, 366.

5. M. Knoedler & Co. account book, where a penciled notation suggests that the panel was previously owned by a Dr. Howard in partnership with Mont and Newhouse. I am very grateful to Nancy Little for access to Knoedler's files.

6. Réau, *Iconographie*, vol. 3, pt. 2, 812–815; F. L. Cross and E. A. Livingstone, eds., *The Oxford Dictionary of the Christian Church*, 2d ed. (Oxford, 1983), 835.

7. Ryan and Ripperger, *The Golden Legend*, 1: 191. I am grateful to Daniel Levine, NGA summer intern, department of northern Renaissance painting, 1986,

for calling attention to this detail. Both Broadley 1960, 14, and Eisler 1977, 4, observe that the point of the lance was a relic that was among the insignia of the Holy Roman Empire and was in Prague by 1350 and Nuremberg from 1424 until it was taken to Vienna in 1800. See Albert Bühler, "'Die Heilige Lanze.' Ein ikonographischer Beitrag zur Geschichte der deutschen Reichskleinodien," *Das Münster* 16 (1963): 85–116. Several other items have been claimed as relics of the Holy Lance, including a point lost in the French Revolution that was given to Saint Louis in 1241, and another portion presented by the Turks in 1492 to the pope and now in Saint Peter's, Rome. See *The Oxford Dictionary of the Christian Church*, 2d ed., 797.

8. Eisler 1977, 1.

9. J. J. Merlo, "Kunst und Kunsthandwerk im Karthäuserkloster zu Köln," *Annalen des historischen Vereins für den Niederrhein insbesondere die alte Erzdiöcese Köln* 45 (1886), 1–2. See also Paul Clemen et al., *Die Kunstdenkmäler der Stadt Köln*, vol. 2, pt. 3 (Düsseldorf, 1934), 137–162; and Otto Braunsberger, "Die Kölner Kartause. Erinnerungen aus alter Zeit," *Stimmen der Zeit. Katholische Monatschrift für das Geistesleben der Gegenwart* 94 (1918), 134–152. If the National Gallery's panel had been in the Charterhouse, it might have remained there until 1794 when the monastery was dispersed.

10. Noted by Eisler 1977, 1. For the Dijon commission and two extant paintings see Cyprien Monget, *La Chartreuse de Dijon d'après les documents des archives de Bourgogne* (Montreuil-sur-Mer, 1898), 1, 175; Charles Sterling, "Oeuvres retrouvées de Jean de Beaumetz, peintre de Philippe le Hardi," *Bulletin des Musées Royaux des Beaux-Arts de Belgique* 4 (1955; Miscellanea Erwin Panofsky), 57–81; Henry S. Francis, "Jean de Beaumetz, Calvary with a Carthusian Monk," *Bulletin of the Cleveland Museum of Art* 53 (1966), 329–338.

11. Bombe 1917, 366.

12. Schweitzer 1935, 70–71.

13. Pieper 1950, 190–191.

14. Pieper 1968, 667, 669; Pieper 1970, 95; Eisler 1977, 2.

15. Zehnder 1981, 94; exh. cat. Cologne 1974, 85.

16. Förster 1923, 41; Stange *DMG*, 3: 58.

17. See Appendix.

18. Eisler 1977, 1–2; see also Braunsberger 1918, 135.

19. Exh. cat. Cologne 1974, 158, no. 18; 156, no. 16; 161, no. 19.

20. Zehnder 1981, 86–87, 91–94; compare also Zehnder's comments in exh. cat. Cologne 1974, 38–39, 84, 85.

21. Budde 1986, 42.

References

1917 Bombe, Walter. "Die Sammlung Dr. Richard von Schnitzler in Cöln." *Der Cicerone* 9: 366, repro. 362.

1920 Lüthgen, Eugen. *Die abendländische Kunst des 15. Jahrhunderts.* Bonn and Leipzig: 55–57, pl. 29.

1921 Lüthgen, Eugen. *Rheinische Kunst des Mittelalters aus kölner Privatbesitz.* Bonn and Leipzig: 97, pl. 63.

1922 o.h.f. [Förster, Otto Helmut?]. "Köln." *Der Cicerone* 14: 984.

1923 Förster, Otto Helmut. *Die Kölnische Malerei. Von Meister Wilhelm bis Stephan Lochner.* Cologne: 41, frontispiece.

1931 Förster, Otto Helmut. *Die Sammlung Dr. Richard von Schnitzler.* Munich: 21, no. 1, pl. 1.

1935 Schweitzer, Klaus-Heinrich. *Der Veronikameister und sein Kreis. Studien zur kölnischen Kunst um 1400.* Würzburg: 70–71.

1938 Stange *DMG*, 3: 58, fig. 63.

1947 "Wynrich (Winrich), Hermann, Maler von Wesel." In Thieme-Becker, 36: 333.

1950 "Meister der [Münchener] hl. Veronika." In Thieme-Becker, 37: 344.

1950 Pieper, Paul. "Die 'Notgottes' in Landesmuseum Münster." *Westfalen* 28: 190–191.

1956 Frankfurter, Alfred. "Crystal Anniversary in the Capital." *ArtN* 55 (March): 35.

1956 Kress: 126, no. 48, repro. 127.

1957 Förster, Otto Helmut. "Um den Meister der Veronika." *WRJ* 19: 245.

1960 Broadley 1960: 14, repro. 15.

1961 Seymour (Kress): 18, 218, pl. 15.

1965 Oldemeyer, Gertrude. "Die Darstellung des gekreuzigten Christus in der Kunst des 'Weichen Stils.'" Ph.D. diss., Albert-Ludwigs-Universität, Freiburg im Breisgau. Aachen: 252.

1967 Stange, Alfred. *Kritisches Verzeichnis der deutschen Tafelbilder vor Dürer.* 3 vols. Munich, 1: 24, no. 35.

1968 Pieper, Paul. "Veronika. Meister der hl. Veronika." *Festschrift für Gert von der Osten.* Cologne: 95.

1974 *Vor Stefan Lochner. Die kölner Maler von 1300 bis 1430.* Exh. cat., Wallraf-Richartz-Museum. Cologne: 38–39, 84–85, 87, repro. 38.

1975 NGA: 226, repro. 227.

1977 Eisler: 1–3, fig. 1.

1978 Zehnder, Frank Günter. "Der kleine Kalvarienberg." In *Die Parler und der schöne Stil 1350–1400.* Exh. cat., Kunsthalle. Cologne: 210.

1981 Zehnder (see Biography): 86–95, (Katalog) 52, (Katalog) 54–56, no. 8, pls. 49–51, 53.

1984 "Meister der heiligen Veronika." *Lexikon der Kunst.* 5 vols. Berlin, 3: 251.

1984 Walker, John. *National Gallery of Art, Washington.* Rev. ed. New York: no. 149, repro.

1985 NGA: 239, repro.

1986 Budde, Rainer. *Köln und seine Maler 1300–1500.* Cologne: 42, 209, no. 23, fig. 27.

1986 Pieper, Paul. *Die deutschen, niederländischen und italienischen Tafelbilder bis um 1530.* Westfälisches Landesmuseum für Kunst und Kulturgeschichte Münster. Landschaftsverband Westfalen-Lippe. Münster: 405.

Hans Mielich

1516–1573

THE YEAR that Hans Mielich (Muelich, Müelich) was born is not documented, but a date of 1516 can be deduced from an illuminated self-portrait of 1571 in which his age is given as fifty-five. His first teacher was almost certainly his father, Wolfgang Mielich, although Hans was also influenced by Ludwig Refinger and Bartel Beham. Around 1536 he moved to Regensburg and his earliest paintings, such as his *Crucifixion* (Niedersächsisches Landesmuseum, Hannover), dated 1536, are dependent on the example of that city's leading painter, Albrecht Altdorfer. By 1539 or at the latest 1540, Mielich was back in Munich. Shortly afterward he journeyed to Italy, where the experience of High Renaissance and mannerist art, of Michelangelo in particular, had a decisive influence on him.

Returning to Munich probably in 1542, Mielich became a master in the painter's guild in 1543. He soon became court painter to Duke Albrecht V of Bavaria, and one of his earliest depictions of Albrecht is the splendid portrait (Alte Pinakothek, Munich) dated 1545. Mielich was also an excellent miniaturist. One of his major accomplishments was the hundreds of illuminations that accompany the deluxe manuscripts of the *Motets* of Cyprian de Rore of 1557/1559 and the *Penitential Psalms* of Orlando di Lasso of 1560/1571 (both Bayerische Staatsbibliothek, Munich). The composers worked at Albrecht's court. Mielich's portraits of court figures and nobility are often highly elaborate and mannered, as, for example, that of Ladislaus von Fraunberg, count of Haag (Prince of Liechtenstein collection, Vaduz), signed and dated 1557. His *Epitaph for the Parents of Oswald Eck* (Bayerisches Nationalmuseum, Munich) of 1554 contains in the upper portion a copy of Michelangelo's *Last Judgment* fresco (Sistine Chapel, Rome). Mielich's last major painting was the altarpiece of the Church of Our Beautiful Lady in Ingolstadt, commissioned by Albrecht V in con-

junction with the centennial of the university of Ingolstadt. Containing more than eighty paintings by Mielich and his workshop, the altar's iconographic program, devised with the help of the university's theologians, depicts Christ as teacher, helper, and redeemer, and scenes from the life of the Virgin. The altarpiece was completed in 1572. On 10 March 1573 Mielich died in Munich. Painter, miniaturist, and draftsman, he was the dominant painter in Munich in the second half of the century.

Bibliography

Röttger, Bernhard Hermann. *Der Maler Hans Mielich.* Munich, 1925.
Röttger, Bernhard Hermann. "Müelich (Mielich, Muelich), Hans." In Thieme-Becker, 25 (1931): 212–213.
Strieder, Peter. "Muelich (Mielich), Hans." *Kindlers* 4 (1967): 523–526.

1984.66.1

A Member of the Fröschl Family

c. 1539/1540
Linden, 64.2 × 47 (25¼ × 18½)
Gift of David Edward Finley and Margaret Eustis Finley

Inscriptions
On reverse: coat-of-arms, *gules, a powert sejant-erect*[1]
At bottom: *E.G.V.* [?]*Z.*

Labels: On reverse: several paper labels.[2]

Technical Notes: The painting is composed of two boards joined vertically along a slight diagonal.[3] There is a convex warp in the panel of approximately 1 cm. at its highest point. The panel appears to have split along the upper and lower ends of the join and the disjoins have been repaired by regluing and by gluing a wooden spline to the reverse of the join. Underdrawing applied with a brush in the landscape and the sitter's hands is visible in infrared photographs; the underdrawing of

Hans Mielich, *A Member of the Fröschl Family*, 1984.66.1

Hans Mielich, *A Member of the Fröschl Family*, 1984.66.1 (reverse)

the proper right hand extends onto the ground of the unpainted lower ledge.

The painting is in very good condition and appears to have been restored shortly before its acquisition by the National Gallery. There are minor inpainted losses along the top and bottom of the join, and very small areas of abrasion and loss in and around the hands. There are some pinpoint inpainted losses in the background, especially in the window frame and along the edges of the painting.

The paint on the reverse is more directly painted with a dry, sketchy technique, and underdrawing is not evident here. The reverse has suffered scattered losses, and along the edges an area of paint approximately 5 cm. wide has been abraded or damaged. Along the join the paint and ground have been sanded away to prepare the area for the reinforcing spline.

Provenance: Lord Northwick [d. 1859], Thirlestane House, Cheltenham, possibly by the early nineteenth century[4] (sale, Phillips, London, 26 July–30 August 1859, no. 134, as Amberger). Alfred Morrison [d. 1897], Fonthill House, Tisbury, Wiltshire, by 1887;[5] by inheritance to his son, Hugh Morrison [d. 1931], Fonthill House, Tisbury, Wiltshire, and Islay House, Argyll; by inheritance to his son, John Granville Morrison, 1st Baron Margadale, Fonthill House and Islay House; (P. & D. Colnaghi & Co., New York, owned jointly with Artemis/David Carritt Limited, London, by 1983);[6] purchased by the National Gallery, November 1984, with funds provided by David Edward and Margaret Eustis Finley.

Exhibitions: Bristol, British Museum Art Gallery, Royal West of England Academy, 1937, *Art Treasures of the*

West Country, no. 195, as by Christopher Amberger. City of Manchester Art Gallery, 1961, *German Art 1400–1800 from Collections in Great Britain*, no. 101, as by Christoph Amberger. New York, Colnaghi, 1983, *The Northern Renaissance, 15th and 16th Century Netherlandish Paintings*, no. 10.

A MEMBER of a patrician south German family, the sitter is simply but strikingly attired in a black damask robe and black cap. The collar and cuffs of his shirt are elegantly embroidered in black. His moustache and long, bifurcated beard tapering into points are fashionably elegant. The sonority and richness of the beautifully finished robe are set off against the broader textures of the mustard-yellow stone walls. Enlivening this restrained color scheme are the blues, greens, and browns of the background landscape.

The portrait of *A Member of the Fröschl Family* and its pendant, the *Portrait of a Woman* (fig. 1),[7] were together until 1859 and attributed to the Augsburg artist Christoph Amberger. That attribution persisted until 1967 when Löcher recognized them as works by Hans Mielich.

The sitters can be identified, to a limited degree, by the coats-of-arms on the reverses of the panels. The frog (*Frosch* in German), on the arms of the male portrait identifies the man as a member of the Fröschl family, prominent in Wasserburg am Inn, a town to the east of Munich. The arms on the woman's portrait (fig. 2) are those of the Reitmor family of Munich and Regensburg.[8] At present it is not possible to be more precise about the sitters' identities. Based on the possibility that these are marriage portraits, Löcher suggested that the man might be Jakob Fröschl, a grain or corn merchant and member of the town council of Wasserburg am Inn, who in 1539 married a woman named Margaretha. Unfortunately, Margaretha's family name is unknown and no documents mentioning a male Fröschl married to a female Reitmor have come to light.[9] Members of both families were, however, portrayed by Mielich; Röttger dated the portrait of Andreas Reitmor (in 1925 in a private collection, England) to c. 1539/1540,[10] and a portrait of a woman, bearing the Fröschl arms, is in the Staatliche Museen in Berlin.[11]

While neither *A Member of the Fröschl Family*

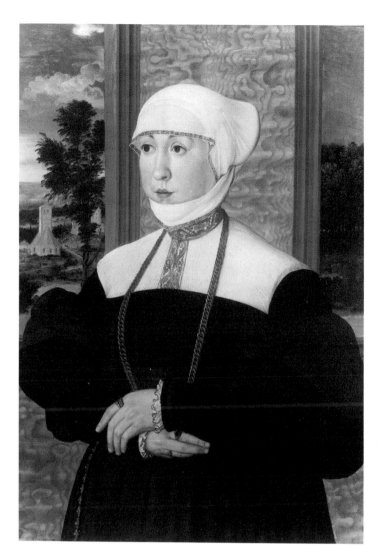

Fig. 1. Hans Mielich, *Portrait of a Woman*, panel, The Schroder Collection, London [photo: Artemis Fine Arts Limited, and A. C. Cooper, Ltd., London]

nor its pendant are signed or dated, Löcher's attribution of the pictures to Hans Mielich is virtually certain, and the paintings are easily situated in the years around 1539/1540. Close comparisons are found in Mielich's undisputed masterpieces, the portraits of Andreas and Apollonia Ligsalz (Alte Pinakothek, Munich), monogrammed and dated 1540.[12] Greater similarities in terms of format and finish appear in the portraits of an unidentified couple (figs. 3, 4) also monogrammed and dated 1540.[13] The same interior is used for the National Gallery portrait and its pendant, but a different view is presented in the background of each. The landscape in the National Gallery's

Fig. 2. Hans Mielich, *Portrait of a Woman* (reverse), panel, The Schroder Collection, London [photo: Eileen Tweedy]

panel has been associated with the Danube School, recalling Mielich's early years in Regensburg with Albrecht Altdorfer; Wolff, in regard to style and date, has called attention to the landscape in Mielich's drawing of the *Crucifixion* (Städelsches Kunstinstitut, Frankfurt), monogrammed and dated 1539.[14] The National Gallery's panel thus belongs to the group of early portraits that are among Mielich's finest works. After his trip to Rome his style changed and his portraits became mannerist and in some instances, as noted by Löcher, coarser.

Notes

1. I am grateful to Walter Angst for the heraldic description (letter to the author, 20 August 1989, in NGA curatorial files). The frog is at present dark brown and should be called *brunâtre*, but as Angst notes, the placement of dark brown on dark red violates the tincture rule of heraldry. The frog might have originally been either green (*vert*) or gold (*or*), but it has not yet been possible to determine whether an alteration has taken place.

2. At top, in black ink on paper: *Alfred Morrison Esq^re W92/Portrait of a Man in black cap &/dress by Amberger/28/12/87 No. 2 Rt.* [or Dr.?] *Hank* [or Frank?] *Eumer Hall*; in brown ink on paper: *From J. C. Morrison Esq^re/Fonthill House/Tisbury/Wilts/Bristol/May 1927*; in light brown ink: *CNY-167*. At bottom left, circular paper sticker: [. . .] *ILL/63/HEIRLOOMS*. At bottom left, paper sticker: *Lot No. P18290. Piece No. 56.*

3. The wood was identified by Peter Klein, examination report, 29 September 1987, in NGA curatorial files, and by the National Gallery's scientific research department.

4. Timothy Bathurst, who knows the Northwick Collection well, suggested that the paintings were acquired early in the century (letter to the author, 30 January 1989, in NGA curatorial files). The first published reference is the Phillips auction catalogue, 1859.

5. The date 28 December 1887 occurs on a paper label on the reverse of the panel.

6. I am grateful to Charles S. Moffett and Timothy Bathurst for information on the joint ownership and for assistance in locating the pendant.

7. Wood (presumably linden), approximately 64.5 × 47 cm. (measured from the reverse). The panel has a slight convex warp but appears to be in excellent condition; the reverse is better preserved than that of the National Gallery's painting. Reverse, bottom center, inscribed: *F.G.VZ*; at bottom right a paper label: *From Lord Northwick's Gallery/at Thirlestane House, Cheltenham/No. 135/Sold in 1859, and bought by Sir Thomas Phillipps Bart./of Middle Hill.* At top right, a circular sticker: *J/449/F.* The painting is no. 135, as Amberger, in the sale, Phillips, London, 26 July–30 August 1859. Purchased by Leggatt Gallery at the sale, Christie, Manson & Woods, London, 26 June 1964, no. 90. According to Löcher 1967, 74, the picture was in the Tribune Gallery, New York, in 1966. I am very grateful to the owner for allowing me to examine the painting.

8. See *Johann Siebmachers Wappen-Buch. Faksimile-Nachdruck der 1701/05 bei Rudolph Johann Helmers in Nürnberg erschienene Ausgabe* (Munich, 1975), pls. 90, 221.

9. Löcher 1967, 75. Most recently Kurt Löcher has suggested to me that the sitters might be Peter Fröschl zu Marzoll und Karlstein and his wife, Anna Reitmor (letter to the author, 16 July 1992, in NGA curatorial files). Unfortunately, the date of their marriage is not known. I am grateful to Dr. Martin Geiger, bürgermeister of Wasserburg am Inn, for information on the Fröschl family (letter to the author, 15 February 1989, in NGA curatorial files). A representation of the Fröschl arms similar to that on the reverse of the National Gallery's panel is found on the armorial gravestone of Peter Fröschl (d. 24 January 1475) in the Church of Saint Jakob, Wasserburg am Inn; see Volker Liedke, *Die Burghauser Sepulkralsklptur der Spätgotik. I. Zum Leben und Werk des Meisters Franz Sickinger* (Munich, 1982), 6, fig. 3.

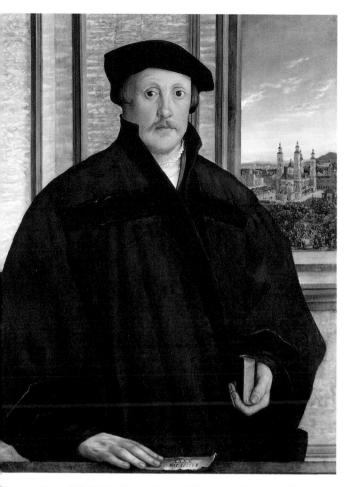

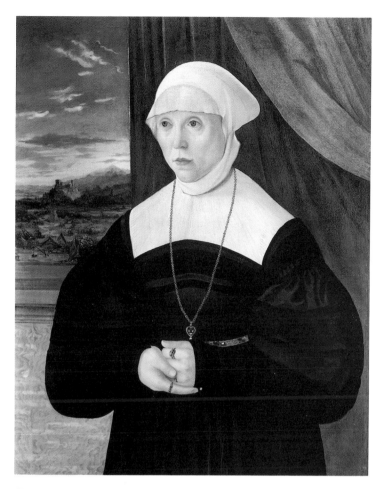

Fig. 3. Hans Mielich, *Portrait of a Man*, panel, 1540, The Toledo Museum of Art, Purchased with funds from the Libbey Endowment, Gift of Edward Drummond Libbey [photo: The Toledo Museum of Art]

Fig. 4. Hans Mielich, *Portrait of a Woman*, panel, The Toledo Museum of Art, Purchased with funds from the Libbey Endowment, Gift of Edward Drummond Libbey [photo: The Toledo Museum of Art]

10. Röttger 1931 (see Biography), 51–53, no. 2, repro.

11. Michaelis 1989, 82–84, no. 2124, repro., states erroneously that this is the pendant to the National Gallery's portrait. See also Löcher 1967, 75; and Bernhard Hermann Röttger, "Zum Werke und zur Beurteilung Hans Mielichs," *Pantheon* 8 (1931), 473, where the painting is mentioned as being in the Galerie Caspari, Munich. While both Löcher and Röttger mention a date of 1556, none is cited by Michaelis.

12. Röttger 1931 (see Biography), 55–58, nos. 4–5, repro.; *Alte Pinakothek Munich: Explanatory Notes on the Works Exhibited* (Munich, 1986), 361–362, nos. 19, 12, repro.

13. Acc. nos. 55.226–55.227. See *Toledo Museum of Art: European Paintings* (Toledo, 1976), 115–116.

14. The association with the Danube School was made in exh. cat. Manchester 1961, 42, no. 101. Martha Wolff, memorandum, 1984, in NGA curatorial files; the

Frankfurt drawing is reproduced in Hans Georg Gmelin, "Ein frühes Gemälde der Kreuzigung Christi von Hans Mielich," *Niederdeutsche Beiträge zur Kunstgeschichte* 16 (1977), 35, fig. 3.

References

1937 Constable, W. G. "Art Treasures of the West Country at Bristol. I. The Pictures." *BurlM* 71:42.

1967 Löcher, Kurt. "Studien zur oberdeutschen Bildnismalerei des 16. Jahrhunderts." *Jahrbuch der Staatlichen Kunstsammlungen in Baden-Württemberg* 4: 74–75, fig. 52.

1985 NGA: 289, repro.

1989 Michaelis, Rainer. *Deutsche Gemälde 14.–18. Jahrhundert. Staatliche Museen zu Berlin. Gemäldegalerie.* Berlin: 82.

1990 Dülberg, Angelica. *Privatporträts. Geschichte und Ikonologie einer Gattung im 15. und 16. Jahrhundert.* Berlin: 109, 200, no. 82, fig. 576.

Workshop of Hans Mielich

1952.5.84 (1163)

The Crucifixion

c. 1550/1575
Poplar(?), 109.4 × 41.9 (43⅛ × 16½);
 painted surface, including added strip at bottom,
 107.5 × 41 (42⅜ × 16⅛)
Samuel H. Kress Collection

Technical Notes: The original support is composed of two pieces of wood with vertically oriented grain.[1] A triangular inset at the top left corner and a strip along the bottom, 1.5–2 cm. in height, are not original. The panel has been thinned, mounted on hardboard with a mahogany veneer, and cradled. Strips of wood were added to all sides. There is no indication of a barbe in the thin, striated ground or of an original edge. Examination with infrared reflectography disclosed an underdrawn grid in a thick line laid in over the ground in what appears to be a liquid material. The figures and landscape are underdrawn in a liquid medium in a free, sketchy manner (fig. 1). Infrared reflectography also indicates changes in the figure of Longinus: in an earlier state the right leg was apparently thinner and more sharply bent and the torso may have been smaller or thinner. At the bottom of the panel, near Longinus' right boot and the hem of the Magdalene's robe, a series of male heads is visible in the x-radiograph (fig. 2) as well as in infrared reflectography and to a much lesser extent as pentimenti. This area is covered with cracked and abraded overpaint that was applied considerably later than the original layer. The deepest shadows of the Virgin's robe are thickly painted.

The painting is abraded throughout, and the heaviest subsequent inpainting is located in the armor of Longinus, in Christ's face and hair, and to the right of the Magdalene's back. The added pieces at the bottom and upper left corner are repainted. The area from Longinus' right boot across the bottom of the Magdalene's dress continuing along the ground is repainted.

Provenance: Possibly a museum in Breslau (now Wrocław).[2] (Charles de Burlet, Berlin, 1916); Dr. Otto Fröhlich, Vienna, 1916;[3] sold to Stefan von Auspitz-Lieben, Vienna. (Rosenberg & Stiebel, New York, owned jointly with Pinakos, Inc. [Rudolf Heinemann], by 1951);[4] purchased 1951 by the Samuel H. Kress Foundation, New York.

1952.5.85 (1164)

Christ in Limbo

c. 1550/1575
Poplar(?), 108.4 × 41.2 (42⅝ × 16¼);
 with added strips: 109.7 × 42.9 (43⅛ × 16⅞)
Samuel H. Kress Collection

Technical Notes: The original support is composed of two pieces of wood with vertically oriented grain. The panel has been thinned, mounted on hardboard with a mahogany veneer, and cradled. Strips of wood were added to all sides. At the left edge the thin ground rises in a ridge that resembles a barbe but is covered with a continuous layer of paint. The right edge appears to have been cut and scraped. Examination with infrared reflectography reveals underdrawing throughout, similar to that found in the companion *Crucifixion*. There is an underdrawn grid laid in with a dry brush (fig. 3). The figures are underdrawn in a free, sketchy manner in a liquid medium, but using a dry brush that in places skips over the striated ground layer. The landscape and the architecture are also underdrawn, although, as in *The Crucifixion*, neither is followed closely in the paint layer. At the bottom of the panel a series of heads, one definitely female, is visible in the x-radiograph (fig. 4) but not in infrared reflectography. The heads have been partially painted out, leaving a 0.5 cm. band of original paint visible at the extreme bottom. In general the underdrawing is more vigorous and the musculature more pronounced than in the painted stage. Abrasion and pitting as well as areas of inpainting are evident throughout.

Provenance: Same as no. 1952.5.84.

THE *Crucifixion* depicts the moment recounted in John 19:34 when a soldier, traditionally identified as Longinus, pierces Christ's side with a lance, causing blood and water to issue forth. Christ's body is brightly lit against the inky darkness of the sky. This is in contrast to the two thieves, who are dark brown and only partly visible at the right edge. The Magdalene kneels at the foot of the cross, while Mary and John the Evangelist stand in sorrow at the right. Mounted centurions in armor witness the scene, and the

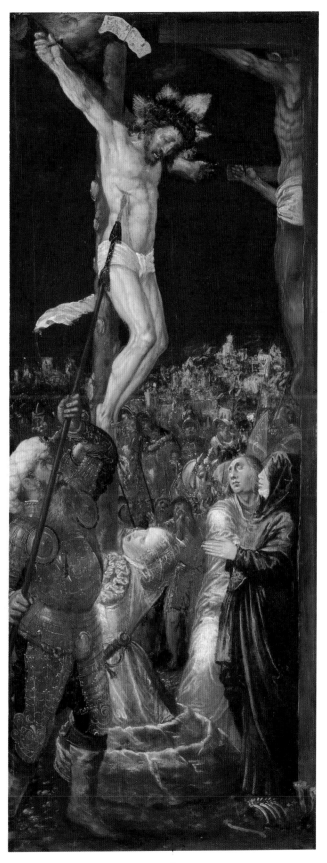

Workshop of Hans Mielich, *The Crucifixion*, 1952.5.84

walled city in the background represents Jerusalem.

The theme of the second panel, *Christ in Limbo*, is not found in the Bible but appears in the apocryphal Gospel of Nicodemus and was popularized by such devotional texts as *The Golden Legend*.[5] According to these accounts, in the time between the Crucifixion and the Resurrection, Christ descended into Limbo, on the borders of Hell, to liberate Adam and Eve, the prophets of the Old Testament, the Holy Innocents, and others. In the National Gallery's painting Christ hovers overhead, blessing the figures below with one

Fig. 1. Infrared reflectogram assembly of a detail of *The Crucifixion*, 1952.5.84

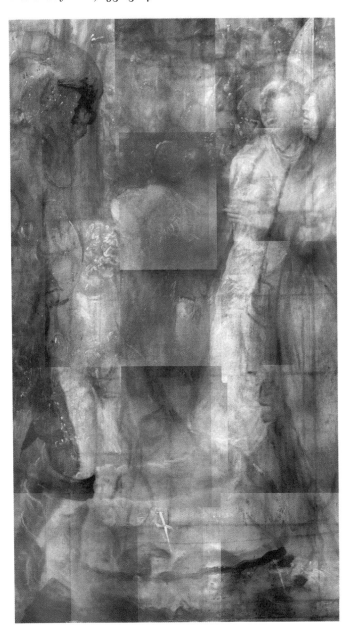

hand and holding a staff with the banner of Resurrection in the other. Behind him is a billowing white cloth that is surrounded by bands of yellow and pink clouds. Limbo is situated in the ruins of classical Rome; at the left are the remains of the Septizonium, while, as noted by Eisler, other structures recall the Baths of Caracalla and the Colosseum.[6] In the distance burn the fires of Hell, and a flying demon can be seen at center right. It is possible to suggest identifications for some of the figures in the lower zone. The muscular male figure standing in the right foreground may be Adam, or possibly John the Baptist.[7] The woman with upraised arms standing behind him is probably Eve. The figure wearing a crown at the left in the middle distance is likely to be King David, often included because Psalm 107:10–16 was interpreted as a prophecy of Christ's descent into Limbo and deliverance of true believers.[8] Eisler suggested that the seated male in the foreground was Abel, and the children flanking him the Holy Innocents.

Suida and Shapley and Eisler have suggested that both panels were originally part of an altarpiece, possibly a large polyptych.[9] It now appears more likely that they were originally the wings of an epitaph, probably installed in the family chapel of a church. The laboratory examination disclosed at the bottom of each panel a series of heads, male at the left and female on the right, that are visible in the x-radiographs. This is almost certainly a family; at the extreme left the bearded father is accompanied by at least three sons, and at the far right the mother, wearing a kerchief and wimple, is joined by two or three daughters. Crosses over the heads of some of the children indicate that they are deceased;[10] one of these, a red cross, is visible in *The Crucifixion* below the hem of the Magdalene's robe. The epitaph might have been in the form of a nonfolding triptych with *The Crucifixion* on the left and *Christ in Limbo* on the right. The now-lost center panel may have borne an inscription containing prayers and information about the deceased, and above it an image, possibly that of the triumphant, resurrected Christ. Clearly appropriate for an epitaph is the theological import of the redemption of sin, salvation, and life after death contained in depictions of Christ's Crucifixion, Resurrection, and

Fig. 2. X-radiograph of a detail of *The Crucifixion*, 1952.5.84

liberation of the inhabitants of Limbo.[11]

Since it is likely that the donors in the National Gallery's panels were shown either kneeling or in half-length, the original appearance of the panels must have been unusually tall and narrow. It is hard, however, to extrapolate from this the width of the center panel.

The somewhat astonishing diversity of stylistic influences discernible in *The Crucifixion* and *Christ in Limbo* has made the task of attribution difficult. Friedländer considered the paintings to be late works by Wolf Huber.[12] Suida initially accepted this attribution but later published the works as by an anonymous German artist working after Huber in the third quarter of the sixteenth century.[13] Rose did not find the attribution to Huber convincing, while Wilhelm believed the panels were painted about 1560/1570 by a south German follower of Huber.[14] There is agreement in many quarters, however, that the panels represent a continuation of the Danube School; there are Danubian precedents for the oblique placement of the crucified Christ and for the fragmented thieves in the work of Wolf Huber and,

as noted by Eisler, in Lucas Cranach the Elder's *Lamentation beneath the Cross* of 1503 (Alte Pinakothek, Munich).[15]

As observed by Suida and Shapley and Eisler, the artist who painted these scenes probably spent time in Italy—Rome in particular—and the influences of Pontormo, Baldassare Peruzzi, Raphael, Michelangelo, and Tintoretto are all cited.[16] To this one might add that the use of an underdrawn grid is more Italianate than Northern. Additionally, as noted by Eisler, Mielke, and Rose, the figures recall the work of Netherlandish Romanists such as Lambert Lombard, Lambert van Noort, or Gerard Grönning. The classicizing architecture reminded Rose of that found in paintings by Pieter Coecke van Aelst.[17]

The best and most specific attribution is that of Jürgen Rapp, who believes that *The Crucifixion* and *Christ in Limbo* are late works by Hans Mielich and were painted around 1559/1560s.[18] This proposal is endorsed by Mielke and Geissler.[19] The most convincing evidence for associating the National Gallery's panels with Mielich lies not in the artist's paintings but rather in the illumina-

Fig. 3.
Infrared reflectogram
assembly of a detail of
Christ in Limbo, 1952.5.85

Fig. 4. X-radiograph
of a detail of *Christ in Limbo*,
1952.5.85

Workshop of Hans Mielich, *Christ in Limbo*, 1952.5.85

tions for the large and sumptuous manuscripts of the *Penitential Psalms* by Orlando di Lasso and the *Motets* by Cyprian de Rore (both Bayerische Staatsbibliothek, Munich). In particular, the first volume of the *Penitential Psalms*, which bears a date of 1565 on the title page and was apparently finished in that year, contains numerous instances of scenes of the Crucifixion and Christ in Limbo as well as individual figures that are extremely similar in composition, conception, and pose. There are also many comparable figures in the second volume, which was probably begun in 1565 and finished in 1570/1571.[20] Even making allowances for the differences in medium and scale, the National Gallery's panels would appear to be the work of another artist, whose style is somewhat rougher and freer; the distinctive "cat's eyes" and ropy muscles in figures such as the bearded male in the foreground of *Christ in Limbo* do not occur in the *Penitential Psalms*. Some comparisons can also be found in the illuminations of the *Motets* by Cyprian de Rore, but there seems to be a distinct shift in style or more than one hand at work.[21]

It is harder to find close comparisons with Mielich's late religious paintings because of both the scarcity of examples and the intervention of what must have been a sizeable workshop. There are, however, some similarities in the chalky whites in the sky and the handling of background figures in *The Conversion of Saul*, left panel of the Ligsalz epitaph of 1545/1550 (Diözesanmuseum, Freising).[22] Mielich's last work, the high altar of the Church of Our Beautiful Lady in Ingolstadt, was completed in 1572 with the discernible assistance of his workshop. The scenes of the *Resurrection* and *Christ in Limbo* on the first set of inner wings show certain compositional and figural similarities but, like the other panels of the altarpiece, are not as calligraphic in brushwork and are smoother and more Italianate than the National Gallery's panels.[23]

In sum, the author of *The Crucifixion* and *Christ in Limbo* would seem to be a member of Mielich's workshop or possibly a close follower. Rapp's dating of the panels to the 1560s is eminently acceptable.[24] If the depiction of the Septizonium and other buildings is, as observed by Rapp, based on Hieronymus Cock's etchings of

Roman ruins published in 1551, this would provide a *terminus post quem*,[25] but a date as late as the mid-1570s should also be considered possible.

A copy of *Christ in Limbo*, attributed to Anthonis Blocklandt, was on the art market in Rome in 1989.[26]

Notes

1. The wood was identified as poplar by Mario Modestini in or before 1953, almost certainly on the basis of a visual examination.

2. Unverified. There are no records of the paintings having been in the Muzeum Narodowe (Mariusz Hermansdorfer, letter to the author, 11 April 1989, in NGA curatorial files), or the Muzeum Archidiecezjalne (Józef Pater, letter to the author, 25 June 1989, in NGA curatorial files). See also note 3.

3. Memorandum of a communication from Lilly Fröhlich, London, 1956, in NGA curatorial files, which states that Otto Fröhlich acquired the paintings in 1916 from an unspecified museum in Breslau through de Burlet and sold them to Stefan Auspitz.

4. Gerald G. Stiebel, letter to the author, 13 April 1989, in NGA curatorial files. The invoice is dated 23 October 1951.

5. Réau, *Iconographie*, vol. 2, pt. 2 (1957), 531–537; Ryan and Ripperger, *The Golden Legend*, 221–223; the Gospel of Nicodemus can be found in Montague Rhodes James, *The Apocryphal New Testament* (Oxford, 1926), 94–146; see also Karl W. Schmidt, *Die Darstellung von Christi Höllenfahrt in den deutschen und den ihnen verwandten Spielen des Mittelalters* (Marburg, 1915).

6. Eisler 1977, 43.

7. Eisler 1977, 43, suggested that the figure might be John the Baptist because of John's appearance in Dürer's depiction of the *Descent into Limbo* in the *Small Passion* woodcut series of 1509/1511.

8. For example, in the account in *The Golden Legend* David is present in Limbo and mentions his prophecy. Eisler 1977, 43, suggested that the figure might be Solomon.

9. Kress 1956, 84; Eisler 1977, 43.

10. Compare, for the example, Pieter Pourbus the Elder's portraits of the family of Anselme de Boodt, dated 1573 (Onze Lieve Vrouwekerk, Bruges), which flank Gerard David's *Transfiguration*. See Paul Huvenne, *Pierre Pourbus. Peintre brugeois 1524–1584* [exh. cat., Musée Memling](Bruges, 1984), 193–197, no. 13, repro. As noted by Huvenne, the red crosses on the heads of three of the seven children indicate that they were dead before 1573.

11. Rapp 1987, 191 n. 17, was the first to suggest that the panels belonged to an epitaph and, in conversation with the author, 16 October 1989, suggested that the inscription would have been between the panels rather

than below them. See Paul Schoenen, "Epitaph," and Kurt Pilz, "Epitaphaltar," *Reallexikon zur deutschen Kunstgeschichte*, 8 vols. (Stuttgart and Munich, 1937–1985), 5: cols. 872–921, 921–932, respectively. In addition to the Resurrection, images of the Lamentation also occur on epitaphs with some frequency.

12. Max J. Friedländer, certificate on the reverse of a photograph, 6 August 1951, in NGA curatorial files.

13. William E. Suida, draft catalogue entry, undated, in NGA curatorial files; Suida, unpublished catalogue entry, 6 March 1953, in NGA curatorial files; Kress 1956, 84, 86, nos. 30, 31.

14. Patricia Rose, letter to the author, 16 June 1989, in NGA curatorial files; Anton Wilhelm, discussion, June 1968, in NGA curatorial files.

15. In addition to Wilhelm's comments (see note 14), Heinrich Geissler, letter to Martha Wolff, 23 July 1984, in NGA curatorial files, while noting the attribution to Mielich, thought that the National Gallery's paintings were definitely south German, probably Bavarian, and dated c. 1540/1550. For compositionally similar representations of the Crucifixion in Huber's work see Franz Winzinger, *Wolf Huber. Das Gesamtwerk*, 2 vols. (Munich and Zurich, 1979), 1: 102, no. 72, 137–138, no. 167 (as copy after a lost original), 180–181, no. 296; 2: figs. 72, 167, 296. Eisler 1977, 43; for the Cranach see *Alte Pinakothek Munich: Explanatory Notes on the Works Exhibited* (Munich, 1986), 150–152, no. 1416, repro.

16. Kress 1956, 84, 86, nos. 30, 31; Eisler 1977, 43.

17. Hans Mielke, letter to the author, 10 May 1989, in NGA curatorial files, saw similarities with the figure drawings of Lambert van Noort and prints by and after Gerard Grönning. Patricia Rose, letter, 16 June 1989, found the figures reminiscent of Jan van Hemessen and the architecture related to that used by Bernard van Orley or Pieter Coecke van Aelst.

18. Rapp 1987, 163, 166; Rapp 1990, 84–85, proposes a date of 1557/1560.

19. Hans Mielke, letter to the author, 7 June 1989, in NGA curatorial files; Heinrich Geissler, letter to Hans Mielke, 30 May 1989, in NGA curatorial files.

20. Staatsbibliothek, Munich, Mus. MS. 1, 2 (Cim 51 I, II). These splendid manuscripts have not received adequate presentation; they are discussed but not reproduced in Lieselotte Schütz, *Hans Mielich's Illustrationen zu den Busspsalmen des Orlando di Lasso* (Munich, 1966). In my own examination of the manuscripts, 16 October 1989, I found the following comparisons to the figures in the National Gallery's panels: vol. 1, fols. 44–45, the Crucifixion with the Magdalene at the foot of the cross; fol. 62, the prodigal son received by his father, with figures similar to those in *Christ in Limbo*; fol. 70, male nude at the top of the page is in almost the same pose, in reverse, as the sitting figure at the bottom of *Christ in Limbo*; a similar sitting figure is at the bottom right-hand corner of fol. 81; fol. 91, the group of naked children at the bottom of the page may be com-

pared with those in *Christ in Limbo*; fol. 145, top left, Christ leading figures out of Limbo; fol. 146, the female face at the center is reminiscent of the face of Eve at the right of *Christ in Limbo*; and vol. 2, fol. 87, Crucifixion, with similar poses but a more active contrapposto; fol. 91, Crucifixion, a similar composition to the National Gallery's painting, but in reverse. I am very grateful to Dr. Karl Dachs and Dr. Hermann Hauke of the Staatsbibliothek for making these and other manuscripts available to me. Now, fortunately, Rapp 1990, 69–75, 78–81, reproduces numerous illuminations from the *Penitential Psalms* and the *Motets*, including some of those cited above and in note 21.

21. Staatsbibliothek, Munich, Cim 52; for example, the Crucifixion on fol. 110 is similar in pose, but in reverse.

22. Rapp 1987, fig. 1a; I am indebted to Jürgen Rapp and Dr. Peter B. Steiner of the Diözesanmuseum, Freising, for facilitating my examination of the paintings there.

23. For the Ingolstadt altarpiece see Röttger 1925 (see Biography), 111–132; Siegfried Hofmann, "Der Hochaltar im Münster zur schönen unserer lieben Frau in Ingolstadt," *Ars Bavarica* 10 (1978), 1–18; Heinrich Geissler, "Der Hochaltar im Münster zu Ingolstadt und Hans Mielichs Entwürfe," *Ingolstadt. Die Herzogsstadt. Die Universitätsstadt. Die Festung*, 2 vols. (Ingolstadt, 1974), 2: 145–178. The *Resurrection* and *Christ in Limbo* are reproduced in Geissler 1974, 155. I am grateful to Pfarrer Meyer of the church of Schönen Unserer Lieben Frau, who enabled me to study the altarpiece at close range.

24. Rapp 1987, 163; Rapp 1990, 84–85.

25. Rapp 1990, 79, 85; ruined buildings very similar to those in Cock's etchings are found in the *Penitential Psalms*, vol. 1, fols. 18, 80, fig. 22; for the series of etchings see Timothy A. Riggs, *Hieronymus Cock. Printmaker and Publisher* (New York and London, 1977), 256–266, figs. 4, 6, 7–11, 13–21, 23–24.

26. Seen by Sally E. Mansfield, May 1989, at the gallery of Luciano Morosi, Rome.

References

1956 Kress: 84, 86, nos. 30, 31, repros. 85, 87.
1975 NGA: 150, repro. 151.
1976 Walker: 151, nos. 165, 166, repro.
1977 Eisler: 43, figs. 41, 42.
1985 NGA: 29, repro.
1987 Rapp, Jürgen. "Das Ligsalz-Epitaph des Münchner Renaissancemalers Hans Mielich." *AdGM*: 163, 166, repro. 165.
1990 Rapp, Jürgen. "Kreuzigung und Höllenfahrt Christi, zwei Gemälde von Hans Mielich in der National Gallery of Art, Washington." *AdGM*: 65–96, repros. 67, 77.

Hans Schäufelein

c. 1480/1485–1538/1540

NOTHING is known about the date and place of the artist's birth or his initial training. Although often called Hans Leonhard Schäufelein, there is apparently no documentation for the name Leonhard. Schäufelein probably entered Albrecht Dürer's Nuremberg workshop in about 1503/1504, and Dürer's influence is evident in Schäufelein's earliest graphic works, the woodcuts he produced for *Der Beschlossen Gart der Rosenkranz*, published by Ulrich Pinder in 1505, and the illustrations to the *Speculum Passionis Domini Nostri Ihesu Christi*, published in 1507. At the time of Dürer's second trip to Italy, Schäufelein seems to have held a responsible position in the shop, for he painted, partly from Dürer's designs, the Ober-Sankt Veit altarpiece (Dom- und Diözesanmuseum, Vienna), commissioned by Elector Friedrich the Wise and his brother John, possibly for a church in Nuremberg. Five of Dürer's drawings for the wings survive (Städelsches Kunstinstitut, Frankfurt).

Schäufelein left Nuremberg around 1507 and seems to have gone first to Augsburg, where he may have worked in the shop of Hans Holbein the Elder. His first dated painting is the *Crucifixion with John the Baptist and King David*, 1508 (Germanisches Nationalmuseum, Nuremberg), and around this time he begins to sign works with the combination of his monogram in ligature and a small shovel (*Schaufel*). He journeyed to the Tirol in 1509/1510, where in Niederlana bei Meran he painted scenes of the Passion on the wings of an altarpiece carved by a local artist, Hans Schnatterpeck. In 1510 he returned to Augsburg, where he was active both as a painter and as a designer of woodcuts. In 1513 he painted a large altarpiece with scenes of the Passion and the Apocalypse for the high altar of the Benedictine abbey at Auhausen, near the Swabian city of Nördlingen.

In 1515 Schäufelein moved to Nördlingen and quickly obtained citizenship. This began a decade of great productivity, which saw several painted commissions, such as the *Last Supper*, dated 1515 (Münster, Ulm), the 1516 *Epitaph for Emmeran Wager* (Reichsstadtmuseum, Nördlingen), and numerous woodcuts for projects ordered by Maximilian I, such as the *Triumphal Procession*, 1516–1518. Schäufelein remained active in Nördlingen well into the 1530s. Among his last works are the illuminations of 1537/1538 in a prayer book done for the counts of Oettingen (Kupferstichkabinett, Berlin). He died sometime between 1538 and 11 November 1540, when his wife is mentioned as a widow.

Although an awareness of Jörg Breu and Lucas Cranach has been seen in Schäufelein's early work, it was the influence and example of Dürer that remained paramount throughout his career. Along with artists such as Hans Süss von Kulmbach or Wolf Traut, Schäufelein was an important and talented continuator of the Dürer style whose works achieve a pensive gentleness.

Bibliography

Winkler, Friedrich. *Die Zeichnungen Hans Süss von Kulmbachs und Hans Leonhard Schäufeleins*. Berlin, 1942.
Meister um Albrecht Dürer. Exh. cat., Germanisches Nationalmuseum. Nuremberg, 1961.
Strieder, Peter. "Schäufelein, Hans." *Kindlers* 5: 222–227.

1937.1.66 (66)

Portrait of a Man

c. 1507
Linden, 39.8 × 32.3 (15⅝ × 12¾)
Andrew W. Mellon Collection

Inscriptions

At upper left, probably by a later hand: 𝕳
At upper right, probably by a later hand: *1507*

Technical Notes: The support is a single piece of linden with vertically oriented grain.[1] The original panel, which was probably thinned, has been marouflaged to a secondary panel and cradled. Examination with infrared reflectography did not disclose underdrawing. The original ground and paint layers do not extend to the extreme edges, although a thin nonoriginal layer and brown overpaint[2] has been applied to the edges.

Examinations in 1973 and 1988 yielded very little hard information about the monogram and date. Both appear to lie directly on the paint surface without an intervening layer, and both have been on the painting long enough to develop the crackle pattern of the black paint underneath. X-ray fluorescence indicated the similarity of the paints, but this cannot be taken as an indication of whether or not the date and monogram were executed at the same time.

The painting is generally in good condition. There are several long vertical checks in the panel. Along the checks and in the face of the sitter there are scattered paint losses that have been filled and inpainted.

Provenance: Supposedly purchased in Germany, c. 1750, by Pehr von Lagerbring [d. 1799], Sweden; sold to David Henric Hildebrand [d. 1791], Castle Ericsberg, Katrineholm, by 1770 or 1771; by descent to his son, David Gotthard Henric Hildebrand [d. 1808]; his grandson, Carl Carlsson Bonde, Castle Ericsberg, as part of the "Fideikommiss"; by descent to Carl Gotthard Carlsson Bonde, Castle Ericsberg. (Galerie Matthiesen, Berlin, 1927).[3] (P. & D. Colnaghi and Co., London and New York, 1927); (M. Knoedler & Co., New York, 1928, owned jointly with Galerie Matthiesen and P. & D. Colnaghi and Co.);[4] purchased 1928 by Andrew W. Mellon, Washington; deeded 30 March 1932 to The A. W. Mellon Educational and Charitable Trust, Pittsburgh.

SET AGAINST A BLACK BACKGROUND, the sitter wears a rather elaborate black cap and a blue-gray robe with lapels of a mixture of light brown, white, and black fur. His long brown hair, enlivened by calligraphic strokes of white, the dark stubble on his chin, the firm mouth, and the upward, distant glance of his blue eyes create the striking effect of a personality at once informal and intense.

Even discounting the monogram, this panel demonstrates such a thoroughgoing absorption and emulation of Dürer's portrait style that both its original attribution to Dürer and the present belief that it was created by a member of Dürer's workshop are quite understandable. Although the National Gallery's official attribution to Schäufelein did not occur until 1973, the ascrip-

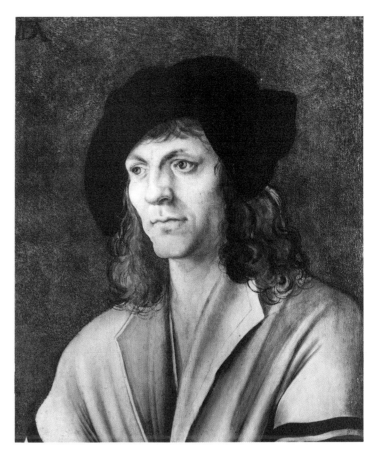

Fig. 1. Hans Schäufelein, *Portrait of a Man*, panel, Muzeum Narodowe, Warsaw [photo: Muzeum Narodowe, Warsaw]

tion to Dürer was always tentative at best and seriously doubted by virtually all major authorities.

Ernst Buchner in 1927 was the first to give the *Portrait of a Man* to Schäufelein, and while it was known to him only through a photograph, he found it "one of the finest and most original male portraits of the early German Renaissance." For Buchner the soft, mild expression, the preoccupied glance, the damp glimmer of the eyes, as well as the soft, flowing brushwork in the hair were traits characteristic of Schäufelein, while the placement of the figure and the lack of understanding of the man's left shoulder did not support an attribution to Dürer. The *Portrait of a Man* in Warsaw (fig. 1) was also attributed to Schäufelein and cited as especially close to the Washington painting.[5]

Although Winkler in 1928 accepted the portrait as by Dürer and Wallach rejected its attribution to Schäufelein in his dissertation published the following year, these are minority opinions.[6] Tietze accepted the portrait as by Schäufelein and reiter-

ated its high quality.[7] The attribution to Schäufelein was affirmed with varying degrees of assurance in monographs on Dürer by the Tietzes, Panofsky, and Winkler and, further, in Winkler's study of Schäufelein's drawings and in Löcher's writings on portraiture in Nuremberg.[8] Unpublished opinions by Seymour, Stechow, Rosenberg, and Talbot unanimously attribute the *Portrait of a Man* to Schäufelein.[9]

The closest comparison to the National Gallery's panel is the *Portrait of a Man* in Warsaw, which is similar in size and bears a false Dürer monogram at the upper left. The picture was cleaned in 1941, revealing a green background. Although they do not depict the same individual, the Washington and Warsaw paintings are remarkably similar in style, pose, and physiognomy. Particularly congruent are the rhythmically undulating contours of the left side of the faces, the pensive expressions and the faraway glances of eyes that are slightly mismatched, and the loose brushwork that forms the hair. Like the Washington panel, the Warsaw picture was first given hesitantly to Dürer, but since at least 1963 it has been attributed by the Muzeum Narodowe to Schäufelein.[10]

As noted by Winkler and Talbot, the attribution of the National Gallery's painting is bolstered by comparison to other portraits firmly given to Schäufelein, notably the *Portrait of Sixtus Oelhafen*, c. 1510 (Martin von Wagner Museum der Universität Würzburg), and the *Portrait of a Man in a Red Cap*, c. 1515 (Kunstmuseum, Basel).[11] Even though later and more complex, both exhibit a softness and pensiveness similar to that in the Washington *Portrait of a Man*.

Buchner, and later Talbot, found several points of comparison between the National Gallery's portrait and figures in the Ober-Sankt Veit altarpiece (Dom- und Diözesanmuseum, Vienna), a commission given to Dürer by Friedrich the Wise but executed by Schäufelein and completed in 1507.[12] Moreover, this author found close parallels in Schäufelein's *Adoration of the Magi*, c. 1505/1508 (Staatsgalerie, Stuttgart), especially in the rendering of the fur collar and hat of the standing center king and the broad brushwork with calligraphic highlights in his hair and beard.[13]

Even though the date was added by a later hand, the *Portrait of a Man* was in all likelihood painted in or around 1507, and the added date might repeat an original date. There is no way of determining whether the portrait was produced in Nuremberg or, as Talbot suggested, whether it was painted shortly after the artist's arrival in Augsburg in 1507.[14]

Interestingly, in their present states, neither the Warsaw nor the Washington portrait bears any information identifying the sitter; presumably inscriptions or coats-of-arms could have been on the original frame or on a cover. One wonders about the function of the Washington portrait and its relationship to the Warsaw picture; might both have been part of a series of "friendship portraits"?[15]

Although the *Portrait of a Man* is most probably by Schäufelein, the attribution is not inviolate. It should be noted that the paintings cited in support of Schäufelein's authorship are themselves attributions. Moreover, critics have consistently observed that the Washington portrait is qualitatively superior to the usual range of his work. And while Schäufelein is considered the best emulator of Dürer during the period 1505/1507, there were other equally talented artists in Dürer's shop. Wolff, for example, wondered if the picture might be by Hans Süss von Kulmbach. While this may not be the case, the possibility that the painting is by another member of Dürer's atelier should not be excluded.[16]

Notes

1. The wood was identified by Peter Klein, examination report, 29 September 1987, in NGA curatorial files.

2. Examination of the brown paint under x-ray fluorescence indicated the presence of cadmium and zinc, suggesting that the paint was manufactured in the nineteenth or twentieth century.

3. This and the preceding information is corroborated by Carl Jedvard Carlsson Bonde, son of Carl Gotthard Carlsson Bonde, letter and postcard to the author, 15 June and 16 September 1976, in NGA curatorial files. This information, in slightly altered form, is contained in an M. Knoedler & Co. brochure, 1928, in NGA curatorial files. I am very grateful to Göran Falkenberg, Stockholm, conversation, 30 October 1989, and Carl Göran Carlsson Bonde, Castle Ericsberg, for information about the Bonde family.

4. Report, 8 March 1988, Provenance Index, J. Paul Getty Trust, Santa Monica, in NGA curatorial files.

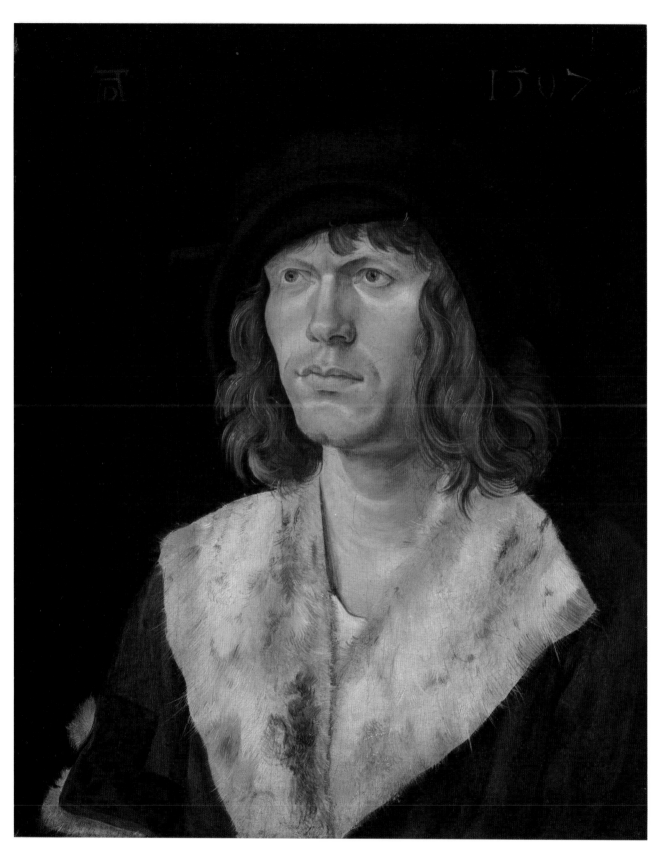

Hans Schäufelein, *Portrait of a Man*, 1937.1.66

5. Buchner 1927, 72.

6. Winkler 1928, 414; Wallach 1929(?), 41.

7. Tietze 1932–1933, 101–104; Tietze 1933, 268.

8. Tietze and Tietze-Conrat 1938, 81, no. A202; Panofsky 1943, 19, no. 98, as probably by Schäufelein; Winkler 1957, 191 n. 2; Winkler 1942 (see Biography), 114, 118; Löcher 1967, 115; Löcher 1986, 86, 350.

9. Charles Seymour, Jr., memorandum, 1 April 1940, in NGA curatorial files, cautiously notes that the weaknesses of the panel "correspond to the relative weaknesses of Schaeuffelein's [sic] style." Wolfgang Stechow, memorandum, 23 March 1971, in NGA curatorial files. Jakob Rosenberg, letter to Charles Parkhurst, 9 April 1971, in NGA curatorial files, calls the painting "one of the most Düreresque Schäuffeleins I have ever seen." Charles Talbot, draft catalogue entry, 1966, in NGA curatorial files. Additionally, Friedrich Winkler, letter to John Walker, 15 February 1952, in NGA curatorial files, finds the Dürer monogram false and favors the attribution to Schäufelein; David Rust, memorandum, 3 October 1967, in NGA curatorial files, cites John Rowlands, in conversation, as believing the painting to be by Schäufelein.

10. Inv. no. 735, wood, 41 × 32 cm. See Jan Białostocki and Michał Walicki, Europäische Malerei in polnischen Sammlungen (Warsaw, 1957), 491, no. 105. The handbook, The National Museum in Warsaw (Warsaw, 1963), no. 39, reproduces the painting as by Hans Schäufelein. The pictures by Dürer that are closest prototypes for both the National Gallery and Warsaw paintings are the Portrait of a Young Man (Palazzo Rosso, Genoa), the portrait of Burkhard von Speyer (Royal Collection, Windsor Castle), both dated 1506, and the Portrait of a Young Man, dated 1507 (Kunsthistorisches Museum, Vienna); reproduced in Anzelewsky 1971, pls. 115, 116, 125.

11. Winkler 1942 (see Biography), 114, 118, mentions the painting in Würzburg, along with the portraits in Washington and Warsaw as Schäufelein's earliest. Talbot, draft catalogue entry, 1966, in NGA curatorial files, cites both the style of the Würzburg and Basel portraits as confirming the attribution to Schäufelein. For the portrait of Sixtus Oelhafen see Tietze and Tietze-Conrat 1938, 82, no. A204, repro. 219; and exh. cat. Nuremberg 1961 (see Biography), 171, no. 298; also 172, no. 301, pl. 63, for the portrait in Basel.

12. Buchner 1927, 72 (followed by Talbot, draft catalogue entry, 1966, in NGA curatorial files), found that certain faces, particularly that of Christ in the Christ Carrying the Cross on the left wing, were close to the Washington portrait, although Talbot noted that the level of execution in the altarpiece was not as high. For the altarpiece see Buchner 1927, 60, 62–65, figs. 8, 14; and exh. cat. Nuremberg 1961 (see Biography), 168, no. 293.

13. Inv. no. 3213, canvas on wood, 138 × 133 cm., photographs in NGA curatorial files. The Adoration of the Magi is part of a dismembered altarpiece that apparently included on the reverse a Nativity and Agony in the Garden (Kunsthalle, Hamburg), Christ among the Doctors and Christ Crowned with Thorns (Shipley Art Gallery, Gateshead), and a Christ Carrying the Cross and Apostles Taking Leave of the Virgin (present location unknown). The Flagellation on the reverse of the Stuttgart panel is attributed by the Staatsgalerie to Schäufelein and the workshop of Hans Holbein the Elder, reflecting the belief of Peter Strieder that the works on the reverse of this and the other panels were finished in Augsburg with the assistance of an unknown member of Holbein the Elder's shop. See Peter Strieder, "Hans Holbein der Ältere zwischen Spätgotik und Renaissance," Pantheon 19 (1961), 98–100; Peter Strieder, "Dokumente und Überlegungen zum Weg Hans Schäufeleins von Nürnberg über Meran nach Augsburg," in Streider 1990, 240–272. I am grateful to Edeltraud Rettich for discussing and facilitating my examination of the Stuttgart panel, 20 September 1988.

14. Talbot, draft catalogue entry, 1966, in NGA curatorial files.

15. For later "friendship portraits" by Albrecht Dürer and the suggestion that the Portrait of a Clergyman (Johann Dorsch?) (1952.2.17) was part of a series see pp. 61–66, note 18.

16. Martha Wolff, letter to Jeffrey Smith, 15 January 1981, in NGA curatorial files. The National Gallery's portrait is not included in Barbara Rosalyn Butts, "'Dürerschüler' Hans Süss von Kulmbach" (Ph.D. diss., Harvard University, 1985). Charles Kuhn, letter to John Walker, 5 March 1940, in NGA curatorial files, expressed unhappiness with the Dürer attribution but found the painting "infinitely superior in quality" to any Schäufelein portraits known to him. Gisela Goldberg, conversation with the author, 10 May 1988, also found the portrait better than the usual run of Schäufeleins and wondered if it might be someone else in Dürer's shop; Fritz Koreny, conversation, May 1988, also found the portrait "besser als Schäufelein."

References

1917 Strömbom, Sixten Georg Mauritz. Portraitsamlingen: Ericsbergs Fideikommiss. Stockholm: 21, no. 32.

1927 Buchner, Ernst. "Der junge Schäufelein als Maler und Zeichner." Festschrift für Max J. Friedländer zum 60. Geburtstage. Leipzig: 72.

1928 Buchner, Ernst. "Hans von Kulmbach als Bildnismaler." Pantheon 1: 135.

1928 Winkler, Friedrich. Dürer. Des Meisters Gemälde, Kupferstiche und Holzschnitte. Klassiker der Kunst, vol. 4. Berlin and Leipzig: 414, repro. 45.

1929(?) Wallach, Hellmuth. Die Stilentwickelung Hans Leonhard Schäufeleins. Munich: 41.

1932–1933 Tietze, Hans. "Dürer in Amerika." AdGM 45–46: 101–104, figs. 66–67.

1933 Tietze, Hans. "Dürer in America." AB 15: 268, fig. 24.

1935 Buchner, Ernst. "Schäufelein, Hans Leonhard." In Thieme-Becker, 29: 558–559.

1936 Kuhn: 54, no. 201, pl. 36.

1937 "Mellon Offers Nation $19,000,000 Collection of Old Masters." *Art Digest* 11 (15 January): 8, repro. 7.

1938 Tietze, Hans, and Erika Tietze-Conrat. *Kritisches Verzeichnis der Werke Albrecht Dürers.* 3 vols. Basel and Lepzig, 2: 81, no. A202, repro. 219.

1941 NGA: 61, no. 66.

1942 Winkler (see Biography): 114, 118.

1943 Panofsky, 2: 19, no. 98.

1949 Mellon: xi, repro. 62.

1949 Roggeveen, L. J. "De National Gallery of Art te Washington." *Phoenix* 4: 340.

1957 Winkler, Friedrich. *Albrecht Dürer. Leben und Werk.* Berlin: 191 n. 2.

1967 Löcher, Kurt. "Nürnberger Bildnisse nach 1520." *Kunstgeschichtliche Studien für Kurt Bauch zum 70. Geburtstag von seinen Schülern.* Munich: 115.

1968 Zampa, Giorgio, and Angela Ottino della Chiesa. *L'opera completa di Dürer.* Milan: 106, no. 126, repro.

1975 NGA: 322, repro. 323.

1976 Walker: 155, no. 173, repro.

1985 NGA: 369, repro.

1986 Löcher, Kurt. "Panel Painting in Nuremberg: 1350–1550" and "Hans Suess von Kulmbach, Portrait of a Young Man." *Gothic and Renaissance Art in Nuremberg 1300–1550.* Exh. cat., Metropolitan Museum of Art, New York, and Germanisches Nationalmuseum, Nuremberg. New York and Munich: 86, 350, no. 167, repro. 84.

1990 Löcher, Kurt. "Zu den frühen Nürnberger Bildnissen Hans Schäufeleins." *Hans Schäufelein. Vorträge, gehalten anlässlich des Nördlinger Symposiums im Rahmen der 7. Rieser Kulturtage in der Zeit vom 14. Mai bis 15. Mai 1988.* Nördlingen: 107–110, repro. 106.

Bernhard Strigel

1460/1461–1528

BERNHARD STRIGEL was born into a family of artists in Memmingen, a city in the Allgäu region of southern Germany. His grandfather, Hans Strigel the Elder, was a painter and the head of a workshop. It is still not determined whether Bernhard's father was Hans Strigel the Younger, a painter, or Hans' brother Ivo Strigel, who was a sculptor. Although we know very little about Bernhard's early years, it is most likely that he was trained as a painter in the family shop. The earliest work that can be associated with him is the left wing of an altarpiece with Saints Vinzentius, Sebastian, and Michael (Schweizerisches Landesmuseum, Zurich), originally located in the church in Splügen (Graubünden). The carved center portion by Ivo Strigel and the other wing are no longer extant. In addition to some Netherlandish influence that may indicate a journey to the Lowlands in the 1480s, Strigel's early work reflects the influence of the late Gothic style of the Ulm painter Bartholomäus Zeitblom. Strigel assisted Zeitblom with the predella and six panels, datable 1493/1494, that form the high altar of the cloister church in Blaubeuren.

In the course of the 1490s Strigel became an independent master in Memmingen and began to produce religious paintings and portraits. Major works of his early maturity include the *Holy Kindred* altarpiece of c. 1505 (Germanisches Nationalmuseum, Nuremberg, and four panels in the collection of Count von Rechberg, Donzdorf), originally installed in the parish church in Mindelheim, and the portrait of Hieronymus Haller, dated 1503 (Alte Pinakothek, Munich). Strigel attracted the attention of Maximilian I, and the portrait dated 1504 (Gemäldegalerie, Berlin) is one of the earliest of numerous portraits of the emperor produced by the artist and his shop. In 1515 Strigel left Memmingen to work in Vienna as court painter to Maximilian. Here, in the same year, he produced one of the earliest group portraits in Germany, the depiction of Maximilian I and his family (Kunsthistorisches Museum, Vienna).

Strigel must have returned to Memmingen almost immediately, for in 1515 he collaborated with the sculptor Hans Thoman on an altarpiece (now lost) for the church in Feldkirch, and between 1516 and 1518 he is recorded as holding significant positions in the Memmingen city government and the trade guild. His depiction on two panels of Konrad Rehlinger the Elder and his children, dated 1517 (Alte Pinakothek, Munich), is at once a superb portrayal and one of the earliest large-scale, full-length independent portraits.

Strigel returned to Vienna in 1520. In the interim the portrait of Maximilian I and his family was acquired by the humanist and court advisor Johannes Cuspinian, who had Strigel add a *Holy Kindred* to the reverse and also paint a separate but matching portrayal of Cuspinian and his family (private collection, Lower Austria). The lengthy inscription on the back is an important primary document. By stating that Strigel was sixty years old in 1520, it helps establish the artist's birth date. One also learns that Strigel painted the Cuspinian portrait with his left hand and was "proclaimed noble" by Maximilian, although it is unclear whether Strigel's nobility took the form of a payment or a title.

Strigel was back in Memmingen by 1521/1522 and working on a "Holy Tomb" for the Church of Our Lady; four paintings of sleeping soldiers (three in the Alte Pinakothek, Munich, and one in the City Art Gallery, York) may have been part of this project. As a person of importance and influence, Strigel was sent between 1523 and 1525 to represent Memmingen at the court in Innsbruck, Ulm, Augsburg, and other cities. As the Reformation engulfed Memmingen in the mid-1520s, Strigel acted as a mediator between the various factions. The artist himself was apparently sympathetic to the new ideas. In his last years he

seems to have abandoned religious works and devoted himself almost exclusively to portraiture.

Strigel died in Memmingen sometime between 4 May and 23 June 1528. His oeuvre consists of approximately ninety paintings and a small corpus of attributed drawings. In the absence of a son, his workshop was taken over by his brother-in-law Hans Goldschmidt, who resided in the Strigel household from at least 1521 on. Strigel's true artistic heir, however, was the Tyrolean painter Hans Maler zu Schwaz (active c. 1510–1530).

Bibliography

Otto, Gertrud. *Bernhard Strigel*. Munich and Berlin, 1964.

1947.6.5 (900)

Margarethe Vöhlin, Wife of Hans Roth

1527
Linden, visible surface: 42.6–43 × 30 (16¾–16⅞ × 11¾); original, engaged frame: 49.6 × 37 (19½ × 14½)
Ralph and Mary Booth Collection

Inscriptions

On bottom edge of frame: *Tausen und funfhundert iar § Auch siben undzwaintzge das ist war ℰ⅃ / Zallt man, do hett ich zwaintzg iar wol ✦ Am tag Margrethe ich sagen sol ℰ⅃*

On reverse: coat-of-arms, *argent, on a fess sable, three majuscule letters "P" silver*; crest, *a demi-vol argent, a fess sable charged with three majuscule letters "P" silver.*[1]

At upper right above coat-of-arms: *U.3.*

Technical Notes: The examination was conducted without disengaging the panel from its frame. The support is a single piece of wood with vertically oriented grain,[2] painted on both sides and set into an engaged frame. It is estimated that the frame, like its pendant, is made of poplar. A barbe is visible on all four edges of the panel, suggesting a once continuous ground and paint layer; it is likely that at the time the panel was cradled it was detached from its frame. Along the left, right, and bottom sides wooden strips are nailed to the

outer edge of the frame. Examination with infrared reflectography revealed a faint outlining of the eyes, which is possibly underdrawing. Infrared photography discloses that the third and fourth fingers of the sitter's hand were originally shorter. The obverse is generally in good condition. There is, however, extensive retouching in the face, and the tops of the letters in the first five words of the inscription show signs of damage and possible retouching.

Reverse: An area roughly the size of the coat-of-arms was prepared with a white ground. A layer of greenish paint and small yellow dots was applied directly to the wood in the remaining areas of the panel and frame. Numerous small losses in the coat-of-arms have been inpainted. There are scratches and losses scattered throughout the greenish area. Examination with infrared reflectography did not reveal underdrawing. The reverse is not varnished.

Provenance: Probably Hans Roth [d. 14 March 1573] and Margarethe Vöhlin [d. 5 July 1582], Memmingen, Augsburg, and Ulm.[3] Manoli Mandelbaum, Berlin. (Julius Böhler, Munich, January 1922); (Paul Cassirer, Berlin); purchased March 1922 by Ralph Harman and Mary B. Booth, Detroit.[4]

Exhibitions: Lent by Ralph H. Booth to the Detroit Institute of Arts, 1923.[5] Detroit Institute of Arts, 1926, *The Third Loan Exhibition of Old Masters* (*Catalogue of a Loan Exhibition from Detroit Private Collections*), no. 20. Detroit Institute of Arts, 1927, *The Fifth Loan Exhibition of Old and Modern Masters*, no. 27. New York, New York World's Fair, 1939, *Masterpieces of Art* (*Catalogue of European Paintings and Sculpture from 1300–1800*), no. 364.

1947.6.4 (899)

Hans Roth

1527
Linden, visible surface: 42.6 × 30.0 (16¾ × 11¾); original, engaged frame: 49.6 × 37.0 (19½ × 14½)
Ralph and Mary Booth Collection

Inscriptions

On bottom edge of frame: *Gleich in gemeldtem iar a̐ch ich § do liess ich Conterfeten mich ℧ 1527 ⌣ / Und ward Octobris sechtzehn tag Alt sechsundzwaintzg iar wie ich sag ℧⅌*

On ring of sitter's forefinger: ЯH and Roth family coat-of-arms

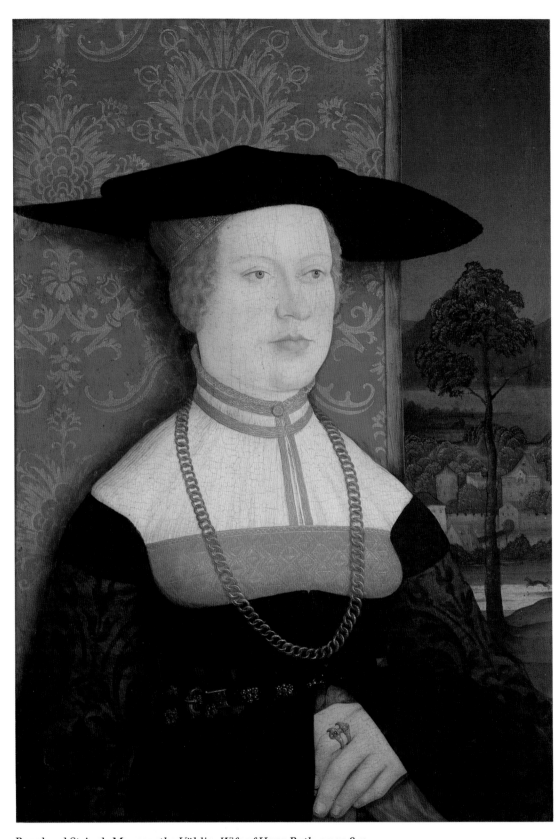

Bernhard Strigel, *Margarethe Vöhlin, Wife of Hans Roth*, 1947.6.5

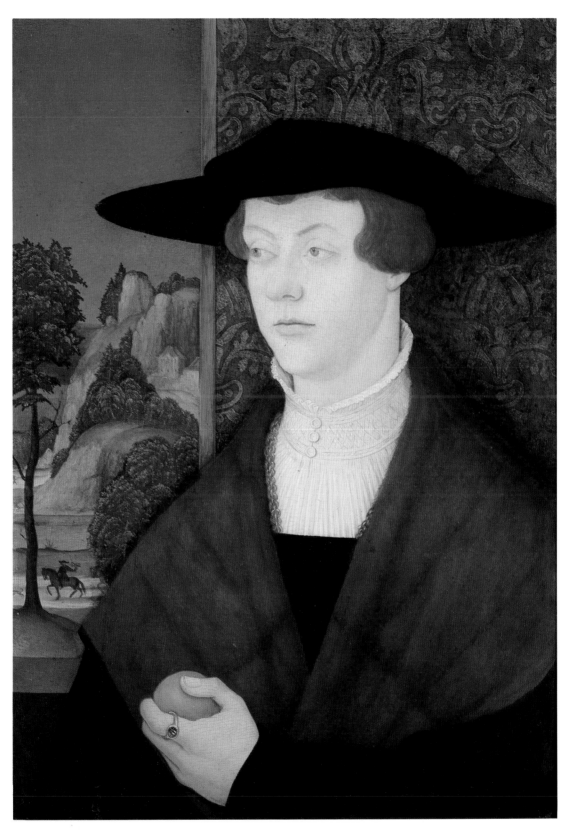

Bernhard Strigel, *Hans Roth*, 1947.6.4

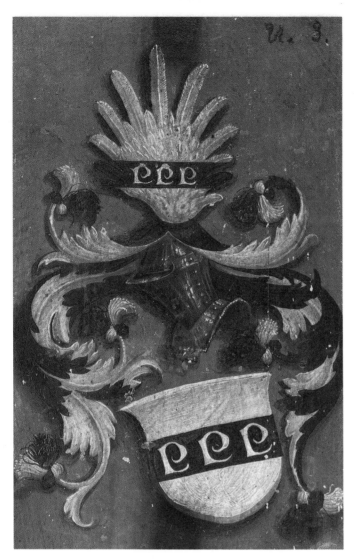

Bernhard Strigel, *Margarethe Vöhlin, Wife of Hans Roth*, 1947.6.5 (reverse: coat-of-arms)

On reverse: coat-of-arms, *per pale sable, a unicorn rampant argent, and silver, a fess also sable*; crest, *a demi-unicorn per fess argent and sable*.[6] At upper right above coat-of-arms: *U.4.*

Technical Notes: The examination was conducted without disengaging the panel from the frame. The support is a single piece of wood with vertically oriented grain. The frame is made of poplar wood.[7] The white ground terminates in a barbe along all four edges of the panel. Along the left, right, and bottom sides wooden strips are nailed to the outer edge of the frame. Examination with infrared reflectography revealed fine outlines of the sitter's eyes and nose, but it was not clear whether this was underdrawing or part of the paint layer. Also visible in the sitter's hand is the

blocked-in shape of an early design stage. There is a vertical check at the left edge of the panel. Retouching is scattered throughout the panel but is concentrated in the sitter's face. The right corner has been cleaned more thoroughly than the rest of the panel.

Reverse: An area roughly the size of the coat-of-arms was prepared with a white ground. A layer of greenish paint and small yellow dots was applied directly to the wood in the remaining areas of the panel and frame. A fine, precise outline underdrawing is discernible in the unicorn in the crest of the coat-of-arms. There are scratches and losses scattered throughout the greenish area. The reverse is not varnished.

Provenance: Same as 1947.6.5

Exhibitions: Lent by Ralph H. Booth to the Detroit Institute of Arts, 1923. Detroit Institute of Arts, 1926, *The Third Loan Exhibition of Old Masters* (*Catalogue of a Loan Exhibition from Detroit Private Collections*), no. 19. Detroit Institute of Arts, 1927, *The Fifth Loan Exhibition of Old and Modern Masters*, no. 26. Art Institute of Chicago, 1933, *A Century of Progress*, no. 32a. New York, New York World's Fair, 1939, *Masterpieces of Art* (*Catalogue of European Paintings and Sculpture from 1300–1800*), no. 363.

THIS WELL-DRESSED and evidently prosperous couple is shown in half length. Brocaded hangings are behind their heads and shoulders—red for the woman and green for the man. The two panels are unified by a continuous landscape of mountains, water, trees, and houses. On the right panel is a procession led by a diminutive horseman holding a bird of prey, probably a falcon. The hunting party is preceded by running dogs, visible on both panels.

The identification of the sitters as Hans Roth and Margarethe Vöhlin can be established with almost virtual certainty from the coats-of-arms on the backs of the panels and the inscriptions on the original frames as well as by the signet ring (fig. 1) with the initials *HR* and the Roth arms worn by the male sitter. The lines under the woman's portrait may be translated: "Thousand and five hundred years, Also seven and twenty that is true./As one counts then I had twenty years full. On Margaret's day I should say." The lines under the man's portrait may be rendered: "Also in the same year I had myself portrayed. 1527/And it was the sixteenth day of October I was twenty-six years old as I say." Margarethe Vöhlin's twentieth birthday was on the feast day of Saint Margaret,

20 July 1527, thus she was born in 1507. We can also infer from the inscription that Hans Roth was born on 16 October 1501.

Both Hans Roth and Margarethe Vöhlin belonged to prominent mercantile families of southern Germany. The Vöhlins were one of the foremost patrician families in Memmingen, appearing in that city around 1340 and not dying out until between 1786 and 1816.[8] It is thus not surprising that members of the Vöhlin family were represented by members of the Strigel family in wall and panel paintings.[9] Margarethe was the daughter of Konrad Vöhlin (d. 1511), who attained a high rank in the civil militia, served six times as mayor, and was probably the most important merchant in Memmingen. Together with his brother-in-law he founded the "Grosse deutsche Kompagnie," a trading company that dealt with such far-flung territories as India and Venezuela. Spices were doubtless a major import and the three *P*s on the Vöhlin coat-of-arms are usually considered an allusion to the family's earlier ventures in the spice trade.[10]

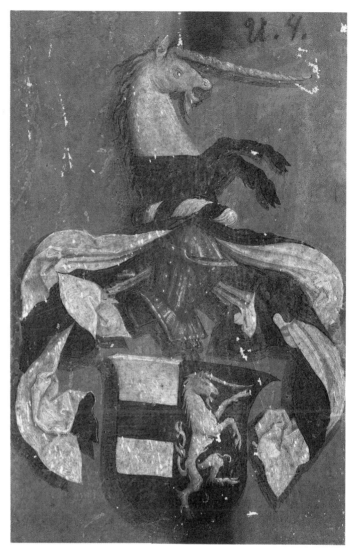

Bernhard Strigel, *Hans Roth*, 1947.6.4
(reverse: coat-of-arms)

Fig. 1. Detail of *Hans Roth*, 1947.6.4

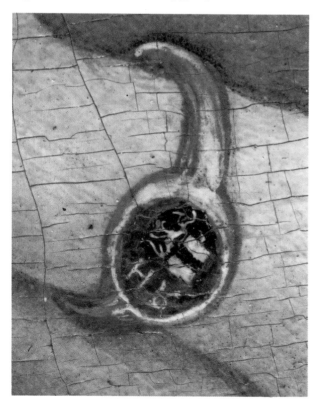

Hans Roth (or Rott) is mentioned in the tax books of Augsburg before 1526, although his family was based in Ulm. He was listed in 1526 as a member of the patrician society "Zum Goldenen Löwen" in Memmingen, and in 1536 he and his wife sold a portion of the revenues from an estate, the "Frauen Mühle," also in Memmingen. Rieber believes Roth was a Protestant by 1530. Roth was back in Ulm by 1542 and had become rich enough as an international merchant and banker to have a castle constructed in Reutti, near Ulm, as well as a large patrician house in Ulm. He and Margarethe had two sons, Georg and Hans, and two daughters, Regina and Margarethe.[11] Roth died on

14 March 1573 and was survived by Margarethe, who died on 5 July 1582.[12]

Hans Roth married Margarethe Vöhlin in the town hall of Augsburg on 5 February 1526.[13] Strigel's paintings are not specifically identifiable as either marriage or engagement portraits, even though executed a year after their marriage; the sitters hold no flowers, and the Vöhlin coat-of-arms is not conjoined with that of Roth. In almost all portrait pairs the male occupies the more important position on the "dexter" side, that is, on the viewer's left.[14] Here that place is taken by Margarethe Vöhlin, and it is quite possible, as suggested by Talbot, that her twentieth birthday was both the occasion for the commission and the reason she is in the position of greater honor and importance.[15]

Painted only a year before the artist's death, the National Gallery's portraits represent the culmination of Strigel's portrait style and achieve a harmonious balance and integration of figure and spatial setting. The external details of the sitters' costumes and physiognomies are carefully recorded, but their expressions are rather lifeless and we are given no insights into their character.

The half-length figure placed in an interior that opens onto a landscape is a type that harks back to Netherlandish models, such as portraits by Dirck Bouts and Hans Memling, but was used by Albrecht Dürer in the late 1490s, in particular in the *Self-Portrait* of 1498 (Museo del Prado, Madrid) and in the portraits of *Hans and Felicitas Tucher* of 1499 (Schlossmuseum, Weimar).[16] Within Strigel's oeuvre, the Washington pictures are closest to the undated but late portraits of an unidentified couple (Prince of Lichtenstein collection, Vaduz) and show similarities in modeling and lettering style to the portrait of Ulrich Wolfhard, which is signed and dated 1526 (Neuerburg collection, Hennef-Sieg).[17]

Notes

1. I am indebted to Walter Angst for the heraldic description.

2. The wood was identified by the National Gallery's scientific research department.

3. Anton H. Konrad, letter to the author, 5 November 1988, in NGA curatorial files, suggested that the pictures remained in the possession of the Roth family in the Schloss at Reutti (now Neu-Ulm) until 1890, when bankruptcy forced the dispersal of the collection. Since the Schloss archive is not extant, this proposal remains unverified.

4. Provenance corroborated by Julius Böhler, letter to the author, 9 November 1987, in NGA curatorial files.

5. See Valentiner 1923, 51–52.

6. Walter Angst provided the heraldic description.

7. See note 2.

8. See U. Westermann, "Die Vöhlin zu Memmingen," *Memminger Geschichts-Blätter* 9 (November–December 1923), 33–40, 41–44.

9. For example, Otto 1964 (see Biography), 12, mentions a fragment of a wall painting done by Hans Strigel the Younger in one of the Vöhlin houses (Marktplatz 6) in Memmingen. The Vöhlin family was responsible for restoration between 1456 and 1460 of the interior of the Frauenkirche in Memmingen, and a wall painting on the north side of the choir, often attributed to Hans Strigel the Younger, depicts a member of the Vöhlin family and the Madonna on a crescent moon; Otto 1964 (see Biography), 18; Theophil Haffelder, *Evang.-luth. Stadtpfarrkirche. Unsere Frauen in Memmingen* (Munich and Zurich, 1983), 18, repro. 19. From Bernhard we have a fragment of a devotional panel depicting a male member of the Vöhlin family and angels (Kisters collection, Kreuzlingen); see Otto 1964 (see Biography), 101, no. 52, fig. 120.

10. Westermann 1923, 39–40; Otto 1964 (see Biography), 81; see also, for the arms, Walter Braun, "Das Wappen der Memminger Familie Vöhlin," *Memminger Geschichtsblätter* (1970), 35–40. The *P*s are commonly believed to refer to pepper (*pfeffer*), part of the family's trade in spices, especially those used in wine (*Würzwein*), and associated with the letters in the following Latin sentences: "Piper Peperit Pecuniam, / Pecunia Peperit Pompam, / Pompa Peperit Pauperiem, / Pauperies Peperit Pietatem." This may be translated: "Pepper produces profit / Profit produces pomp / Pomp produces poverty / Poverty produces piety."

11. The arms in the National Gallery's panel correspond to those of the Roth family of Ulm; *Johann Siebmachers Wappen-Buch*, pt. 1, facsimile (1703; Battenberg, 1975), pl. 209. For the mention of Hans Roth in the tax books of Augsburg, I am grateful to Dr. Wüst, Stadtarchiv, Augsburg, letter to the author, 26 July 1988, in NGA curatorial files. See also Otto 1964 (see Biography), 81; and Albrecht Rieber, *Reutti. Stadt Neu-Ulm. Evangelische Pfarrkirche St. Margareta*, Schwäbische Kunstdenkmale, vol. 32 (Weissenhorn, 1984), 10. Rieber cites an epitaph panel in the church, probably the work of the Ulm painter Georg Rieder the Younger, containing the Resurrection of Christ and portraits of Hans Roth and his wife and children.

12. Dr. Gebhard Weig, Stadtarchiv, Ulm, letter to the author, 10 August 1988, in NGA curatorial files.

13. Helmut Rischert, Stadtarchiv, Augsburg, letter to the author, 29 December 1988, in NGA curatorial files, citing the *Augsburger Hochzeitsbuch 1484–1700*,

fol. 29, in the Stadtarchiv. The same information was provided by Anton H. Konrad, letter to the author, 5 November 1988, in NGA curatorial files, along with a photocopy of Albert Haemmerle, *Die Hochzeitsbücher der Augsburger Bürgerstube und Kaufleutestube bis zum Ende der Reichsfreiheit* (Munich, 1936), 19, no. 287. I am grateful for the assistance of Gebhard Weig, Stadtarchiv, Ulm, where numerous documents collected in the late eighteenth century concerning the Roth family are housed.

14. See Berthold Hinz, "Studien zur Geschichte des Ehepaarbildnisses," *Marburger Jahrbuch für Kunstwissenschaft* 19 (1974), 139–218; Erwin Panofsky, *Early Netherlandish Painting: Its Origins and Character* (Cambridge, Mass., 1953), 294, 479–480 n. 16, for Netherlandish portraits.

15. Charles Talbot, draft catalogue entry, 1966, in NGA curatorial files.

16. Peter Strieder, *Albrecht Dürer: Paintings, Prints, Drawings*, trans. Nancy M. Gordon and Walter L. Strauss (New York, 1982), 25, 230–231, pls. 23, 271–272.

17. Otto 1964 (see Biography), 106, no. 84, figs. 150–151, and no. 86, color repro. 75.

References
1923 Valentiner, Wilhelm R. "Ralph H. Booth Loan Collection." *Bulletin of the Detroit Institute of Arts* 4: 51–52, repro. 54.

1924 Poland, Reginald. "Art in Detroit Homes." *Art and Archaeology* 17: 111, repro.

1925 Parker, Karl Theodor, and Walter Hugelshofer. "Bernhardin Strigel als Zeichner." *Belvedere* 8: 33 n. 4, fig. 5.

1926 Götz, O., Georg Swarzenski, and A. Wolters. *Ausstellung von Meisterwerken alter Malerei aus Privatbesitz.* Exh. cat., Städelsches Kunstinstitut, Frankfurt: 70, under no. 201.

1929 Mayer, August L. "Bernhard Strigel als Porträtmaler." *Pantheon* 3: 1, repro.

1933 "Century of Progress Exhibit List." *ArtN* 31 (27 May): 4.

1934 Hugelshofer, Walter. "Ein signiertes Bildnis von Bernhard Strigel." *Pantheon* 14: 306.

1936 Kuhn: 63, nos. 258–259, pl. 52.

1948 Frankfurter, Alfred M. "Booth: Hand-Picking the Renaissance." *ArtN* 47 (March): 37, repro.

1948 *Recent Additions to the Ralph and Mary Booth Collection.* Washington: unpaginated, repro.

1957 Stange *DMG*, 8: 150.

1959 Rettich, Edeltraud. "Bernhard Strigel, Ergänzungen und Berichtigungen zu: Alfred Stange 'Deutsche Malerei der Gotik, VIII. Band, Schwaben.'" *Zeitschrift für Kunstgeschichte* 22: 167.

1964 Otto (see Biography): 81, 106–107, no. 87, color repros. 78–79, figs. 154–155.

1970 Stange, Alfred. *Kritisches Verzeichnis der deutschen Tafelbilder vor Dürer.* 3 vols. Munich 2: 221, no. 966.

1975 NGA: 332, repro. 333.

1976 Walker: 155, nos. 168–171, repro. 154.

1985 NGA: 382, repro.

1990 Dülberg, Angelica. *Privatporträts. Geschichte und Ikonologie einer Gattung im 15. und 16. Jahrhundert.* Berlin: 23, 127, 208–209, nos. 114–115, figs. 467–470.

1961.9.88 (1640)

Saint Mary Cleophas and Her Family

c. 1520/1528
Fir, 125.5 × 65.8 (49⅜ × 25⅞)
Samuel H. Kress Collection

Inscriptions
On halo of female figure: *SANCTA MARIA CLEOP[H(?)]E*
On halo of naked child: *SANCTVS IVDAS XPI APOSTOLV*
On halo of middle child: *SCTVS SIMON*
On halo of standing child: *ST[] SANCTVS IOSEPHI*
On halo of child playing with dog: *SANCTVS IACOBVS MINOR AIPHE*

Technical Notes: The painting is on a panel composed of three boards, with vertical grain, of nearly equal width.[1] In 1947 the panel was thinned, marouflaged to mahogany, and cradled. The ground is applied rather thickly, as indicated by the relatively deeply incised decoration in the gilding. The bole is reddish in tone. Examination with infrared reflectography discloses extensive underdrawing in what appears to be a liquid medium applied with a brush. The expressive, individual style (fig. 1) is often characterized, particularly in areas of drapery (fig. 2), by calligraphic strokes ending in hooks or circles.

The picture is essentially in good condition. Some worm tunneling has occurred in the past. There is some flaking and lifting of paint in areas, generally around the figures' heads, where paint is applied over gold and adhesion is poor. Retouching occurs along the joins, some contours, and most heavily in the body of the naked infant. There appear to have been two applications of retouching.

Provenance: Possibly O. Streber, Munich.[2] (Haskard Bank, Florence, and Charles Fairfax Murray, as agent, by 1900);[3] (Thos. Agnew & Sons, London, 1900); sold to Rodolphe Kann [d. 1905], Paris, May 1900;[4] by descent to executors of the Kann estate: Edouard Kann, Paris, Betty Schnaffer (née Kann), Frankfurt, Martin and Eleanore Bromberg (née Kann), Hamburg, Jacob and Mathilde Emden (née Kann), Hamburg, and Edmond

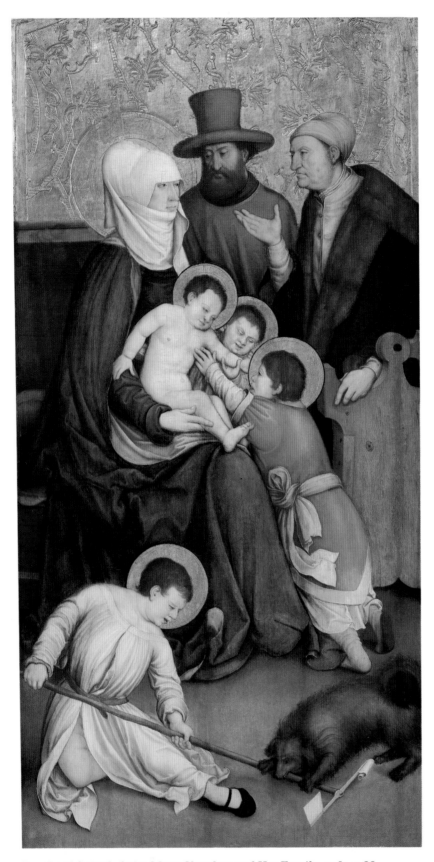

Bernhard Strigel, *Saint Mary Cleophas and Her Family*, 1961.9.88

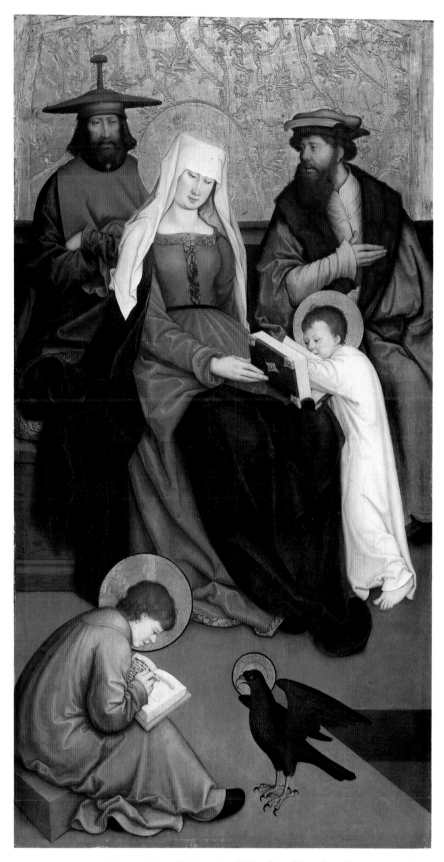

Bernhard Strigel, *Saint Mary Salome and Her Family*, 1961.9.89

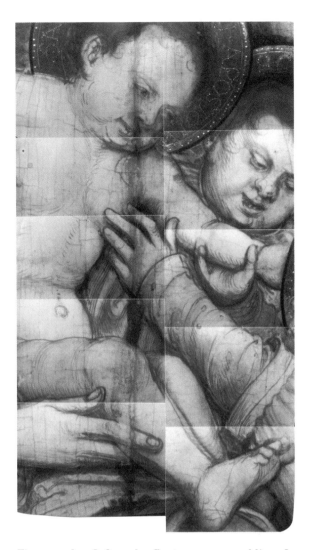

Figs. 1 and 2. Infrared reflectogram assemblies of details of *Saint Mary Cleophas and Her Family*, 1961.9.88 [infrared reflectography: Molly Faries]

and Madeline Bickard See (née Kann), Paris.[5] (Duveen Brothers, Paris, August 1907);[6] purchased by members of the Kann family, possibly Martin and Eleanore Bromberg, Hamburg, August 1907.[7] Possibly Dr. Jacob and Mathilde Emden, Hamburg, by 1939?[8] (Wildenstein & Co., New York, by 1939);[9] purchased 1954 by the Samuel H. Kress Foundation, New York; Denver Art Museum, Colorado, 1954–1958.[10]

Exhibitions: Kansas City, Missouri, William Rockhill Nelson Gallery of Art and Mary Atkins Museum of Fine Arts, 1940–1941, *Seventh Anniversary Exhibition of German, Flemish, and Dutch Painting*, no. 56, as *The Holy Family*. Indianapolis, John Herron Art Museum, 1950, *Holbein and His Contemporaries*, no. 68. National Gallery of Art, Washington, from February 1958.

1961.9.89 (1641)

Saint Mary Salome and Her Family

c. 1520/1528
Fir, 125 × 65.7 (49¼ × 25⅞)
Samuel H. Kress Collection

Inscriptions
On halo of female figure:
 SANCTA MARIA SALOME
On halo of child at center:
 SANCTVS IACOBVS MA
On halo of child at lower left:
 SANCTV IOHANES EWAN

Technical Notes: The painting is on a fir panel apparently composed of two boards with vertical grain,[11] although numerous cracks make it difficult to determine the number of joins. In 1947 the panel was thinned, marouflaged to mahogany, and cradled. As with the pendant, the ground is rather thick and the bole under the gilding is reddish in tone. The same extensive underdrawing is revealed under examination with infrared reflectography; changes in the eye and thumb of the man to the right of Mary Salome are visible (fig. 3).

The picture is basically in good condition. There is a certain amount of worm tunneling, visible at the edges of the panel. The paint layer is in generally good condition; retouching is confined to the edges, the joins, and the numerous vertical cracks in the bottom third of the painting.

Provenance: Same as 1961.9.88, except that this panel was not at the Denver Art Museum.

Exhibitions: Kansas City, Missouri, William Rockhill Nelson Gallery of Art and Mary Atkins Museum of Fine

Arts, 1940–1941, *Seventh Anniversary Exhibition of German, Flemish, and Dutch Painting*, no. 57, as *The Virgin Instructing the Infant*. Indianapolis, John Herron Art Museum, 1950, *Holbein and His Contemporaries*, no. 68. National Gallery of Art, Washington, from 1956.

THESE TWO PANELS depict branches of what might be called the extended family of Christ, and in all likelihood, they were originally part of an altarpiece dedicated to the Holy Kindred. Although well established in fourteenth-century devotional literature, the theme of the Holy Kindred was given additional impetus in the late fifteenth and early sixteenth centuries through the growing veneration of Saint Anne that occurred in northern Europe. A major aspect of the legend is the *trinubium Annae*, or three marriages of Saint Anne. Anne's first marriage was to Joachim, and their daughter was Mary, the mother of Christ. Following Joachim's death, Anne married Cleophas and gave birth to another daughter named Mary, called Saint Mary Cleophas. Mary Cleophas married Alphaeus, and their four children were Saint James the Less, Saint Simon, Saint Jude, and Saint Joseph the Just. After Cleophas died, Anne's third marriage was to Salomas, and this union produced a third daughter named Mary, called Saint Mary Salome. Mary Salome married Zebedee, and their two children were Saint James the Greater and Saint John the Evangelist.[12]

In the panel representing Saint Mary Cleophas and her family, Mary's husband, Alphaeus, stands next to her, while her father, Cleophas, is at the right. Inscriptions in the halos identify the four children: the naked child in Mary's lap is Jude, flanked at the right by Simon and, reaching upward, Joseph the Just. James the Less uses a whirligig to play with a dog. In the Saint Mary Salome panel Mary's father, Salomas, is at the left and, as observed by Eisler, wears a hat that identifies him as Jewish.[13] At the right is Mary Salome's husband Zebedee. James the Greater occupies himself with a book (a Bible?) in Mary's lap, while John the Evangelist, seated at the lower left and accompanied by his attribute the eagle, writes in a book, almost certainly an allusion to his composition of the Book of Revelation.

The original commission or location of the

Holy Kindred altarpiece that included the National Gallery's panels is not known. In 1959 Rettich suggested that a depiction of *Eliud before Mary and the Christ Child* (fig. 4) of virtually identical dimensions was once part of the same altarpiece.[14] This has been accepted by subsequent authors, particularly Otto, who noted that since the Berlin panel lacks a gold background it might have been the reverse of one of the Washington panels and would have been visible when the shutters were closed. As first proposed by Otto, both contemporary usage and the vertical emphasis of the surviving panels make it likely that the center portion was sculpted either in the round or in high relief and may well have been in the style of the Ottobeuren Master (Hans Tho-

Fig. 3. Infrared reflectogram assembly of a detail of *Saint Mary Salome and Her Family*, 1961.9.89 [infrared reflectography: Molly Faries]

Fig. 4. Bernhard Strigel, *Eliud before Mary and the Christ Child*, panel, Staatliche Museen zu Berlin, Gemäldegalerie [photo: Staatliche Museen zu Berlin]

man) who was active in Memmingen and collaborated with Strigel.[15]

From the surviving fragments, it is not possible to be clear or precise about the extent of the iconographic program or the orientation of the National Gallery's panels within the altarpiece. There is general agreement that the central section probably contained a representation of Saint Anne, the Virgin, and the Christ Child, and possibly Joachim and Joseph as well. Since Eliud was the daughter of Anne's sister, Esmeria, Otto hypothesized that on the reverse of another shutter was a depiction, now lost, of Esmeria's other daughter, Elizabeth, her husband Zacharias, and their child Saint John the Baptist.[16]

The strong glance toward the right of Saint Mary Cleophas and the bracketing gesture of Saint James the Less suggest that the *Saint Mary Cleophas and Her Family* panel was a left shutter. Although several authors, including Otto, believe that the *Saint Mary Salome and Her Children* panel was on the right, Suida pointed out that both Mary Salome and Saint John the Evangelist face right and that this also might have been a left-hand shutter. If this were the case, then the two right-hand shutters have also been lost.[17]

Strigel's authorship of *Saint Mary Cleophas and Her Children* and *Saint Mary Salome and Her Children* has never been questioned, and beginning with Baum in 1938 almost all authors have agreed that the panels date from Strigel's last period, c. 1520/1528. Stange's isolated attempt to date the pictures c. 1510 was quickly refuted by Rettich.[18] Otto, perhaps the leading Strigel scholar, regards the Washington panels as the masterpieces of Strigel's late style, characterized by a shallow space, strong plasticity of individual figures, and strict, closed compositions, as well as manifesting a soft, flowing line, a deepening of form and color, and an increased subtlety of interpretation and execution. The National Gallery's panels, in Otto's view, surpass even the *Holy Kindred* of 1520 on the reverse of the portrait of Maximilian I and his family (Kunsthistorisches Museum, Vienna). Otto also observed that the Washington pictures shared with Strigel's other late works a sense of Gothic sentiment ("gotisches Empfinden") and that in their elongated figures, suppressed space, and gold backgrounds they are more Gothic than some of Strigel's earlier works.[19]

Thümmel noted that in the Saint Mary Cleophas panel the features of the man at the far right correspond generally to those of the Holy Roman Emperor Frederick III (d. 1493), father of Maximilian I.[20] The face is particularly close to that of the kneeling Magus in *The Adoration of the Magi* by the Master of Frankfurt and his shop (Koninklijk Museum voor Schone Kunsten, Antwerp)—a visage usually identified as Frederick[21]—and may also be compared with the posthumous woodcut in Hans Burgkmair's *Geneologie*.[22] While there is a tradition of representing members of the Austrian imperial family in the guise of members of

the Holy Kindred,[23] it is hard to know what, if anything, is meant in this instance, since the other faces are not portraits but seem to be Strigel's stock types, and there is no internal evidence of imperial patronage.

Notes

1. The wood was identified as fir by Michael Palmer, National Gallery's scientific research department; Eisler 1977 listed the support of this painting and 1961.9.89 as linden.

2. Unverified, cited by Stange 1970, 204, no. 899.

3. Richard Kingzett, Thos. Agnew & Sons, Ltd., London, letter to Colin Eisler, 24 January 1969, in NGA curatorial files.

4. Kingzett to Eisler, 24 January 1969.

5. Duveen stock book, Metropolitan Museum of Art, New York, archives; I am extremely grateful to the late Guy Bauman, department of European paintings, for making this information available (letter, 23 February 1987, in NGA curatorial files).

6. Bauman, letter, 23 February 1987; Edward Fowles, *Memories of Duveen Brothers* (London, 1976), 36–43.

7. Bauman, letter, 23 February 1987, notes that in both the stock book and the sales book the paintings are listed only as having been sold to "Kann relations."

8. Wildenstein & Co. brochure in the National Gallery's Kress files lists Bromberg and Dr. Emden as previous owners.

9. Ay-Whang Hsia, Wildenstein & Co., letter to the author, 14 September 1988, in NGA curatorial files.

10. Suida 1954, 64, no. 28; Louise H. Kleopov, Denver Art Museum, letter to the author, 10 November 1987, in NGA curatorial files. Eisler 1977, 26, reversed the exhibition dates for this and 1961.9.89.

11. See note 1.

12. The literature on the Holy Kindred is extensive, but see F. Falk, "Die Verehrung der h. Anna im fünfzehnten Jahrhundert," *Der Katholik* 58 (1878), 60–75; Karl Künstle, *Ikonographie der christlichen Kunst*, 2 vols. (Freiburg im Breisgau, 1928), 1: 328–332; Beda Kleinschmidt, *Die heilige Anna. Ihre Verehrung in Geschichte, Kunst und Volkstum* (Düsseldorf, 1930), 252–282; M. Lechner, "Sippe, Heilige," in *LexChrI*, 4: 163–168.

13. Eisler 1977, 27.

14. Cat. no. 606D, fir or pine, 125 × 65 cm. Rainer Michaelis, Staatliche Museen zu Berlin, letter to the author, 5 August 1988, in NGA curatorial files, also states that the panel is 0.3 cm. thick and was cradled in the nineteenth century. Rettich 1959, 163–164. Michaelis 1989, 110, repro.

15. Otto 1964 (see Biography), 50. Collaboration with Hans Thoman is suggested in Otto 1951, 1–2. For the Ottobeuren Master, who is often identified with

Hans Thoman, see Michael Baxandall, *The Limewood Sculptors of Renaissance Germany* (New Haven and London, 1980), 24–25, 305–307, pls. 85–89.

16. Otto 1964 (see Biography), 50, who cites Martin Schaffner's Hutz altarpiece of 1521 (Münster, Ulm) as a parallel for the probable arrangement and iconography of the carved center portion.

17. Kress 1956, 172; Charles Talbot, draft catalogue entry, 1965, in NGA curatorial files, notes that the size of the panels seems more consistent with the idea that each was a single shutter. There is no clear-cut method of determining what subjects might have been on the putative right-hand shutters. We might note, however, that Strigel's *Holy Kindred* altarpiece, c. 1505 (Germanisches Nationalmuseum, Nuremberg), originally in the parish church in Mindelheim (Otto 1964 [see Biography], 94, no. 16, pls. 45–54) contains depictions of Ysathar and Susanna with Hismeria and Anne (fig. 45), and Hismeria and Effra with Eliud and Elizabeth (fig. 51).

18. Stange *DMG* 1957, 144; Rettich 1959, 164–165.

19. Otto 1964 (see Biography), 48–51. In addition to likenesses to the Vienna *Holy Kindred* already mentioned, Otto also noted similarities of style and figure type with the *Death of the Virgin* of 1518 (formerly Musée des Beaux-Arts, Strasbourg); Otto 1964 (see Biography), 97, no. 85, fig. 85.

20. Thümmel 1980, 108 n. 36, where possible self-portraits as Cleophas by artists such as Jan van Scorel and Cranach are also discussed.

21. Stephen H. Goddard, *The Master of Frankfurt and His Shop* (Brussels, 1984), 94, fig. 12. Goddard dates the painting c. 1510/1515 in *Friedrich III* [exh. cat., Kaiserresidenz] (Wiener Neustadt, 1966), 399, no. 232, pl. 12. I owe this last reference to Larry Silver, who also tends to agree with the identification (letter to the author, 8 June 1988, in NGA curatorial files).

22. Ludwig Baldass, *Der Künstlerkreis Kaiser Maximilians* (Vienna, 1923), 46–47, fig. 73; the series dates between 1509 and 1512.

23. See Thümmel 1980, especially 104–109.

References

1907 Bode, Wilhelm von. *Catalogue of the Rodolphe Kann Collection*. 2 vols. Paris, 2: nos. 115–116, repro.

1914 Weizinger, Franz Xavier. "Die Maler-Familie der 'Strigel' in der ehemals freien Reichsstadt Memmingen." *Festschrift des Münchener Altertums-verein zur Erinnerung an das 50. Jahr Jubiläum*, 143: no. 31.

1928 Weizinger, Franz Xavier. "Bernhard Strigel 1460–1528." *Memminger Geschichts-Blätter* 14 (June): 10.

1938 Baum, Julius. "Strigel." In Thieme-Becker, 32: 189.

1951 Otto, Gertrud. "Zwei Sippenbilder von Bernhard Strigel." *Memminger Geschichts-Blätter*, 1–2.

1954 Suida, William E. *Paintings and Sculpture of the Samuel H. Kress Collection.* Denver: 64, no. 28, repro.

1955 Bach, Otto Karl, et al. "European Art. The Denver Art Museum Collection." *Denver Art Museum Winter Quarterly* 15: no. 31, repro. 14.

1956 Frankfurter, Alfred. "Crystal Anniversary in the Capital." *ArtN* 55 (March): 26, repro.

1956 Kress: 172, no. 68, repro. 173.

1957 Stange *DMG*, 8: 144, fig. 299.

1959 Rettich, Edeltraud. "Bernhard Strigel. Ergänzungen und Berichtigungen zu: Alfred Stange 'Deutsche Malerei der Gotik, VIII. Band, Schwaben.' " *Zeitschrift für Kunstgeschichte* 22: 163–165.

1960 Broadley 34, repro. 35.

1964 Otto (see Biography): 48, 50–51, 98, no. 38a–38b, repros. 47, 49 (color), figs. 94–95.

1968 Musper, Heinrich Theodor. "Strigel, Bernhard." *Kindlers*, 5: 436.

1970 Stange, Alfred. *Kritisches Verzeichnis der deutschen Tafelbilder vor Dürer.* 3 vols. Munich 2: 204, no. 899a–b.

1975 NGA: 334, repro. 335.

1976 Walker: 151, nos. 161, 162, repro. 150.

1977 Eisler: 26–28, figs. 18, 19.

1980 Thümmel, Hans Georg. "Bernhard Strigels Diptychon für Cuspinian." *Jahrbuch der kunsthistorischen Sammlungen in Wien* 76: 108 n. 36.

1983 Wolff: unpaginated, repro.

1985 NGA: 383, repro.

1989 Michaelis, Rainer. *Deutsche Gemälde 14.–18. Jahrhundert. Staatliche Museen zu Berlin. Gemäldegalerie. Katalog.* Vol. 3. Berlin: 110.

Tyrolean

1952.5.71 (1150)

Portrait of a Man

c. 1490/1500
Linden, 56.5 × 40 (22¼ × 15¾)
Samuel H. Kress Collection

Technical Notes: The panel is probably composed of two boards with vertical grain,[1] but the possible join cannot be confirmed because a long, repaired check at the same place, 23.5 cm. from the left, confuses the image seen in the x-radiograph. The panel has been thinned to a thickness of 0.5 cm. and marouflaged to plywood. Calcium carbonate is the pigment in the thick white ground. Infrared reflectography discloses underdrawing consisting mainly of curvilinear strokes in a liquid medium that broadly outline forms. In the landscape, however, buildings that were not followed in the paint stage were underdrawn in a fine outline (fig. 1). Glazes were used in certain areas, such as the design in the sitter's robe. The panel has a slight concave warp but is in good condition. There are small, scattered inpainted losses throughout, for example, along the check and in the dark areas of the robe, and retouched abrasion in the right halves of the top and bottom edges of the collar.

Provenance: Probably the dukes of Anhalt, Gotisches Haus, Wörlitz, near Dessau.[2] (Duveen Brothers, New York).[3] Clarence H. Mackay [d. 1938], Roslyn, New York, by 1929;[4] by inheritance to Mrs. Anne Case Mackay. (On consignment with Paul Drey, New York, for sale by French & Company, New York, 1951);[5] purchased March 1951 by the Samuel H. Kress Foundation, New York.

Exhibitions: New York, M. Knoedler & Co., 1935, *Fifteenth Century Portraits*, no. 15, as by Carlo Crivelli.

THE SITTER in this highly unusual portrait rests his hand on a stone ledge that is articulated by profiles of architectural molding. Draped over the ledge is a carpet whose design appears to be a composite of Anatolian carpet types.[6] The figure is set in a room with brick walls and a timbered ceiling; at the right a window looks out onto a landscape of trees and hills. The sitter is dressed in a black robe with a green pomegranate design and wears a tall hat that is perhaps closer to Netherlandish than German examples.[7] Hanging on the back wall is a piece of blue moiré silk that functions as a cloth of honor, framing the subject. The figure is identified as a member of the patrician or noble classes by both his costume, including the finger rings, and the setting, although his name is not known.[8] Especially striking is the sitter's fixed, almost vacant stare and prominent bony hand.

This *Portrait of a Man* was initially attributed to Carlo Crivelli by Cortissoz, Venturi, Fiocco, Berenson, and van Marle, and was thus claimed as Crivelli's only portrait.[9] Fiocco later suggested that the artist was possibly a miniaturist who worked in Ferrara, Padua, or Parenzano.[10] In 1967 Anzelewsky proposed that the panel was painted by a Tyrolean artist, close to the Master of Uttenheim, and possibly depicts a member of the Habsburgs, Duke Sigismund, count of the Tyrol.[11] Zeri found it impossible to associate the painting with an Italian artist and agreed with Anzelewsky that the artist was Tyrolean.[12] While accepting the work as a Tyrolean princely portrait, Ringler disagreed with Anzelewsky's association of the *Portrait of a Man* with the Master of Uttenheim and further asserted that neither the unplastered brick wall nor the landscape were typically Tyrolean.[13] Bonsanti suggested that the portrait might be an early work by Michael Pacher, dating from the 1470s or 1480s.[14] Shapley catalogued the painting as north Italian, c. 1460, but later attributed it to a Swiss master. The latter ascription was based on the opinion of Oberhuber, who saw similarities with the work of the Master of Sierenz, a follower of Konrad Witz, and with a painting of 1479 by an Upper Rhenish master.[15]

As regards unpublished opinions, Löcher thought that the portrait was produced around 1490 in the Tyrol or possibly in Salzburg.[16] Gmelin also suggested that the panel was Tyrolean.[17] The *Portrait of a Man* has, however, prompted other wide-ranging responses, namely that it is Italian,[18] Milanese,[19] French,[20] from the Savoy,[21] or

Tyrolean, *Portrait of a Man*, 1952.5.71

Fig. 1. Infrared reflectogram assembly of a detail of *Portrait of a Man*, 1952.5.71

even possibly by a Hungarian working for Matthias Corvinus.[22] This diversity of opinion reflects the painting's uniqueness, for, in terms of format, composition, and style, an exact cognate has thus far not been found. Nevertheless, it seems most likely that the *Portrait of a Man* originated in the Tyrol, that is, in the eastern Alpine region of present-day western Austria, between Bavaria and northern Italy. It is here, in what was essentially a transitional border region, that one would expect the kind of mixture of Italianate and Germanic elements that appear in the painting. As observed by Anzelewsky and others, profile portraits from the second half of the fifteenth century and early sixteenth century were done almost exclusively

in central and north Italian painting.[23] Similarly, it is in north Italian paintings and manuscripts by artists such as Carlo Crivelli and Cristoforo Landino that one sees an oriental carpet draped over a parapet.[24] In contrast, Tyrolean portraiture of the late fifteenth and early sixteenth century usually depicts the sitter in the traditional three-quarter view used in Germany and the Netherlands. An interior setting, sometimes with a window, is found in Tyrolean and other German portraits as well as in the National Gallery's picture.[25]

It appears highly unlikely that the painter of the Washington panel is Italian. The precision of detail and the manner of conception and execution all point to a Northern hand. Technical evidence—the calcium carbonate rather than calcium sulfate in the ground,[26] the linden wood support, and the probable use of oil in glazes—while also suggesting a northerner, is in itself inconclusive.[27] Although the *Portrait of a Man* exists in seeming isolation, a few admittedly generalized points of comparison may be cited. In the *Martyrdom of Saint Andrew*, dated c. 1500 and attributed to an anonymous Tyrolean artist (Germanisches Nationalmuseum, Nuremberg), there are certain similarities in the figures' ruddy bulbous noses and pinched features, particularly in the profile of the man seated at the right.[28] As noted by Anzelewsky, there are rather general similarities in the crisp features and prominent staring eyes of figures in paintings by the Master of Uttenheim,[29] a Tyrolean artist, characteristics that may also be seen in the *Portrait of Duke Sigismund, Count of Tyrol(?)*, c. 1465/1470 (Alte Pinakothek, Munich), by the Master of the Mornauer Portrait.[30] These works underscore the plausibility of localizing the *Portrait of a Man* in the Tyrol.

Since the sitter is male and facing right, it is possible that the National Gallery's painting once had as a pendant a portrait of the sitter's wife. The wall and window at the upper right, however, appear to cut off the space to an adjoining panel, which would create a rather curious juxtaposition.

Finally, the distant gaze, the odd proportions of the arm and forearm, and the use of a strict profile raise speculations as to whether this unknown man was alive or dead.[31] Posthumous profile portraits, perhaps deriving from antique examples,

can be found on coins and medals and in paintings both in Italy and in the North.[32] Pertinent comparisons are to be found in the group of portraits of Mary of Burgundy usually given to Hans Maler zu Schwaz but recently attributed to Niclas Reiser. Paintings in the Kunsthistorisches Museum, Vienna, in Schloss Ambras, Innsbruck, and elsewhere show Mary in profile standing in front of a cloth of honor; one example shows a ledge in the foreground, and another provides a view through a window to a landscape.[33] The relevance of these images is twofold: first, they are dated, at the earliest, around 1500 and hence after Mary's death in 1482; and second, both Hans Maler and Niclas Reiser were active in Schwaz in the Tyrol, indicating something of the availability of this type of portrait in the region around the turn of the century. In this regard it should be noted that other portraits of nobility, particularly of the Habsburgs, by Hans Maler and his probable teacher Bernhard Strigel, are profiles.[34] In sum, the possibility should be considered that the *Portrait of a Man* is a posthumous portrait of a nobleman. As suggested by Löcher, Schütz, and others, the painting may be dated c. 1490/1500.[35]

Notes

1. The wood was identified as linden by Michael Palmer, National Gallery's scientific research department.

2. Unverified, but quite likely; mentioned as coming from the dukes of Anhalt by Venturi 1930, 384, and by Peter J. Wojcik, Paul Drey Gallery, letter to the author, 4 October 1989, in NGA curatorial files.

3. Wojcik to author, 4 October 1989.

4. Cortissoz 1929 records the painting as belonging to Mackay.

5. Wojcik to author, 4 October 1989.

6. Charles Grant Ellis, letter to Fern Rusk Shapley, 12 May 1971, in NGA curatorial files. For a discussion of the appearance of oriental carpets in paintings see John Mills, *Carpets in Paintings* (London, 1983).

7. Martha Wolff, memorandum of a communication with Stella Newton, 2 April 1984, in NGA curatorial files. For examples of a tall cap in Netherlandish portraits in the 1460s (Dirck Bouts) and 1480s (Master of the View of Sainte Gudule) see Margaret Scott, *A Visual History of Costume: The Fourteenth and Fifteenth Centuries* (London, 1986), 97, 111, nos. 100, 119. It should be pointed out, however, that a tall cap similar to that in the National Gallery's painting is worn by the male sitter in a portrait formerly in Schloss Hohenzollern, Sigmar-

ingen, attributed to a Munich artist working around 1470; see Ernst Buchner, *Das Deutsche Bildnis der Spätgotik und der frühen Dürerzeit* (Berlin, 1953), 104, 203, no. 108, fig. 108.

8. For examples of rings similar to those depicted, which were apparently worn by both the bourgeois and the nobility, see *Die Renaissance im deutschen Südwesten zwischen Reformation und Dreissigjährigem Krieg* [exh. cat., Badisches Landesmuseum], 2 vols. (Karlsruhe, 1986), 2: 698–699, nos. L160–L161, repro.; and in the British Museum, O. M. Dalton, *Franks Bequest: Catalogue of the Finger Rings, Early Christian, Byzantine, Teutonic, Medieval, and Later* (London, 1912), 256, 267, nos. 1809, 1890, 1891, pl. 25. For Sixten Ringbom, "Filippo Lippis New Yorker Doppelporträt: Eine Deutung der Fenstersymbolik," *Zeitschrift für Kunstgeschichte* 48 (1985), 135–136, the window or loggia is a symbol of dignity and majesty.

9. Cortissoz 1929, 34; Venturi 1930, 384, 393; Fiocco 1931, 250; Berenson 1932, 161; van Marle 1936, 18, 20–22. Shapley 1968, 39, cites Berenson in a manuscript opinion, 1951, as attributing the painting to Girolamo di Giovanni da Camerino, but no document appears in NGA curatorial files.

10. Fiocco 1932, 340.

11. Anzelewsky 1967, 156–164.

12. Zeri 1969, 455.

13. Ringler 1970, 77–78.

14. Bonsanti 1983, 18–19.

15. Shapley 1968, 38–39; Shapley 1979, 437–438; Konrad Oberhuber associated the National Gallery's portrait with *Saint Martin* and *Saint George* (Kunstmuseum, Basel) by the Master of Sierenz (memorandum to Anna Voris, 1974, in NGA curatorial files). See Walter Ueberwasser, *Konrad Witz* (Basel, 1938), figs. 95–96. Ann Sutherland Harris, letter to J. Carter Brown, 27 September 1971, in NGA curatorial files, thought the portrait was related to Witz but dated it after the artist's lifetime because of the hat. Konrad Oberhuber, letter to Fern Rusk Shapley, 10 May 1978, in NGA curatorial files, called attention to the similarities in color and facial types to the *Finding of the True Cross* by the Upper Rhenish Master of 1479 (Kunstmuseum, Basel); see *Kunstmuseum Basel. Katalog. I. Die Kunst bis 1800. Sämtliche ausgestellten Werke* (Basel, 1966), 20, inv. no. 204.

16. Kurt Löcher, in conversation, 12 September 1988.

17. Hans Georg Gmelin, letter to the author, 21 October 1988, in NGA curatorial files. Jochen Luckhardt, in conversation, 20 October 1989, and Bernhard Schnackenburg, in conversation, 19 October 1989, also expressed opinions that the portrait was Tyrolean.

18. Paul Boerlin, in conversation, 22 September 1987.

19. Erich Egg, letter to the author, 16 June 1989, in NGA curatorial files; he also thought it might be Venetian.

20. Gisela Goldberg, in conversation, 24 September 1987.

21. Stella Newton, as per Martha Wolff memorandum, 2 April 1984, suggested both Basel and Savoy. For painting in Savoy see Charles Sterling, "Etudes savoyardes au temps du Duc Amédée," *L'Oeil* 178 (October 1969), 2–13; Conrad de Mandach, "De la peinture savoyarde au XVe siècle," *GBA* 10 (1913), 103–130.

22. Fritz Koreny, in conversation, 14 October 1987; he also thought the portrait might be Tyrolean, but not Italian. See Jan Białostocki, *The Art of the Renaissance in Eastern Europe: Hungary, Bohemia, Poland.* The Wrightsman Lectures (Ithaca, N.Y., 1976), 7–9.

23. Anzelewsky 1967, 160–161; see also John Pope-Hennessy, *The Portrait in the Renaissance* (New York, 1966), 35–63, 155–171, with numerous illustrations; Jean Lipman, "The Florentine Profile Portrait in the Quattrocento," *AB* 18 (1936), 54–102.

24. For example, in Crivelli's *Annunciation with Saint Emidius* (National Gallery, London) of 1486, illustrated and discussed in John Mills, *Carpets in Paintings* (London, 1983), 20–21, 24, 53, 54, pls. 14, 15. An interesting parallel to the National Gallery's panel is found in Cristoforo Landino's illuminations to *Disputationes Camaldulenses*, c. 1475 (Biblioteca Apostolica Vaticana, Rome, MS. Urb. lat. 508), where on fol. 1r there is a double portrait of the artist and Federigo di Montefeltro, framed by a window and a carpet hanging over the ledge. Montefeltro is in profile. See *Quinto centenario della Biblioteca Apostolica Vaticana 1475–1975* [exh. cat., Biblioteca Apostolica Vaticana] (Rome, 1975), 70, no. 181, pl. 32. I thank Jochen Luckhardt for this reference.

25. Ernst Buchner, *Das Deutsche Bildnis der Spätgotik und der frühen Dürerzeit* (Berlin, 1953): for Bavaria and Austria, including the Tyrol, see 104–121, nos. 108–135a, and accompanying plates; for comparative examples elsewhere in Germany see nos. 15, 28, 31, 33–34, 35, 85, 137, 150.

26. Identification by the National Gallery's scientific research department.

27. For example, Peter Klein, letter to Sarah Fisher, 15 July 1988, in NGA curatorial files, notes that linden was used throughout Europe and thus cannot be used to exclude any one nationality of artist.

28. Inv. no. Gm. 1192; photograph in NGA curatorial files. The painting is not in the best condition.

29. Anzelewsky 1967, 162–163, reproduces the *Saint Augustine as Bishop* and the *Refusal of Joachim's Offering* (both Stiftsgalerie, Neustift bei Brixen). Compare also the *Saint Monica and Saint Augustine* (Bayerisches Nationalmuseum, Munich), given to the Uttenheim Master but attributed to Michael Pacher in Peter Volk et al., *Bayerisches Nationalmuseum München. Führer durch die Schausammlung* (Munich, 1988), 47, repro.

30. Reproduced in Anzelewsky 1967, 159; see also Christian A. zu Salm and Gisela Goldberg, *Alte Pina-* *kothek München. Katalog. II. Altdeutsche Malerei* (Munich, 1963), 138, no. 10650. Although somewhat removed in terms of date and place, it is still possible to find points of comparison in the expressive, idiosyncratic facial types of the Master of the Polling Altarpiece, who worked in Upper Bavaria around 1440/1450. Wings from two of his altarpieces are in the Alte Pinakothek, Munich; see Erich Steingräber et al., *Alte Pinakothek Munich: Explanatory Notes on the Works Exhibited* (Munich, 1986), 335–338.

31. The only author to raise this question was van Marle 1936, 22: "It might easily be believed that the artist wished to convey the idea that the unhealthy looking youth is already dead, were it not for the fact that on other occasions he [Crivelli] has revealed a similar taste for manifestations of unwholesome charm."

32. See F. Parkes Weber, *Aspects of Death and Their Effects on the Living, as Illustrated by Minor Works of Art* (London and Leipzig, 1910), 57–59; G. F. Hill, "The Portraits of Giuliano de' Medici," *BurlM* 25 (1914), 117–118; Pope-Hennessy 1966, 37–41.

33. Both examples belong to the Kunsthistorisches Museum, Vienna; see Günther Heinz and Karl Schütz, *Katalog der Gemäldegalerie. Porträtgalerie zur Geschichte Österreichs von 1400 bis 1800* (Vienna, 1976), 225–227, nos. 193–194, figs. 20, 22. I am grateful to Karl Schütz for bringing these paintings to my attention in association with the National Gallery's portrait. Heinz Mackowitz, "Der Maler Hans von Schwaz" (Ph.D. diss., Universität Innsbruck, 1960), 37–57, 154, nos. 1–2, dates both paintings 1500/1510 but believes the portrait on loan to Schloss Ambras (inv. no. 4400) might be by the workshop. For the attribution to Niclas Reiser see Erich Egg, "Zur maximilianischen Kunst in Innsbruck," *Veröffentlichungen des Tiroler Landesmuseum Ferdinandeum* 46 (1966), 11–35. Bonsanti 1983 discusses and reproduces other paintings showing Mary of Burgundy in profile (pls. 6, 10a–b, 12a) as well as medals depicting her in profile (pls. 20, 21a–d). Even though Maximilian I married Bianca Maria Sforza in 1494, he would have encouraged the production of posthumous portraits of Mary as reminders of Habsburg-Burgundian alliance in the Netherlands.

34. For example, Hans Maler's portraits of Ferdinand I (one in the Galleria degli Uffizi, Florence); Mackowitz 1960, 158, 162, nos. 16, 17, 32, and Strigel's numerous portraits of Maximilian I; see Gertrud Otto, *Bernhard Strigel* (Munich and Berlin, 1964), 101–102, nos. 54, 58–60, figs. 123, 126–128.

35. Löcher, conversation, 12 September 1988; Karl Schütz, letter to the author, 8 February 1989, in NGA curatorial files, and in conversation, 24 February 1989.

References

1929 Cortissoz, Royal. "The Clarence H. Mackay Collection." *International Studio* 94: 34, repro. 32.
1930 Venturi, Lionello. "Contributi a Carlo Cri-

velli, a Vittore Carpaccio." *L'Arte*, n.s. 1: 384, 393, repro. 385.

1931 Fiocco, Giuseppe. "Ein neuer Crivelli." *Pantheon* 7: 250.

1931 Venturi, Lionello. *Pitture italiane in America*. Milan: pl. 278.

1932 Berenson, Bernhard. *Italian Pictures of the Renaissance*. Oxford: 161.

1932 Fiocco, Giuseppe. "Porträts aus der Emilia." *Pantheon* 10: 340, repro. 341.

1933 Venturi, Lionello. *Italian Paintings in America*. 3 vols. New York and Milan. 2: pl. 372.

1936 Berenson, Bernhard. *I pittori italiani del rinascimento*. Milan: pl. 6.

1936 van Marle, Raimond. *The Development of the Italian Schools of Painting*. 19 vols. The Hague. 18: 18, 20–22, fig. 12.

1967 Anzelewsky, Fedja. "Ein unbekanntes deutsches Fürstenporträt des 15. Jahrhunderts." *JbBerlin* 9: 156–164, repro

1968 Shapley, Fern Rusk, *Paintings from the Samuel H. Kress Collection: Italian Schools XV-XVI Century*. London: 38–39, fig. 91.

1969 Zeri, Federico. Review of *Paintings from the Samuel H. Kress Collection: Italian Schools XV–XVI Century* by Fern Rusk Shapley. *BurlM* 111: 455.

1970 Ringler, Josef. "Ein tiroler Fürstenbildnis der Spätgotik in Washington." *Der Schlern* 44: 77–78, repro. opposite 76.

1975 NGA: 254, repro. 255.

1976 Walker: 116, no. 99, repro.

1979 Shapley: 437–438, pl. 317.

1983 Bonsanti, Giorgio. "Maria di Borgogna in un ritratto di Michael Pacher." *Paragone* 34, no. 397: 18–19, pl. 9.

1985 NGA: 293, repro.

Tyrolean

FOUR PANELS FROM AN ALTARPIECE

1972.73.1 (2634)

Saint Alban of Mainz

c. 1500/1525
Spruce, 155.6 × 51.7 (61¼ × 20⅜)
Gift of Joanne Freedman

Inscriptions

Across bottom: ✛ *Sanctus* + *Albannus* ✛

On back of glove: ☖

On clip of pennant: ℳ

Technical notes: The panel is constructed from four boards of spruce wood joined vertically.[1] Dendrochronological analysis reveals that the boards of the *Saint Alban* panel match those of the *Saint Alcuin* panel (1972.73.4) in reverse, and thus that *Saint Alban* originally appeared on the interior and *Saint Alcuin* on the exterior of a single panel as one wing of an altarpiece. Likewise, *Saint Wolfgang* would have appeared on the exterior and *Saint Valentine* on the interior of another wing of an altarpiece. Dendrochronology also shows that all boards used in construction of the original two panels came from the same three trees, with an earliest felling date of 1495 (see Appendix), indicating the early sixteenth century as a plausible date for the creation of the altarpiece. The extreme thinness of the panels (0.1–0.5 cm.) appears to be the result of the separation at some time of obverse from reverse. The panels have been cradled.

Cloth, apparent in raking light and x-radiograph, has been applied over the ground in the upper section of the panel, above the screen. Underdrawing, applied with a brush in a vigorous style, is visible to the naked eye in the more thinly applied areas of the flesh. Examination under infrared reflectography further reveals that washes were applied to establish shadow, with line drawing used extensively to set outline and interior detail. The area of the screen has been textured, first by tooling in the ground layer, then by application of ridges of thick paint over a warm brown underlayer. This area was subsequently gilded, and bright green and black paint was applied to add depth and detail, with the green creating additional ridges. This tech-

nique is observable under microscopic examination. The flesh areas are very thinly painted.

Washboarding, warping, and localized splitting are present in the center of the panel. There is a long check (approximately 146 cm.) extending up through the saint's left shoulder and above his head, and a join is partially visible in his face. Losses have occurred throughout the panel, but especially in the lower section. There is blistering in the saint's red cloak above the trim; to the left of the central join in the floor, just below the cloak; and below left of the saint's foot. Unusual losses in the form of regular rectangles are scattered over the surface but occur mostly in the lower part of the robe.

Two stages of retouching are present. The older stage is generalized and extends over original paint in the inner sleeves, inner cloak, and extensively in the floor platform. The second stage is confined to areas of loss, primarily along the three joins and along the sides and top edge. All of the retouching is discolored and frequently matte.

Provenance: Joanne Freedman [d. 1982], Washington, D.C., by 1972.

1972.73.2 (2635)

Saint Wolfgang

c. 1500/1525
Spruce, 155.5 × 51.5 (61¼ × 20¼)
Gift of Joanne Freedman

Inscriptions

Across bottom: ✛ *Sanctus* ✛ *Wolfgang* ✛

On clip of pennant: *iℏs*

Technical Notes: The dendrochronological analysis shows that the three vertically joined spruce wood boards used to construct the panel match those of the *Saint Valentine* panel (1972.73.3), in reverse.[2] The technique is consistent with that in *Saint Alban of Mainz* (1972.73.1) except for the absence of fabric on the upper third of the panel. Areas to be gilded, such as the tracery, staff, and miter, were worked first, with gilding applied directly onto the white ground; no bole layer

appears between. Infrared reflectography reveals that underdrawing established outlines throughout and that washes were used to create shadows. The only change seems to be in the saint's right hand; the outline of the index finger extends farther in the underdrawing than in the final painted version. The screen is textured, with a combination of tooled lines and thick paint, as in the *Saint Alban*. The surface pattern was created in black paint; black outlines also appear in the tracery, around the model of the church, and around the axe.

Throughout the panel there are areas of severe cupping, slight washboarding, and a series of checks. The left side of the saint's cloak is badly damaged, and there are severe losses along the bottom edge of the panel, along the central join, and in the saint's upper left arm, extending into the background. Retouching appears to be have been carried out in two stages: the first and older stage was more generalized, extending over original paint; the second was confined to specific losses. The retouching is visible in the gilded areas, along the sides of the panel, in the lower section, in the figure, and following the lines of the tracery. The crudely applied lines in the model of the church are later retouching.

Provenance: Same as 1972.73.1.

1972.73.3 (2636)

Saint Valentine

c. 1500/1525
Spruce, 155.6 × 51.7 (61¼ × 20⅜)
Gift of Joanne Freedman

Inscription

Across bottom: ✚ *S us* ⌐ *Vallentin* ꝰ ✚

Technical Notes: Like *Saint Wolfgang* (1972.73.2) this panel is composed of three boards of spruce wood. Dendrochronological analysis has shown that the boards of this panel match those of the *Saint Wolfgang* panel in reverse, the two having once been obverse and reverse of one wing of an altarpiece. The *Saint Valentine*, like the *Saint Alban of Mainz*, was an interior wing, and the two are technically quite similar. The ground is formed by a relatively thin white layer, which has discolored. In the upper section of the panel, above the screen, cloth has been applied over the relatively thin white ground, as in the *Saint Alban* panel, but here the cloth is of a tighter weave. Underdrawing, applied with a brush in a vigorous style, is visible in the flesh tones. Infrared reflectography reveals that it is used extensively to outline and detail forms, with wash used to

create shadows. The painted image follows the underdrawing.

The condition of the panel is similar to that of the *Saint Alban* panel. The paint surface is cupped, and there are rather extensive losses. There is some blistering in the bottom section, particularly in the retouching to the left of the letter *V* and near the barbe on the right-hand side. In areas of red pigment there is some evidence of shrinkage of the paint film during drying. Retouching was carried out in two stages. The earlier, more generalized stage covered much original paint in the figure and in the bottom section, mainly along the left-hand side. The second stage of retouching covered losses along the left join, near the saint's upper right arm, across the platform, along the top edge of the panel, and in scattered small areas throughout. There is a split in the panel along the left edge, and there are several checks. The small donor figure in seventeenth-century dress has been painted over the letters ". . . anct" and is a later addition.

Provenance: Same as 1972.73.1.

1972.73.4 (2637)

Saint Alcuin

c. 1500/1525
Spruce, 155.3 × 51.6 (61⅛ × 20⅜)
Gift of Joanne Freedman

Inscriptions

Across bottom: ✚ *Sanctus* ◇ *Alcuinus* ◂ ✗

On scroll across chest: 𝔐 𝔄𝔩𝔰𝔩𝔳𝔖

On blade of sword: 𝔐

On back of glove: Ⓐ

Technical Notes: The panel is constructed of four boards of spruce wood, joined vertically, with vertical grain. Dendrochronological analysis revealed that the boards match those of the *Saint Alban of Mainz* panel (1972.73.1) in reverse, the two once having formed obverse and reverse of one wing of an altarpiece.[3]

The *Saint Alcuin* panel is comparable to the *Saint Wolfgang* panel in technique, with both having formed exterior wings. The panel has a relatively thin white ground. Work was first carried out on areas to be gilded, such as the tracery, staff, sword, and decoration of the miter. Gilding was applied directly to the white ground, with black underpaint used to create shadows. Underdrawing is visible to the naked eye in areas of flesh tone. Viewed with infrared reflectography, it appears to have

been applied throughout the composition in a vigorous style with a brush. Line drawing establishes both outline and detail; washes are used to establish shadow.

As is the case with the other three panels of the altarpiece, losses have been rather extensive, there is a slight washboarding effect, the paint surface has cupped, and there are a number of checks. Retouching was carried out in two stages. There is a fair amount of retouching from the first, older state in the saint's right side, on the miter, on the bottom of the panel to either side of the saint, in the lettering, and in the gilded areas, especially following the tracery. This retouching is quite generalized and covers much original paint. The second stage of retouching, which seems confined to losses, can be seen in the center of the figure. There are also some unusual paint losses. These are rectangular in shape and appear in the saint's left hand, sword hilt, cloak, and lower and central parts of his robe.

Provenance: Same as 1972.73.1.

AS SHOWN by the technical analysis, these four panels originally formed two wings of a larger retable, with Saints Alcuin and Wolfgang facing center on the exterior and Saints Alban and Valentine facing center on the interior. All four figures are depicted in full length and nearly life-size, in three-quarter view. The format of each panel is divided horizontally into four sections: the identification of the saint, a platform floor, a cloth of honor, and a solid-colored top section. The exterior wings included tracery decoration, and the interior wings are bracketed by columns imitative of carved retables. All four saints are depicted as bishops.

The previous attribution of these works to a late fifteenth-century follower of Michael Pacher can no longer be supported.[4] Schütz believes the paintings are later and more provincial than Pacher and places them c. 1500 or in the first years of the sixteenth century.[5] Goldberg dates them c. 1500/1520, placing them in south Germany, more exactly in Swabia, with Urbach concurring that they are more Swabian.[6] Robertson suggests a date of 1510–1520, not associating the works with Pacher but with a more northerly, possibly Swabian provenance.[7] Dendrochronological analysis confirms an earliest felling date of 1495 for the trees used to make the panels, indicating the early sixteenth century as a likely date for the creation of the altarpiece.

Unfortunately there is a paucity of comparable Swabian work. Only Goldberg suggests an example, citing the somewhat earlier (c. 1470) Swabian panels of *Saint Wolfgang and Saint Ottilla* and *Saint Barbara and Saint Dorothea* (Bayerisches Nationalmuseum, Munich) as exhibiting a similarly wooden physiognomy.[8] The type of large-scale, full-length saint in three-quarter view that dominates a single wing of an altarpiece is also to be found in a retable from Hagnau (Ulmer Museum, Ulm), dated 1518, from the Upper Swabian workshop of Master HG and Master HHS,[9] but there is no stylistic similarity to the National Gallery's panels.

It is, rather, in the Tyrol that examples of this type abound, popularized by such followers of Michael Pacher as Marx Reichlich in the six saint panels of the wings of the Perckhamer altarpiece (private collection),[10] and the Master of Uttenheim (Master Hans von Brixen) in his figures of female saints in the Uttenheim altarpiece (Österreichische Galerie, Vienna).[11] The pervasive influence of such full-length carved figures as the *Saint Wolfgang* and *Saint Benedict* in Pacher's *Saint Wolfgang* altarpiece (Parish Church of Saint Wolfgang, Abersee)[12] and such painted figures as *Saint Jerome, Saint Augustine, Saint Gregory,* and *Saint Ambrose* in the Altarpiece of the Church Fathers (Alte Pinakothek, Munich)[13] is seen by such authors as Semper as having inspired not only members of the Pacher workshop but generations of unknown provincial Tyrolean artists as well. A series of eight panels of individual saints—depicted in large scale, at full length, and in three-quarter view before simplified backgrounds—is assigned by Semper to a Brixen (Bressanone) artist associated with the workshop of Friedrich Pacher.[14] *Saint Stephan* and *Saint Elegius* particularly share with the National Gallery's panels a certain untutored awkwardness. Anatomy is imperfectly understood in the relation of one body part to another and in the recession of hands and elbows into space. Bodies are not apparent under drapery, which has an outsized and rigid life of its own, similar to that in numerous examples of the same type of saintly figure represented in altar wings in carved relief.[15] Tracery work and columnar divisions between panels are also common in these same works in relief.

The great majority of these retables in relief,

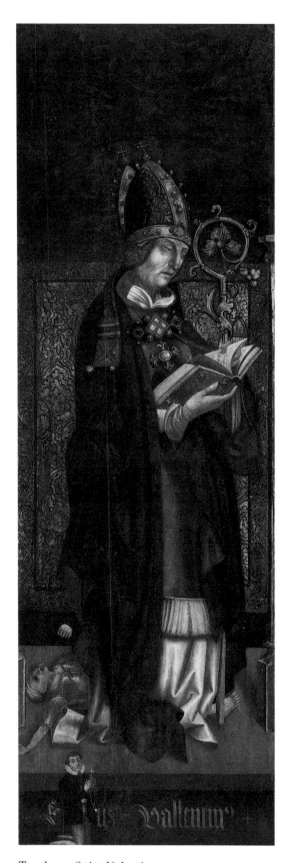

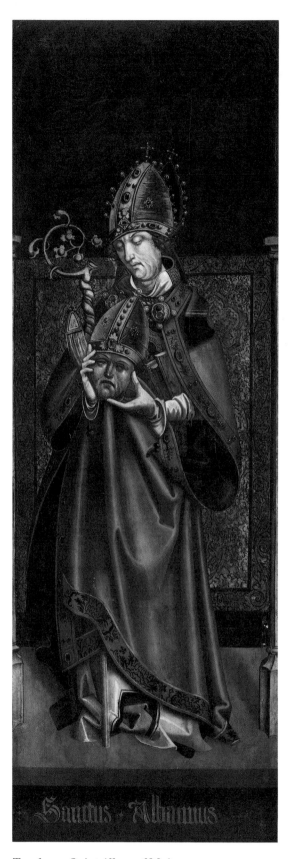

Tyrolean, *Saint Valentine*, 1972.73.3

Tyrolean, *Saint Alban of Mainz*, 1972.73.1

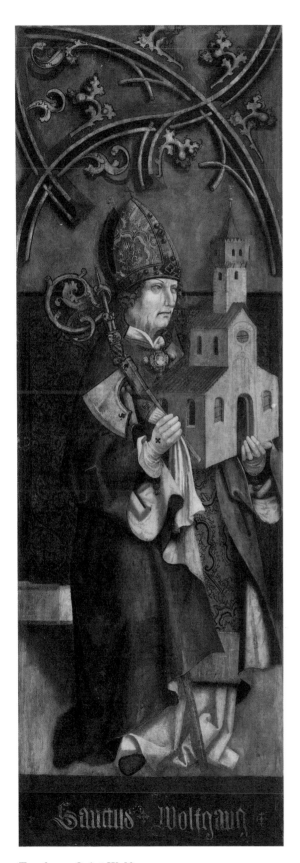

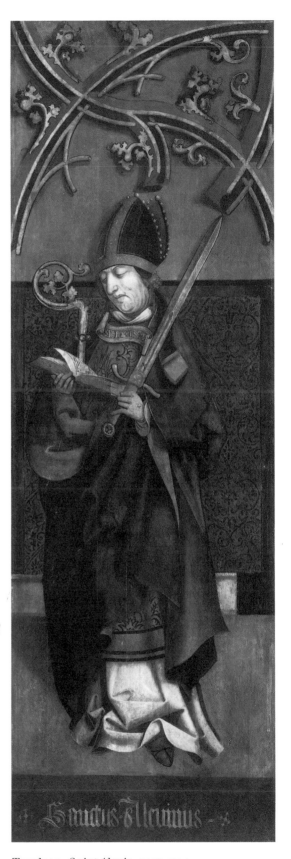

Tyrolean, *Saint Wolfgang*, 1972.73.2 Tyrolean, *Saint Alcuin*, 1972.73.4

whose wings are so similar to our painted examples, have high-relief or nearly free-standing carvings of a Madonna and Child as the center, usually with two flanking attendant saints. Reichlich's painted Perckhamer altarpiece has these carved figures at its center, and the painted Uttenheim altarpiece has a Madonna and Child enthroned with two angels as its center panel. The preponderance of examples with this arrangement makes it tempting to suggest that the lost center of the altarpiece once formed by the National Gallery's panels might also have included a Madonna and Child, possibly flanked by saints, possibly also carved.

The similarity of the type of saintly depiction in the National Gallery's panels to that found in painted and relief examples from the Tyrol, coupled with the awkwardness and limitations of the artist's style, argue for an attribution of these paintings to a provincial artist of the Tyrol. A connection with the Tyrol may further be suggested by the saints represented. Both Saints Valentine and Wolfgang were widely venerated in that area.

Saint Valentine (Valentin) was an abbot and then became the first bishop of Passau and Rätien (Rhätein). Later he traveled as an itinerant missionary bishop. Upon his death in 470 he was interred in Mais, near Merano, in the Italian Tyrol. His legs were translated to Trent in 739 or 750 and moved again in 764 or 768 by Tassilo III, duke of Bavaria, to the city of Passau. Saint Valentine was made patron of the diocese. He was frequently represented in art in the late fifteenth and early sixteenth centuries, with special popularity in Germany and many churches in the Tyrol.[16] He is usually depicted, as seen here, as a bishop with miter, crozier, and sword, and with a cripple or epileptic beneath his feet. The legend of his healing of these afflicted was appropriated from the story of another Saint Valentine, bishop of Terni.[17]

Saint Wolfgang was born in Swabia in 924 and studied at the Abbey of Reichenau on an island in Lake Constance. He taught at Würzburg and Trier, and in 965 became a Benedictine monk at Einsiedeln. In 968 he became a priest and was sent to teach the Magyars in Hungary. A great reformer and teacher, he was made bishop of Regensburg, retiring to the convent at Mondsee in 976. He died while traveling in Puppingen near

Linz in 994 and was buried at Regensburg in the cloister church of Saint-Emmeram. The cult of Saint Wolfgang is localized in Bavaria, Austria, Hungary, and the Tyrol, and the saint is patron of Bavaria, of the city and diocese of Regensburg, and of Hungary. Most representations of him date from the fifteenth and early sixteenth centuries, where he appears as seen here, as a bishop with crozier and miter. His individual attributes, the hatchet and the model of the church, refer to the legend that, in order to fix the spot for his monastery at Salzkammergut, he threw the hatchet—an old German custom to claim territory—and then built the church of Saint Wolfgang at Abersee with his own hands.[18]

Saint Alcuin (Alkuin, Alcwin) shares with Saint Wolfgang an eminence in the Benedictine Order. Theologian, grammarian, poet, philosopher, astronomer, and the "schoolmaster" and "Erasmus of his age," Alcuin was born in about 730/735 to a noble family in York, England. He entered the Benedictine Order there and in 767 became the director of the cathedral school where he had studied. In 780 he traveled to Rome, and on his return journey he met Charlemagne and joined his court as an ecclesiastical advisor. In France he helped to found several schools and was one of the driving forces of the Carolingen Renaissance. He was director of the palace school at Aachen and in 796 became abbot of Tours, traveling for Charlemagne and attending councils at Frankfurt and Aachen. He also held abbeys at Ferrières, Troues, and Cormery. He died on 19 May 804, leaving behind many religious and educational writings; his relics are at Saint Martin of Tours. Alcuin was beatified but never canonized, and his cult was not confirmed until 1907. Representations of him are rare; his memory was only celebrated in Benedictine cloisters.[19] In the National Gallery's panel he appears as a bishop (although he was not) with crozier, miter, and book. The sword may be a reference to his close relationship to Charlemagne *ecclesial defensor et amator* or because his name appears in the Benedictine martyrology. The obscurity of visual representations of Alcuin may account for the artist's repeated labeling of him: below the saint's feet, in a banner across his chest, and in the initial *A* that appears both on his glove and his sword.

Saint Alban (Albinus, Albanus) was a Greek or Albanian priest who traveled to Germany at the urging of Saint Ambrose and was martyred near Mainz in about 405/406 (before 451), beheaded by vandals. He miraculously carried his head in both his hands to his resting place. In the late fifth century his relics were moved from outside the city to a hill called Albansberg. A Benedictine abbey was erected there toward the end of the eighth century and later became famous. Alban is the patron saint of Mainz and Namur. He is frequently represented in art with his head in his hands, as in the National Gallery's panel. In the fifteenth and sixteenth centuries he appears, as here, as a bishop, although he, like Saint Alcuin, was not one.[20] A Saint Albinus, bishop of Brixen (Bressanone) in the Tyrol in about the fourth century, is also mentioned.[21]

The importance of Saint Valentine and Saint Wolfgang in the Tyrol reinforces the typological and stylistic relationships of these panels to the area. The further association of Saint Wolfgang, Saint Alcuin, and Saint Alban with the Benedictine Order, and the fact that the memory of Saint Alcuin was celebrated only in Benedictine cloisters, suggests that these four paintings might have formed wings of a larger altarpiece once created for a Benedictine monastery in the Tyrol.

Notes

1. As identified by Peter Klein, examination report, 26 September 1987, in NGA curatorial files.

2. See note 1 and Appendix.

3. See note 1 and Appendix.

4. The earliest references to the panels are Anna Voris, memorandum, 30 June 1972, in NGA curatorial files, who calls them "Tyrolean, late XV century (Follower of Michael Pacher, possibly Friedrich Pacher)"; see also NGA 1975, 258; NGA 1985, 297.

5. Karl Schütz, conversation with the author, 24 February 1989.

6. Gisela Goldberg, letter to the author, 20 July 1989, in NGA curatorial files. Susan Urbach, in conversation, 18 September 1989.

7. David Robertson, letter to the author, 6 September 1989, in NGA curatorial files.

8. *Kataloge des bayerischen Nationalmuseums in München.* Vol. 8. *Katalog der Gemälde des bayerischen Nationalmuseums* (Munich, 1908), 84, nos. 276, 277.

9. See *Bildhauerei und Malerei von 13. Jahrhundert bis 1600: Kataloge des Ulmer Museums* (Ulm, 1981), 196, 197, no. 129.

10. See Vinzenz Oberhammer, "Der Perckhamer-Altar des Marx Reichlich," *Pantheon*, n.s., 28 (1970), 374–375, 377.

11. See Erich Egg, *Kunst in Tirol: Malerei und Kunsthandwerk* (Innsbruck, n.d.), 77, no. 43.

12. See Nicolò Rasmo, *Michael Pacher* (London, 1971), repros. 75, 76, 79, 80; and for further comparison, painted figures of bishop saints in panels of *Curing the Woman Possessed by the Devil*, repro. 104.

13. See Rasmo 1971, repros. 56, 59; note also, for comparison, bishop saints in the panels of *The Miraculous Cure* and *A Disputation with the Devil*, repros. 66, 68, and *Saints Erasmus and Elizabeth*, repros. 110, 111.

14. Hans Semper, *Michael und Friedrich Pacher. Ihr Kreis und ihre Nachfolger* (Eszlingen an Neckar, 1911), 231–234, nos. 96–99.

15. For examples see Semper 1911, 276, no. 116; 283, no. 119; 304, no. 134; 307, no. 137; 308, no. 138; 315, no. 140; 323, no. 143; and Karl Atz, *Kunstgeschichte von Tirol und Vorarlberg* (Innsbruck, 1909), 529, no. 570; 531, no. 571; 533, no. 573; 535, no. 575; 536, no. 576; 540, no. 580; 547, no. 586; 555, no. 591; 559, no. 593; 562, no. 595; 573, no. 601; 595, no. 616; 601, no. 620.

16. See Anton Maurer, "St. Valentin und seine Kirchen in Südtirol," *Der Schlern* 41, no. 2 (1967), 61–66.

17. For Saint Valentine see Thurston and Attwater, 4: 47; Réau, *Iconographie*, vol. 3, pt. 3, (1959), 1303–1304; Joseph Braun, *Tracht und Attribute der Heiligen in der deutschen Kunst* (Stuttgart, 1943), cols. 711–712; Braunfels, *LexChrI*, 8: cols. 529–530.

18. For Saint Wolfgang see Thurston and Attwater, 4: 230–231; Réau, *Iconographie*, vol. 3, pt. 3, 1348–1350; Braun 1943, cols. 756–760; *LexChrI*, 8: cols. 626–629. For Saint Wolfgang am Abersee see Robert Stiassny, *Michael Pachers St. Wolfganger Altar* (Vienna, 1919), 1–16.

19. For Saint Alcuin see Thurston and Attwater, 2: 348–349; *LexChrI*, 5: col. 98; *Bibliotheca Sanctorum* 1 (Rome, 1961), cols. 730–735; Johan Evang. Stadler and Franz Joseph Heim, *Vollständiges Heiligen-Lexikon*, 5 vols. (1858; reprint, Augsburg, 1975), 1: 116–117; Michael Buchberger, *Lexikon für Theologie und Kirche*, 10 vols. (Freiburg, 1957), 1: cols. 340–341; F. G. Holweck, *A Biographical Dictionary of the Saints* (1924; reprint, Detroit, 1969), 42; M. L.-J. Guénebault, *Dictionnaire iconographique des figures, légendes et actes des saints, tant de l'ancienne que la nouvelle loi, et répertoire alphabétique des attributs* (Paris, 1830), col. 40.

20. For Saint Alban of Mainz see Thurston and Attwater, 2: 608–609; Réau, *Iconographie*, vol. 3, pt. 1, 44; Braun 1943, cols. 49–52; *LexChrI*, 5: cols. 68–70.

21. Guénebault 1830, col. 60.

References

1975 NGA: 258, repro. 259.
1985 NGA: 297, repro.

Dendrochronological Analysis of German Panels in the National Gallery of Art

Dr. Peter Klein, of the Ordinariat für Holzbiologie, Universität Hamburg, conducted dendrochronological examinations of the National Gallery's German panels on 12–16 September 1983, 18 February–8 March 1986, and 27 August–12 September 1986. It was not possible to examine all of the paintings, and not all examinations yielded concrete results.

Unlike Netherlandish artists, who generally used oak, German artists painted on a variety of woods: oak from both western Europe and the Baltic/Polish region, beech, spruce, fir, poplar, and linden. Linden was often used, and several of the National Gallery's German paintings are on linden, but it has not been possible to establish a master chronology for this wood. The chronologies established for other wood species by the Ordinariat für Holzbiologie were used as the basis for interpreting the data gathered from the National Gallery's panels.

In manufacturing oak panels, the panel makers normally used radially cut wood planks. The bark and the light and perishable sapwood were cut off, making a determination of the exact felling year impossible. Only the year of the last measured growth ring can be determined exactly.

The estimate of the number of sapwood rings to be added is derived by statistical evaluation, which must consider each case separately (table 1). For the sapwood statistic, the provenance of the oak wood is significant. The number of sapwood rings is different in western and eastern Europe. The new evidence elaborated in the revised eastern provenance chronology for oak panels must be considered in determining the sapwood allowance. It has been proven that the wood used for Netherlandish panels originated mainly from the Baltic region (Eckstein et al. 1986).

An analysis of the number of sapwood rings from north Poland and the Baltic region resulted in a median value of 15, with 50% of all values lying between 13 and 19, a minimum of 9, and a maximum of 36. In addition, the number of sapwood rings also depends on the age of the tree, that is, one expects more sapwood rings on a tree 300 years old than on a tree 100 years old. Panels from eastern Europe that include a few sapwood rings make possible determination of the felling date within the range of $+4$ and -2 years. Where the sapwood is missing, the felling date can only be approximated; this is illustrated by the mathematical term 15^{+x}_{-2}. . . . In this expression the "$15-2$" accounts for the sapwood rings possibly involved, while "x" stands for an unknown number of missing heartwood rings.

For oak that has been dated with western European chronologies a median value of 17 sapwood rings is used, with 50% of all values lying between 13 and 23 rings. For the determination of an earliest possible felling date, a minimum of 7 sapwood rings must be considered. A probable felling date can be estimated by adding 17^{+6}_{-4} or 17^{+x}_{-4}.

Because beech and spruce do not contain visible sapwood, it may be assumed that in making the panels only the bark was removed and the entire tree was utilized (table 2). Therefore the last measured ring always means the earliest felling date. For beech, mainly used by Lucas Cranach the Elder, storage time can be estimated between 2 and 7 years. For spruce in the sixteenth century a similar length of storage time can be presumed.

TABLE 1

Artist	Species	Number of Boards	Number of Growth Rings	Latest Growth Ring	Earliest Felling Date[1]	Probable Felling Date[2]	Remarks
Attributed to Bartholomaeus Bruyn the Elder *Portrait of a Man* 1953.3.5	Oak	I	132	1475	1484	1490	The wood comes from the Baltic/Polish region.
German *Portrait of a Lady* 1942.16.3	Oak	I II III	92 67 53	1522 1515 1522	1529	1539	All boards came from the same tree. The wood comes from western or central Europe. The date of 1532 on the panel could be reconciled with the dendrochronology if the minimum of 7 sapwood rings were present, no further heartwood rings were cut off, and storage time was at a minimum of two years. This would give an earliest possible felling date of 1529 and an earliest creation time of 1531.
Hans Holbein the Younger *Edward VI as a Child* 1937.1.64	Oak	I II	130 133				Comparisons with extant master chronologies for Europe did not yield dates.
Hans Holbein the Younger *Sir Brian Tuke* 1937.1.65	Oak	I II	182 (+40) 77	1510 1515	1519 1524	1525 1530	The wood comes from the Baltic/Polish region.
Johann Koerbecke *The Ascension* 1959.9.5	Oak	I II III	109 95 78	1403 1348 1401	1410	1420	The wood comes from central Europe, and all boards are from the same tree.
Nicolaus Kremer *Portrait of a Nobleman* 1947.6.3	Oak	I II III	165	1476	1483	1493	The panel is dated 1529. Only the middle board, which comes from central Europe, could be measured.
Master of Saint Veronica *The Crucifixion* 1961.9.29	Oak	I	110	1381	1388	1398	The wood comes from central Europe; its growth ring structure is identical to that in panels of the Cologne School.

1. With 7 or 9 sapwood rings dependent on the origin of the wood.
2. With the range of 15^{+4}_{-2}, 15^{+X}_{-2} or 17^{+6}_{-4}, 17^{+X}_{-4} sapwood rings.

TABLE 2

Artist	Species	Number of Boards	Number of Growth Rings	Latest Growth Ring	Earliest Felling Date	Remarks
Lucas Cranach the Elder *Madonna and Child* 1953.3.1	Beech	I II	48 32	1453 1513	1513	
Lucas Cranach the Elder *Portrait of a Man* 1959.9.1	Beech	I II	161 117	1516 1514	1516	The portrait is dated 1522.
Lucas Cranach the Elder *Portrait of a Woman* 1959.9.2	Beech	I II	130 152	1475 1516	1516	
Lucas Cranach the Elder *The Crucifixion with the Converted Centurion* 1961.9.69	Beech	I II	46 92	1531 1530	1531	The panel is dated 1536. The two boards came from the same tree.
Tyrolean *Saint Alban of Mainz* 1972.73.1	Spruce	I II III IV	63 101 78 41	1493° 1490* 1493° 1462°		Boards with the same symbols (°, *, ♦) come from the same tree. The boards were measured using a chronology established for the Alpine region. With a minimum of 2 years storage a probable earliest use date of 1497 or later can be proposed, but based on the storage time of 5–20 years for the spruce in string instruments, a date in the early sixteenth century is more plausible.
Tyrolean *Saint Wolfgang* 1972.73.2	Spruce	I II III	90 116 103	1491* 1495♦ 1481♦	1495	
Tyrolean *Saint Valentine* 1972.73.3	Spruce	I II III	104 116 87	1482♦ 1494♦ 1489*		
Tyrolean *Saint Alcuin* 1972.73.4	Spruce	I II III IV	42 80 90 62	1462° 1492° 1489* 1492°		

Bibliography

Bauch, Josef, Dieter Eckstein, and Peter Klein. "Dendrochronologische Untersuchungen an Gemäldetafeln des Wallraf-Richartz-Museums, Köln." In Frank Günter Zehnder, *Katalog der altkölner Malerei. Kataloge des Wallraf-Richartz-Museums XI.* Cologne, 1990, 667–683.

Eckstein, Dieter, et al. "New Evidence for the Dendrochronological Dating of Netherlandish Paintings." *Nature* (1986), 320, 465–466.

Klein, Peter. "Dendrochronological Analysis of Early Netherlandish Panels in the National Gallery of Art." In John Oliver Hand and Martha Wolff, *Early Netherlandish Painting.* Systematic Catalogue of the Collections of the National Gallery of Art. Washington 1986, 259–260.

Klein, Peter. "Zum Forschungsstand der Dendrochronologie europäischer Tafelmalerei." *Restauratorenblätter IIC* 10. Vienna, 1989, 33–47.

Klein, Peter. "Tree-Ring Chronologies of Conifer Wood and Its Application to the Dating of Panels." *ICOM Committee for Conservation.* Vol. 1. Dresden, 1990, 58–60.

Kunsthalle, Kupferstichkabinett
 Liss, Johann, *Fighting Gobbi Musicians,* 120
Hannover
 Niedersächisches Landesmuseum
 Mielich, Hans, *Crucifixion,* 9, 146
Heemskerck, Maerten van, 8, 22
Heiligenkreuz, Cistercian abbey, 127
hell, 154, *ill. on 153*
Henry VIII, king of England, 83, 86, 87, 88, 92
Holbein, Ambrosius, 82, 100
 works:
 depiction of a young man in an architectural set-
 ting (Hermitage, St. Petersburg), 100
 signboard for Oswald Geisshüsler (Kunstmu-
 seum, Basel), 82
 works attributed to, 101 note 14
Holbein, Hans, the Elder, 70, 82, 160
 drawing of Hans and Ambrosius (Kupferstichkabi-
 nett, Berlin), 82
Holbein, Hans, the Younger, xii, 27, **82–83**
 works:
 The Ambassadors (National Gallery, London), 83
 Bonifacius Amerbach (Kunstmuseum, Basel), 100
 Catechism by Thomas Cranmer, woodcut series,
 88
 Coverdale's 1535 translation of the Bible, wood-
 cut frontispiece, 88
 Dead Christ in the Tomb (Kunstmuseum, Basel),
 82
 Dorothea Kannengiesser (Kunstmuseum, Basel),
 82, 100
 drawings of the tomb sculptures of Jean, duc de
 Berry, and his wife, 82
 Edward VI as a Child [1937.1.64], 83–91, *ill. on
 85*
 copies by Hollar, 87 (figs. 3 and 4)
 copy by Oliver, 86 (fig. 2), 88, 88 note 3
 copy (Earl of Yarborough collection), 88
 copy (panel, Duke of Northumberland, Syon
 House), 88
 Latin inscription by Sir Richard Morison, 84,
 86, 87, 88
 preparatory drawing (Royal Library at Windsor
 Castle, London), 86 (fig. 1), 88
 *Enthroned Madonna and Child with Saints Nich-
 olas and George* (Museum der Stadt, Solo-
 thurn), 82
 Erasmus of Rotterdam (Kunstmuseum, Basel),
 100–101
 Family of Sir Thomas More (destroyed), 83
 drawing (Kunstmuseum, Kupferstichkabinett,
 Basel), 83
 Hermann Wedigh (Metropolitan Museum of Art,
 New York), 94
 Jacob Meyer zum Hasen (Kunstmuseum, Basel),
 82, 100
 Johannes Zimmermann (Xylotectus) (Germani-
 sches Nationalmuseum, Nuremberg), 101

*Madonna and Child with Jacob Meyer and His
 Family* (Schlossmuseum, Darmstadt), 82,
 83
marginal pen illustrations for Erasmus' *The
 Praise of Folly* (Kunstmuseum, Kupfer-
 stichkabinett, Basel), 82
Nicholas Kratzer (Musée du Louvre, Paris), 94
portrait of Erasmus (collection of the Earl of Rad-
 nor, Longford Castle, Wiltshire), 82
portrait of Erasmus (Musée du Louvre, Paris), 82
portrait of his wife and two children (Kunstmu-
 seum, Basel), 83, 100
portraits of German steelyard merchants, 94
signboard for Oswald Geisshüsler (Kunstmu-
 seum, Basel), 82
Sir Brian Tuke [1957.1.65], 91–97, *ill. on 93*
 copies, 95
Sir Henry Guildford (Royal Collection, Windsor
 Castle, London), 94
Sir Henry Wyatt (Musée du Louvre, Paris), 94
Sir Thomas More (Frick Collection, New York),
 94
Thomas Godsalve with His Son, John (Gemälde-
 galerie Alte Meister, Dresden), 94
Whitehall Palace fresco (destroyed), 83
cartoon (National Portrait Gallery, London), 83
works attributed to:
 Portrait of a Young Man [1961.9.21], 98–102, *ill.
 on 99*
 infrared reflectogram, 98 (fig. 1)
 A Schoolmaster Teaching Two Adults to Write
 (signboard, Kunstmuseum, Basel), 82
Huber, Wolf, 3, 155

I

Ingolstadt
 Church of Our Beautiful Lady
 Mielich, Hans, altarpiece, 146, 158
 Christ in Limbo, 158
 Resurrection, 158
International Style, 144

J

Jerusalem, 152–154, *ill. on 153*
Job, Book of, 67, 94
Jordaens, Jacob, *The Satyr and the Peasant* (Musées
 Royaux des Beaux-Arts, Brussels), 122

K

Karlsruhe
 Staatliche Kunsthalle
 Baldung Grien, Hans, drawings of the harbor and
 buildings on the island of Rhodes, 19
 Grünewald, Matthias
 Crucifixion, 74, 76, 77 (fig. 5)
 grisaille representations of saints for Domini-
 can church in Frankfurt, 70

Concordance of Old–New Titles

Artist	Accession No.	Old Title	New Title
Workshop of Albrecht Altdorfer	1952.5.31a–c	*The Fall of Man*	*The Rule of Bacchus, The Fall of Man, The Rule of Mars*
Albrecht Dürer	1952.2.17	*Portrait of a Clergyman*	*Portrait of a Clergyman (Johann Dorsch?)*
Bernhard Strigel	1947.6.4	*Hans Rott, Patrician of Memmingen*	*Hans Roth*
Bernhard Strigel	1947.6.5	*Margaret Vöhlin, Wife of Hans Rott*	*Margarethe Vöhlin, Wife of Hans Roth*

Concordance of Old–New Attributions

Old Attribution	Accession No.	New Attribution
Anonymous German, sixteenth century	1952.5.84	Workshop of Hans Mielich
Anonymous German, sixteenth century	1952.5.85	Workshop of Hans Mielich
Hans Baldung (called Grien)	1961.9.62	Hans Baldung Grien
Bartholomaeus Bruyn the Elder	1953.3.5	Attributed to Bartholomaeus Bruyn the Elder
Hans Holbein the Younger	1937.1.65	Attributed to Hans Holbein the Younger
North Italian, fifteenth century	1952.5.71	Tyrolean
Follower of Michael Pacher	1972.73.1	Tyrolean
Follower of Michael Pacher	1972.73.2	Tyrolean
Follower of Michael Pacher	1972.73.3	Tyrolean
Follower of Michael Pacher	1972.73.4	Tyrolean
Ludger tom Ring the Elder	1942.16.3	German

1937.1.64	(64)	Hans Holbein the Younger, *Edward VI as a Child*
1937.1.65	(65)	Hans Holbein the Younger, *Sir Brian Tuke*
1937.1.66	(66)	Hans Schäufelein, *Portrait of a Man*
1942.9.39	(635)	Johann Liss, *The Satyr and the Peasant*
1942.16.3	(700)	German, *Portrait of a Lady*
1947.6.1	(896)	Lucas Cranach the Elder, *A Prince of Saxony*
1947.6.2	(897)	Lucas Cranach the Elder, *A Princess of Saxony*
1947.6.3	(898)	Nicolaus Kremer, *Portrait of a Nobleman*
1947.6.4	(899)	Bernhard Strigel, *Hans Roth*
1947.6.5	(900)	Bernhard Strigel, *Margarethe Vöhlin, Wife of Hans Roth*
1952.2.16a–b	(1099)	Albrecht Dürer, *Madonna and Child*; reverse: *Lot and His Daughters*
1952.2.17	(1100)	Albrecht Dürer, *Portrait of a Clergyman (Johann Dorsch?)*
1952.5.31a–c	(1110)	Workshop of Albrecht Altdorfer, *The Rule of Bacchus, The Fall of Man, The Rule of Mars*
1952.5.71	(1150)	Tyrolean, *Portrait of a Man*
1952.5.83	(1162)	Master of Heiligenkreuz, *The Death of Saint Clare*
1952.5.84	(1163)	Workshop of Hans Mielich, *The Crucifixion*
1952.5.85	(1164)	Workshop of Hans Mielich, *Christ in Limbo*
1953.3.1	(1173)	Lucas Cranach the Elder, *Madonna and Child*
1953.3.5	(1179)	Attributed to Bartholomaeus Bruyn the Elder, *Portrait of a Man*
1957.12.1	(1497)	Lucas Cranach the Elder, *The Nymph of the Spring*
1959.9.1	(1371)	Lucas Cranach the Elder, *Portrait of a Man*
1959.9.2	(1372)	Lucas Cranach the Elder, *Portrait of a Woman*
1959.9.5	(1528)	Johann Koerbecke, *The Ascension*
1961.9.19	(1379)	Matthias Grünewald, *The Small Crucifixion*
1961.9.21	(1381)	Attributed to Hans Holbein the Younger, *Portrait of a Young Man*
1961.9.29	(1390)	Master of Saint Veronica, *The Crucifixion*
1961.9.62	(1614)	Hans Baldung Grien, *Saint Anne with the Christ Child, the Virgin, and Saint John the Baptist*
1961.9.69	(1621)	Lucas Cranach the Elder, *The Crucifixion with the Converted Centurion*
1961.9.78	(1630)	Master of the Saint Bartholomew Altar, *The Baptism of Christ*
1961.9.88	(1640)	Bernhard Strigel, *Saint Mary Cleophas and Her Family*
1961.9.89	(1641)	Bernhard Strigel, *Saint Mary Salome and Her Family*
1972.73.1	(2634)	Tyrolean, *Saint Alban of Mainz*
1972.73.2	(2635)	Tyrolean, *Saint Wolfgang*
1972.73.3	(2636)	Tyrolean, *Saint Valentine*
1972.73.4	(2637)	Tyrolean, *Saint Alcuin*
1984.66.1		Hans Mielich, *A Member of the Fröschl Family*